FIFTH EDITION

LEGAL GUIDE

FOR THE

VISUAL ARTIST

TAD CRAWFORD

Other Books by Tad Crawford

FIFTH EDITION
LEGAL GUIDE
FOR THE
VISUAL ARTIST
TAD CRAWFORD

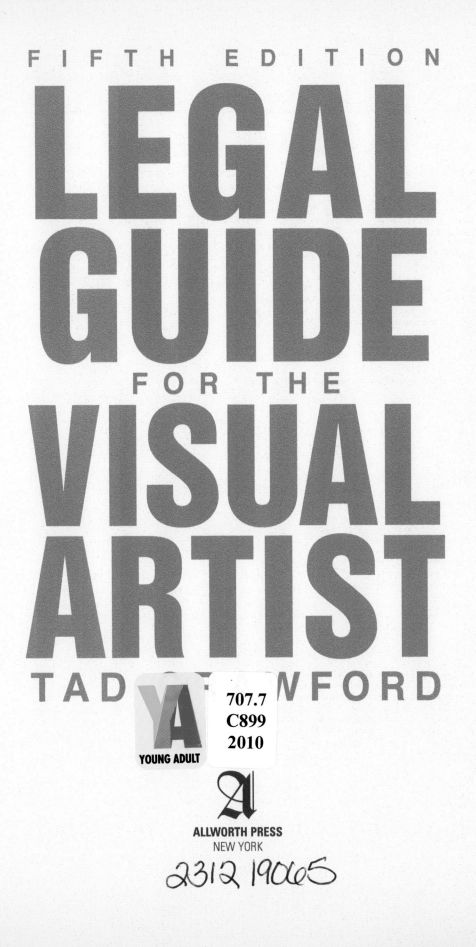

ALLWORTH PRESS
NEW YORK

Allworth Press books may be purchased in bulk at special discounts for sales promotion, corporate gifts, fund-raising, or educational purposes. Special editions can also be created to specifications. For details, contact the Special Sales Department, Allworth Press, 307 West 36th Street, 11th Floor, New York, NY 10018 or info@ skyhorsepublishing.com.

Published by Allworth Press, an imprint of Skyhorse Publishing, Inc., 307 West 36th Street, 11th Floor, New York, NY 10018.

Allworth Press® is a registered trademark of Skyhorse Publishing, Inc.®, a Delaware corporation.

www.allworth.com

18 17 16 15 14 13 12 11 10 8 7 6 5 4 3

Cover design by Mary King

ISBN: 978-1-58115-742-0

Library of Congress Cataloging-in-Publication Data

Crawford, Tad, 1946-
 Legal guide for the visual artist / Tad Crawford. – 5th ed.
 p. cm.
Includes bibliographical references and index.
ISBN 978-1-58115-742-0 (pbk. : alk. paper)
1. Artists–Legal status, laws, etc.–United States. I. Title.

 KF390.A7C73 2010
 340.02'47—dc22

 2010018844

Printed in Canada

CONTENTS

ACKNOWLEDGMENTS

This fifth edition of *Legal Guide for the Visual Artist* bene-fitted greatly from the exacting work of my superb research assistant, Arka Chatterjee, Esquire. I also want to thank Alma Robinson and Christina Wiellette of the California Lawyers for the Arts. In addition, I was fortunate to have the unfailing support of the Allworth Press staff—Robert Porter, Marrissa Jones, Sara Hendricksen, Shea Connelly, and Sydney Ann Lee. I am also deeply appreciative for the invaluable encouragement and assistance that I received from many friends and colleagues in creating the first four editions this book. Their advice helped both to form the book and to reshape it to match the countless transforma-tions of art law and technology. For their contributions, I would like to express my appreciation to Nyier Abdou; Bill Beckley; Jeffrey Cooper, Esquire; Jack Crawford, Jr.; Hal Daub, Esquire; Chuck DeLaney; Eileen Farley; Arthur Eisman, C.P.A.; Ted Gachot; James L. Garrity, Esquire; Diane Ginsberg; Simon Gluckman, C.P.A.; Rubin L. Gorewitz, C.P.A.; Anne Hellman; Paul Jacobs, Esquire; Tim Jensen, Esquire; Arie Kopelman, Esquire; Caryn Leland, Esquire; Tony Lyons, Esquire; Laura Mankin; Elsie Mills; Professor Joseph M. Perillo; MaryBeth Peters, Esquire; Phyllis Pollock; Robert Porter; Brenda Ramirez; Cynthia Rivelli; Gebrina Roberts; Zulema Rodriguez; the School of Visual Arts; the School of Visual Arts Alumni Association; Carolyn Trager; Roger Welch; and Carl Zanger, Esquire.

I would also like to thank Bill Beckley for co-author-ing the discussion of uniqueness in chapter 13; the National Endowment for the Arts for assistance that enabled me to interview Alberto Vargas and Alfred Crimi; and Barry Blackman, Art Rogers, and James Earl Reid for their gen-erous permission to reproduce images of their art.

Business art is the step that comes after Art. I started as a commercial artist, and I want to finish as a business artist. After I did the thing called "art," or whatever it's called, I went into business art. I wanted to be an Art Businessman or a Business Artist. Being good in business is the most fascinating kind of art. During the hippie era people put down the idea of business—they'd say, "Money is bad," and "Working is bad," but making money is art and working is art and good business is the best art.

> —Andy Warhol, pop artist, from *The Philosophy of Andy Warhol: From A to B and Back Again*

The immediate cause of the sense of infinite corruption, degradation and humiliation that is the normal lot of the American artist today is the art world. . . .One has only to observe what happens to the sense of friendship, love, fraternity and comradeship among artists as they are "picked up" by the art world to see, instantly, that the rewards of such "success" are death and degradation. The art world is a poison in the community of artists and must be removed by obliteration. This happens the instant artists withdraw from it.

> —Carl Andre, minimal artist, from *Open Hearing*

I collect money, not art. . . .There is only one measure of success in running a gallery: making money. Any dealer who says it's not is a hypocrite or will soon be closing his doors.

> —Frank Lloyd, gallery owner, from his obituary in *The New York Times*

1

THE BUSINESS OF ART

This is the fifth edition of *Legal Guide for the Visual Artist*. The book has a broad scope and uses "visual artist" to include cartoonists, craftspeople, graphic designers, illustrators, painters, photographers, printmakers, sculptors, and textile designers. All of the people in these categories are artists, and all need and will benefit from the information offered in this book.

What I find remarkable in looking back to 1977 when I wrote the first edition of *Legal Guide* is how legal protections have expanded for artists and how technology has changed the way in which information, including the information contained in art, can be processed and disseminated to the public. The text will elaborate these themes, but certainly the passage of the Visual Artists Rights Act and the rapid evolution of digital technologies are dramatic examples of the legal and technological changes affecting artists.

Art law, although drawn from many areas of the law, has developed more and more into a distinct entity over the last fifty years. *Legal Guide for the Visual Artist* seeks to introduce artists to the legal issues of both art in commerce and artists' rights. It deals with each of the sequence of issues that begin as soon as the artist contemplates creating a work of art, including copyright, contracts of all types, taxes, estate planning, and public support for artists.

Action in the legal sphere may appear to be an anomaly for the artist involved with creative work. Perhaps, as Carl Andre suggests, the artist should seek to withdraw from the art world and the dangers of success. Yet the artist seeking to earn his or her living from an art career must focus on art as commerce, what Andy Warhol calls being "a business artist."

All artists, whether they agree with Carl Andre or Andy Warhol, must be capable of resolving business and legal issues. In this respect, a greater familiarity with art law and other sources of support will help the artist. Artists should never feel intimidated, helpless, or victimized. Legal and business considerations exist from the moment an artist conceives a work or receives an assignment. While no handbook can solve the unique problems of each artist, the artist's increased awareness of the general legal issues pertaining to art will aid in avoiding risks and gaining benefits that might otherwise pass unnoticed.

Artists' Groups

Artists' groups provide a valuable support network. There are too many of these groups across the country to mention each by name, but those with a special interest in artists' rights, including legal and business issues, are listed in the Appendix on pages 257–263.

Many of the groups offer newsletters and other information services of value to their members. A few provide legal services, while others lobby for legislation favorable to artists. Health, life, and even automobile insurance are frequently offered at group rates. Some of the groups promote art by sponsoring shows, publishing books, or maintaining slide registries of art.

Within the boundaries of the antitrust laws, certain groups publish surveys to help members determine fair pricing practices. A number of the groups have codes of ethics, which dictate standards for both business and art practices in the profession.

Joining an artists' group can be an important step for an artist in terms of protecting rights and advancing his or her professional prestige.

Lawyers for the Arts

The search for a lawyer is often time-consuming and disheartening. Not only are fees high, but many lawyers are not knowledgeable about the issues encountered by artists. Standard techniques for finding a lawyer include asking a friend who consulted a lawyer for a similar problem, calling a local bar association's referral service, or going to a legal clinic. All of these approaches have merits, but today the artist may be able to locate a knowledgeable lawyer with far greater precision.

The very definition of an area of the law as "art law" is an encouraging sign for the expertise lawyers will bring to the artist's problems. The literature and educational programs for lawyers have vastly increased. Many law schools now offer art-law courses and bar associations are paying greater attention to art and the artist. The Selected Bibliography shows how many art-law books are now available for lawyers.

Equally encouraging are the lawyers across the country volunteering to help needy artists. Both volunteer lawyers' groups and artists' groups, several of which maintain rosters of attorneys who will help members at a reduced fee, are good resources to use when seeking a lawyer with art-law expertise. Such referrals may result in finding lawyers who either do not charge or work at more affordable rates. Up-to-date information on the volunteer lawyers closest to a specific location can be obtained from one of the following established groups:

CALIFORNIA
California Lawyers for the Arts
 (*www.calawyersforthearts.org*)
Fort Mason Center
Building C, Room 255
San Francisco, CA 94123
(415) 775-7200
cla@calawyersforthearts.org
or
1641 18th Street
Santa Monica, CA 90404
(310) 998-5590
UserCLA@aol.com

ILLINOIS
Lawyers for the Creative Arts
 (*www.law-arts.org/*)
213 West Institute Place, Suite 411
Chicago, IL 60610
(312) 649-4111

NEW YORK
Volunteer Lawyers for the Arts
 (*www.vlany.org/*)
1 East 53rd Street
New York, NY 10022
(212) 319-2787

The Visual Artists Information Hotline

The New York Foundation for the Arts operates a toll-free information hotline to help individual fine artists in almost any discipline. The hotline number is 1-800-232-2789. The hotline operates Monday through Friday, from 3:00 to 5:00 *pm* eastern standard time. Artists may also email their questions to *source@nyfa.org*.

The hotline is primarily a referral service. The staff provides the details of a wide variety of programs and services that are available to artists. The hotline does not assist nonprofit groups.

Among the topics on which the hotline offers referral information are grants, fellowships, scholarships, workshops, slide registries, emergency funds, health and safety, insurance, artist communities, international opportunities, public art, studio space (for artists in Manhattan), legal information, job information, publications, exhibitions, competitions, how to apply for grants, and how to market art.

Value of the Legal Guide

Legal Guide for the Visual Artist trains the artist to think in a new way. It alerts the artist to issues that are likely to trap the unwary. It opens doors to those who seek to better their business practices, increase their incomes, and protect their art. Knowing when it is advisable to consult with a lawyer can itself be a great asset.

The artist who conducts his or her business affairs with clarity and confidence gains not only a better livelihood but also peace of mind. It is for those artists who seek self-reliance, confidence, and success that *Legal Guide for the Visual Artist* will be most valuable.

2 COPYRIGHT: GAINING AND KEEPING PROTECTION

Copyright is the source of all the reproduction rights that an artist sells in an artwork. The brief history of copyright at the end of this chapter discusses the visual arts in relation to the development of copyright and the tension between the individual's copyright and the public's desire for access to and use of artistic works.

On January 1, 1978, an entirely new copyright law replaced the law that had been in effect since 1909. While the changes in the 1978 law generally favored the creator, each artist must be aware of the provisions of the law to achieve maximum benefit from it and, particularly, to avoid the work-for-hire pitfall explained in chapter 4.

An important legal resource for any artist is the Copyright Office's official Web site, located at *www.copyright.gov*. Artists using any internet-enabled computer equipped with Adobe Acrobat Reader can view copyright forms, circulars, fact sheets, and other informative publications.

The fastest way to acquire these materials is to download them from the Copyright Office's Web site. They can also be requested by mailing the Copyright Office, Library of Congress, Washington, D.C. 20559. The Copyright Information Kit includes the Copyright Office's regulations, the copyright application forms, and circulars explaining a great deal about copyright and the operation of the Copyright Office. Free publications that help give an overview include Circular 1, "Copyright Basics," and Circular 2, "Publications on Copyright." A number of circulars describe the registration procedures for various types of visual art, including Circular 40, "Copyright Registration for Works of the Visual Arts," Circular 44, "Cartoons and Comic Strips," and Circular 55, "Copyright Registration for Multimedia Works." Also, the Copyright Office publishes its regulations in Circular 96, which includes provisions relevant to the visual arts. For artists wishing to purchase a copy of the complete copyright law, it can be ordered as Circular 92 for $28, or downloaded at no cost.

The Copyright Office will supply copies of any application form free of charge. In addition to being available on the Internet at *www.copyright.gov/forms/*, The Forms and Publications Hotline has been established by the Copyright Office to expedite requests for registration forms. This 24-hour resource can be reached at (202) 707-9100. Artists may also request forms be mailed to them using the Copyright Office's "Forms by Mail" system, at *www.copyright.gov/forms/formrequest.html*.

Effective Date

Younger artists may well have created all of their work since 1978. The 1978 copyright law is no longer new, yet it is important to keep in mind that copyright transactions prior to January 1, 1978, are governed by the 1909 law. For example, if the copyright on a drawing has gone into the public domain under the 1909 law (a work in the public domain has no copyright and can be freely copied by anyone), the 1978 law would not revive this lost copyright, even if the copyright would not have gone into the public domain had the 1978 law been in effect. However, the 1978 law does govern the treatment of copyrights that were in existence on January 1, 1978.

Single Copyright System

Before 1978, copyright existed in two quite distinct forms: common law copyright and statutory copyright. Common law copyright derived from precedent in the courts, while statutory copyright derived from federal legislation and, at times, regulations implemented by the Copyright Office. Common law copyright protected works as soon as created without any copyright notice; statutory copyright protected works only when registered with the Copyright Office or published with copyright notice. Common law copyright lasted forever unless the work was published or registered; statutory copyright lasted for a twenty-eight-year term that could be renewed for an additional twenty-eight years.

The 1978 law almost entirely eliminated common law copyright, a reform that substantially simplified the copyright system. All works are now protected by statutory copyright the moment they are created in tangible form. This immediate statutory copyright protection, independent of registration or publication with copyright notice, was an important change in the law. It is not necessary to comply with any formalities to get a statutory copyright, because it comes into being as soon as an artist creates a work.

However, as explained in chapter 3, the formalities of registration and deposit are neither difficult nor expensive to comply with and do offer advantages to the artist.

What Is Copyrightable?

Pictorial, graphic, and sculptural works are copyrightable. The law includes in these categories such items as "two-dimensional and three-dimensional works of fine, graphic and applied art, photographs, prints and art reproductions, maps, globes, charts, models, and technical drawings, including architectural plans."

Audiovisual works form another category of copyrightable work and cover "works that consist of a series of related images which are intrinsically intended to be shown by the use of machines or devices such as projectors, viewers, or electronic equipment, together with accompanying sounds." The form of an audiovisual work, be it a tape, film, or set of related slides intended to be shown together, doesn't matter as long as the work meets the definition just given. A motion picture is a distinct type of audiovisual work that also imparts an impression of motion, something the other audiovisual works don't have to do. The law makes clear that the soundtrack is to be copyrighted as part of the audiovisual work and not as a separate sound recording.

Work must be original and creative to be copyrightable. Originality simply means that the artist created the work and did not copy it from someone else. If, by some incredible coincidence, two artists independently created an identical work, each work would be original and copyrightable. Creative means that the work has some minimal aesthetic qualities. A child's painting, for example, could meet this standard. All the work of a professional artist should definitely be copyrightable.

While part of a given artist's work may infringe upon someone else's copyrighted work, the artist's own creative contributions may still be protected. For example, if an artist publishes a group of drawings as a book and fails to get permission to use one copyrighted drawing, the rest of the book would still be copyrightable. On the other hand, if someone were simply copying one film from another copyrighted film without permission, the entire new film would be an infringement and would not be copyrightable. If new elements are added to a work in the public domain, the new work would definitely be copyrightable. However, the copyright would only protect the new elements and not the original work that was in the public domain.

Ideas, titles, names, and short phrases are usually not copyrightable because they lack a sufficient amount of expression. Ideas can be protected by contract as discussed on pages 112–113 . Likewise, style is not copyrightable, but specific pieces of art created as the expression of a style are copyrightable. Utilitarian objects are not copyrightable, but a utilitarian object incorporating an artistic motif, such as a lamp base in the form of a statue, can be copyrighted to protect the artistic material. Basic geometric shapes, such as squares and circles, are not copyrightable, but artistic combinations of these shapes can be copyrighted.

Typeface designs are also excluded from being copyrightable, but computer programs are copyrightable even if the end result of using them involves uncopyrightable typefaces. Calligraphy may be copyrightable insofar as a character is embellished into an artwork,

although the Copyright Office has not issued clear guidelines on this. Calligraphy would not be copyrightable if merely expressed in the form of a guide such as an alphabet.

Computer programs and the visual images created through the use of computers are both copyrightable, unless the image itself is uncopyrightable, (for example, because it is a typeface or a basic geometric shape) in which case the computer program is still copyrightable.

If pictorial images on computer and video screens are copyrightable, what about an image composed solely of text? Is this copyrightable? This question raises the larger issue of whether the design of text in general is copyrightable. Or, for that matter, is the design of a book or magazine cover copyrightable if no picture is used? Typefaces are not copyrightable, but can an arrangement of uncopyrightable type elements create a copyrightable cover?

In August of 1985 *Conservative Digest* was acquired by a new publisher and, subsequently, changed the look of its cover to bear a close resemblance to the cover of *Reader's Digest*. This new look for *Conservative Digest* was publicized at a press conference held at the National Press Club where a copy of the October 1985 issue was displayed.

The editor-in-chief stated that if *Conservative Digest* "looks like *Reader's Digest*, I'm sure that Wally and Lila are somewhere up there saying, 'That's great, kids. Keep it up.'" Wally and Lila were DeWitt Wallace, the founder of *Reader's Digest*, and his wife.

Whatever Wally and Lila might have thought, *Reader's Digest* warned *Conservative Digest* not to use such a similar design. Despite the agreement by *Conservative Digest* not to use the design after the October and November issues, *Reader's Digest* brought suit for copyright infringement. The two covers appear in black and white as figures 1 and 2.

Before the court could conclude that an infringement had taken place, it had to decide whether the cover of *Reader's Digest* was copyrightable. The court's opinion is quite interesting on this point: "None of the individual elements of the *Reader's Digest* cover—ordinary lines, typefaces, and colors—qualifies for copyright protection. But the distinctive arrangement and layout of these elements is entitled to protection as a graphic work."

Finding the two designs substantially similar and noting that *Conservative Digest* had access to the *Reader's Digest* cover and thus could have copied it, the court upheld the

Figure 1. Cover of *Reader's Digest*.

Figure 2. Cover of *Conservative Digest*.

determination that there had been a copyright infringement. However, since *Conservative Digest* had already stopped the infringement, the award for copyright infringement was only $500. The court refused to award attorney's fees. Under the trade dress provisions of the Lanham Act, the court ordered that *Conservative Digest* make no further use of the two offending covers from October and November. (*The Reader's Digest Association, Inc. v. The Conservative Digest, Inc.*, 642 F. Supp. 144, *aff'd* 821 F.2d 800).

Multimedia works, which combine two or more media, are becoming more prevalent, especially online and also as CD-ROMs. Such works are certainly copyrightable. A helpful publication for such works is Circular 66, "Copyright Registration for Online Works".

Who Can Benefit from Copyright?

If works are unpublished, the law protects them without regard for the artist's nationality or where the artist lives. If works are published, the law will protect them if one or more of the artists is (1) a national or permanent resident of the United States; (2) a stateless person; or (3) a national or a permanent resident of a nation covered by a copyright treaty with the United States or by a presidential proclamation.

The United States is a party to the Universal Copyright Convention, so publication in any nation that is a party to that Convention will also gain protection in the United States. The copyright notice for the Universal Copyright Convention must include the symbol ©, the artist's full name, and the year of first publication. Thus, the short form notice using the artist's initials, (© JA, discussed on page 24) should be avoided when protection is desired under the Universal Copyright Convention. For the Buenos Aires Convention, covering many countries in the Western Hemisphere, the phrase "All rights reserved" should be added to the notice.

Because the United States joined the Berne Union on March 1, 1989, it is no longer necessary for artists in the United States to publish simultaneously in a Berne Union country to gain protection under the Berne Convention. In fact, because the Berne Convention forbids member countries from imposing copyright formalities as a condition of copyright protection for the works of foreign authors, a number of changes have been made in the United

States copyright law. These changes will be described in relation to the appropriate sections of the text.

Details of the international copyright relations of the United States can be obtained from the Copyright Office in Circular 38a, "International Copyright Relations of the United States." While most countries belong to both the Berne Convention and the Universal Copyright Convention, many belong to the Berne Convention but not to the Universal Copyright Convention and a few belong to the Universal Copyright Convention but not the Berne Convention. The wisest course is to obtain protection under both conventions, if possible.

Manufacturing Requirement

The manufacturing requirement expired on June 30, 1986, so there is no longer any requirement that books or pictorial or graphic works be manufactured in the United States.

Term of Copyright

Recent legislation has extended the various copyright terms. If the artist is not doing work for hire, the term will generally be the artist's life plus seventy years. The additional complexity wrought by legislative changes to the law is discussed at length in Circular 15a. Also, a convenient reference chart, compiled by the Cornell Law School, can help to demystify the statutory intricacies of term length by clearly describing what works are protected, and what works are in the public domain. It is available at *copyright.cornell.edu/resources/publicdomain. cfm#Footnote_1*.

The term of copyright under the 1978 law had been the artist's life plus fifty years. The 1909 copyright law had an original twenty-eight-year term and a renewal term of twenty-eight years, so the life-plus-seventy term is much longer. For works created anonymously, under a pseudonym or as a work for hire, the term shall be either ninety-five years from first publication of the work or 120 years from its creation, whichever period is shorter. The Copyright Office maintains records as to when an artist dies, but a presumption exists that a copyright has expired if ninety-five years have passed and the records disclose no information indicating the copyright term might still be in effect. If the name of an artist who has created a work anonymously or using

a pseudonym is recorded with the Copyright Office, the copyright term then runs for the artist's life plus seventy years.

The term of copyright for a jointly created work is the life of the last surviving artist plus seventy years. A joint work is defined as a work prepared by two or more artists with the intention that their contributions be merged into inseparable or interdependent parts of a unitary whole.

Copyrights in their renewal term that would have expired on or after September 19, 1962, were extended due to the deliberations over the revision of the copyright law. They fall under the general rule that the terms of statutory copyrights in existence on January 1, 1978, are extended to seventy-five years and, by the more recent legislation, to ninety-five years.

However, any copyrights obtained prior to 1978 that were still in their first twenty-eight-year term would have had to be renewed on Form RE in order to benefit from the extension to what has become a total term of ninety-five years. A 1992 amendment waived this renewal requirement, so that all works copyrighted between January 1, 1964, and December 31, 1977, automatically have their term extended by sixty-seven years. However, there are benefits to filing Form RE and paying the one-hundred-and-fifteen dollar fee for renewal, including that the renewal certificate is considered proof that the copyright is valid and the facts stated in the certificate are true. Circular 15, "Renewal of Copyright," offers additional information about copyright renewal.

Circular 15t, "Extension of Copyright Terms," discusses the extended terms of copyrights in existence on January 1, 1978, whether the copyright was in its first twenty-eight-year term or in its renewal term.

Since common law copyright has basically been eliminated, all works protected by common law copyright as of January 1, 1978, will have a statutory copyright term of the artist's life plus seventy years. In no event, however, will such a copyright previously protected under the common law expire prior to December 31, 2002, and, if the work is published, the copyright will extend at least until December 31, 2047.

The 1978 law provides that all copyright terms will run through December 31 of the year in which they are scheduled to expire. This will greatly simplify determining a copyright's term and, when necessary, renewing a copyright.

Exclusive Rights

The owner of a copyright has the exclusive rights to reproduce the work, sell and distribute the work, prepare derivative works, perform the work publicly, and display the work publicly. A derivative work adapts or transforms an earlier work, such as using the image from a painting for a picture on the front of a tee shirt, taking an old drawing and adding new elements to it so that the new drawing would be a substantial variation from the original drawing, or making a novel into a film. The right to sell and distribute the work doesn't prevent someone who has purchased a lawfully made copy from reselling it.

The right to display the work does not prevent the owner of a copy of the work from displaying it directly or with the aid of a projector to people present at the place of display, such as exhibiting a fine print in a gallery. For an audiovisual work, including a motion picture, a display is defined as showing its images nonsequentially. The owner of a copy could do this publicly. Performing an audiovisual work, which is showing its images sequentially, would be allowed only if the owner of the copy did it in private. To perform the work publicly, either in a public place or to an audience including a substantial number of people besides the family and its normal circle of friends, permission of the copyright owner would be needed. If a gallery or museum does not own copyright-protected art that it wishes to display, it will need the permission of the copyright owner.

Each of the exclusive rights belonging to the copyright owner can be subdivided. For example, the reproduction rights sold might be "first North American serial rights" instead of "all rights." All rights would be the entire copyright. First North American serial rights is a subdivided part of the exclusive right to authorize reproduction of the work. It is still an exclusive right, because it gives a magazine the right to be first to publish the work in a given geographical area. It is important to understand how to subdivide rights, because this is how the artist limits what rights are transferred to the other party and retains the greatest possible amount of rights for future use.

There are some limited exceptions to the exclusive rights of the copyright owner. Both fair use and compulsory licensing, discussed on pages 45–48, are statutory limitations on exclusive rights that set forth when an individual or company can use a copyrighted work without asking permission of the copyright owner. As a general rule, however, anyone using a work in violation of the copyright owner's exclusive rights is an infringer who must pay damages and can be restrained from continuing the infringement.

Transfers and Nonexclusive Licenses

All copyrights and subdivided parts of copyrights must be transferred in writing, except for nonexclusive licenses. This requirement of a written transfer had not been the case for common law copyrights (except in California and New York), which could be transferred verbally, and is an important protection for the artist.

An exclusive license gives someone a right that no one else can exercise. For example, an artist might give a manufacturer the right to be the only maker and distributor of a certain tee shirt design for five years in the United States. This would be giving an exclusive license to the manufacturer. The exclusivity could be increased or decreased based on duration of the license, geographic extent of the license, and types of products or uses to be permitted. The contractual limitations that can be imposed, along with model contract forms, are discussed in chapter 15.

On the other hand, nonexclusive licenses allow two parties to do the same thing. For example, an artist could verbally give two magazines "simultaneous rights." Such rights are not exclusive but specifically permit giving the same rights to other magazines at the same time and for the same area.

Since nonexclusive licenses can be transferred verbally, it's necessary to watch out for publishers or manufacturers who try to get more than a one-time use of artwork through masthead notices or memoranda that might create an implied agreement. The additional uses would be nonexclusive, but the artist would not be paid again. For example, a store might purchase the right to use copies of a work in a window display, but later want to use the same work in printed advertising. The artist should know exactly what rights are being sold, preferably by having them detailed in a purchase order obtained prior to doing the work. If there is no express agreement when dealing with a magazine or other collective work, the law provides a presumption as to what rights are transferred (discussed later in this chapter). Even when dealing with nonexclusive licenses, the wisest course is to use written contracts. Otherwise, memories fade and conflicts are more likely. Also, the fact that a nonexclusive license is written may protect the recipient of the license if a conflicting transfer is made to another party.

Copies of documents recording transfers of copyrights or exclusive licenses should be filed with the Copyright Office by the person receiving the transfer to protect that person's ownership rights. This filing should be done within one month if the transfer took place in the United States and within two months if the transfer took place outside of the United States. Nonexclusive licenses can also be recorded with the Copyright Office. Circular 12, "Recordation of Transfers and Other Documents," gives details about recordation.

A form for the assignment of all right, title, and interest in a copyright is included here. In general, it should not be used to sell rights, since limited rights transfers are far better for the artist. However, this form can be used when the artist is reacquiring rights in a copyright— for example, if a right granted reverts back to the artist by contract.

Copyright Assignment Form

For valuable consideration, the receipt of which is hereby acknowledged, (name of party assigning the copyright), whose offices are located at (address), does hereby transfer and assign to (name of party receiving the copyright), whose offices are located at (address), his or her heirs, executors, administrators, and assigns, all its right, title, and interest in the copyrights in the works described as follows: (describe work, including registration number, if work has been registered) _____

_____ ,

including any statutory copyright together with the right to secure renewals and extensions of such copyright throughout the world,

for the full term of said copyright or statutory copyright and any renewal or extension of same that is or may be granted throughout the world.

In Witness Whereof, (name of party assigning the copyright) has executed this instrument by the signature of its duly authorized corporate officer on the _____ day of _____, 20____.

ABC Corporation

By:_____
Authorized Signature

Name Printed or Typed

Title

Termination

Another significant provision of the 1978 law is the artist's right to terminate transfers of either exclusive or nonexclusive rights. If, after January 1, 1978, an artist grants exclusive or nonexclusive rights in a copyright, the artist has the right to terminate this grant during a five-year period starting at the end of thirty-five years after the execution of the grant or, if the grant includes the right of publication, during a five-year period beginning at the end of thirty-five years from the date of publication or forty years from the date of execution of the grant, whichever term ends earlier.

Similarly, if before January 1, 1978, the artist or the artist's surviving family members made a grant of the renewal right in one of the artist's copyrights, that grant can be terminated during a five-year period starting fifty-six years after the copyright was first obtained. However, the artist has no right of termination in transfers by will or in works for hire.

The mechanics of termination involve giving notice two to ten years prior to the termination date and complying with regulations the Copyright Office can provide, but the important point is to remember that such a right exists. The purpose of the right of termination is to provide creators the opportunity to share in an unexpected appreciation in the value of what has been transferred.

The twenty-year extension of the copyright term affects the right of termination. If the right of termination has not been exercised, then it may be exercised with respect to the twenty-year extension during the five-year period commencing at the end of seventy-five years from when the copyright was secured.

Selling to Magazines and Other Collective Works

Magazines, newspapers, anthologies, encyclopedias—anything in which a number of separate contributions are combined together—are defined as "collective works." The law specifically provides that the copyright in each contribution is separate from the copyright in the entire collective work. The copyright in a contribution belongs to the contributor who can give the owner of the copyright in the entire work whatever rights the contributor wishes in return for compensation.

However, especially where magazines are concerned, it is not uncommon for a contribution to be published without any express agreement ever being made as to what rights are being transferred to the magazine. The 1978 law deals with this situation by providing that, in a case where there is no express agreement, the owner of copyright in the collective work gets the following rights: (1) the nonexclusive right to use the work in the issue of the collective work for which it was contributed; (2) the right to use the contribution in a revision of that collective work; and (3) the right to use the contribution in any later collective work in the same series.

For example, a drawing is contributed to a magazine without any agreement with respect to what rights are being transferred. The magazine can now use that drawing in one issue and again in later issues, but it cannot publish that drawing in a different magazine. Magazines are not usually revised, but anthologies and encyclopedias are. In that case the drawing could be used in the original issue of the anthology or encyclopedia and any later revisions, but it couldn't be used for a new anthology or a different encyclopedia.

Of course, only nonexclusive rights are transferred to the magazine or other collective work, so the drawing could be contributed elsewhere at the same time. The artist will have to weigh whether this is practical in terms of keeping the good will of the various clients.

In August of 1997, the court interpreted copyright law as applied to electronic publication in the case of *Tasini v. New York Times* (972 F. Supp. 804). The plaintiffs, all freelance writers, claimed that the defendants, all large publishing companies, had infringed their copyrights by placing the contents of their periodicals on electronic databases and CD-ROMs without first securing the permission of the plaintiffs whose contributions were included in those periodicals. The plaintiffs argued that all parties implicitly understood that the authors were selling only First North American Serial Rights, and reserving secondary rights such as syndication, translations, and anthologies for separate sale. The court, under then-district judge Sonia Sotomayor, decided in favor of the publishers, finding the articles originally appearing in the magazine to be substantially similar to the online and disc versions, and thus construing them to be permissible "revisions" under the Copyright Act. On appeal, however, the Second Circuit Court of Appeals reversed in favor of the writers, and the Supreme Court affirmed that view in *New York Times Co., Inc. v. Tasini*, (533 U.S. 483). Justice Ginsburg held that electronic databases containing individual articles from multiple editions of periodicals could not be reproduced and distributed as part of revisions of individual periodical issues from which articles were taken. Therefore publishers of periodicals could not relicense individual articles to databases under a collective works theory, unless the individual authors transferred copyrights or other rights to the individual articles.

The rule of *Tasini*, which dealt with written works, has been expanded to include photographs. In *Greenberg v. National Geographic*, (533 F.3d 1244), photographer Jerry Greenberg brought a lawsuit against National Geographic, which had featured Greenberg's images in four issues of its monthly magazine. In 1996, National Geographic sought to release a digital archive of its magazines on CD-ROM. This 30-disc archive would contain electronic versions of all published articles from 1888 to 1996, and would include reduced-resolution samples of all the photographs featured in those articles. Greenberg sued, alleging that he deserved additional compensation for this use. In essence, Greenberg argued that he only gave National Geographic permission to publish pictures in four printed magazine editions, and

that the proposed digital collection was a new and categorically different work that required additional permission. After a long and circuitous journey through the federal courts, Greenberg ultimately lost his case. The court held that the digital archive was a merely a "revision" of National Geographic's collection of magazines. Though the medium was different, the collective works themselves remained unchanged, and thus, the CD-ROM collection was nothing more than an alternative version of National Geographic's amassed paper magazine archive.

The fundamental difference between Greenberg and Tasini was that in the former case, National Geographic's digital archive did not separate Greenberg's photos from the articles in which they were featured. By contrast, the parsing of newspaper articles from their original published context into various searchable databases was deemed to infringe the rights of various authors in *Tasini*. In keeping with this the court in *Greenberg* held that National Geographic did infringe Greenberg's copyright if it displayed the photos outside of the articles in which they appeared. In particular, the *Greenberg* court held that National Geographic's introductory sequence, featuring animated logos, covers, photos, and music, were *not* privileged revisions, and that any attempt to use Greenberg's photos in that sequence would infringe his copyright.

The best solution is simply to have a written agreement signed by the artist or his or her authorized agent transferring limited rights and dealing with whether any electronic rights are included in the transfer. For example, the limited rights might be defined as "first North America rights for non-electronic usage only" in the contribution to the collective work. This transfers exclusive first-time rights in North America, but it has the advantage of restricting the magazine or other collective work from making subsequent uses of the contribution without payment or from making any electronic use. It also makes the sale governed by terms agreed to and understood by both parties, instead of by a law that may not satisfactorily achieve the end result desired by either party. The need for a signed written transfer can be satisfied by a simple letter stating: "This is to confirm that in return for your agreement to pay me $_____, I am transferring to you first North American rights in my work titled _____

described as follows:_____ for non-electronic usage only in your magazine titled:_____. For purposes of this agreement, electronic rights are defined as rights in the digitized form of works that can be encoded, stored, and retrieved from such media as computer disks, CD-ROM, computer databases, and network servers."

Entering Contests

The artist may want to enter contests sponsored by professional organizations or companies. Many contests pose no problem, but any application form should be closely scrutinized with respect to reproduction rights. Does winning, or even entering, the contest, require that the artist transfer the copyright to the sponsor? If so, the contest should not be entered.

If the contest requires that exclusive rights be transferred to the sponsor in the event the artist wins, then the artist must evaluate whether this transfer of rights is reasonable. The sponsor should only seek limited rights, such as the right to publish the art in a book of contest winners or to make a poster for a certain specified distribution. If the sponsor seeks more than this, the artist should demand fair compensation for the additional rights that appear unnecessary to fulfill the purpose of the contest.

In addition, if the sponsor seeks free art to use for commercial purposes, such as promoting or advertising its products, then the artist should be especially wary of entering. Not only does this situation appear very similar to working on speculation, which should be anathema to all artists, but it would require a prize that would be a fair fee for the winner.

Just as the artist safeguards his or her copyright, so ownership should be maintained over the physical artwork embodying the copyright. Contest applications must be read carefully and contests entered only after thoroughly weighing whether the impact of the contest on ownership of the copyright and the physical art is fair and ethical.

Ownership of the Physical Work

Copyright is completely separate from ownership of a physical artwork. An artist can often sell the physical work verbally, but the copyright or any exclusive license must always be transferred in writing and the artist or the artist's authorized agent must sign that transfer. Because prior to 1978 it appeared the sale of an artwork might transfer the common law copyright to the purchaser, New York and California have enacted statutes reserving the common law copyright to the artist unless a written agreement transfers the common law copyright to the purchaser. The New York statute covers sales of paintings, sculptures, drawings, and graphic works. The broader California statute covers commissions as well as sales of fine art (defined to include mosaics, photography, crafts, and mixed media) and also includes the categories covered under the New York statute. These statutes will continue to be of importance with respect to sales that took place prior to 1978. After 1978, the copyright law provides the same protection and has been held to preempt these laws.

Publication with Copyright Notice

Due to joining the Berne Union, as of March 1, 1989, the United States copyright law no longer requires copyright notice to be placed on published works. In fact, however, most copyright proprietors will continue to use copyright notice. The notice warns potential infringers of the copyright. Use of the copyright notice prevents an infringer from being allowed to ask the court for mitigation of damages on the grounds that the infringement was innocent. Also, the Universal Copyright Convention still requires copyright notice. As discussed earlier, a number of nations who signed the Universal Copyright Convention did not also sign the Berne Convention.

In some cases, the time when publication occurs can be confusing. Publication in the 1978 law basically means public distribution. This occurs when one or more copies of a work are distributed to people who are not restricted from disclosing the work's content to others. Distribution can take place by sale, rental, lease, lending, or other transfer of copies to the public. Also, offering copies to a group of people for the purpose of further distribution, public performance, or public display is a publication. In circulating copies of a work to publishers or other potential purchasers, it would be wise to indicate on the copies that the contents are not to be disclosed to the public without the artist's consent. Even if this is not done, however, it should be implicit that such public disclosure is not to be allowed.

The history of the law's enactment (in the form of a statement by Congressman

Kastenmeier in the Congressional Record) indicated that Congress did not intend for unique art works, those that are one of a kind, to be considered published when sold or offered for sale in such traditional ways as through an art dealer, gallery, or auction house. Works intended to be sold in multiple copies, however, would be considered published if publicly distributed or offered for sale to the public, even if the offering for sale occurs at a time when only a single prototype exists.

But unique works should be registered in any case, since they can still be infringed by someone who has access to them. Also, some experts believe that unique works are published when offered for sale by a dealer, gallery, or auction house. To warn the public of the artist's copyright and to avoid taking any chances that a court in the future might decide that unique works can be published, copyright notice should be placed on such works as soon as they are created. This does not change the term of copyright protection, but it prevents having to worry about ambiguities in the definition of publication.

For works created prior to 1978, it is worthwhile to discuss the meaning of "publication" under the old law. For both common law and statutory purposes, publication generally occurred when copies of the work were offered for sale, sold, or publicly distributed by the copyright owner or under his or her authority. However, artworks are frequently first exhibited or offered for sale not through copies but by use of an original work or works. The consensus was that the exhibition of an uncopyrighted artwork would not be a publication if copying of the work, usually by photography, was prohibited and if this prohibition was enforced at the exhibition. On the other hand, such an exhibition would have been a publication if copies could be freely made or disseminated. Authority was also divided over whether the sale of an original uncopyrighted artwork was a publication that would bring an end to common law copyright protection. Despite this, both New York and California enacted the statutes discussed earlier, which provided that the sale of an uncopyrighted artwork did not transfer the right of reproduction to the buyer unless a written agreement was signed by the artist or the artist's agent expressly transferring such right of reproduction.

Form of Copyright Notice

The form of the copyright notice is as follows: Copyright or Copr. or ©, the artist's name or an abbreviation by which that name can be recognized or an alternative designation by which the artist is known, and the year date of publication (or the year date of creation, if the work is unpublished and the artist chooses to place notice on it). Valid notice could, therefore, be ©JA 2012, if the artist's initials were JA. In general, the Copyright Office takes the position that an artist's initials are insufficient unless the artist is well known by his or her initials. If the artist is not well known by his or her initials, the Copyright Office will treat the notice as lacking any name. The year date can be omitted only from artwork reproduced on or in greeting cards, postcards, stationery, jewelry, dolls, toys, or any useful articles. If a work consists preponderantly of one or more works created by the United States Government, a statement indicating this must be included with the copyright notice. If this is not done, an innocent infringer will be able to ask the court to mitigate damages, which the court may do in its discretion.

Circular 3, "Copyright Notice" discusses both the form and placement of copyright notice.

Placement of Copyright Notice

The copyright notice should be placed so as to give reasonable notice to an ordinary user of the work that it is copyrighted. The Copyright Office regulations are very liberal as to where notice can be placed, but, in fact, any reasonable placement of notice will be valid. Of course, it would be wise to follow the guidelines given in the regulations and explained here.

The notice requirements for pictorial, graphic and sculptural works insure that the use of copyright notice will not impair the aesthetic qualities of the art.

For a two-dimensional work, such as a fine print or poster, the copyright notice can go on the front or back of the work or on any backing, mounting, matting, framing, or other material to which the work is durably attached so as to withstand normal use or in which it is permanently housed. The notice can be marked on directly or can be attached by means of a label that is cemented, sewn, or otherwise permanently attached. A slide that is not part

of a series of related slides would be a two-dimensional work and the copyright notice would go on the slide's mounting.

For a three-dimensional work, such as a sculpture, the copyright notice can be placed on any visible portion of the work or on any base, mounting, framing, or other material to which the work is permanently attached or in which it is permanently housed. Again, the notice can be marked on directly or can be attached by means of a label that is cemented, sewn, or otherwise durably attached so as to withstand normal use. If, in an unusual case, the size of the work or the special characteristics of the material composing the work make it impossible to mark notice on the work directly or by a durable label, the notice could be placed on a tag of durable material attached with sufficient permanency to remain with the work while passing through the normal channels of commerce.

If a work is reproduced on sheet-like or strip materials bearing continuous reproductions, such as wallpaper or textiles, the copyright notice may be placed in any of the following ways: (1) on the design itself; (2) on the margin, selvage, or reverse side of the material at frequent and regular intervals; (3) if the material has neither selvage nor a reverse side, then on tags or labels attached to the materials and to any spools, reels, or containers housing them so that the notice is visible during the entire time the materials pass through their normal channels of commerce.

If a work is permanently housed in a container, such as a game or puzzle, a notice reproduced on the permanent container will be acceptable.

For a contribution to a collective work, such as a magazine or anthology, the regulations state that copyright notice can be placed in any of the following ways: (1) if a contribution is on a single page, the copyright notice may be placed under the title of the contribution, next to the contribution, or anywhere on the same page as long as it is clear that the copyright notice is to go with the contribution; (2) if the contribution takes up more than one page in the collective work, the copyright notice may be placed under the title at or near the beginning of the contribution, on the first page of the body of the contribution, immediately following the end of the contribution, or on any of the pages containing the contribution as long as the contribution is less than twenty

pages and it is clear the notice applies to the contribution; (3) as an alternative to numbers (1) or (2), the copyright notice may be placed on the page bearing the notice for the collective work as a whole or on a clearly identified and readily accessible table of contents or listing of acknowledgments appearing either at the front or back of the collective work as a whole. For (3), there must be a separate listing of the contribution by its title or, if it has no title, by an identifying description.

For works that are reproduced in machine-readable copies, the notice can go near the title or at the end of the work on printouts. Other placements include at the user's terminal at sign-on, on continuous display on the terminal, or on a label securely affixed to a permanent container for the copies.

For motion pictures and other audiovisual works, the copyright notice is acceptable if it is embodied in the copies by a photomechanical or electronic process so that it appears whenever the work is performed in its entirety and is located in any of the following positions: (1) with or near the title; (2) with the cast, credits, or similar information; (3) at or immediately following the beginning of the work; or (4) at or immediately preceding the end of the work. Since a series of related slides intended to be shown together is considered an audiovisual work, the notice would have to be visible when the work is performed in one of the positions just listed. There would be no requirement, however, that notice appear on the mounting of the slides as on the case of a slide that is not part of a related series. Also, a motion picture or other audiovisual work distributed to the public for private use (such as a video recording cassette) may have the notice on the container in which the work is permanently housed if that would be preferred to one of the four placements listed above.

Circular 3, "Copyright Notice," is also helpful on this topic.

Defective Notice
Since copyright notice is permissive after March 1, 1989, works published without notice are fully protected and the provisions on defective notice are not relevant. However, the changes in the copyright law are not retroactive, so works published without copyright notice prior to March 1, 1989, may have gone into the public domain. There are two

categories of pre-March 1, 1989 works that must be discussed: those published between January 1, 1978 and March 1, 1989, and those published before January 1, 1978.

Between January 1, 1978 and March 1, 1989, a copyright was not necessarily lost if the copyright notice was incorrect or omitted when authorized publication took place either in the United States or abroad. For example, if the wrong name appeared in the copyright notice, the copyright was still valid. This meant that if an artist contributed to a magazine or other collective work but there was no copyright notice in the artist's name with the contribution, the copyright was still protected by the copyright notice in the front of the magazine even though the notice was in the publisher's name. Notice in the publisher's name did not, however, protect advertisements that appeared without separate notice (unless the publisher was also the advertiser). If an earlier date than the actual date of publication appeared in a copyright notice, the term of copyright was simply computed from the earlier date, but the copyright remained valid. Computing the copyright from the earlier date would not make any difference, since the term of the copyright is measured by the artist's life plus seventy years (not a fixed time period which could be shortened by computing the term from the earlier date).

If the name or date was simply omitted from the notice, or if the date was more than one year later than the year in which publication actually occurred, the validity of the copyright was governed by the same provisions that applied to the complete omission of copyright notice. In such a case, the copyright was valid and did not go into the public domain if any one of the following three tests was met: (1) the notice was omitted from only a relatively small number of copies distributed to the public; (2) the notice was omitted from more than a relatively small number of copies, but registration was made within five years of publication and a reasonable effort was made to add notice to copies distributed in the United States that did not have notice (such a reasonable effort at least required notifying all distributors of the omission and instructing that they add the proper notice; foreign distributors did not have to be notified); or (3) the notice had been left off the copies against the artist's written instructions that such notice appear on the work.

However, an innocent infringer who gave proof of having been misled by the type of incorrect or omitted notice discussed in the preceding paragraph would not have been liable for damages for infringing acts committed prior to receiving actual notice of the registration. Also, the court in its discretion might have allowed the infringement to continue and required the infringer to pay a reasonable licensing fee.

Prior to 1978, a defective notice usually caused the loss of copyright protection because statutory copyright for published works was obtained by publication with copyright notice. If, for example, a year later than the year of first publication was placed in the notice, copyright protection was lost. There were exceptions, however. For example, the use in the notice of a year prior to that of first publication merely reduced the copyright term but did not invalidate the copyright. Also, if copyright notice was omitted from a relatively small number of copies, the copyright continued to be valid, but an innocent infringer would not be liable for the infringement.

A Brief History of Copyright

This brief history of copyright reveals some of the underlying forces that have shaped the copyright law in force today. A tension exists between the rights of the public and the rights of the artist. Copyright is a monopoly favoring authors, artists, or right holders, and like any monopoly, it imposes limitations on the public. The artist reaps economic gains for the term of the copyright while the public is denied the fullest access to its own images and culture. In justifying this monopoly by ancient concepts of property law, copyrights are considered one category of intellectual property.

The etymological derivation of property is from the Latin word "proprius," which means private or peculiar to oneself. Intellectual comes from the Latin verb "intellegere," which is to choose from among, hence to understand or to know. Contained within "intellegere" is the verb "legere," which means to gather (especially fruit) and thus to collect, to choose, and ultimately to assemble (the alphabetical characters) with the eyes and to read.

So the private inspiration that finds fruition in art is rewarded with monopoly rights that last longer than the artist's life. Yet new means to create, store, and deliver art place pressure

on the system of copyright. Arguments are made for rights of public access to and use of all imagery, perhaps on the model of a compulsory license created by statute in which copyright owners have no right to control usage but do receive a fee fixed either by voluntary arrangements or government fiat. Would the public be better served by ending copyright as a monopoly and allowing the most widespread dissemination of literature, art, and other products of the mind? Is the public's right to access art, writing, or other forms of creative expression greater than any right that the art's creator might assert?

To place this debate in perspective, we must remember that copyright is neither ancient nor uncontroversial. The Roman legal system, for example, had no copyright. If a man could own slaves (who might carry fabulous creations in their minds), why should the ownership of words be separate from the ownership of the parchment containing the words? Trained slaves took dictation to create thousands of copies of popular works for sale at low prices. The poet Martial complained that he received nothing when his works were sold. Even if works could be sold, as were the plays written by Terence, no protection existed against piracy. The profits from any sales of the copied manuscripts went to the property owner, not the author.

Indeed, this collective view of creativity held sway through the Middle Ages. Religious literature predominated; individual creativity was not rewarded. The reproduction of manuscripts rested in the dominion of the Church, and it was only with the rise of the great Universities in the twelfth and thirteenth centuries that lay writers began producing works on secular subjects. Extensive copying by trained scribes again became the norm, with only the publishers, or "stationarii" as they were called, gaining any profit. Even before the introduction of block printing into the west in the fifteenth century, the publishers had formed a Brotherhood of Manuscript Producers in 1357 and were soon given a charter by the Lord Mayor of London. Johannes Gutenberg's introduction of the printing press to the Western world in 1437 gave individual authors an even greater opportunity for self-expression. The printer's movable type foreshadowed the author's copyright protection.

William Caxton introduced these printing techniques to England in 1476, which led to an even greater demand for books. Seven years later, Richard III lifted the restrictions against aliens if those aliens happened to be printers. Within fifty years, however, the supply of books had far exceeded the demand and Henry VIII passed a new law providing that no person in England could legally purchase a book bound in a foreign nation (this was the forerunner to the manufacturing clause that finally expired in 1986).

At about this time the Brotherhood of Manuscript Producers, now known as the Stationers' Company, was given a charter—that is, a monopoly—over publishing in England. No author could publish except with a publisher belonging to the Stationers' Company. This served the dual purpose of prohibiting any writing that was either seditious to the Crown or heretical to the Church. The right of ownership was not in the author's creation, but rather in the right to make copies of that creation. Secret presses came into existence, but the Stationers' Company sought to maintain its monopoly with the aid of repressive decrees from the notorious Star Chamber.

Due largely to the monopoly of the Stationers' Company, a recognition had come into being of a right to copy which might also be called a common law copyright—that is, a right supposedly existing from usages and customs of immemorial antiquity as interpreted by the courts. With this concept of property apart from the physical manuscript established, the Stationers' Company objected vehemently when their charter and powers expired in 1694 and Scotch printers began reprinting their titles. The stationers pushed for a new law, but this law, enacted in 1710 and called the Statute of Anne, was largely drafted by two authors, Joseph Addison and Jonathan Swift. The result was a law that protected authors as well as publishers by the creation of statutory copyright (that is, copyright protected under a statute). At this point authors had something to sell on the market, a copyright that had been created to encourage "learned men to compose and write useful books."

The intellectual property manifested by words had been protected, but what of images? Preyed upon repeatedly by plagiarists who undersold his own prints, William Hogarth and other artists petitioned Parliament to extend copyright protection to pictures and prints. In 1735 this protection was granted, but not

before the pirates created their own version of *The Rake's Progress* by sending their agents posing as potential buyers to Hogarth's house to see the series of prints. These agents then attempted to remember and reproduce what they had seen. Their efforts were, as Hogarth said, "executed most wretchedly both in Design and Drawing. . . ."

The copyright laws of the United States stand on this structure, originally built in England. The Confederation of States had no power to legislate with respect to copyright. Between 1783 and 1789 Noah Webster successfully lobbied in twelve states for the passage of copyright laws. Finally, the Federal Constitution provided that "The Congress shall have the power. . . To promote the Progress of Science and useful Arts, by securing for limited Times to Authors and Inventors the exclusive Right to their respective Writings and Discoveries."

In 1790 Congress enacted our first federal copyright statute providing copyright for an initial term of fourteen years plus a renewal term of fourteen years. It applied to the making of copies of books, maps and charts. This law was amended in 1802 to apply to engraving and etching of historical and other prints. In 1831 the initial term of copyright was lengthened to 28 years. In 1865 the law was amended to include photographs and negatives. In 1870 it was revised to cover paintings, drawings, statuaries, and models or designs of works of the fine arts. From the artist's viewpoint, it is interesting that drawings and paintings were added as a postscript to the copyright law.

In 1909 the copyright law was revised again. The initial term of copyright remained twenty-eight years and the renewal term was lengthened to twenty-eight years for potential protection of fifty-six years. In fact, statutory copyrights that would have expired at the end of the renewal term on or after September 19, 1962, were extended to a term of seventy-five years from the date copyright was originally obtained. Recent legislation has extended the term to the artist's life plus seventy years for works create after 1977. For works created before 1978 that must be renewed, the total term has been extended to ninety-five years.

Radio, television, motion pictures, satellites, and other technological innovations required revision of the 1909 law. After a long gestation, the complete revision of the law took effect on January 1, 1978. No doubt future revisions lie ahead as the Internet and other new tools to make, store, and deliver creative works shape the copyright needs of creators, users, and society itself. In this vein, legislative efforts to deal with emerging problems created by the Internet are discussed on page 45.

At first blush, the copyright law appears to limit the public's ability to benefit from artistic and literary works. However, the purpose of copyright is to benefit the public as well as the author. Copyright laws are founded on the assumption that granting authors limited economic monopolies over their own creations encourages them to create innovative new works of creative expression. This stimulus to authorship, provided by economic incentives, ultimately bequests a richer cultural legacy to the public than would a system that allowed the public to pirate at will. Society renounces piracy, because it believes that the cultural wealth increases when the artists and authors that create that wealth have incentive to create it in the first place. Viewed in this way, the conflict between the artist and the public vanishes. For what is the artist but a part of society? And what are the artist's freedom and copyright but a reflection of the society's liberty and legacy?

3 COPYRIGHT: REGISTRATION

All works subject to copyright protection may be registered with the Copyright Office, whether or not they have been published. Before 1978 some people would place manuscripts or copies of artwork in a self-addressed envelope and send the envelope to themselves by registered mail. This was called "poor man's copyright" and was, frankly, of little value even before 1978. Today, it should never be done. The Copyright Office is an official repository for copyright applications. All works, whether published or unpublished, can be registered. The cost of registration is not great, and groups of works can be registered for one fee in many cases. The registration process has become one predominantly performed through the Internet, and the Office actively discourages the use of traditional paper forms. The fees, and the Office's marked preference for online registration, will be discussed further in this chapter. That being said, certain kinds of registration, including group registration, and copyright renewals, require submission of paper forms. Regardless of how a work is registered, however, there are substantial benefits to registering a work with the Copyright Office. In addition, even if a work is denied registration, a copy of the deposit is maintained by the Copyright Office.

Choosing the Copyright Form

The Copyright Office's preferred approach to registration is through the electronic copyright office, or eCO. The eCO system is the ways in which works can be registered over the Internet. It can be used to register single or, in certain cases, multiple works claimed by the same artist, author, or rights holder. The procedure permits online payment of the $35 application fee via credit card or direct transfer from a checking account, after which the artist can upload a digital version of the work to the Copyright Office. The speed of the Internet connection determines how much an applicant may upload, as the eCO system gives all users up to sixty minutes before terminating an upload. The system permits registrants to pay for and track their applications online, and submit the works over the Internet. In the event the artist wants to also submit a hard copy, they can print out a shipping label for each registered work using the eCO system, and mail the work to the office using those labels.

In addition to eCO, the copyright office also offers registrants Form CO, a unified form that supplants prior specialized forms, such as the Form VA. Though the earlier forms are available by mail request, only the Form CO is published on the copyright register's Web site. Form CO is designed to be filled out electronically, printed, and then mailed back to the Copyright office along with a copy of the work to be registered. The filing fee for the paper form was recently raised to $50, again signaling the Copyright Office's increasing hostility to paper submissions.

The predecessors to eCO and Form CO are specialized forms for registering visual or written works (VA and TX respectively), are available by mail request to the Copyright Office. On the Copyright Office Website, they are also available as part of the downloadable GR/CP forms described later in this chapter. A copy of Form VA is also printed on page 26–29. In keeping with the Copyright Office's preference for electronic filings, however, the

fees for submitting paper forms ($65) are almost twice as high as the eCO. The process also takes longer, since all communication is carried out over U.S. Post and the information in the paper form must be digitized by the Copyright Office.

When registering something with visual and written components, form CO allows an artist to classify the work as either a literary work or a visual arts work. In the prior forms regime, the predominance of textual or visual elements would govern which registration form was required. However, such classifications are for administrative purposes only, and protection will not be diminished simply because the artist makes a mistake in choosing the correct classification. Also, when registering a contribution to a magazine or other collective work, the class to be used is that for the contribution and not the class into which the entire collective work falls.

A copy of Form VA appears on pages 26–29. This is a simple two-page form with step-by-step directions explaining how to fill it out. Along with the appropriate form, the filing fee of $65 and copies of the work being registered must be sent to the Copyright Office. The application form, copies of the work and fee should be mailed in one package, unless the artist doesn't have to include the fee because he or she maintains a deposit account with the Copyright Office.

Advantages of Registration

Registration is not necessary to gain copyright protection—protection exists the moment a work is created under the 1978 law. But registration does have the following important advantages: (1) the certificate of registration, if issued either before or within five years of first publication, is presumptive proof of the validity of the copyright and the truth of the statements made in the copyright application; (2) registration must be made before an infringement commences in order to qualify to receive attorney's fees and "statutory" damages (a special kind of damages that an artist can elect to receive if actual damages are hard to prove), except that a published work registered within three months of publication would still qualify; (3) registration is necessary in order to bring a suit for infringement of copyright (unless the infringed work is protected under the Berne Convention and its country of origin is not the

United States); and (4) with respect to works published from January 1, 1978 to March 1, 1989, registration cuts off certain defenses that an innocent infringer might be able to assert due to a defective copyright notice.

Congress attempted, at one point, to eliminate the need for registration as prerequisite to bringing infringement litigation or obtaining statutory damages and attorney fee awards. The effort received strong support from the Graphic Artists Guild and the American Society of Media Photographers, but was opposed by the Authors Guild. Its ultimate defeat left Section 412, "Registration as a prerequisite to certain remedies for infringement," as the only governing law.

As mentioned, works originating in a Berne Union country other than the United States do not have to be registered prior to commencing a lawsuit for infringement. Because of the other advantages of registering, the copyright owners of such foreign works will presumably be inclined toward registration.

Registration requires submission of an acceptable application, deposit of the work to be protected, and a fee. The date on which the Copyright Office receives all three elements generally determines the effective date of registation.

To correct a mistake or amplify information contained in a completed registration, Form CA for supplementary registration is used. Form CA may only be submitted after a registration number has been obtained for the work. It should not be used to renew copyright, or to update copyright on a work which has substantially changed since it was first registered. In the latter case, the artist should submit a new registration form for the changed work.

Circular 40, "Copyright Registration for Works of the Visual Arts," offers information as to registering single or multiple works. Circular 44, "Cartoons and Comic Strips," discusses both registration and deposit for cartoons and comic strips. Circular 55 discusses registration of "multimedia works" combining two or more forms of expression, while Circular 66 details registration of "online works," which includes websites and other works made available over a communications network. Fact Sheet FL 107, "Copyright Registration of Photographs," describes the process for registering unpublished or published photos. Fact Sheet FL 124, "Group Registration of

Published Photographs," discusses how up to 750 published photographs may be registered under a single application and fee. Though FL 124 generally discusses group registration of published photographs, the reference to group registrations exceeding 750 images deals only with unpublished images. As discussed below, this kind of registration can be done using form CO and a number of Form CON continuation sheets, or through the eCO.

Group Registration Using eCO or CO

Neither eCO nor Form CO is designed for group registration, though certain kinds of group registration are possible using these approaches. For example, a collection of unpublished works by the same author or claimant can be registered using Form CO or eCO. Similarly, a collection of published works contained in a single publication (i.e. a photo-book or calendar containing multiple images) can be registered using eCO or form CO.

What if work has been published in a number of magazines? Though the eCO does not address this situation, the law specifically provides for group registration of contributions to periodicals and newspapers made by an artist during a twelve-month period, as long as each contribution has the same copyright claimant (and, if published before March 1, 1989, also had copyright notice in the name of the copyright claimant). In such a case, Form GR/CP is used as an addition to the basic application on Form VA or Form CO; both VA and GR/CP are available for download as a single package on the "Forms" section of the Copyright website. A copy of Form GR/CP also appears on page 40.

Thus published contributions to magazines and, as discussed in the next section, unpublished photographs can be registered as groups either over the Internet or using paper applications.

Group Registration Not Using eCO and CO

For other types of group registration, however, an applicant must resort to the use of the more traditional paper forms.

A group registration of unpublished works can be made under a single title and registration fee. Registering an unpublished collection can sharply reduce the cost of registering each work in the collection (and no copyright notice need be placed on unpublished work). To qualify for such a group deposit, the following conditions have to be met: (1) the deposit materials are assembled in an orderly form; (2) the collection bears a single title identifying the work as a whole, such as "Collected Drawings of Jane Artist, January, 2012"; (3) the person claiming copyright in each work forming part of the collection is also the person claiming copyright in the entire collection; and (4) all the works in the collection are by the same person or, if by different persons, at least one of them has contributed copyrightable material to each work in the collection.

There is no limit on the number of works that can be included in a collection. Also, the law specifically states that a work registered when unpublished need not be registered again when published. Of course, if new material is added to the work or it is transposed into a new medium, creating a substantial variation from the registered work, it would be desirable to register the work again to protect the changed version. In the event of litigation, it is important that the work deposited with the Copyright Office show all of the aspects protected by the copyright being contested in the lawsuit. Also, for any deposit with the Copyright Office, the deposit materials should not be likely to fade or alter with time.

A separate procedure exists for registering groups of published photographs. Up to 750 photographs, taken by a single photographer in and published within a 12-month period, may be registered under a single fee using Forms VA and Gr/PPh/CON. The process requires the registrant to submit a Form VA, and attach to it a number of continuation sheets (Gr/PPh/CON) stating the name and publication date of the photographs in the group. Because eCO does not support the uploading of so many images in a single application, the deposit for a Gr/PPh/CON continuation form must be mailed, either in the form of prints, slides, contact sheets, videos, photocopies of the published form, or on CD/DVD-ROM. If the photos were published at different times, the applicant must indicate the name or number of each photograph, and its date of publication, using "continuation sheets." Each Gr/PPh/CON continuation sheet accommodates up to fifteen photos, and an applicant may submit a maximum of fifty such sheets with a single Form VA.

The Copyright office also permits applicants to register more than 750 unpublished photographs in a single application. This can be done using either Form VA and accompanying Form CON continuation sheets, Form CO, or the newer eCO procedure.

The artist will want to register contributions, even if the periodical or newspaper is also registered by the owner of its copyright. The registration of the collective work by its owner may not confer the benefits of registration on the artist, since the artist's copyright in the contribution is separate from the copyright in the collective work (but see, for a case in which a magazine's registration did effectively register a contribution, *Curtis v. General Dynamics Corp.*, 1991 Copyright Law Decisions, Paragraph 26,776). Also, if the artist is going to use Form GR/CP with Form VA, it would be wise to file every three months in order to be certain of qualifying for attorney's fees and statutory damages in the event of an infringement, as explained in the section on registration.

Deposit

With the registration form and fee, one complete copy of an unpublished work or two copies of a published work should be sent to the Copyright Office. If editions of differing quality have been published, the Copyright Office regulations provide guidelines to determine which edition is to be considered the best. These guidelines are examined in Circular 7b, "'Best Edition' of Published Copyrighted Works for the Collections of the Library of Congress." For works first published outside of the United States, only one complete copy of the work need be deposited. If a work is published simultaneously in the United States and abroad, it is treated as if first published in the United States. A helpful publication from the Copyright Office is Circular 40a, "Deposit Requirements for Registration of Claims to Copyright in Visual Arts Material."

For registrations under the provision allowing group registrations for contributions to periodicals and newspapers, the deposit materials can be one copy of any of the following: (1) one complete copy of each periodical or section of a newspaper in which the work appeared; (2) the entire page containing the contribution; (3) the contribution clipped from the collective work; or (4) one photocopy of the contribution.

When registering published greeting cards, picture postcards, or stationery, only one complete copy need be deposited. Similarly, only one complete copy has to be deposited for commercial prints, labels, advertising catalogs, and other advertising matter used in connection with the rental, lease, lending, licensing, or sale of articles of merchandise, works of authorship, or services. This would include, for example, the advertising used in connection with a motion picture. If the print, label, advertising catalogs or other advertising material appears in a larger work, the page or pages on which it appears can be submitted in place of the larger work. If it appears on a three-dimensional work, an alternate deposit must be made as explained in the next section.

Only one complete copy of the best edition of a published work must be deposited for two-dimensional games, decals, fabric patches or emblems, calendars, instructions for needle work,, needle work, and craft kits. Likewise, only one copy need be deposited for a box, case, carton, or other three-dimensional container.

For a published motion picture, whether on film or videotape, only one complete copy need be deposited. For an unpublished motion picture, one complete copy must be deposited or, instead, the alternate deposit materials described in the next section may be submitted. It is possible, when submitting a copy of a published motion picture, to enter into a "Motion Picture Agreement" with the Librarian of Congress. This Agreement provides for the copy to be immediately returned to the artist subject to recall by the Library of Congress. There is no requirement to deposit photographs with either a published or an unpublished motion picture, but in either case the deposit must include a separate description with respect to the content of the work, such as a continuity, press book, or synopsis.

For a multimedia kit first published in the United States, the required deposit is one complete copy of the best edition. Circular 55, "Copyright Registration for Multimedia Works," discusses the variety of deposit requirements, as well as the appropriate applications forms, for the different combinations of works that may compose a multimedia kit.

The deposit for works fixed in CD-ROM format is one complete copy, which includes a copy of the disk, a copy of any accompanying

operating software and instructional manual, and, if the work is in print as well as on the disk, a printed version of the work. All of these components should be provided, whether or not individually copyrightable.

Alternate Deposit

In certain situations it is possible to make an alternate deposit in place of the actual work itself. This may allow saving a great deal of expense by depositing something in place of copies of a work. Regardless of whether a work is published or unpublished, generally only one set of alternate deposit materials need be sent in. Combining this with the group deposit provisions, all the benefits of registration may be gained without great cost.

Alternate deposit can be made for an unpublished motion picture or, in some cases, for a published or unpublished soundtrack that is an integral part of a motion picture. It can be made for pictorial or graphic works if: (1) the work is unpublished; (2) less than five copies of the work have been published; or (3) the work has been published and sold or offered for sale in a limited edition consisting of no more than three hundred numbered copies. If the work is too valuable to deposit, a special request may be made to the Copyright Office for permission to submit identifying material rather than copies of the actual work.

Alternate deposit materials must be sent in for three-dimensional works and oversize works (which are those exceeding ninety-six inches in any dimension). If this mandatory requirement of alternate deposit would create a hardship due to expense or difficulty, a special request may be made to the Copyright Office to deposit actual copies of a work.

The regulations allow the deposit of an actual copy of small pieces of published jewelry made of inexpensive metal and of published games consisting of multiple parts in boxes or containers no greater than twelve-by-twenty-four-by-six inches.

The alternate deposit for an unpublished motion picture can be either: (1) an audio cassette or other reproduction of the entire soundtrack of the motion picture and a description of the motion picture; or (2) a set consisting of one frame enlargement or similar visual reproduction from each ten minute segment of the motion picture and a description of the motion picture. The description can be a continuity, a pressbook or a synopsis, but it must in all cases include: (1) the title or continuing title of the work and the episode title, if any; (2) the nature and general content of the program; (3) the date when the work was created and whether or not it was simultaneously transmitted; (4) the date of the first transmission, if any; (5) the running time; and (6) the credits appearing on the work, if any. A motion picture's soundtrack can be registered separately if it has not been embodied in any form other than as a soundtrack that is integral to a motion picture. The alternate deposit for a soundtrack consists of a transcription of the entire work, or a reproduction of the entire work on a tape or record, accompanied by photographs or other reproductions from the motion picture showing the title of the picture, the soundtrack credits and the copyright notice for the soundtrack, if any. For both motion pictures and separate motion picture soundtracks, the reproductions for deposit can be photographic prints, transparencies, photostats, drawings, or similar two-dimensional renderings that are visible without use of a machine.

A different set of rules for alternate deposit apply for works that are pictorial or graphic, three-dimensional, or oversize. The materials used for alternate deposit can be photographic prints, transparencies, photostats, drawings, or similar two-dimensional reproductions or renderings of the work in a form that can be looked at without the aid of a machine. The materials used for alternate deposit should all be of the same size, with photographic transparencies at least 35mm (mounted if three-by-three inches or less, and preferably mounted even if greater than three-by-three inches) and all other materials preferably eight-by-ten inches (but no less than three-by-three inches and no more than nine-by-twelve inches).

For pictorial and graphic work, the materials must reproduce the actual colors of the work. In all other cases, the materials may be either in color or in black and white. Also, except for transparencies, the image of the work must be life size or larger or, if it is less than life size, it must be large enough to show clearly the entire copyrightable content of the work. The title and an exact measurement of one or more dimensions of the work must appear on the front, back, or mount of at least one piece of the identifying material, and the position and form of the copyright notice must

be shown clearly on at least one piece of the identifying material if the work has been published. The piece showing the copyright notice does not have to be of uniform size with the material showing the work itself. For example, a 35mm transparency of the work could be accompanied by a drawing of up to nine by twelve inches showing the exact appearance and contents of the notice, its dimensions and its position on the work.

Deposit for the Library of Congress

In addition to depositing copies for copyright registration, copies may also have to be deposited for the Library of Congress when work is published in the United States on or after March 1, 1989 (or if the work was published with a copyright notice in the United States from January 1, 1978 to March 1, 1989). For published work, the requirement of deposit for the Library of Congress can be satisfied by simply making the correct deposit for registration and sending in the application form and fee with the deposit within three months of publication. For work that has previously been registered as unpublished, within three months of publication two copies of the best edition of the work should be deposited for the Library of Congress.

However, many works will be exempt from deposit, including three-dimensional sculptural works; contributions to collective works; greeting cards, picture postcards, and stationery; prints, labels, advertising catalogs and other advertising matter published in connection with renting, leasing, lending, licensing, or selling merchandise, works of authorship, or services; and any works published only on jewelry, dolls, toys, plaques, floor coverings, wallpaper, textiles and other fabrics, packaging, or other useful articles.

In addition, for published pictorial and graphic works, it is possible to deposit one complete copy or make an alternate deposit of identifying materials if either: (1) fewer than five copies of the work have been published, or (2) the work is published and offered for sale in a limited edition of three hundred or fewer numbered copies. This is of particular help to printmakers, who had to deposit two copies of fine prints prior to 1978.

The requirement of deposit for the Library of Congress does not in any way affect the copyright protection already in effect. If, for example, an artist registered a work when unpublished and didn't bother to send in the required copies upon publication, the Register of Copyrights could request copies from the artist. Only if the artist didn't comply with such a request within three months would he or she become liable for fines and other penalties. However, the copyright would remain valid.

The Process of Electronically Registering a Copyright

The simplest and least expensive method for registration of copyright is through the eCO (Electronic Copyright Office). This icon, which is prominently located on the Copyright Office's main page, directs applicants to a collection of rules and guidelines for using the system. The eCO is usable by any applicant registering (1) a collection of works first published in the same unit of publication; (2) a collection of unpublished works, (3) collective works, and (4) single works, even if those works containing multiple authorship elements by different authors. The key underlying requirement is that a single claimant be making the registration, and that the claimant have copyrightable contributions in all of the works he or she seeks to register.

The system requires applicants to create a user profile that they may revisit in the future. In it, the Copyright Office will ask for an applicant's name, an e-mail address, phone number, and postal address. Applicants will also create a username and password identifying their account, and thereby permitting them to file multiple applications, and track the status of pending or completed registrations. The $35 fee for using the service is payable by credit or debit card. Alternatively, applicants can open an account with the Copyright office using the Pay.gov system, and deduct the cost of multiple applications from such accounts.

Once payment is made, applicants may upload their deposit in electronic form. The various electronic formats that the Copyright Office supports are described at *www.copyright.gov/eco/help-file-types.html*. If the applicant's upload is not among the file types described in the eCO guidelines, he or she must convert it before uploading.

Though there is no set size limit on files, there is a time limit for file uploads. Applicants have up to an hour before the Copyright server times out; hence, an applicant with

fast broadband Internet connection can upload much larger files than an applicant using a dial-up services. In the event that the work requires physical deposit, the "best edition" guidelines are discussed in Circular 7b. the eCO system permits applicants to print special shipping labels, hence assuring that the mailed materials are not mismatched or assigned to a different application.

Filling out Copyright Forms

Most applicants who cannot or choose not to use eCO will use the Form CO to register their copyright. This form is designed to be filled out using a computer, printed, and mailed back with the appropriate fee and deposit. The form itself is self-explanatory; the process of filling it out is described in a separate, downloadable instruction sheet, and is also described below in abbreviated form.

First, check the box that best describes the type of work being submitted for registration. If the work contains more than one type of authorship, choose the type predominates in the work.

Next, provide a single title, as it appears on the copy, in the appropriate space. If there is no title on the copy, give an identifying phrase to serve as the title or state "untitled." Use standard title capitalization without quotation marks; for example, The Old Man and the Sea. Up to fifty additional titles can be registered by clicking the "additional title" button as many times as necessary. To register more than fifty titles, file electronically or request the appropriate paper application with continuation sheets by mail (Form CON). In the "previous or alternative title" section, provide any additional titles the work may be known by.

Next, enter the year in which the submitted work was completed. Do not submit the completion dates of newer or older versions of the same work. If the work has been published, the year of completion cannot be later than the year of first publication.

If the work was published, enter the complete date, (mm/dd/ yyyy) on which the work was first published. Do not enter future publication dates. Next, enter the nation where the work was first published. Enter "United States" if the work was published in the United States at the same time or before it was published in abroad.

If this work has been published as part of a larger work, enter the title of that larger work in the field "Published as a contribution in a larger work entitled." If the larger work includes a volume, number, and/or issue date, add that information in the lines provided.

In Section 2, complete the "Personal name" entry by entering the author's name into 2a. If the work was "made for hire," enter the fullest form of the corporation or organization that commissioned the work into 2b. Under no circumstance should 2a and 2b be completed, as they are mutually exclusive fields. In general, the individual who actually created the work is the author; in the case of a "work made for hire," however, the hiring party owns the copyright. See chapter 4 for a detailed discussion of "work for hire." Also, in section 2c, the registrant may give the name under which the author does business by prefacing the name with phrases like "doing business as," "trading as," "sole owner of," or "also known as." Additional authors may be added by clicking the "additional authors" button.

In field 2d, provide the author's year of birth. Though this is an optional field, it is very useful as a form of author identification, since many authors share the same name. 2e calls for the author's year of death; this information is required if the author is deceased, since it is crucial for determining the length of the copyright term. In 2f, check to indicate whether the author is a U.S. citizen. If not, enter the author's country of citizenship. Alternatively, the registrant may name the nation where the author is permanently resides.

Complete 2g only if the work is "made for hire," if the author is anonymous, or if the author uses pseudonyms or fictitious names. Details on the "work for hire" doctrine can be found in chapter 4 of this book, and in Circular 9, which can be downloaded from the Copyright Register's website. If the author is anonymous, make sure that the author's legal name is listed in 2a, or that the word "anonymous" appears in field 2a. If the author uses pseudonyms, provide them in the appropriate box in 2g, and in 2a.

In field 2h, check the box that describes the kind of authorship the author contributed to the work being submitted. There are a number of options in selectable checkboxes, and an "other" box that allows registrants to describe forms of authorship not covered by the default options. Examples of such contributions might include choreography, musical arrangement,

translation, dramatization, or fictionalization. Contributions listed in 2h cannot pertain to conceptualization, procedure, development of ideas, or invention; copyright is designed to protect the fixed and tangible expression of an idea or concept, rather than the idea or concept itself.

Section 3 collects the copyright claimant's information. While one normally thinks of the author or artist as the owner of a copyright in a work, quite often the copyright in a work of visual art is owned by someone other than the artist. For example, if a work was "made for hire," the hiring party owns the copyright. Further, artists can transfer copyright in their work to others, who would then seek to register their rights.

Fields 3a and 3b are mutually exclusive; an individual registrant should enter a personal name in 3a, while an organizational registrant should enter the full name of the organization. As in 2a and 2b, registrants can submit alternate "doing business as" names, provided they preface the name with the appropriate prefix, such as "also known as," "trading as," and so on. 3c requires registrants to submit their postal and email addresses, and phone numbers.

3e applies to any registrant who did not author the work being submitted for registration. If the registrant is not the artist, he or she must indicate how they acquired ownership by checking the appropriate box.

Section 4 applies to artists whose work is based on materials that were previously published, copyrighted by another, in the public domain, or otherwise not owned by the claimant. The purpose of the section is to limit the scope of copyright protection, so that only the new subject matter in the submitted works is registered. 4a allows the registrant to identify text, artwork, drawings, photographs, or video that were not created or owned by the author or registrant. 4b asks the registrant to identify prior versions of the work that have already been registered, or to identify multiple registrations. 4c requires the registrant to specifically identify what aspects of the submitted works are new, and therefore deserving of copyright protection.

Section 5 identifies to the public who should be contacted in the event someone wants to secure a right or license to the copyrighted work. The artist or registrant can enter his or her own contact information here, but doing so makes the contact information available to the public. He or she may also use Section 5 to designate another party to receive inquiries as to rights and licensing in the registered work.

The information provided in Section 6 apprises the Copyright Office of who to contact if there are questions or concerns surrounding the registration of the submitted materials. Section 7 allows the registrant to designate an address to which the registration certificate will be mailed. Finally, Section 8 requires the registrant to sign, date, and certify the application to register the submitted work.

Using Paper Forms

While eCO, or alternatively Form CO, are the preferred registrations forms for most work, as described earlier in the chapter there are certain materials that must be registered using paper forms. For those situations, or if the artist simply prefers to use the paper forms and pay more, the following discussion reviews a number of alternatives. Note that although Form VA is not ordinarily available through the Copyright Web site (and must be requested in paper form from the Copyright Office), the GR/CP form download includes a copy of Form VA in electronic form that can filled in and printed out.

The assumption is that an individual artist, working under his or her own name, created a work and now wants to register it. If these assumptions are correct and, in addition, the work is completely new (does not contain previously published or public domain work), then Short Form VA could be used instead of Form VA. Filling out Short Form VA would be like filling out Form VA but even simpler.

1. Unpublished pictorial, graphic, or sculptural works. Use Form VA. Space 1—Fill in the title of the work and the nature of the work, such as its being an oil painting or a charcoal drawing. Space 2—Give the artist's name and indicate that the work is not a work for hire. Give the date of the artist's birth, indicate the appropriate country of his or her citizenship or permanent residence, and indicate that the work is neither anonymous nor written under a pseudonym. Where it says "Author of," check the appropriate box. Space 3—For an unpublished work give the year the work was finished; leave blank the date and nation of first publication.

Space 4—The artist's name and address should be shown for the copyright claimant. Space 5—Answer no, as the artist will not have previously registered the work. A yes answer would be appropriate if the artist were adding new material to work that had been previously registered, in which case the appropriate box should be checked. Space 6—If the artist has added new material to a previously registered work, explain what material the artist added to the old work to make a derivative work. The artist's registration would then protect the new elements of the derivative work. Space 7—Fill in the information about a deposit account if the artist has one. Also, give the artist's name and address for correspondence purposes. Space 8—Check the box for author, sign your name and then print or type his or her name. Space 9—Enter the artist's name and address so that the certificate of registration will be mailed to the artist.

2. Group registration for unpublished pictorial, graphic, or sculptural works. Use Form VA, filling it out exactly as for an unpublished pictorial, graphic, or sculptural work, except for the changes shown here. Space 1—The collection must have its own title, and it is that title which is used here. Space 3—The year in which creation of the work was completed is the year in which the most recently completed work contained in the collection was completed.

3. Published pictorial, graphic, or sculptural works. Use Form VA, filling it out exactly as for an unpublished pictorial, graphic, or sculptural work, except for the changes shown here. Space 3—In addition to giving the date of creation, give the date and nation of first publication of the work.

4. Group registration of published contributions to periodicals. Use Form VA if the contributions are pictorial or graphic, along with the adjunct Form GR/CP. To qualify, the contributions must meet the criteria listed on page 26. Form VA is filled out exactly as for a published pictorial or graphic work, except for the changes shown here. Space 1—In the space for the title, write "See Form GR/CP, attached" and leave the other parts of Space 1 blank. Space 3—Give the year of creation of the last work completed and leave blank the date and nation of first publication.

Then fill out Form GR/CP. Space A—Mark Form VA as the basic application and give the artist's name as both author and copyright claimant. Space B—For each box, fill in the requested information about the title of the contribution, the title of and other information about the periodical and the date and nation of first publication. Mail Form GR/CP with Form VA, the deposit copies, and the filing fee.

5. Unpublished audiovisual works, including motion pictures. Use Form PA. This is filled out in essentially the same way as for an unpublished pictorial, graphic, or sculptural work.

6. Published audiovisual works, including motion pictures. Use Form PA. This is filled out essentially the same way as for a published pictorial, graphic, or sculptural work.

☺ Form VA ☺

Detach and read these instructions before completing this form.
Make sure all applicable spaces have been filled in before you return this form.

BASIC INFORMATION

When to Use This Form: Use Form VA for copyright registration of published or unpublished works of the visual arts. This category consists of "pictorial, graphic, or sculptural works," including two-dimensional and three-dimensional works of fine, graphic, and applied art, photographs, prints and art reproductions, maps, globes, charts, technical drawings, diagrams, and models.

What Does Copyright Protect? Copyright in a work of the visual arts protects those pictorial, graphic, or sculptural elements that, either alone or in combination, represent an "original work of authorship." The statute declares: "In no case does copyright protection for an original work of authorship extend to any idea, procedure, process, system, method of operation, concept, principle, or discovery, regardless of the form in which it is described, explained, illustrated, or embodied in such work."

Works of Artistic Craftsmanship and Designs: "Works of artistic craftsmanship" are registrable on Form VA, but the statute makes clear that protection extends to "their form" and not to "their mechanical or utilitarian aspects." The "design of a useful article" is considered copyrightable "only if, and only to the extent that, such design incorporates pictorial, graphic, or sculptural features that can be identified separately from, and are capable of existing independently of, the utilitarian aspects of the article."

Labels and Advertisements: Works prepared for use in connection with the sale or advertisement of goods and services are registrable if they contain "original work of authorship." Use Form VA if the copyrightable material in the work you are registering is mainly pictorial or graphic; use Form TX if it consists mainly of text. **NOTE:** Words and short phrases such as names, titles, and slogans cannot be protected by copyright, and the same is true of standard symbols, emblems, and other commonly used graphic designs that are in the public domain. When used commercially, material of that sort can sometimes be protected under state laws of unfair competition or under the federal trademark laws. For information about trademark registration, write to the Commissioner of Patents and Trademarks, Washington, D.C. 20231.

Architectural Works: Copyright protection extends to the design of buildings created for the use of human beings. Architectural works created on or after December 1, 1990, or that on December 1, 1990, were unconstructed and embodied only in unpublished plans or drawings are eligible. Request Circular 41 for more information. Architectural works and technical drawings cannot be registered on the same application.

Deposit to Accompany Application: An application for copyright registration must be accompanied by a deposit consisting of copies representing the entire work for which registration is to be made.

 Unpublished Work: Deposit one complete copy.

 Published Work: Deposit two complete copies of the best edition.

 Work First Published Outside the United States: Deposit one complete copy of the first foreign edition.

 Contribution to a Collective Work: Deposit one complete copy of the best edition of the collective work.

The Copyright Notice: Before March 1, 1989, the use of copyright notice was mandatory on all published works, and any work first published before that date should have carried a notice. For works first published on and after March 1, 1989, use of the copyright notice is optional. For more information about copyright notice, see Circular 3, "Copyright Notice."

For Further Information: To speak to an information specialist, call (202) 707-3000 (TTY: (202) 707-6737). Recorded information is available 24 hours a day. Order forms and other publications from the address in space 9 or call the Forms and Publications Hotline at (202) 707-9100. Most circulars (but not forms) are available via fax. Call (202) 707-2600 from a touchtone phone. Access and download circulars, forms, and other information from the Copyright Office website at *www.copyright.gov.*

LINE-BY-LINE INSTRUCTIONS

Please type or print using black ink. The form is used to produce the certificate.

SPACE 1: Title

Title of This Work: Every work submitted for copyright registration must be given a title to identify that particular work. If the copies of the work bear a title (or an identifying phrase that could serve as a title), transcribe that wording *completely* and *exactly* on the application. Indexing of the registration and future identification of the work will depend on the information you give here. For an architectural work that has been constructed, add the date of construction after the title; if unconstructed at this time, add "not yet constructed."

 Publication as a Contribution: If the work being registered is a contribution to a periodical, serial, or collection, give the title of the contribution in the "Title of This Work" space. Then, in the line headed "Publication as a Contribution," give information about the collective work in which the contribution appeared.

 Nature of This Work: Briefly describe the general nature or character of the pictorial, graphic, or sculptural work being registered for copyright. Examples: "Oil Painting"; "Charcoal Drawing"; "Etching"; "Sculpture"; "Map"; "Photograph"; "Scale Model"; "Lithographic Print"; "Jewelry Design"; "Fabric Design."

 Previous or Alternative Titles: Complete this space if there are any additional titles for the work under which someone searching for the registration might be likely to look, or under which a document pertaining to the work might be recorded.

SPACE 2: Author(s)

General Instruction: After reading these instructions, decide who are the "authors" of this work for copyright purposes. Then, unless the work is a "collective work," give the requested information about every "author" who contributed any appreciable amount of copyrightable matter to this version of the work. If you need further space, request Continuation Sheets. In the case of a collective work, such as a catalog of paintings or collection of cartoons by various authors, give information about the author of the collective work as a whole.

 Name of Author: The fullest form of the author's name should be given. Unless the work was "made for hire," the individual who actually created the work is its "author." In the case of a work made for hire, the statute provides that "the employer or other person for whom the work was prepared is considered the author."

 What is a "Work Made for Hire"? A "work made for hire" is defined as: (1) "a work prepared by an employee within the scope of his or her employment"; or (2) "a work specially ordered or commissioned for use as a contribution to a collective work, as a part of a motion picture or other audiovisual work, as a translation, as a supplementary work, as a compilation, as an instructional text, as a test, as answer material for a test, or as an atlas, if the parties expressly agree in a written instrument signed by them that the work shall be considered a work made for hire." If you have checked "Yes" to indicate that the work was "made for hire," you must give the full legal name of the employer (or other person for whom the work was prepared). You may also include the name of the employee along with the name of the employer (for example: "Elster Publishing Co., employer for hire of John Ferguson").

 "Anonymous" or "Pseudonymous" Work: An author's contribution to a work is "anonymous" if that author is not identified on the copies or phonorecords of the work. An author's contribution to a work is "pseudonymous" if that author is identified on the copies or phonorecords under a fictitious name. If the work is "anonymous" you may: (1) leave the line blank; or (2) state "anonymous" on the line; or (3) reveal the author's identity. If the work is "pseudonymous" you may: (1) leave the line blank; or (2) give the pseudonym and identify it as such (for example: "Huntley Haverstock, pseudonym"); or (3) reveal the author's name, making clear which is the real name and which is the pseudonym (for example: "Henry Leek, whose pseudonym is Priam Farrel"). However, the citizenship or domicile of the author **must** be given in all cases.

 Dates of Birth and Death: If the author is dead, the statute requires that the year of death be included in the application unless the work is anonymous or pseudonymous. The author's birth date is optional but is useful as a form of identification. Leave this space blank if the author's contribution was a "work made for hire."

Author's Nationality or Domicile: Give the country of which the author is a citizen or the country in which the author is domiciled.Nationality or domicile **must** be given in all cases.

Nature of Authorship: Catagories of pictorial, graphic, and sculptural authorship are listed below. Check the box(es) that best describe(s) each author's contribution to the work.

3-Dimensional sculptures: fine art sculptures, toys, dolls, scale models, and sculptural designs applied to useful articles.

2-Dimensional artwork: watercolor and oil paintings; pen and ink drawings; logo illustrations; greeting cards; collages; stencils; patterns; computer graphics; graphics appearing in screen displays; artwork appearing on posters, calendars, games, commercial prints and labels, and packaging, as well as 2-dimensional artwork applied to useful articles, and designs reproduced on textiles, lace, and other fabrics; on wallpaper, carpeting, floor tile, wrapping paper, and clothing.

Reproductions of works of art: reproductions of preexisting artwork made by, for example, lithography, photoengraving, or etching.

Maps: cartographic representations of an area, such as state and county maps, atlases, marine charts, relief maps, and globes.

Photographs: pictorial photographic prints and slides and holograms.

Jewelry designs: 3-dimensional designs applied to rings, pendants, earrings, necklaces, and the like.

Technical drawings: diagrams illustrating scientific or technical information in linear form, such as architectural blueprints or mechanical drawings.

Text: textual material that accompanies pictorial, graphic, or sculptural works, such as comic strips, greeting cards, games rules, commercial prints or labels, and maps.

Architectural works: designs of buildings, including the overall form as well as the arrangement and composition of spaces and elements of the design.

NOTE: Any registration for the underlying architectural plans must be applied for on a separate Form VA, checking the box "Technical drawing."

SPACE 3: Creation and Publication

General Instructions: Do not confuse "creation" with "publication." Every application for copyright registration must state "the year in which creation of the work was completed." Give the date and nation of first publication only if the work has been published.

Creation: Under the statute, a work is "created" when it is fixed in a copy or phonorecord for the first time. Where a work has been prepared over a period of time, the part of the work existing in fixed form on a particular date constitutes the created work on that date.The date you give here should be the year in which the author completed the particular version for which registration is now being sought, even if other versions exist or if further changes or additions are planned.

Publication: The statute defines "publication" as "the distribution of copies or phonorecords of a work to the public by sale or other transfer of ownership, or by rental, lease, or lending"; a work is also "published" if there has been an "offering to distribute copies or phonorecords to a group of persons for purposes of further distribution, public performance, or public display." Give the full date (month, day, year) when, and the country where, publication first occurred. If first publication took place simultaneously in the United States and other countries, it is sufficient to state "U.S.A."

SPACE 4: Claimant(s)

Name(s) and Address(es) of Copyright Claimant(s): Give the name(s) and address(es) of the copyright claimant(s) in this work even if the claimant is the same as the author. Copyright in a work belongs initially to the author of the work (including, in the case of a work made for hire, the employer or other person for whom the work was prepared). The copyright claimant is either the author of the work or a person or organization to whom the copyright initially belonging to the author has been transferred.

Transfer: The statute provides that, if the copyright claimant is not the author, the application for registration must contain "a brief statement of how the claimant obtained ownership of the copyright." If any copyright claimant named in space 4 is not an author named in space 2, give a brief statement explaining how the claimant(s) obtained ownership of the copyright. Examples: "By written contract"; "Transfer of all rights by author"; "Assignment"; "By will." Do not attach transfer documents or other attachments or riders.

SPACE 5: Previous Registration

General Instructions: The questions in space 5 are intended to find out whether an earlier registration has been made for this work and, if so, whether there is any basis for a new registration.As a rule, only one basic copyright registration can be made for the same version of a particular work.

Same Version: If this version is substantially the same as the work covered by a previous registration, a second registration is not generally possible unless: (1) the work has been registered in unpublished form and a second registration is now being sought to cover this first published edition; or (2) someone other than the author is identified as a copyright claimant in the earlier registration, and the author is now seeking registration in his or her own name.If either of these two exceptions applies, check the appropriate box and give the earlier registration number and date. Otherwise, do not submit Form VA; instead, write the Copyright Office for information about supplementary registration or recordation of transfers of copyright ownership.

Changed Version: If the work has been changed and you are now seeking registration to cover the additions or revisions, check the last box in space 5, give the earlier registration number and date, and complete both parts of space 6 in accordance with the instruction below.

Previous Registration Number and Date: If more than one previous registration has been made for the work, give the number and date of the latest registration.

SPACE 6: Derivative Work or Compilation

General Instructions: Complete space 6 if this work is a "changed version," "compilation," or "derivative work," and if it incorporates one or more earlier works that have already been published or registered for copyright, or that have fallen into the public domain.A "compilation" is defined as "a work formed by the collection and assembling of preexisting materials or of data that are selected, coordinated, or arranged in such a way that the resulting work as a whole constitutes an original work of authorship." A "derivative work" is "a work based on one or more preexisting works." Examples of derivative works include reproductions of works of art, sculptures based on drawings, lithographs based on paintings, maps based on previously published sources, or "any other form in which a work may be recast, transformed, or adapted." Derivative works also include works "consisting of editorial revisions, annotations, or other modifications" if these changes, as a whole, represent an original work of authorship.

Preexisting Material (space 6a): Complete this space **and** space 6b for derivative works.In this space identify the preexisting work that has been recast, transformed, or adapted.Examples of preexisting material might be "Grunewald Altarpiece" or "19th century quilt design." Do not complete this space for compilations.

Material Added to This Work (space 6b): Give a brief, general statement of the **additional** new material covered by the copyright claim for which registration is sought.In the case of a derivative work, identify this new material.Examples: "Adaptation of design and additional artistic work"; "Reproduction of painting by photolithography"; "Additional cartographic material"; "Compilation of photographs." If the work is a compilation, give a brief, general statement describing both the material that has been compiled **and** the compilation itself.Example: "Compilation of 19th century political cartoons."

SPACE 7, 8, 9: Fee, Correspondence, Certification, Return Address

Deposit Account: If you maintain a Deposit Account in the Copyright Office, identify it in space 7a. Otherwise, leave the space blank and send the fee of $30 with your application and deposit.

Correspondence (space 7b): This space should contain the name, address, area code, telephone number, email address, and fax number (if available) of the person to be consulted if correspondence about this application becomes necessary.

Certification (space 8): The application cannot be accepted unless it bears the date and the **handwritten signature** of the author or other copyright claimant, or of the owner of exclusive right(s), or of the duly authorized agent of the author, claimant, or owner of exclusive right(s).

Address for Return of Certificate (space 9): The address box must be completed legibly since the certificate will be returned in a window envelope.

Copyright Office fees are subject to change. For current fees, check the Copyright Office website at *www.copyright.gov*, write the Copyright Office, or call (202) 707-3000.

FORM VA
For a Work of the Visual Arts
UNITED STATES COPYRIGHT OFFICE

REGISTRATION NUMBER

VA VAU

EFFECTIVE DATE OF REGISTRATION

Month Day Year

DO NOT WRITE ABOVE THIS LINE. IF YOU NEED MORE SPACE, USE A SEPARATE CONTINUATION SHEET.

1

Title of This Work ▼ NATURE OF THIS WORK ▼ See instructions

Previous or Alternative Titles ▼

Publication as a Contribution If this work was published as a contribution to a periodical, serial, or collection, give information about the collective work in which the contribution appeared. **Title of Collective Work ▼**

If published in a periodical or serial give: **Volume ▼** **Number ▼** **Issue Date ▼** **On Pages ▼**

2 a

NAME OF AUTHOR ▼ DATES OF BIRTH AND DEATH
 Year Born ▼ Year Died ▼

NOTE

Under the law, the "author" of a "work made for hire" is generally the employer, not the employee (see instructions). For any part of this work that was "made for hire" check "Yes" in the space provided, give the employer (or other person for whom the work was prepared) as "Author" of that part, and leave the space for dates of birth and death blank.

Was this contribution to the work a "work made for hire"?
☐ Yes
☐ No

Author's Nationality or Domicile
Name of Country
OR { Citizen of _____
 Domiciled in _____

Was This Author's Contribution to the Work
Anonymous? ☐ Yes ☐ No
Pseudonymous? ☐ Yes ☐ No

If the answer to either of these questions is "Yes," see detailed instructions.

Nature of Authorship Check appropriate box(es).**See instructions**
☐ 3-Dimensional sculpture ☐ Map ☐ Technical drawing
☐ 2-Dimensional artwork ☐ Photograph ☐ Text
☐ Reproduction of work of art ☐ Jewelry design ☐ Architectural work

b

Name of Author ▼ Dates of Birth and Death
 Year Born ▼ Year Died ▼

Was this contribution to the work a "work made for hire"?
☐ Yes
☐ No

Author's Nationality or Domicile
Name of Country
OR { Citizen of _____
 Domiciled in _____

Was This Author's Contribution to the Work
Anonymous? ☐ Yes ☐ No
Pseudonymous? ☐ Yes ☐ No

If the answer to either of these questions is "Yes," see detailed instructions.

Nature of Authorship Check appropriate box(es).**See instructions**
☐ 3-Dimensional sculpture ☐ Map ☐ Technical drawing
☐ 2-Dimensional artwork ☐ Photograph ☐ Text
☐ Reproduction of work of art ☐ Jewelry design ☐ Architectural work

3 a

Year in Which Creation of This Work Was Completed
_____ Year
This information must be given in all cases.

b

Date and Nation of First Publication of This Particular Work
Complete this information ONLY if this work has been published.
Month _____ Day _____ Year _____
_____ Nation

4

See instructions before completing this space.

COPYRIGHT CLAIMANT(S) Name and address must be given even if the claimant is the same as the author given in space 2. ▼

Transfer If the claimant(s) named here in space 4 is (are) different from the author(s) named in space 2, give a brief statement of how the claimant(s) obtained ownership of the copyright. ▼

DO NOT WRITE HERE OFFICE USE ONLY

APPLICATION RECEIVED

ONE DEPOSIT RECEIVED

TWO DEPOSITS RECEIVED

FUNDS RECEIVED

MORE ON BACK ▶
• Complete all applicable spaces (numbers 5-9) on the reverse side of this page.
• See detailed instructions. • Sign the form at line 8.

DO NOT WRITE HERE

Page 1 of _____ pages

DO NOT WRITE ABOVE THIS LINE. IF YOU NEED MORE SPACE, USE A SEPARATE CONTINUATION SHEET.

PREVIOUS REGISTRATION Has registration for this work, or for an earlier version of this work, already been made in the Copyright Office?

☐ Yes ☐ No If your answer is "Yes," why is another registration being sought? (Check appropriate box.) ▼

a. ☐ This is the first published edition of a work previously registered in unpublished form.

b. ☐ This is the first application submitted by this author as copyright claimant.

c. ☐ This is a changed version of the work, as shown by space 6 on this application.

If your answer is "Yes," give: **Previous Registration Number** ▼ **Year of Registration** ▼

5

DERIVATIVE WORK OR COMPILATION Complete both space 6a and 6b for a derivative work; complete only 6b for a compilation.

a. Preexisting Material Identify any preexisting work or works that this work is based on or incorporates. ▼

b. Material Added to This Work Give a brief, general statement of the material that has been added to this work and in which copyright is claimed. ▼

6

a

See instructions before completing this space.

b

DEPOSIT ACCOUNT If the registration fee is to be charged to a Deposit Account established in the Copyright Office, give name and number of Account.

Name ▼ **Account Number** ▼

7

a

CORRESPONDENCE Give name and address to which correspondence about this application should be sent. Name/Address/Apt/City/State/ZIP ▼

b

Area code and daytime telephone number () Fax number ()

Email

CERTIFICATION* I, the undersigned, hereby certify that I am the

check only one ▶
- ☐ author
- ☐ other copyright claimant
- ☐ owner of exclusive right(s)
- ☐ authorized agent of _____
 Name of author or other copyright claimant, or owner of exclusive right(s) ▲

8

of the work identified in this application and that the statements made by me in this application are correct to the best of my knowledge.

Typed or printed name and date ▼ If this application gives a date of publication in space 3, do not sign and submit it before that date.

_____ Date _____

Handwritten signature (X) ▼

X _____

Certificate will be mailed in window envelope to this address:	Name ▼	**YOU MUST:** • Complete all necessary spaces • Sign your application in space 8	**9**
	Number/Street/Apt ▼	**SEND ALL 3 ELEMENTS IN THE SAME PACKAGE:** 1. Application form 2. Nonrefundable filing fee in check or money order payable to *Register of Copyrights* 3. Deposit material	Fees are subject to change. For current fees, check the Copyright Office website at www.copyright.gov, write the Copyright Office, or call (202) 707-3000.
	City/State/ZIP ▼	**MAIL TO:** Library of Congress Copyright Office 101 Independence Avenue, S.E. Washington, D.C. 20559-6000	

*17 U.S.C. § 506(e): Any person who knowingly makes a false representation of a material fact in the application for copyright registration provided for by section 409, or in any written statement filed in connection with the application, shall be fined not more than $2,500.

Rev: June 2002—20,000 Web Rev: June 2002 ♻ Printed on recycled paper U.S. Government Printing Office: 2000-461-113/20,021

Adjunct Application Form GR/CP

Detach and read these instructions before completing this form.
Make sure all applicable spaces have been ⊠lled in before you return this form.

BASIC INFORMATION

When to Use This Form

Use Form GR/CP when you are submitting a basic application on Form TX, Form PA, or Form VA for a group of works that qualify for a single registration under section 408(c)(2) of the copyright statute.

This Form:

- Is used solely as an adjunct to a basic application for copyright registration.
- Is not acceptable unless submitted with Form TX, Form PA, or Form VA.
- Is acceptable only if the group of works listed on it all qualify for a single copyright registration under 17 *USC* §408 (c)(2).

When Does a Group of Works Qualify for a Single Registration Under 17 *USC* §408(c)(2)?

For all works first published on or after March 1, 1989, a single copyright registration for a group of works can be made if *all* the following conditions are met:

1 All the works are by the same author, who is an individual (not an employer for hire); and

2 All the works were first published as contributions to periodicals (including newspapers) within a 12-month period; and

3 All the works have the same copyright claimant; and

4 The deposit accompanying the application consists of one copy of the entire periodical issue or newspaper section in which each contribution was first published; or a photocopy of the contribution itself; or a photocopy of the entire page containing the contribution; or the entire page containing the contribution cut or torn from the collective work; or the contribution cut or torn from the collective work; or photographs or photographic slides of the contribution or entire page containing the contribution as long as all contents of the contributions are clear and legible; and

5 The application identifies each contribution separately, including the periodical containing it and the date of its first publication.

> **Note:** For contributions that were first published prior to March 1, 1989, in addition to the conditions listed above, each contribution as first published must have borne a separate copyright notice, and the name of the owner of copyright in the work (or an abbreviation or alternative designation of the owner) must have been the same in each notice.

How to Apply for Group Registration

1 Study the information on this page to make sure that all the works you want to register together as a group qualify for a single registration.

2 Read through the procedure for group registration in the next column. Decide which form you should use for the basic registration. Be sure to have all the information you need before filling out both the basic and the adjunct application forms.

3 Complete the basic application form, following the detailed instructions accompanying it *and the special instructions on the reverse of this page.*

4 Complete the adjunct application on Form GR/CP and mail it, together with the basic application form, the fee, and the required copy of each contribution, to: *Library of Congress, Copyright Office, 101 Independence Avenue SE, Washington, DC 20559-6000*

Unless you have a Deposit Account in the Copyright Office, send a check or money order payable to *Register of Copyrights.*

Procedure for Group Registration

Two Application Forms Must Be Filed When you apply for a single registration to cover a group of contributions to periodicals, you must submit two application forms:

1 A basic application on either Form TX, Form PA, or Form VA. It must contain all the information required for copyright registration except the titles and information concerning publication of the contributions.

2 An adjunct application on Form GR/CP. This form provides separate identification for each contribution and gives information about first publication, as required by the statute.

Which Basic Application Form to Submit The basic application form you choose should be determined by the nature of the contributions you are registering. If they meet the statutory qualifications for group registration (outlined above), the contributions can be registered together even if they are entirely different in nature, type, or content. However, you must choose which of three forms is generally the most appropriate on which to submit your basic application:

- Form TX for nondramatic literary works consisting primarily of text. Examples are fiction, verse, articles, news stories, features, essays, reviews, editorials, columns, quizzes, puzzles, and advertising copy.

- Form PA for works of the performing arts. Examples are music, drama, choreography, and pantomimes.

- Form VA for works of the visual arts. Examples are photographs, drawings, paintings, prints, art reproductions, cartoons, comic strips, charts, diagrams, maps, pictorial ornamentation, and pictorial or graphic material published as advertising.

If your contributions differ in nature, choose the form most suitable for the majority of them.

Registration Fee for Group Registration Unless you maintain a deposit account in the Copyright Office, the registration fee must accompany your application forms and copies. Make your remittance payable to *Register of Copyrights.* Copyright Office fees are subject to change. For current fees, check the Copyright Office website at *www.copyright.gov*, write the Copyright Office, or call (202) 707-3000.

ISSN If a published serial has not been assigned an ISSN, application forms and additional information may be obtained from *Library of Congress, National Serials Data Program, Serial Record Division, Washington, DC 20540-4160.* Call (202) 707-6452. Or obtain information at *www./loc.gov/issn.*

What Copies Should Be Deposited for Group Registration? The application forms you file for group registration must be accompanied by one complete copy of each published contribution listed on Form GR/CP. For a description of acceptable deposits, see (4) under "When Does a Group of Works Qualify for a Single Registration under 17 *USC* §408(c)(2)?"

> **Note:** Since these deposit alternatives differ from the current regulations, the Office will automatically grant special relief upon receipt. There is no need for the applicant to request such relief in writing. This is being done to facilitate registration pending a change in the regulations.

The Copyright Notice: Before March 1, 1989, the use of a copyright notice was mandatory on all published works, and any work first published before that date should have carried a notice. Furthermore, among the conditions for group registration of contributions to periodicals for works first published prior to March 1, 1989, the statute establishes two requirements involving the copyright notice: (1) Each of the contributions as first published must have borne a

continued ▶

separate copyright notice; and (2) "The name of the owner of copyright in the works, or an abbreviation by which the name can be recognized, or a generally known alternative designation of the owner" must have been the same in each notice. For works first published on and after March 1, 1989, use of the copyright notice is optional. For more information about copyright notice, request Circular 3, *Copyright Notice.*

For Further Information: To speak to a Copyright Office staff member, call (202) 707-3000 (TTY: (202) 707-6737). Recorded information is available 24 hours a day. Order forms and other publications from *Library of Congress, Copyright Office, 101 Independence Avenue SE, Washington, DC 20559-6000* or call the Forms and Publications Hotline at (202) 707-9100. Access and download circulars, forms, and other information from the Copyright Office website at *www.copyright.gov.*

Note: The advantage of group registration is that it allows any number of works published within a 12-month period to be registered "on the basis of a single deposit, application, and registration fee." On the other hand, group registration may also have disadvantages under certain circumstances. If infringement of a published work begins before the work has been registered, the copyright owner can still obtain the ordinary remedies for copyright infringement (including injunctions, actual damages and profits, and impounding and disposition of infringing articles). However, in that situation—where the copyright in a published work is infringed before registration is made—the owner cannot obtain special remedies (statutory damages and attorney's fees) unless registration was made within 3 months after first publication of the work.

INSTRUCTIONS FOR THE BASIC APPLICATION FOR GROUP REGISTRATION

In general, the instructions for filling out the basic application (Form TX, Form PA, or Form VA) apply to group registrations. In addition, please observe the following specific instructions:

SPACE 1: Title

Do not give information concerning any of the contributions in space 1 of the basic application. Instead, in the block headed "Title of this Work," state: "See Form GR/CP, attached." Leave the other blocks in space 1 blank.

SPACE 2: Author

Give the name and other information concerning the author of all of the contributions listed in Form GR/CP. To qualify for group registration, all of the contributions must have been written by the same individual author.

SPACE 3: Creation and Publication

In the block calling for the year of creation, give the year of creation of the last of the contributions to be completed. Leave the block calling for the date and nation of first publication blank.

SPACE 4: Claimant

Give all of the requested information, which must be the same for all of the contributions listed on Form GR/CP.

Other Spaces

Complete all of the applicable spaces and be sure that the form is signed in the certification space.

HOW TO FILL OUT FORM GR/CP

Please type or print using black ink.

A PART A: Identification of Application

Identification of Basic Application: Indicate, by checking one of the boxes, which of the basic application forms (Form TX, Form PA, or Form VA) you are filing for registration.

Identification of Author and Claimant: Give the name of the individual author exactly as it appears in line 2 of the basic application, and give the name of the copyright claimant exactly as it appears in line 4. These must be the same for all of the contributions listed in Part B of Form GR/CP.

B PART B: Registration for Group of Contributions

General Instructions: Under the statute, a group of contributions to periodicals will qualify for a single registration only if the application "identifies each work separately, including the periodical containing it and its date of first publication." Part B of the Form GR/CP provides enough lines to list 19 separate contributions; if you need more space, use additional Forms GR/CP. If possible, list the contributions in the order of their publication, giving the earliest first. Number each line consecutively.

Important: All of the contributions listed on Form GR/CP must have been published within a single 12-month period. This does not mean that all of the contributions must have been published during the same calendar year, but it does mean that, to be grouped in a single application, the earliest and latest contributions must not have been published more than 12 months apart.

Example: Contributions published on April 1, 1978, July 1, 1978, and March 1, 1979, could be grouped together, but a contribution published on April 15, 1979, could not be registered with them as part of the group.

Title of Contribution: Each contribution must be given a title that identifies that particular work and can distinguish it from others. If the contribution as published in the periodical bears a title (or an identifying phrase that could serve as a title), transcribe its wording completely and exactly.

Identification of Periodical: Give the overall title of the periodical in which the contribution was first published, together with the volume and issue number (if any) and the issue date.

Pages: Give the number of the page of the periodical issue on which the contribution appeared. If the contribution covered more than one page, give the inclusive pages, if possible.

First Publication: The statute defines "publication" as "the distribution of copies or phonorecords of a work to the public by sale or other transfer of ownership, or by rental, lease, or lending"; a work is also "published" if there has been an "offering to distribute copies or phonorecords to a group of persons for purposes of further distribution, public performance, or public display." Give the full date (month, day, and year) when, and the country where, publication of the periodical issue containing the contribution first occurred. If first publication took place simultaneously in the United States and other countries, it is sufficient to state "U.S.A."

ADJUNCT APPLICATION
for Copyright Registration for a
Group of Contributions to Periodicals

- Use this adjunct form only if you are making a single registration for a group of contributions to periodicals, and you are also filing a basic application on Form TX, Form PA, or Form VA. Follow the instructions, attached.
- Number each line in Part B consecutively. Use additional Forms GR/CP if you need more space.
- Submit this adjunct form with the basic application form. Clip (do not tape or staple) and fold all sheets together before submitting them.
- **Copyright Office fees are subject to change. For current fees, check the Copyright Office website at** *www.copyright.gov***, write the Coyright Office, or call (202) 707-3000.**

ⓒ Form GR/CP

UNITED STATES COPYRIGHT OFFICE

REGISTRATION NUMBER

TX	PA	VA

EFFECTIVE DATE OF REGISTRATION

Month	Day	Year

FORM GR/CP RECEIVED

Page _____ of _____ pages

DO NOT WRITE ABOVE THIS LINE. FOR COPYRIGHT OFFICE USE ONLY

A
Identification of Application

IDENTIFICATION OF BASIC APPLICATION:
This application for copyright registration for a group of contributions to periodicals is submitted as an adjunct to an application filed on: (Check which)

☐ Form TX ☐ Form PA ☐ Form VA

IDENTIFICATION OF AUTHOR AND CLAIMANT: Give the name of the author and the name of the copyright claimant in all of the contributions listed in Part B of this form. The names should be the same as the names given in spaces 2 and 4 of the basic application.

Name of Author _____

Name of Copyright Claimant _____

B
Registration for Group of Contributions

COPYRIGHT REGISTRATION FOR A GROUP OF CONTRIBUTIONS TO PERIODICALS: To make a single registration for a group of works by the same individual author, all first published as contributions to periodicals within a 12-month period (see instructions), give full information about each contribution. If more space is needed, use additional Forms GR/CP.

☐ Title of Contribution _____
Title of Periodical _____ Vol.____ No._____ Issue Date _____ Pages _____
Date of First Publication _____ Nation of First Publication _____
(Month) (Day) (Year) (Country)

☐ Title of Contribution _____
Title of Periodical _____ Vol.____ No._____ Issue Date _____ Pages _____
Date of First Publication _____ Nation of First Publication _____
(Month) (Day) (Year) (Country)

☐ Title of Contribution _____
Title of Periodical _____ Vol.____ No._____ Issue Date _____ Pages _____
Date of First Publication _____ Nation of First Publication _____
(Month) (Day) (Year) (Country)

☐ Title of Contribution _____
Title of Periodical _____ Vol.____ No._____ Issue Date _____ Pages _____
Date of First Publication _____ Nation of First Publication _____
(Month) (Day) (Year) (Country)

☐ Title of Contribution _____
Title of Periodical _____ Vol.____ No._____ Issue Date _____ Pages _____
Date of First Publication _____ Nation of First Publication _____
(Month) (Day) (Year) (Country)

☐ Title of Contribution _____
Title of Periodical _____ Vol.____ No._____ Issue Date _____ Pages _____
Date of First Publication _____ Nation of First Publication _____
(Month) (Day) (Year) (Country)

☐ Title of Contribution _____
Title of Periodical _____ Vol.____ No._____ Issue Date _____ Pages _____
Date of First Publication _____ Nation of First Publication _____
(Month) (Day) (Year) (Country)

DO NOT WRITE ABOVE THIS LINE. FOR COPYRIGHT OFFICE USE ONLY.

B

Continued

☐ Title of Contribution _____
Title of Periodical _____ Vol.___ No.____ Issue Date _____ Pages _____
Date of First Publication _____ Nation of First Publication _____
(Month) (Day) (Year) (Country)

☐ Title of Contribution _____
Title of Periodical _____ Vol.___ No.____ Issue Date _____ Pages _____
Date of First Publication _____ Nation of First Publication _____
(Month) (Day) (Year) (Country)

☐ Title of Contribution _____
Title of Periodical _____ Vol.___ No.____ Issue Date _____ Pages _____
Date of First Publication _____ Nation of First Publication _____
(Month) (Day) (Year) (Country)

☐ Title of Contribution _____
Title of Periodical _____ Vol.___ No.____ Issue Date _____ Pages _____
Date of First Publication _____ Nation of First Publication _____
(Month) (Day) (Year) (Country)

☐ Title of Contribution _____
Title of Periodical _____ Vol.___ No.____ Issue Date _____ Pages _____
Date of First Publication _____ Nation of First Publication _____
(Month) (Day) (Year) (Country)

☐ Title of Contribution _____
Title of Periodical _____ Vol.___ No.____ Issue Date _____ Pages _____
Date of First Publication _____ Nation of First Publication _____
(Month) (Day) (Year) (Country)

☐ Title of Contribution _____
Title of Periodical _____ Vol.___ No.____ Issue Date _____ Pages _____
Date of First Publication _____ Nation of First Publication _____
(Month) (Day) (Year) (Country)

☐ Title of Contribution _____
Title of Periodical _____ Vol.___ No.____ Issue Date _____ Pages _____
Date of First Publication _____ Nation of First Publication _____
(Month) (Day) (Year) (Country)

☐ Title of Contribution _____
Title of Periodical _____ Vol.___ No.____ Issue Date _____ Pages _____
Date of First Publication _____ Nation of First Publication _____
(Month) (Day) (Year) (Country)

☐ Title of Contribution _____
Title of Periodical _____ Vol.___ No.____ Issue Date _____ Pages _____
Date of First Publication _____ Nation of First Publication _____
(Month) (Day) (Year) (Country)

☐ Title of Contribution _____
Title of Periodical _____ Vol.___ No.____ Issue Date _____ Pages _____
Date of First Publication _____ Nation of First Publication _____
(Month) (Day) (Year) (Country)

☐ Title of Contribution _____
Title of Periodical _____ Vol.___ No.____ Issue Date _____ Pages _____
Date of First Publication _____ Nation of First Publication _____
(Month) (Day) (Year) (Country)

Form GR/CP–Full Rev: 07/2006 Print: 07/2006 Printed on recycled paper

U.S. Government Printing Office: 2006-xxxx

Instructions for Short Form VA

For pictorial, graphic, and sculptural works

USE THIS FORM IF—

1. You are the *only* author and copyright owner of this work, *and*
2. The work was *not* made for hire, *and*
3. The work is completely new (does not contain a substantial amount of material that has been previously published or registered or is in the public domain).

If any of the above does not apply, you may register online at www.copyright.gov or use Form VA.

NOTE: *Short Form VA is not appropriate for an anonymous author who does not wish to reveal his or her identity.*

HOW TO COMPLETE SHORT FORM VA

• Type or print in black ink.
• Be clear and legible.
• Give only the information requested.

Note: You may use a continuation sheet (Form ___/CON) to list individual titles in a collection. Complete space A and list the individual titles under space C on the back page. Space B is not applicable to short forms.

1 Title of This Work

You must give a title. If there is no title, state "UNTITLED." If you are registering an unpublished collection, give the collection title you want to appear in our records (for example: "Jewelry by Josephine, 1995 Volume"). Alternative title: If the work is known by two titles, you also may give the second title. If the work has been published as part of a larger work (including a periodical), give the title of that larger work instead of an alternative title, in addition to the title of the contribution.

2 Name and Address of Author and Owner of the Copyright

Give your name and mailing address. You may include your pseudonym followed by "pseud." Also, give the nation of which you are a citizen or where you have your domicile (i.e., permanent residence).

Give daytime phone and fax numbers and email address, if available.

3 Year of Creation

Give the latest year in which you completed the work you are registering at this time. A work is "created" when it is "fixed" in a tangible form. Examples: drawn on paper, molded in clay, stored in a computer.

4 Publication

If the work has been published (i.e., if copies have been distributed to the public), give the complete date of publication (month, day, and year) and the nation where the publication first took place.

5 Type of Authorship in This Work

Check the box or boxes that describe your authorship in the material you are sending. For example, if you are registering illustrations but have not written the story yet, check only the box for "2-dimensional artwork."

6 Signature of Author

Sign the application in black ink and check the appropriate box. The person signing the application should be the author or his/her authorized agent.

7 Person to Contact for Rights/Permissions

This space is optional. You may give the name and address of the person or organization to contact for permission to use the work. You may also provide phone, fax, or email information.

8 Certificate Will Be Mailed

This space must be completed. Your certificate of registration will be mailed in a window envelope to this address. Also, if the Copyright Office needs to contact you, we will write to this address.

9 Deposit Account

Complete this space only if you currently maintain a deposit account in the Copyright Office.

MAIL WITH THE FORM

• The filing fee in the form of a check or money order (*no cash*) payable to *Register of Copyrights*. (Copyright Office fees are subject to change. For current fees, check the Copyright Office website at *www.copyright.gov*, write the Copyright Office, or call (202) 707-3000 or 1-877-476-0778 (toll free)).

• One or two copies of the work or identifying material consisting of photographs or drawings showing the work. See table (right) for requirements for most works. **Note:** Read Circular 40a for the requirements for other works. Copies submitted become the property of the U.S. government.

Mail everything (application form, copy or copies, and fee) *in one package* to: *Library of Congress*
Copyright Office-VA
101 Independence Avenue SE
Washington, DC 20559

Questions? Call (202) 707-3000 or 1-877-476-0778 (toll free). Recorded information is available 24 hours a day. Order forms and other publications from *Library of Congress, Copyright Office-COPUBS, 101 Independence Avenue, SE, Washington, DC 20559*, or call (202) 707-9100. Download circulars and other information or register online at *www.copyright.gov*.

If you are registering:	And the work is *unpublished/published*, send:
• 2-dimensional artwork in a book, map, poster, or print	a. And the work is *unpublished*, send one complete copy or identifying material b. And the work is *published*, send two copies of the best published edition
• 3-dimensional sculpture • 2-dimensional artwork applied to a T-shirt	a. And the work is *unpublished*, send identifying material b. And the work is *published*, send identifying material
• a greeting card, pattern, commercial print or label, fabric, or wallpaper	a. And the work is *unpublished*, send one complete copy or identifying material b. And the work is *published*, send one copy of the best published edition

Short Form VA

For a Work of the Visual Arts

UNITED STATES COPYRIGHT OFFICE

REGISTRATION NUMBER

VA VAU

Effective Date of Registration

Application Received

Deposit Received

One Two

Fee Received

Examined By

Correspondence ❑

TYPE OR PRINT IN BLACK INK. DO NOT WRITE ABOVE THIS LINE.

1 **Title of This Work:**

Alternative title or title of larger work in which this work was published:

2 **Name and Address of Author and Owner of the Copyright:**

Nationality or domicile:

Phone, fax, and email:

Phone () Fax ()

Email

3 **Year of Creation:**

4 *If work has been published,* **Date and Nation of Publication:**

a. Date _____ Month _____ Day _____ Year *(Month, day, and year all required)*

b. Nation

5 **Type of Authorship in This Work:**

Check all that this author created.

❑ 3-Dimensional sculpture ❑ Photograph ❑ Map

❑ 2-Dimensional artwork ❑ Jewelry design ❑ Text

❑ Technical drawing

6 **Signature:**

Registration cannot be completed without a signature.

I certify that the statements made by me in this application are correct to the best of my knowledge. Check one:

❑ Author ❑ Authorized agent

X _____

7 **Name and Address of Person to Contact for Rights and Permissions:**

Phone, fax, and email:

❑ Check here if same as #2 above.

Phone () Fax ()

Email

OPTIONAL

8 Certificate will be mailed in window envelope to this address:

Name ▼

Number/Street/Apt ▼

City/State/Zip ▼

Complete this space only if you currently hold a Deposit Account in the Copyright Office.

9 Deposit account #_____

Name _____

DO NOT WRITE HERE Page 1 of _____ pages

*17 U.S.C. §506(e): Any person who knowingly makes a false representation of a material fact in the application for copyright registration provided for by section 409, or in any written statement filed in connection with the application, shall be fined not more than $2,500.

Form VA-Short Rev: 02/2012 Printed on recycled paper

U.S. Government Printing Office: 2012-xxx-xxx/xx,xxx

4 COPYRIGHT: WORKS FOR HIRE AND JOINT WORKS

Both works for hire and joint works present pitfalls for the artist. When an artist does work for hire, the employer or other commissioning party owns the copyright in the work as if they, in fact, created the work. This means that the artist does not even have the ability to get the rights back by termination after thirty-five years, because there was no transfer initially. Also, if an artist later copied all or part of a work that he or she had done as work for hire, the artist would be infringing his or her own work, since the copyright to that work belongs to the person who hired the artist. Perversely, if an artist does enough work for hire, he or she may soon discover his or her "alter ego" (in the form of a large supply of the artist's work that can be reused and modified) may actually compete with the artist, and damage the artist's livelihood.

In *Community for Creative Non-Violence v. Reid* (490 U.S. 730), the United States Supreme Court decided an important work-for-hire case in favor of artists. Nonetheless, work for hire remains a serious problem, especially for struggling artists who lack substantial bargaining power. And, in part because of the favorable ruling for artists, art directors commissioning work may contend that they are the joint authors of the work and entitled to co-own the copyright.

The Copyright Office offers information about work for hire in Circular 9, "Works-Made-for-Hire Under the 1976 Copyright Act." A work for hire can come into being under two clauses: (1) an employee creating copyrightable work in the course of his or her employment, or (2) certain specially commissioned or ordered work, if both parties sign a contract agreeing it is work for hire.

Who Is an Employee?

If an employee creates copyrightable art in the course of his or her employment, the employer will be treated as the creator of the art and owner of the copyright. But what makes a person fit the definition of an employee? Someone who is paid a salary for working from 9:00 AM to 5:00 PM from Monday through Friday under the control and direction of the employer and at the employer's office is certainly an employee. This type of employee will have state and federal tax payments withheld from the weekly paycheck and receive any benefits to which employees are entitled.

What if the artist is a freelancer who receives an assignment from an art buyer and executes it in the artist's own studio? This artist should not be considered an employee. However, before 1989, some cases had adopted the now discredited rationale that if the commissioning party exercises sufficient control and direction, the freelancer should be treated as an employee for copyright purposes.

The split between federal appellate courts over the issue of work for hire finally led to the *Community for Creative Non-Violence v. Reid* decision by the United States Supreme Court. This case arose on unusual facts and with a unique cast of characters. James Earl Reid, a Baltimore sculptor, was commissioned to create a sculpture for the Community for Creative Non-Violence (referred to as "CCNV"), a Washington, D.C. group that helps the homeless. CCNV's founder Mitch Snyder conceived the idea of a modern Nativity scene with the Holy Family replaced by two adults and an infant who are homeless and African-American. To be titled *Third World America*, the tableau would be on a steam grate and

the legend would read "And Still There Is No Room At The Inn." A photograph of the sculpture appears as figure 3.

Reid executed the sculpture without a fee, receiving payment only for his expenses. CCNV built the pedestal in the form of the steam grate and gave ideas as the work progressed (such as insisting that the family have their belongings in a shopping cart rather than bags or suitcases). After the work was finished, a dispute arose over ownership of the copyright when CCNV wanted to take the sculpture on tour. No written contract had been signed between the parties.

In an important victory for artists and other creators, the Court decided that whether someone is an employee must be decided under the law of agency. Under the law of agency one factor is "the hiring party's right to control the manner and means by which the product is accomplished." However, the Court went on to state:

In determining whether a hired party is an employee under the general common law of agency, we consider the hiring party's right to control the manner and means by which the product is accomplished. Among the factors relevant to this inquiry are the skill required; source of instrumentalities and tools; the location of the work; the duration of the relationship between parties; whether the hiring party has the right to assign additional projects to the hired party; extent of hired party's discretion over when and how long to work; the method of payment; the hired party's role in hiring and paying assistants; whether the work is part of the regular business of hiring party; whether the hiring party is in business; the provision of employee benefits; and the tax treatment of the hired party. . . .No one of these factors is determinative. (Footnotes omitted.)

Based on these factors, it should be unlikely that freelance artists working on assignment will ever be found to be employees. However, reliance on the *CCNV* factors has yielded some inconsistent results, since different courts may apply varying degrees of emphasis or importance to any particular *CCNV* factors discussed above. Indeed, outcomes usually turn upon

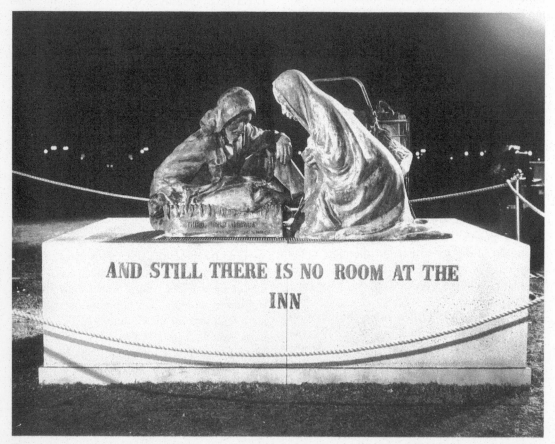

Figure 3. *Third World America* by James Earl Reid.

which of the *CCNV* factors the particular court has chosen to weigh more heavily. The trend in the circuits has been to adopt an individually modified version of these factors, with some circuits adding factors, and others paring the list down significantly. The Sixth Circuit in *Hi-tech Video Production, Inc. v. Capital Cities* (58 F.3d 1093) placed great emphasis on the parties' perceptions of the relationship, noting that Hi Tech's employees readily referred to the members of the production team as "freelancers," "independent contractors, and "subcontractors." Alternatively, the Second Circuit developed a weighted five factor test that derived from the original 13-factor test described in *CCNV. Carter et. al. v. Helmsley-Spear* (71 F.3d 77, *cert. denied,* 517 U.S.1208).

The *CCNV* case illustrates another trap for the unwary, especially for volunteers good-hearted enough to work without pay. If an artist falls within the definition of an employee, then the work may be work for hire despite the fact that the artist was never paid for doing the work.

However, the *CCNV* decision should mean that for freelancers to do work for hire, the assignment will have to come under clause 2 of the work-for-hire definition.

Specially Commissioned or Ordered Work

While *CCNV* is no hollow victory for artists, its ultimate effect was merely to turn the clock back to 1984. That year, the Graphic Artists Guild, the American Society of Media Photographers, and the New York Society of Illustrators had already been fighting for six years to change the copyright law with respect to work for hire. In June of 1978, only six months after the new law took effect, the Guild had documented to Congress the widespread use of work-for-hire contracts under Clause 2 of the definition of work for hire. The three groups spearheaded the creation of the Copyright Justice Coalition, which included in its membership nearly fifty organizations representing creative professionals. This Coalition gave testimony at the 1982 hearings on work for hire before the Senate subcommittee responsible for copyrights.

Clause 2 allows a freelancer to do an assignment as work for hire if a written contract is signed by both parties, the contract states that it is work for hire, and the assignment falls into one of the following listed categories:

- a contribution to a collective work, such as a magazine, newspaper, encyclopedia, or anthology;
- a contribution used as part of a motion picture or other audiovisual work;
- a translation;
- a compilation, which is a work formed by collecting and assembling pre-existing materials or data;
- an instructional text;
- a test or answer material for a test;
- an atlas; and
- a supplementary work, defined as a work used to supplement a work by another author for such purposes as illustrating, explaining, or assisting generally in the use of the author's work. Examples of supplementary works are forewords, afterwords, pictorial illustrations, maps, charts, tables, editorial notes, appendixes, and indexes.

The crucial point is that the artist must agree in writing that a work is for hire. If the artist doesn't agree in writing that a work is a work for hire, then it can't be (unless the artist is treated as an employee under clause 1). Since it is not clear whether other language can be used in place of the phrase "work for hire," artists should also refuse to sign anything with language in it that sounds similar to "work for hire" or an employment-type relationship. In one case, a court decided that an artist contributing to a collective work did work for hire even though the contract did not use the phrase "work for hire" but merely stated that the art would "remain the sole property of [the commissioning party] and cannot be reproduced or used for any other purpose. . . ." *Armento v. The Laser Image* (1998 Copyright Law Decisions, Paragraph 27,723). While this decision appears to be incorrect and contrary to the intent of the copyright law, the artist should take care to specify a limited transfer of rights. Since an unlimited transfer of rights may be construed as a total surrender of the artist's copyright, an artist creating work for another should clearly and unambiguously stake some copyright claim to the work.

Also, if an artist does a specially ordered or commissioned work that is outside of the categories shown above, it cannot be a work for hire, unless the artist is treated as an employee. For example, a portrait of someone done on a

commission basis should not be a work for hire because it doesn't fit any of the categories. In *Lulirama Ltd., Inc. v. Axcess Broadcast Services, Inc.* (128 F.3d 872), the court concluded that even though the written contract for advertising jingles stated the work was "for hire," such jingles did not fall into a category of specially commissioned works eligible to be work for hire and, therefore, could not be. If work is created independently and submitted in final form to a potential buyer, the work-for-hire problem should not arise. But, even here, caution dictates that the artist should not sign anything implying a work-for-hire situation, in order to avoid any confusion over copyright ownership.

Some clients seek all rights or work-for-hire contracts because they fear the artist will sell the work to a competitor. If this is the client's concern, a noncompetition provision is a far fairer solution. The artist would transfer limited rights, such as first North American serial rights, and agree not to sell the same drawing to a competitor of the client. Since the definition of a competitor may be an issue, the provision might read, "The artist agrees not to resell the work for uses competitive with the client's use. In the event of a resale, the artist agrees to obtain the written approval of the client, which approval shall not be unreasonably withheld." The artist should be careful that such a noncompetition clause applies only to the work being purchased and not other work the artist might do on commission.

Of course, in some cases an artist may be perfectly willing to work under an agreement specifying that work in one of the enumerated categories will be work for hire. In that case, it is important that the artist be aware that he or she is not the author of the work—the party commissioning or ordering the work is. They will own the copyright completely, so that it cannot be terminated after thirty-five years. This complete ownership is, therefore, even more than the transfer of "all rights" in a copyright. With this in mind, the artist should consider carefully what to charge for such work. The greater the right of usage the other party gets, the more they should pay for it.

Why Joint Works?

After the work-for-hire decision favoring artists in *CCNV*, the relationship between art director and talent underwent greater scrutiny. Because work for hire (in which the commissioning party owns the copyright) had been restricted, the commissioning party might want to assert that the art director and artist were joint authors. This would mean that the art director and artist would jointly own the copyright. Each would be able to license usage of the art without asking the permission of the other. Any money received from this licensing would have to be equally shared (regardless of whether the creative contribution was equal).

Why wouldn't a commissioning party obtain a written transfer explicitly setting forth the rights of copyright needed to exploit the work? Certainly this should be done. However, the decision in *CCNV* had presented a chaos factor for corporate counsels. From 1984 through 1989, many companies relied on their right to supervise a commissioned work as creating work-for-hire. After *CCNV*, however, it became clear that this reliance was misplaced. Without a written contract, companies might have already infringed commissioned work by additional usage or, if this was not the case, might wish to make additional usage but feel uncertain whether this was permissible. If the commissioned works were joint works, the company would not be an infringer if it used the work, but would have to account to the other joint author (ie., the illustrator or photographer) and share any profits earned from the usage.

The enterprising art director might wonder what his or her benefit would be from all this. If the art director is an employee and the art direction is done in the scope of the employment, then the company will own any copyrights created by the art director. This would include the joint ownership interest in a jointly authored work. If the art director is a freelancer, the joint ownership interest would vest in the art director.

What Is a Joint Work?

The 1978 copyright law defines a joint work as "a work prepared by two or more authors with the intention that their contributions be merged into inseparable or interdependent parts of a unitary whole." This definition is difficult to apply in practice; since authors often fail to take the precaution of a written agreement, the "intention" of the parties working together on a project may be difficult to ascertain. Also, what is inseparable or interdependent?

Before these issues can be resolved, each party must contribute some authorship. The facts underlying *CCNV v. Reid* provide a useful backdrop for trying to understand what constitutes "authorship." For starters, ideas are not copyrightable; only the artistic expression of an idea is. Take for example, the *idea* of creating a statue depicting a modern Nativity scene, in which two homeless adults and a homeless child huddle over a steam grate. This concept is not in itself copyrightable, though Reid's actual sculpture based on that idea is. In *CCNV*, Reid sculpted every part of the statue but the steam grate, which was supplied by CCNV (with some input from Reid). That grate was built by a cabinet-maker, and the steam was supplied using special-effects equipment from Hollywood.

There is no doubt that Reid contributed sufficient expression to make his sculpture copyrightable. But did CCNV? If the steam grate is not copyrightable, then CCNV could not claim joint authorship. Even if the steam grate is copyrightable, the issues of intention and merger into an interdependent work would still have to be addressed. While observing that the record lacked sufficient facts to decide this issue, the Court of Appeals stated that the case:

. . . might qualify as a textbook example of a jointly-authored work in which the joint authors co-own the copyright. . . . CCNV's contribution to the steam grate pedestal added to its initial conceptualization and ongoing direction of the realization of 'Third World America;' and the various indicia of the parties' intent, from the outset, to merge their contributions into a unitary whole, and not to construct and separately preserve discrete parts as independent works.

The United States Supreme Court sent this issue back to the federal district court for further findings of fact. In a judgment to which both parties consented, the district court ordered that Reid be recognized as the sole author of *Third World America*. However, CCNV was made the sole owner of the original copy of the works and all copyrights in that original. Reid was given the copyright with respect to three-dimensional reproductions, while both CCNV and Reid were given the right to make and sell two-dimensional reproductions without sharing any revenues earned with the other party. Other restrictions on the manner of portrayal of the sculpture in reproductions, authorship credit, use of the steam grate, and use of the inscription, "And Still There Is No Room At The Inn," were also part of the compromise.

The settlement avoided a showdown on the issue of what constitutes a joint work. It also offered an artful illustration of how a copyright can be subdivided between parties with differing or competing interests. With this settlement, CCNV is no longer an active case but rather a landmark of copyright history (although one further round of litigation was necessary for Reid to gain temporary possession of the sculpture so he could make the master mold necessary for him to benefit from his three-dimensional reproduction rights). What is difficult to accept, however, is that so little creativity might qualify CCNV as a joint author. Certainly, the artistry of the sculpture is far greater than any artistry present in the pedestal. If Reid and CCNV had been found to be joint authors, each would have had the right to license usage of the work and be entitled to 50 percent of any income, despite the disparity of their artistic contributions.

A number of joint work cases have now come before the courts. As so often happens, artistic issues do not always fit easily into the judicial framework. In *Strauss v. The Hearst Corporation* (1988 Copyright Law Decisions, Paragraph 26,244), the photographer Steve Strauss created the photograph for use inside *Popular Mechanics*. Later the magazine reused the photograph without permission on a promotional insert touting the magazine.

Strauss sued for copyright infringement, but the court found that Strauss and the magazine were joint owners of the copyright.

[I]t is hard to imagine a set of facts that is clearer on that point. It is apparent from Strauss' deposition that he knew captions and other copy would be superimposed upon the photograph when the article was put in final form. To that end he was careful to leave space in the composing of the photograph that would accommodate such future additions. Add to those truths the fact that [the art director] designed the layout for the photo and supervised some of the actual shoots, and that other artists and technicians hired by Popular Mechanics *retouched significant portions of the photo, and the conclusion is inescapable. . . .*

Of course, Strauss would be entitled to a share of the profits generated by the magazine's use of the photograph. But what are the profits? "I have serious doubt as to plaintiff's ability to prove, with sufficient certainty, the amount due him under an accounting," the court observed. Since the photograph was reused as part of a promotional piece, the court believed that it would be "difficult for plaintiff to establish a direct causal connection between defendant's use of the joint work and any profits received by defendant." If such a connection could not be proven by the photographer, he would receive nominal damages of $1. This interpretation of joint works simply creates a license to steal without consequences.

However, the court overlooked the fact that Strauss, as the joint owner of the pages in the magazine, was entitled to a share of the profits for that issue of the magazine as well as a share of the profits for the promotional usage. What a nightmare it would be for the corporate commissioning parties if joint works became more prevalent! Every commissioned work found to be jointly created would raise the risk of an accounting for the profits derived from the use. In such a case, any fee paid would presumably be a mere advance against the creator's total share. In addition, the Hearst Corporation wanted foreign rights, but most foreign countries require the consent of all joint owners to any planned usage. Faced with these difficulties, the Hearst Corporation settled with Strauss for a sum substantially in excess of $1.

The determination in *Strauss v. The Hearst Corporation* that the photograph was a joint work is certainly open to debate. What did the art director contribute that was copyrightable? Was Strauss's intention to create an inseparable or interdependent work? Even if these questions have favorable answers for the artist, the disturbing possibility remains that a commissioning party who contributes anything to the work may contend, even unreasonably, that it is a joint work. For this reason, a written contract specifying the exact rights transferred remains a wise precaution. If a problem with respect to ownership of the copyright is anticipated, the contract might even go so far as to include a provision stating: "This work is not a joint work or a work for hire under the copyright law of the United States."

Other joint work cases are far more favorable to the artist. For example, in *Steve Altman Photography v. The United States* (18 Cl. Ct. 267), the photographer was commissioned to do assignments that included taking portraits of the Board of Directors of the Overseas Private Investment Corporation (OPIC). The defendant was authorized to use these portraits in the 1982 annual report and did so, but then made unauthorized use of the portraits in the 1983 annual report. Relying on the language about joint works in CCNV, the defendant tried to argue that by giving the assignment it had become a co-author and that the portraits were joint works. The court rejected this argument as follows:

Unlike Reid, OPIC and plaintiff did not jointly contribute to the conception and artistic production of the portraits. OPIC did no more than ask plaintiff to photograph the board members in front of a neutral backdrop. Plaintiff, on the other hand, selected all the camera angles, film, and settings to make best use of the light and features of the subjects. . . . Plaintiff alone contributed that artistic content.

The portraits were not joint works because the defendant had not contributed anything and the parties did not intend to create a joint work.

Another important case involving portraits came to the same conclusion. In *Olan Mills, Inc. v. Eckerd Drug of Texas, Inc.* (1989 Copyright Law Decisions, Paragraph 22,630), the photographic studio Olan Mills and the Professional Photographers of America brought a copyright infringement suit against a photo lab that made copies of photographs at the request of the people pictured in the portraits. The defendant argued that the people in the portraits were joint owners of the copyright with the photographer. The court correctly analyzed this defense as follows:

The simple fact that an individual brings his own image to the studio is not enough to give that person a protectable property right in the portrait. The court finds no basis . . . to conclude that the subject of a portrait is a co-creator of the photograph.

Similarly, in *Ashton-Tate Corporation v. Ross and Bravo* (916 F.2d 516), the court concluded that a user interface for a spreadsheet program had not become a joint work. The

court stated, "Even though this issue is not completely settled in the case law, our circuit holds that joint authorship requires each author to make an independently copyrightable contribution." So the defendant's contribution to the interface of ideas, which are not copyrightable, did not make him a co-owner or make the interface a joint work.

Yet another interesting case that may be familiar to creators or consumers of comic books is *Gaiman v. McFarlane* (360 F.3d 644), which pitted a well-known fantasy writer against an equally famous comic book artist and publisher. The dispute pertained to the now-famous *Spawn* comic series, which was initially criticized for its poor writing and shallow story development. In an effort to prop up *Spawn's* popularity, series creator Todd McFarlane asked writer Neil Gaiman to conceive several new characters. In return for his efforts, McFarlane orally promised to pay Gaiman more generously than a larger comic book publisher like DC or Marvel would. Gaiman set to work developing several characters, including a peculiarly prescient and knowledgable "bum" who went by the name Count Nicholas Cogliostro.

Cogliostro, and several of Gaiman's other characters, contributed to an uptick in sales, and the ultimate success of the *Spawn* series. Perhaps predictably, a dispute soon arose regarding Gaiman's compensation for his contributions. Gaiman claimed that he was a joint creator of Cogliostro, and that he was entitled to a fair accounting of the profits earned from the use of Cogliostro and his other characters. McFarlane argued that the characters, as conceived by Gaiman, were not copyrightable, and that it was McFarlane's artistry that made them visually unique creations. He made two distinct arguments; that the characters were mere ideas not protected by copyright, or in the alternative that they were unoriginal "stock characters" that did not require the kind of creativity needed to secure copyright protection. The court did not agree with either argument, however, and held that Gaiman's Cogliostro was distinctive and copyrightable even before McFarlane's inkers and colorists "dolled" him up into visible character. Hence, Gaiman preserved his rights as a co-author, and his entitlement to profit from his copyrightable contributions to these jointly created characters.

Community Property

Community property laws have been adopted by nine states—Arizona, California, Idaho, Louisiana, Nevada, New Mexico, Texas, Washington, and Wisconsin. While there are variations from state to state, community property laws make both spouses the owners of property acquired during the marriage (with some exceptions, such as gifts or bequests). The question naturally arises as to whether artworks and copyrights created during a marriage are community property in these states.

A California case raised this issue for the first time, when a husband sought to argue that books he wrote during the marriage were not community property. The court wrote:

Our analysis begins with the general proposition that all property acquired during marriage is community property. Thus, there seems little doubt that any artistic work created during the marriage constitutes community property. . . Since the copyrights derived from the literary efforts, time, and skill of husband during the marriage, such copyrights and related tangible benefits must be considered community property. (In re Marriage of Worth, *195 Cal. App.3d 768*)

The court rejected the argument that the federal copyright law, which vests copyright in the author (rather than in the author and the author's spouse), would preempt the state community property law. While *In re Worth* can hardly be definitive, and other state or federal courts may take a different view, it certainly seems that copyrights are likely to be considered community property. This case leaves unresolved such matters as who has the right to renew a copyright or terminate a grant of rights once a copyright is designated community property. These and other complex issues are explored in "Copyright Ownership by the Marital Community: Evaluating Worth" by David Nimmer. (36 UCLA Law Review 383).

A Proposal for Reform

Throughout the 1980s, the Copyright Justice Coalition sought to reform the copyright law with respect to works-for-hire and joint works. Despite hearings before a senate subcommittee in 1982 and 1989 that documented widespread abuses with respect to work for hire, no bill is currently pending to amend the law and protect artists. After expending so much effort,

artists' groups have realized that reform will be immensely difficult to achieve.

In the hope that these reform efforts will be revived, I am concluding this chapter with a brief discussion of what must be included in any bill to reform the law. These proposals are drawn from the best versions of the bills that I authored on behalf of the Graphic Artists Guild and the American Society of Media Photographers, before the inevitable negotiation and compromise in the legislative process diluted the effectiveness of the proposed safeguards.

With respect to clause 1, an "employee" should be defined as a "formal salaried employee." This would be even more restrictive than the agency test adopted by the Supreme Court in *Community for Creative Non-Violence v. Reid*, since employees would have to receive a salary and employee benefits.

With respect to clause 2, certain categories should be deleted from those types of assignments that can be done as work for hire by a freelancer. The categories deleted should include all those in which visual creators are most likely to work: (1) contributions to collective works; (2) parts of audiovisual works (but not parts of motion pictures); (3) instructional texts; and (4) supplementary works.

If no more were done than to remove these categories from those which can be work for hire, undoubtedly "all rights" contracts would immediately become standard for publishers in place of work for hire. Safeguards need to be provided against the indiscriminate use of all rights transfers in the categories being removed from work for hire. This preserves the artist's access to the future stream of residual income that each image potentially represents.

Existing law has a presumption as to what rights are acquired in a contribution to a collective work if no explicit agreement has been reached between the parties. This presumption could be extended to cover parts of audiovisual works (excluding motion pictures), instructional texts, and supplementary works. Under the presumption, a publisher acquires art in these categories only for use in a particular larger work, such as a book, any revision of that larger work, and any work in the same series as the original larger work, unless an explicit agreement has been reached between the parties as to a different transfer of rights.

With respect to works commissioned from freelancers, any written work-for-hire contract should have to be obtained before the commencement of work and such a written contract should be required for each assignment.

The situation regarding joint works should be clarified by requiring that each author make an original, copyrightable contribution and that the parties agree in writing if they intend a work to be a joint work.

Finally, such a bill should also provide that the sale of a right of copyright does not transfer ownership of any original art unless such originals are transferred in writing. Several states, including New York and California, have enacted such legislation regarding ownership of originals when reproduction rights are sold.

Of course, these reform proposals have not been enacted, so discussing them here may simply extend the futile efforts that began in 1978. On the other hand, the legislative campaigns of the Graphic Artists Guild and the American Society of Media Photographers have helped to educate a generation of artists about the ethics of the art business. Beyond this, who can say that future champions of reform will not be more effective in ensuring that creativity is protected and rewarded in the way that the founding fathers so clearly intended when they enshrined copyright in our Constitution?

5 COPYRIGHT: INFRINGEMENT, FAIR USE, COMPULSORY LICENSING, AND PERMISSIONS

If someone uses a work without the copyright owner's permission (subject to the various exemptions, such as fair use and compulsory licensing), that person is an infringer. To win an infringement suit, the artist must prove that he or she owned the copyright and the work was copied by the infringer. Copying is often inferred from the infringer's access to a work and the substantial similarity of the work alleged to be infringing.

Reference Files

One of the most frequently asked questions is whether the use of another artist's imagery is an infringement of copyright. In particular, illustrators often maintain files of images to fulfill assignments with deadlines too short to permit contacting anyone for permissions. The names for these files—the sedate "reference" file, the offhand "scrap" file or the larcenous "swipe" file—suggest the ambiguity felt when using such imagery. After all, the people who made that imagery are also artists and copyright proprietors like the illustrator who wants to use it. Increasingly, illustrators looking for references can casually download such artwork from the Internet, and use powerful digital imaging tools to seamlessly incorporate referenced pieces into their own work. In this increasingly digitized artistic universe, understanding the scope of an artist's copyright becomes especially important to the modern artist.

An artist suing another for infringement has to prove that an ordinary person would be able to tell his work was copied. The artist can then secure money damages *unless* the copying was trivial or insubstantial, or it was a "fair use."

The Test for Infringement

The reference file probably contains a lot of photography and some illustration and design. To start with an obvious case, let's assume that an illustrator is asked to do a large painting of people on a beach as a magazine illustration. Finding a perfect full-page illustration in a competitive magazine, the illustrator copies it. Since the painting is far larger than the magazine page, the illustrator feels this won't be an infringement. Indeed, some artists may opt to use a digital version of the photograph as a template for creating a "painted-over" version, effectively re-rendering the original photograph using digital brushes.

What is the test for copyright infringement? It is whether an ordinary observer, looking at the original work and the work allegedly copied from it, recognizes that a copying has taken place. In the example of the painting, the ordinary observer test will certainly yield a conclusion of infringement. The fact that the painting is larger, or digitally painted over, carries no significance if it was copied in the first instance. Similarly, a change of media—such as making an illustration from a photograph or, alternatively, photographing an illustration—does not change the fact that the copying is an infringement.

Altering some parts of the original work will not avoid an infringement when application of the ordinary observer test leads to the conclusion that more than a trivial amount of the original work has been copied. Some art school instructors tell their students that if more than a certain percentage of the original work is changed, perhaps 25 or 33 percent, the new work will not be an infringement. These

instructors are incorrect, because the copyright law neither includes nor recognizes such a percentage test.

Any creator or buyer of images must be certain that no infringement will take place. So, the new work must be changed to the point where it can be said without doubt that no ordinary observer would believe the new image was copied from the original. At that point, of course, the reference file becomes a more difficult resource to use.

What if the original work were used as a part of a collage of many works? This would be an infringement as long as the original work was recognizable, unless the use were determined to be a fair use, a concept to be discussed later in this chapter.

Damages for Infringement

An infringer can be sued for the artist's actual damages, plus any profits made by the infringer that aren't included in the computation of actual damages. If an artist is going to have trouble proving actual damages, the court can be asked to award statutory damages (assuming the artist qualifies for statutory damages as explained in chapter 4 on registration). Statutory damages are an amount between $750 and $30,000 awarded in the court's discretion for each work infringed. These damages may be lowered to $200 by the court if the infringer shows the infringement was innocent, or increased to $150,000 if the copyright owner shows the infringement was willful. In addition to damages, the court can also issue injunctions to prevent additional infringements, impound and dispose of infringing items, award discretionary court costs, and award attorney's fees (if the artist qualifies for attorney's fees as explained in chapter 4 on registration).

Prior to March 1, 1989, one advantage of having copyright notice appear in the artist's own name with the contribution to a collective work was that such a notice prevented an innocent infringer, a person who reprinted the work because he or she obtained permission from the owner of copyright in the collective work, from being able to use the fact of having permission as a defense. Registration of the contribution also cut off this defense. Of course, even if the innocent infringer had a defense, the magazine or other collective work would have had to repay to the artist whatever they had received by wrongfully selling reprint

rights in the contribution. In general, copyright notice in the artist's name alerts third parties that they should go directly to the artist for reprint rights and not deal with the owner of the collective work.

Who Is Liable for Infringement

In the business world, one of the most important reasons to form a corporation is to secure limited liability. The corporation is liable for debts or damages from lawsuits, but the individual shareholders are not. Yet the limited liability normally provided by corporations may not shield its employees or officers from individual liability in a copyright infringement lawsuit. In particular, if a corporate officer participates in the infringement or uses the corporation for the purposes of carrying out infringements, he or she can be held personally liable. Likewise an employee who, in exercising his or her discretion, commits or causes the employer to commit an infringement can be held personally liable.

For example, in *Varon v. Santa Fe Reporter* (1983 Copyright Law Decisions, Paragraph 25,499), a photographer sued a newspaper and its employees for copyright infringement. The photographer had taken photographs of Georgia O'Keeffe and her artworks. These photographs were published with the photographer's approval in *Art News* in December, 1977, and were then published without the photographer's permission in the July 31, 1980, issue of the *Santa Fe Reporter*. The court concluded that not only was the Santa Fe Reporter liable for the infringement, but the publishers were also individually liable despite the fact that they were only employees. This was because they failed to set a strong policy about guidelines for the use of photographs and had the power to control the actions of the editor, even though both defendants were out of the country when the particular issue was published. The author of the article that accompanied the photographs was not liable, since he had nothing to do with the choice to infringe the photographs. Individuals who gain financially by an infringement are likely to be held personally liable.

Another deterrent for infringers is that this personal liability is usually, in legal terms, joint and several. This means that all of the defendants are liable for the full amount of the damages. If one defendant flees the country or

goes bankrupt, the damages owed to the plaintiff will not be lessened. So four defendants who owed damages of $500,000 might each pay $125,000, but, if one of the defendants could not be found, the remaining three defendants would still be liable for the full $500,000. In one case, for example, the publisher and the printer were jointly and severally liable for the damages when they infringed the copyright in a book (*Fitzgerald Publishing Co. v. Baylor Publishing Co.*, 807 F.2d 1110).

A troubling case for artists involved a state-owned university sued by a photographer for infringement (*Richard Anderson Photography v. Radford University*, 633 F.Supp. 1154, *aff'd* 852 F.2d 114, *cert. denied* 489 U.S. 1033). In this case, the Eleventh Amendment of the Constitution was construed to give states and state-owned entities immunity from lawsuits for copyright infringement, though the court ultimately held that the university's publicity director was personally liable for her infringing use of the plaintiff's photographs. In 1990, Congress codified this result by amending the copyright law; the resulting Copyright Remedy Clarification Act expressly provides that any state, state-owned entity, or state officer or employee is subject to lawsuits for copyright infringement.

Though some courts expressed doubt that the the Copyright Remedy Clarification Act was within the scope of Congress's Constitutional powers, the Supreme Court laid the issue to rest in subsequent cases. *See University of Houston, Texas v. Chavez*, 517 U.S. 1184 (1998). In a related case involving patents (*College Savings Bank v. Florida Prepaid Postsecondary Education Expense Board*, 148 F.3d 1343), the Supreme Court held that Congress had clearly expressed the intent to abrogate states' immunity from patent infringement claimants.

Fair Use

Every unauthorized use of someone else's copyrighted work does not necessarily infringe. For example, a magazine might use one drawing to illustrate an article about the artist who did the drawing. That would be considered a fair use. The 1978 Copyright law includes a fair use provision that is meant codify the decisions courts had already rendered on fair use. It provides that fair use of a copyrighted work for "purposes such as criticism, comment, news reporting, teaching (including multiple copies for classroom use), scholarship, or research, is not an infringement of copyright." To determine whether a use is a fair use, four factors are given: (1) the purpose and character of the use, including whether or not it is for profit; (2) the character of the copyrighted work; (3) how much of the total work is used in the course of the use; and (4) what effect the use will have on the market for or value of the copyrighted work.

The guidelines for fair use can be difficult to apply to specific cases. For example, an artist may see a variation of one of his or her drawings and consider the copying an infringement rather than a fair use. Or an artist may be wondering whether to use someone else's work as a background for some figures. These issues are factual and almost impossible to resolve other than by use of common sense. Satire, for example, may comment on another work by legitimately using parts of the original work. Or it may cross the line by using so much of the original work that the value of the satiric piece is simply what has been copied rather than any fair comment upon it. (in which case a copyright infringement is likely to have occurred). In one case, self-proclaimed parodists drew a series of "underground" comics prominently featuring Disney characters as members of a "free thinking, promiscuous, drug ingesting counterculture." The court held that the exactness of the parodist's copying was more than was necessary to parody Mickey Mouse and his cartoon friends, and held them liable for copyright infringement. (*Walt Disney Productions v. Air Pirates*, 581 F.2d 751).

Remember that the basic test for infringement asks whether an ordinary observer, looking at the two works, would believe one has been copied from the other. But fair use muddies the waters by creating a number of possible situations where such copying would not be considered unlawful. For example, if an author penned a review or scholarly article discussing another work, that work could be copied exactly and it still wouldn't amount to an infringement. As a result, the guidelines for fair use must be carefully considered in every case to determine whether or not an artist can safely use someone else's copyrighted work.

One interesting example of fair use given by the House Judiciary Committee involves the practice of calligraphers who reproduce excerpts from copyrighted literary works in

making their artwork. The committee concluded that a calligrapher's making of a single copy for a single client would not be an infringement of the copyright in the literary work.

Educators, authors, and publishers have agreed to special guidelines covering the fair use copying of books and periodicals for classroom use in nonprofit educational institutions. To give an overview, brief portions of copyrighted works may be used for a class if the teacher individually decides to do so, the copyright notice in the owner's name appears on the class materials and this kind of use is not repeated too extensively. Instructors or students in educational or non-profit institutions may also display pictorial, graphic, or sculptural work, or perform audiovisual work, including motion pictures, if done for educational purposes, or in the course of face-to-face teaching.

Several cases follow to show how the factors for fair use have been applied to different factual patterns.

Parody in Advertising

The tendency of parody to infringe is governed by what makes the parody valuable. Does its value arise directly from the content that it is trying to poke fun at, or is it valuable because it creatively parodies its subject matter? If the former is true, the parody is an infringement. If the latter is true, any copying within the parody would be considered a fair use.

One case found two unlikely contestants battling over the issue of parody. Eveready Battery Company had created and run an Energizer Bunny ad campaign for several years. This ad was a response to an ad by competitor Duracell, which featured mechanical bunnies beating drums until only the bunny with the Duracell battery was left drumming. The voice-over claimed that Duracell batteries outlasted the batteries of competitors. Eveready's initial response was an ad in which mechanical bunnies beat on drums, with the toy Energizer Bunny later entering the fray (dressed in sunglasses and beach thongs). The voice-over would then explain that, "Energizer was never invited to their playoffs . . . because nothing outlasts the Energizer. They keep going and going and going"

After the initial Energizer Bunny campaign, Eveready hired a new ad agency, Chiat/Day/Mojo, which created the commercial-within-a-commercial concept. In these nearly two-dozen ads, what appears to be a commercial is interrupted by the arrival of the Energizer Bunny in its characteristic sunglasses and beach thongs. The voice-over concludes by saying, "Still going. Nothing outlasts the Energizer. They keep going and going . . . [voice fades out]."

When Coors Light's marketing department wanted to run a series of commercials in the spring of 1991, its ad agency, Foote, Cone and Belding Communications, was given the task of creating a humorous commercial using the well-known actor Leslie Nielsen. Nielsen had been featured in a number of previous Coors Light commercials. The Coors commercial starts with a voice speaking over background music and describing the virtues of an unnamed beer. The visual shows a close-up of beer being poured into a glass. Then a drum beat accompanies Leslie Nielsen walking across the set. He is dressed in a conservative suit and also wears fake white rabbit ears, a fuzzy white tail, and rabbit feet (which look like pink slippers). Carrying a drum with the Coors Light logo, the actor beats the drum several times, then spins about half a dozen times, recovers from apparent dizziness and then says "Thank you" before exiting. As he exits, the voice-over says, "Coors Light, the official beer of the nineties, is the fastest growing light beer in America. It keeps growing and growing and growing"

Under the terms of the contract with Leslie Nielsen, Coors had only six weeks in which to air this commercial (and the six weeks ended on June 28, 1991 when Naked Gun 2½ was scheduled for release). Eveready, having heard of the Coors ad, sued Coors and an expedited hearing was granted to determine whether a preliminary injunction should be issued to prevent Coors from airing the spot. The most important factor in granting a preliminary injunction is whether the plaintiff is likely to succeed when the case is later tried on its merits.

The court noted Eveready's clear ownership of a valid copyright, and observed that copying had taken place. While such facts would be essential for winning a copyright suit, the court referred to the fair use provisions of the copyright law to see if the copying was fair. If copying is a fair use, it will not be an infringement. The tests for fair use include "(1) the purpose and character of the use, including

whether such use is of a commercial nature...." Eveready argued from this that parody in a commercial could not be protected as a fair use. The court disagreed, noting that the other factors—"(2) the nature of the copyrighted work; (3) the amount and substantiality of the portion used in relation to the copyrighted work

Figure 4. *Puppies* by Art Rogers.

Figure 5. *String of Puppies* by Jeff Koons.

as a whole; and (4) the effect of the use upon the potential market for or value of the copyrighted work"—all favored Coors.

The court concluded that the Coors spot had not borrowed too much from Eveready, but rather had used only enough to let viewers realize that the Coors ad was, in fact, a parody. So Eveready's motion for a preliminary injunction was denied and Coors was free to run the ad in the contractually specified time frame. (*Eveready Battery Company, Inc. v. Adolph Coors Company*, 765 F. Supp. 440).

Parody in Art

A widely publicized fair use case pitted a photographer against a fine artist. In *Rogers v. Koons and Sonnabend Gallery, Inc.* (960 F.2d 301, *cert. denied* 113 S. Ct. 365), the artist Jeff Koons purchased a notecard containing a black-and-white photograph titled *Puppies* by photographer Art Rogers. Koons tore the copyright notice in Rogers' name off the notecard and sent it to his artisans to be copied as a sculpture entitled *String of Puppies*; the work was then exhibited in the Banality Show at Sonnabend Gallery. Three copies of the work were sold for $367,000 in total, with Koons keeping a fourth copy for himself. The notecard and a black-and-white photograph of the sculpture, which was in color, appear as figures 4 and 5.

Rogers learned of the exhibition and sued Koons for copyright infringement and unfair competition. Koons argued that images such as the puppies with the man and woman were part of the collective subconscious and so, implicitly, freely available to be copied by anyone. In fact, Koons argued that the photograph should not be copyrightable on the grounds that it was not original. The court easily disposed of this, pointing out that "the quantity of originality that need be shown is modest—only a dash of it will do." The court also made the interesting point that, "No copier may defend the act of plagiarism by pointing out how much of the copy he has not pirated."

The court then turned to the fair use defense, since Koons argued that his work should be treated as satire, parody, or commentary upon a culture that would want to see, or attach value to, a photograph like *Puppies*. The first factor, the purpose and character of the use, was at least partially against Koons, because he had profited so greatly from the

copying. However, the court also concluded that *String of Puppies* was not a parody of *Puppies* because "the copied work must be an object of the parody" But the audience for *String of Puppies* would have no awareness of *Puppies*, so *Puppies* could not be the object of the parody. The first factor was against fair use.

In discussing the second factor, the nature of the copyrighted work, the court pointed out that fair use is more applicable to factual works than to fictional, creative works. Since *Puppies* is an imaginative artwork and Rogers intended to earn income from its exploitation, the second factor was also against fair use. The third factor, the amount and substantiality of the work used, also went against fair use, since the photograph was almost totally copied to make the sculpture. Finally, the fourth factor is whether the unauthorized use will injure the market for the original. The court pointed out that "the owner of a copyright with respect to this market-factor need only demonstrate that if the unauthorized use becomes 'widespread' it would prejudice his potential market for his work." The court determined that this factor too was against fair use. Having removed the shield of the fair use defense, the court found for the photographer and held that *String of Puppies* infringed *Puppies*.

Though the *Rogers* case did not go well for Koons,' it was not the last time he would be dragged into court. In a more recent case, *Blanch v. Koons* (467 F.3d 244), a fashion photographer alleged that one of Koons' paintings prominently featured her photograph of a woman's feet and shoes. The photograph, entitled *Silk Sandals*, depicted a woman's feet, crossed over each other, wearing red sandals, and resting on a male model's lap. Koons' painting, entitled *Niagara*, depicted the same feet and shoes, but in his painting, Koons reoriented them so they appeared to be hanging downward. They also appeared as just one element in a multipart collage; the painting also depicted several other pairs of feet that were either dangling down or standing. The original photograph and painting are reproduced below.

In this case, Koons' fair use defense won the day. The district court applied the four fair use factors, and found that each one favored Koons. Koons' painting transformed Blanch's photograph. As to the nature of Blanch's work, the court described copied portions as "banal" rather than creative. Further, the court held that

Figure 6. *Silk Sandals* by Andrea Blanch.

Figure 7. *Niagra* by Jeff Koons.

the substantiality of Koons' use was largely immaterial, since Blanch's photograph was of "limited originality." Finally, the court found that, "Blanch's photograph could not have captured the market occupied by *Niagara*.

The Court of Appeals for the Second Circuit agreed, for the most part. It noted that Blanch's photograph served a very different

purpose than Koons' interpretation of that photograph in *Niagara*. Transformation is an often confusing concept that the court took pains to clarify. While the mere act of turning a photograph into a painting was not transformative, the differing motivations underlying the creation of *Silk Sandals* and *Niagara* were dispositive. While Blanch shot *Silk Sandals* as an advertising piece presumably designed to sell sandals, Koons sought to comment on society generally, with the hope that his viewers might "gain new insight into how these [products, objects, and images] affect our lives." Hence, because Koons was "using Blanch's image as fodder for his commentary on the social and aesthetic consequences of mass media," the court was inclined to find his use to be fair.

The court of appeals did not agree with the lower court that Blanch's work, as copied, was "banal rather than creative." Nonetheless, the court held that the transformative nature of Koons' painting was a more instructive factor than any inherent creativity in the work he copied. Further, the court held that the amount and substantiality of Koons' copying was reasonable in light of his artistic purpose, noting that he only copied the feet and sandals, and did not copy the photo's backdrop, or the male model on which the feet and shoes were resting. With respect to the fourth and final "market" factor, the court held that Koons' painting did not compete in any market that Blanch's photo might exploit. Observing that potential markets include "only those that creators of original works would in general develop or license others to develop," the court noted that Blanch had never before licensed her photos for use in graphic or other visual arts.

The two Koons litigations involved the same defendant asserting a fair use defense, but the outcomes were quite different. In the first case, a sculpture referenced almost verbatim from a photograph was not protected by fair use. Since the photograph itself was not widely known, a three-dimensional copy of that photograph would not appear to the ordinary observer as a social commentary or parody. The court was also troubled by the fact that Koons earned a lot of money selling a sculpture that the plaintiff would probably have licensed. In the *Blanch* case, however, the court accepted Koons' defense, because Koons was able to persuade the court that he copied portions of Blanch's better-known photograph with the

intent to pass artistic comment on it. Further, the court was not convinced that the Audrey Blanch would ever have thought to license her image to a visual artist like Koons.

Advertising Use of Editorial Art

Art directors often buy art or photography for editorial usage, only to discover that they want to use the editorial page incorporating the art or photography in an advertisement. If the rights granted are restrictive, for example, editorial use on cover only, can the art director reuse the image in advertising?

This question arose when the reuse of a stock photograph pitted a New York photographer against his client, a not-for-profit society of engineers. The photographer had used a "stock photo invoice" to sell an image to the client for use on the cover of the client's magazine. This cover was nominated for a National Magazine Award (an "Ellie"). This pleased the engineering society so much that it ran advertisements in publications such as *Ad Week* and *Ad Age* and reprinted the cover using the photographer's image in the lower left-hand corner of the advertisement.

In suing, the photographer claimed that the client had violated the restriction in the Stock Photo Invoice, which provided for "one time nonexclusive English language rights for use in the November 1988" issue of the client's magazine. The client argued that publicizing a cover nominated for an award served the public good and should be a fair use.

The court disagreed, saying that fair use was inapplicable since the unauthorized usage had damaged the market value of the photograph. The photographer had given a limited copyright license, and the client had to pay additional amounts to obtain additional usage. The photographer also sought to sue for breach of contract, but the court concluded that the claim under the contract was the same as the claim under the copyright law. Since the copyright law preempts state rights that are equivalent to rights under the copyright laws, the contract claim was preempted (*Wolff v. The Institute of Electrical and Electronics Engineers, Inc.*, 769 F. Supp. 66).

One troubling implication of this case pertains to infringement by a party to the contract. An artist may enter into a contract believing that the damages clause specified in the agreement would apply in the event of a copyright

infringement. This court, however, held that it would not.

More recently, the same court was presented with a similar situation, and reached a different conclusion (*Architectronics, Inc. v. Control Systems, Inc.* 935 F. Supp. 425). A software development firm brought an action against two former joint venturers and two related corporations for breach of contract and copyright infringement, among other things. The *Architectronics* court criticized the decision in *Wolff*, stating, "The Court did not consider whether a promise ever could supply the 'extra element' necessary to defeat preemption. Moreover, *Wolff* rests almost entirely on what I believe are mistaken inferences from the legislative history of Section 301 [of the Federal Copyright Act]." Accordingly, the action in state court for breach of contract could be maintained despite the fact that it might also have been grounds for a federal copyright infringement suit.

Also in contrast to *Wolff*, a magazine was free to use the cover of a competing magazine for comparative purposes in television advertising. In considering the first factor, the court found that while the purpose of the comparison was certainly to make a profit, the profit was not being made by stealing the cover image but rather by trying to convince people to switch magazines. The second factor proved ambiguous, since the commercial nature of the copyrighted work could be argued to make fair use more or less likely. The third factor, the amount of material taken, was clearly in favor of fair use, since the essence of the magazine was the television schedules contained inside it, and these schedules were not copied. Finally, as to the fourth factor, the court felt no damage had been done to the market value of the first magazine due to the comparative advertising. So the court concluded that the usage was protected under the fair use defense. (*Triangle Publications, Inc. v. Knight-Ridder Newspapers, Inc.*, 626 F.2d 1171)

Permissions

Our discussion has assumed that the work the artist wishes to use is protected by copyright. Some work, however, will be in the public domain. This means that copyright was never obtained for the work or has now expired. Unfortunately, it is difficult to learn this simply by examining work in a reference file. Tear sheets or image downloads without copyright notice may be protected because they came from copyrighted publications. For work published after January 1, 1978, it is difficult to rely on the absence of notice as a basis for concluding a work is in the public domain. This is because the 1978 law had several provisions to protect copyrights even if notice was omitted from a work and, after March 1, 1989, copyright notice is no longer required.

If an artist obtained a copyright between 1909 and 1934, the initial term was twenty-eight years and, after renewal, the renewal term was an additional twenty-eight years. So a work published and registered in 1910 and renewed in 1938 would have had its copyright expire in 1966. However, all copyrights in their renewal term on September 19, 1962, received an extension of the renewal term to forty-seven years (for a total term of seventy-five years). This meant that the 1910 work would have its copyright expire in 1985.

To further complicate matters, all copyrights in their renewal terms in 1998 had their renewal terms extended to sixty-seven years (for a total term of ninety-five years), but this did not revive copyrights that had already expired and gone into the public domain. So copyrights on works published and registered during or before 1922 would, if renewed, have had a total term of seventy-five years that expired in 1997 or earlier. These works are in the public domain. Works published in 1923 or later, and renewed, will now have a total term of ninety-five years and not expire until December 31, 2018 at the earliest (which would be for a 1923 work). However, if the work is protected in foreign countries, the term of protection may be based on the creator's life plus fifty or seventy years and exceed either the seventy-five- or ninety-five-year terms for pre-1978 works. In any event, the public domain is of limited value to a creator who maintains a current reference file, or actively seeks inspiration from more modern works populating the Internet.

If the public domain provides little succor, what about simply obtaining permission to use the work from the creator or present copyright owner? This can be done using a brief letter that sets forth the artist's project, what material the artist wants to copy, what rights the artist needs in the material, what credit line

and copyright notice will be given, and what payment, if any, will be made. To make the letter binding, the words "Consented and Agreed To" would be added at the bottom with a line underneath for the signature of the person owning the copyright. If the person is signing as the representative of a magazine or other organization, the name of the organization and the title of the person signing should be indicated. The sample release form appearing here can be used as a model adaptable to particular situations. The permitted use would be sharply delineated to protect the party selling the rights from giving up too much and to guarantee the party obtaining rights that what is needed has been lawfully acquired. The fact that re-use fees normally increase with greater usage is another reason to give an accurate description of intended usage. If electronic usage is to be made of the work, it would be wise to include that in the permission form.

Permission Form

Dear _____:

I am preparing a book titled _____ to be published by _____. May I please have your permission to include the following material: (specify the material and, for a published work, include the original place of publication, date, and page numbers) in my book and in future revisions and editions thereof, including electronic versions and nonexclusive world rights in all languages. These rights will in no way restrict republication of your material in any other form by you or others authorized by you. Should you not control these rights in their entirety, would you kindly let me know to whom else I must write. Unless you indicate otherwise, I will use the following credit line (specify credit line) and copyright notice (specify the form of the copyright notice which will protect the material the artist is asking to use):

_____.

I would greatly appreciate your consent to this request. For your convenience a release form is provided below and a copy of this letter is enclosed for your files.

 Sincerely yours,
 Jane Artist

I (We) grant permission for the use requested above.

(Specify name and title, if any)　　Date

Locating Copyright Owners

The problem with permissions arises when the copyright owner can't be located. Some work is very difficult to trace, especially if a tight deadline is involved. As discussed in Circular 22, "How to Investigate the Copyright Status of a Work," the Copyright Office in Washington, D.C. will search its records at the prescribed statutory rate, billing for every hour or fraction thereof spent searching the records. Additionally, all works registered after 1978 may be found via the Copyright Office's "automated catalog," which may be accessed over the Internet. However, many pieces of art and photography have never been registered. They may be protected by copyright, but they cannot be found by a search of the records in the Copyright Office. Even works that have been registered can be difficult to find, since titles may not aid sufficiently in locating a work.

Stock houses and archives for photography and illustration may very well prove the best resource when it is impossible to determine if a work is in the public domain or to reach a copyright owner to pay for a re-use. Millions of images are quickly available to use as reference, and the staff usually provide expert guidance. Again, the fee for such uses should be included in the estimate for the assignment.

Compulsory Licensing

The law provides for the compulsory licensing of published pictorial, graphic, and sculptural works for transmission by noncommercial educational broadcast stations. A compulsory license means that the copyright owner has no right to prevent the use of copyrighted work. Compulsory licensing, however, does not permit a program to be drawn to a substantial extent from a compilation of pictorial, graphic, or sculptural works, nor does it permit any use whatsoever of audiovisual works. If an artist could make a direct agreement with a station, it would replace the compulsory licensing provisions.

Very low rates have been set for the royalties to be paid when such works are used. While records must be kept of compulsory licensings, to date almost no fees have been paid to visual artists. Either the stations are not using any works or they are not accounting for the usage that they are making.

This ill-conceived infringement on the traditional rights of the copyright owner has been a complete failure and should be repealed as to pictorial, graphic, and sculptural works. Nonetheless, compulsory licensing will continue under the governance of the Copyright Office.

Orphan Works

Bills were introduced in 2008 in the 110th Congress in both the United States House of Representatives and Senate to address the status of so-called "orphan" works (an orphan work being a work whose owner cannot be located). In commenting on an earlier version of these bills, I had written, "In fact, the Orphan Works bill is simply an appealing description for what should be called free use or, less politely, theft. Everyone roots for an orphan to be adopted, but what if we called the bill the Protection of Copyright Theft Act? . . . The potential magnitude of the unrecompensed taking of creative work is staggering." In my opinion, the proposed free use of orphan works is as egregious as the compulsory licensing scheme that has been an abysmal failure.

Fortunately, the bills introduced in the 110th Congress did not pass. As this book goes to press, no comparable bills have been introduced in the 111th Congress. However, the likelihood that such bills will be introduced in the future by proponents of free use make an examination of the bills worthwhile.

The House bill (H.R. 5889, 110th Congress) sponsored by Representative Howard L. Berman of California adopted a number of provisions to safeguard copyright owners while the Senate bill (S.2913, 110th Congress) tracked closely with the House bill introduced in 2006 in the 109th Congress and opposed by the community of artists.

The 2006 House bill (H.R. 5439) allowed the use of a work without permission if the user had "performed and documented a reasonably diligent search in good faith to locate the owner of the infringed copyright." If the search did not locate the owner of the copyright, then the user could proceed to use the work. Even though this use was technically an infringement, the penalties for the infringement were minimal or nonexistent. Should a copyright owner discover such an infringement, the owner could only obtain "reasonable compensation" and the infringement could continue. In addition, the owner was not allowed to seek damages, cost, or attorney's fees, which the owner would normally be allowed to seek in a copyright infringement suit if the work had been registered prior to the infringement. Should the infringement be "without any purpose of direct or indirect commercial advantage and primarily for a charitable, religious, scholarly, or educational purpose," and the usage ceased after the copyright owner complains, then the owner would not even have had the right to ask for reasonable compensation.

One central problem of H.R. 5439 was the requirement that a potential user conduct a "reasonably diligent search." This required searching the "records of the Copyright Office" as well as other sources to find information as to copyright ownership. Since only the tiniest fraction of copyright-protected works of visual art are registered with the Copyright Office and no other source even remotely approaches being definitive with respect to owners' identities, any "reasonably diligent search" will probably not find the copyright owner of a work.

The Senate bill (S.2913) was replaced in the Judiciary Committee by a bill that closely resembled the 2006 House bill. Under the bill's provisions, an infringer was not subject to penalties if before using the work the infringer performed in good faith a "reasonably diligent search" but could not find the copyright owner. With respect to what would be a reasonably diligent search, the Register of Copyrights was to issue best practices with respect to searching relevant records of the Copyright Office, private databases, and online databases as well as the use of technology tools and expert assistance. In addition, the use had to give whatever attribution was possible with respect to the work. Monetary compensation was limited to "reasonable compensation" based on what a "willing buyer and a willing seller would have agreed with respect to the infringing use of the work immediately before the infringing work began."

The Senate bill differed from the 2006 House bill by adding to the "educational, religious, or charitable" exemption from liability, the requirement that the infringer be, "a nonprofit education institution, museum, library, archives, or a public broadcasting entity . . . or any of such entities' employees . . ." Another new requirement was that any usage pursuant to the Senate bill would have to include a mark indicating this in a form that would be prescribed by the Register of Copyrights. In addition, "useful articles" containing pictorial, graphic, or sculptural works were excluded from being considered orphan works. These were small concessions that improved the bill from the viewpoint of creators but went nowhere near far enough to make the bill acceptable for copyright creators.

Protection for Creators

From the creators' viewpoint, the newer bill introduced in the House (H.R. 5889) contained positive features missing from the Senate bill. The key improvement was a requirement that infringers file a Notice of Use with the Register of Copyrights *before* using a work. Such a Notice of Use would include the following information: (1) the type of work; (2) a description of the work; (3) a summary of the search for the copyright owner; (4) the owner, author, title, or other identifying information to the extent that the infringer knows any of this; (5) a certification that the search was done in good faith; and (6) the infringer's name and how the infringer will use the work. The notices would have been kept in an archive and made available pursuant to regulations that would be adopted by the Copyright Office.

This archive would have presumably allowed creators and their organizations to police the types of usage taking place, although the bill was not clear on this point and it was possible that the archive would be "dark" (i.e., with access not allowed to the public) as opposed to transparent. It's quite important that the archive be transparent, since its most important potential use is to allow copyright owners to search for usage of their works. If it is transparent, it will be far better than entrusting infringers to search but placing no affirmative requirement on them to make a public record of the use. Since infringers should be going to the trouble to search, the

requirement that a Notice of Use be filed seems like a small burden compared to the benefit of coming within the protection proposed by the concept of orphan works.

The newer House bill echoed the Senate bill's requirement that a mark specified by the Register of Copyrights accompany any use of an orphan work. It would have also excluded from protection as an orphan work any use of art in a "useful article that is offered for sale or other distribution to the public."

The Register of Copyrights would have had to create a process to certify electronic data bases that could then be used for the "diligent search" for the copyright owner that must be made by the infringer. For "pictorial, graphic, and sculptural works" the effective date under the newer House bill would have been the earlier of: (1) when the Copyright Office certifies at least two "separate, comprehensive, electronic databases, or (2) January 1, 2013. The Senate bill also had a certification process for databases, but with a lower standard as to what the data bases would contain.

The House bill's improvements in terms of protections for creators have created a dilemma for creators' organizations. If this is close to the best bill possible from the creators' point of view, should their organizations support it? The answer turns on a subtlety. If this "favorable" bill is not enacted, is it likely that a much worse bill will be enacted in the future? If so, perhaps creators' organizations should support this bill despite being basically against the concept of orphan works.

The difficulty with this analysis is that creators are called on to support a bill for pragmatic reasons that instinctually they oppose. Personally, I think opposition is the best course. If the bill is going to be enacted, to oppose it may also limit its negative aspects. But if orphan works bills are introduced in the future, the decisions made by artists' organizations to minimize the damage to artists' rights will make the struggle a fascinating exercise in *realpolitik*.

A Question of Ethics

Infringements, reference files, compulsory licensing, and free use of orphan works all raise ethical questions. It is not merely that using another artist's work without permission is a copyright infringement. The purpose

of copyright is to reward creativity. This sensitivity toward other creators is, in its deepest sense, self-protective. No artist wants his or her work copied without the opportunity to receive a fee, be credited as author of the original work, make certain the work is not to be unacceptably altered in its new usage or, in some cases, to forbid the use altogether. By understanding the ethical and copyright implications in these areas, artists can advance the professional status of all visual communicators.

6 COPYRIGHT AND THE DIGITAL REVOLUTION

The extraordinary power of computers has transformed both the creation of images, and the ways by which they reach the public. Artists, especially in the commercial fields, now create their imagery through a combination of techniques, some traditional and others reliant on computers and specialized programs that allow the manipulation of digitized images. The images that are manipulated may be created in the computer, scanned from material created outside the computer, or obtained in digital form using virtual sculpting or painting software, or digital cameras whose imaging qualities often exceed anything ever achieved using traditional film.

This transformation of the way in which images flow from talent to client to the public raises complicated issues regarding ownership of what is created, when images created by others may be used, and what constitutes infringement. Technology has often pushed the boundaries of the copyright law. For example, photography did not exist when the first copyright law in the United States was enacted in 1790. Other inventions, such as phonographs, jukeboxes, radio, television, communications satellites, computers, and now the Internet have each raised the question of whether the copyright law must itself transform to ensure a proper balance between rewarding creativity and ensuring that the public enjoys the fruits of this creativity.

The Power to Transform

The advent of sophisticated software to create and manipulate images may, from the copyright viewpoint, simply be old wine in new bottles. Many of the images that the software makes possible could be created by traditional methods, but these traditional methods would be far more costly and time-consuming. And, while pre-Internet pirates may not have had scanners, they certainly had other methods to duplicate and steal creative works.

To see whether the traditional tests for infringement or fair use are workable in view of the changing technology, let us examine a photograph created by the manipulation of pre-existing photographs. These images, created by New York based advertising photographer and computer illustrator Barry Blackman, do not raise issues of copyright infringement because Blackman created the pre-existing photographs as well as the end photograph, which appear as figures 6 and 7. However, after we examine the techniques and results of the computer manipulation, we can consider whether these end images would have been infringements if the pre-existing photographs had been taken by someone else. Please note that these photographs were originally in color, although they are reproduced in black and white here.

Blackman created the final composite image by using his in-house system of Barco Creator software running on a Silicon Graphics 240GTX Power Series. Though the technology used to create the composite is quite primitive by modern standards, the elements present within the image very clearly illustrate how each element was used to comprise the whole. As we can see from the illustrations, the end image using the nude is composed of seven pre-existing images. A number of techniques were used to transform and combine these pre-existing images into the final image.

For the nude, warping was used to give the clock the rippled effect as it lies on the water. The distortion capability of the program

compressed the hourglass, after which the warped clock was merged into the hourglass. Once the distorted hourglass existed as a separate image, it was repeated in smaller and smaller sizes until it vanished into the horizon. The model's torso was silhouetted, the brick wall was mapped to follow the contour of the body, and then warping was used to create the shedding of the skin.

The sky's color was corrected to match the color of the water. Also, the lake was stretched and flattened by perspective distortion to give the sense of a far larger body of water in the background. Mirror imaging then created the reflection of the torso on the water, but with transparency so the ripples of the water could still be seen.

The red lips were silhouetted in order to create a repeat pattern of the lips without any background. In 3-D, two wire frame spheres were constructed, one inside the other. On the inner sphere, the brick wall was mapped, while the outer sphere was made transparent and had the lips mapped on it. The placement of the various altered images into the final image was done by cutting and pasting in the program.

If Blackman had created the final image without having rights to use the pre-existing images, would the end results have been copyright infringements or fair use? To answer this, we have to consider the tests for infringement (in which the use is impermissible and the user is liable for damages) and fair use (in which the use does not require that permission be obtained from the copyright owner). In reviewing these tests, keep in mind that the rights of the copyright owner create a tension with the First Amendment rights protecting Free Speech, and the dissemination of information to the public. Fearing that copyright law might suppress First amendment freedom of speech and access to speech, courts and the Congress have developed a body of "fair use" laws to provide an escape valve by which certain "uses" of speech do not run afoul of copyright's monopoly.

Old Wine in New Bottles?

As discussed in the last chapter, the test for copyright infringement is twofold: (1) proof of access by the infringer to the work alleged to be infringed must be shown (or, if the similarity between the two works is striking enough, this access can be inferred); and (2) the

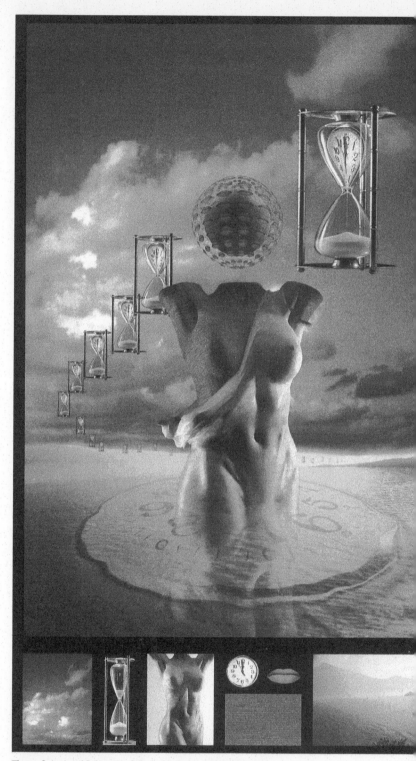

Figures 8. (top) and 9 (bottom). © Barry Blackman 1988.

jury must conclude that an ordinary observer would believe one work is indeed copied from another. On the other hand, fair use has a four-fold test: (1) the purpose and character of the use, including whether or not it is for profit; (2) the character of the copyrighted work (use of an

informational work is more likely to be a fair use than use of a creative work); (3) how much of the total work is used in the course of the use; and (4) what effect the use will have on the market for or value of the copyrighted work.

Applying these tests, I believe that the end image would be an infringement. This is because the nude torso has been taken and used in a recognizable way in the final images. However, seeing the strengths of the image-creation process suggests some of the dangers that the future certainly holds.

For example, some of the changes in Blackman's illustration push the boundary of what might be considered an infringement. Would an ordinary observer conclude that the warped clock face was taken from the original clock face? Or that the hourglass was taken from the original, elongated hourglass? Would the ordinary observer—or, for that matter, even the photographer who created the original image—realize that the seascape around the model's torso came from the original image of the lake? Or see that the contoured bricks on the torso and the sphere came from the image of a brick wall? If the photographer has difficulty in tracing the origins of the final image, how will the ordinary observer succeed in seeing the copying?

Standards in a Digital Age

The new technology certainly makes policing far more difficult. If a photographer might have difficulty seeing that his or her image has been manipulated in an unauthorized re-use, who will be able to do better? Even if a watchdog agency could be created (like ASCAP or BMI for music), the manipulative powers of the software operator can make it extraordinarily difficult to know whether an end image has resulted from unauthorized manipulation of pre-existing images.

Against this background, it is interesting that the United States Court of Appeals for the Ninth Circuit concluded that even the unauthorized loading of copyrighted software into a computer's random access memory can be an infringement. Such a loading is a copying, because it meets the copyright law's definition of a copy by being "sufficiently permanent or stable to permit it to be perceived, reproduced, or otherwise communicated for a period of more than transitory duration" (*Mai Systems Corp. v. Peak Computer, Inc.*, 991 F.2d 511).

The Digital Millennium Copyright Act of 1998 clarifies the issue of infringement when the owner or lessee of a computer makes a copy for purposes of repair or maintenance. The Act provides:

. . . it is not an infringement for an owner or lessee of a machine to make or authorize the making of a copy of a computer program if such copy is made solely by virtue of the activation of a machine that lawfully contains an authorized copy of the computer program, for purposes only of maintenance or repair

Any parts of the computer program that are not needed for the machine to be activated may not be accessed except for purposes of making the copy and the copy must be destroyed when the repair or maintenance is completed.

The rationale of *Mai Systems Corp.* leads to the conclusion that the scanning of an image is also the making of a copy and a copyright infringement (unless the copyright owner's consent is obtained)—even if the work is then manipulated in such a way as to become unrecognizable when compared to the original image that was scanned. Manipulating the work may allow the computer artist to avoid detection and litigation, but the initial copying is nonetheless illicit.

Educating about Ethics

A hallmark of the last forty years has been the exciting growth in awareness about rights and ethics that took off in the 1970s. The amount of information about all aspects of business has increased vastly for the communications professional. The work of groups like the Graphic Artists Guild and the American Society of Media Photographers changed the environment in which business was conducted. Rights, ethics, and re-use fees became important issues that many art directors understood and viewed with sympathy.

However, the artistic fields seem to have a new generation every few years, as art schools churn out wave after wave of emerging artists. Each new generation must be educated about professional standards; each new generation must confront the tradeoffs between self-advancement and the nurturing of an environment that supports all professionals. While we may wish that the schools would fulfill their obvious obligation to educate their students about professional matters, we can only

observe that most schools fail abjectly to meet this responsibility.

What has blunted the enthusiasm for that educational process about rights and responsibilities, a process that improved the working environment for all creators? Can it be the impact of new technologies, a change so profound that we have not yet sufficiently altered our way of conceiving of the process of creating and disseminating imagery? If so, is this leading us toward something even more amorphous, a different attitude, perhaps a different view of the role of imagery in the larger society?

Appropriation in the Digital World

Digitally created images derive from prior techniques, yet offer the power to meld and manipulate images that bring the very truth of those images into question. Unlike fine art, in which the brush stroke may establish uniqueness and, therefore, value, the digital image exists in a different construct and can be infinitely reproduced without any generational loss of image quality. Certainly the digital world is a more hospitable environment for copying than the world of the brush stroke or even the transparency. In fact, the truth of the image is so vulnerable to manipulation that some advocates for ethical practices have proposed what amount to labeling requirements that would disclose when work has been altered. Of course, infringers would ignore such disclosure requirements in the same way that they ignore the boundaries set by the copyright law with respect to copying. Implicit in all this is the power of the computer to take existing images and change them beyond recognition.

So the digital image not only eliminates originality in the sense of physical uniqueness (since the art can be reproduced an infinite number of times without any generational loss of image quality), but it also challenges the concept of the individual creator's originality as the memory of the computer holds more and more appropriated imagery.

Appropriation art is a postmodern theme. Some gallery artists gain fame by appropriating the images, and sometimes the life styles, of their famous, painterly predecessors. Is appropriation the proper response to consumerism and the money excesses of the art world? Is this an attitude that has perhaps gained wider

acceptance than we might imagine? Is the easy taking of the appropriation artist being paralleled by the budget-conscious behavior of corporations whose bottom-line concerns are paramount? The answers to these questions will become apparent with the passage of time. For now, we can only emphasize that infringement is unlawful and unethical. Artists must do whatever they can to protect their images and ensure that appropriation, in whatever guise, is not allowed to become an artistic norm.

The Impact of Internet—Thumbnails as Appropriation

Digital databases and the Internet create new tensions with respect to appropriation of copyrighted works. One situation where this arises was discussed earlier in *Tasini*, (Ch. 2). Another, more common problem is created by search engines such as Google, which offer thumbnails of images on the Internet through their "Image search" feature. The idea of using low-resolution "thumbnail" samples to display the contents of an image catalog is nothing new, but the widespread adoption of "thumbnail" previewing by major Internet search engines raises new questions about the appropriation of copyrighted works. By copying images displayed elsewhere, downsizing them, and presenting them to any curious Internet user, does Google, Yahoo, or Bing! infringe copyright?

Two recent cases address the thumbnailing problem in favor of Internet search companies. The first was *Kelly v. Arriba Soft* (336 F.3d 811). In that case, photographer Leslie Kelly claimed that Arriba Soft's Ditto.com search engine was infringing copyright in his photographs of the American West. Arriba Soft's product would, in a manner familiar to anyone using modern search engines, display downsized "thumbnails" of Kelly's photographs when they were relevant to an Internet user's search request. The court held that such thumbnailing was a fair use, since the search engine's purpose for copying and transforming was not to displace Kelly or otherwise profit at her expense. Rather, the search engine sought to increase the efficiency by which Internet users could find and access online content.

The second case concerned the online search giant Google, and was brought by Perfect 10, an adult entertainment company. The ultimate holding was similar to the result

in *Kelly v. Arriba Soft*. Most Web-enabled artists are familiar with Google's nearly ubiquitous "image search" feature, which responds to user-submitted keyword searches by seeking out images scattered all over the World Wide Web. In visually organizing the search results, Google displays shrunken thumbnails of each image it finds, allowing a user to click on that image to access the full size image as it appears on the Internet. Perfect 10 argued that this presentation of its images infringed its copyrights. While the court agreed that Google trammeled Perfect 10's distribution rights, it ultimately found that Google's display of the images was a fair use. In so doing, the court noted that the down-sizing process, accompanied by the attached link-through to the full size image, transformed the nature and purpose for which Google was displaying the images. While Perfect 10 sought to profit from its full size images, Google's compressed thumbnails were designed to allow Internet users to more easily find those images. *Perfect 10 v. Amazon.com*, 487 F.3d 701 (9th Cir. 2007).

What do these cases mean for artists who display their work on the World Wide Web? The *Perfect 10* and *Kelly* cases present an interesting study on how exercising a creator's rights may actually hinder his or her ability to disseminate his work. Most artists look to the modern Web as a way to enhance their visibility. Search engines like Google facilitate that by connecting Internet searchers with an artist's content. Hence, most creators would probably not share Perfect 10's or Kelly's insistence upon licensing fees, since profits earned would be offset by the fact that Google's "image search" would become impossibly expensive to operate. The disappearance of effective image searching may end up costing an artist more than he would earn in licensing fees. Clearly, the court was also uncomfortable with Perfect 10's position, believing that it threatened to diminish a search engine's ability to improve access to information on the internet. Thus, it protected first Arriba Soft's, and later Google's thumbnailing as a "fair use." The decision is one that most artists would likely applaud, given the power of search engines to increase artists' opportunities to market themselves before a large international audience.

The Impact of the Internet—Frames, Linking, and Other Potentially Infringing Activities

The world of web design has given rise to a number of particular problems that have often led to copyright litigation. Such problems typically arise when one site refers to another website, or links users to infringing content. It is important for web designers to understand how these practices can get them or their clients into trouble. In the landmark decision, *Metro-Goldwyn Mayer Studios v. Grokster,* the Supreme Court held a peer-to-peer file sharing service liable for copyright infringement, since it induced users to seek out and download unlawfully copied media content. (545 U.S. 913) This very important case will be discussed further in the section on indirect infringement, but needless to say this kind of secondary liability might easily ensnare web designers who too casually link potential web surfers to infringing content elsewhere on the Internet. Hence, some common yet controversial "linking" practices are discussed in this section.

One apparently unresolved but controversial area is the practice of linking in "frames." Framing is a process by which a portal website links to another website's content, but displays the linked content within a "frame." The edges of the frame typically contain information or advertisements that promote or otherwise benefit the portal. Courts appear to be quite suspicious of this practice, and portal operators facing infringement suits usually elect to disable such frames, or attempt to show that their practices do not amount to "framing." In one case, Total News, Inc. established a portal site that linked to several primary sources of news. One of these primary sources, the Washington Post, sued Total News, alleging that the defendant's practice of "framing" the primary source with Total News content infringed the Post's copyright. The case ultimately settled, with Total News agreeing to link without the frames.

Another interesting case involved WhenU, a company that produced "contextualized" marketing software. In essence, WhenU's software would monitor an Internet user's browsing habits, and display customized advertising content in "pop up" windows. Wells Fargo, a large bank based in San Francisco, soon

brought suit against WhenU. The bank alleged that WhenU's pop-ups, which often advertised for competing banks, effectively "framed" Wells Fargo's own website. The court rejected the idea that such framing could occur since the ads appeared in separate pop-up windows. While the court did not expressly state that framing would infringe copyright, WhenU's eagerness to avoid such a finding is indicative of the negative view courts take to this practice. *Wells Fargo & Co. v. WhenU.com, Inc.* (293 F.Supp.2d 734).

Another form of linking that courts frown upon is "deep linking," whereby a given website links directly to content on another's Web site without recognizing the linked site's entitlement to profit from its content, or the linked site's right control its own bandwidth. As an example, a portal or news-and-commentary hub such as realclearpolitics.com may directly link to a story on CNN's website, hence bypassing the content most users would encounter if they browsed to the story from the *www.cnn.com* homepage. Such linking bypasses the overall superstructure a linked site may place upon its "deep" or nested content. Worse, it often displays that content "inline," causing a user to believe that the linking site itself was providing the content.

The practice is troubling to the providers of original content for a number of reasons. Websites furnishing interesting content often rely upon advertising displayed on their homepages to finance their operations. Some even create security barriers to restrict "deep content" to paying subscribers only. Further, "inline" linking further harms the original providers of content by allowing linking websites to display content outside of their original context. Thus, if a given video clip appeared alongside a sponsoring advertisement, or as part of a news story, users of the linking website could view the content without viewing the associated advertisement.

Finally, direct linking permits visitors of an external site to enjoy a content provider's online materials, and effectively steal the provider's bandwidth. In this context, bandwidth describes the total amount of data a website owner's online audience may download in a given month. For example, a website operator may be able to store up to 200 GB of data on a host's servers, but the host may only permit that site's visitors to download a total of 20

GB per month. Usage is cumulative, which means that each visit by the same or different Internet users eats into the website operator's total monthly bandwidth limit. Once the limit is reached, further visitors will be barred from viewing the site until the site operator purchases more bandwidth, or until the month ends and the limit resets. Because bandwidth costs money, a website operator must be able to anticipate how much traffic might pass through his or her site, and eke out some profit from each visit. However, if another site is embedding content in a manner that allows remote viewing of images, videos, or audio information, it is effectively "free-riding" on the content provider's bandwidth. Worse, the users of the external site will probably not realize that the "linked" content is being furnished, quite literally, at someone else's expense.

The controversy surrounding deep linking has, predictably, spilled into the courts. One interesting case was *Live Nation Motor Sports v. Davis* (2006 WL 3616983). The plaintiff in the case was SFX, a company that organized sport-motorcycling "Supercross" events. SFX broadcast live coverage of these events over the Internet free of charge, though the webcasts were accompanied by a number of sponsoring advertisements. The defendant Davis was the owner and operator of a "Supercross" enthusiast site, and he routinely linked directly to these webcasts, completely bypassing the ads and other content presented on the SFX website. The court granted a preliminary injunction against Davis, noting that his direct linking harmed SFX financially, and that SFX would likely prevail in its claims of copyright and trademark infringement.

In another case, Ticketmaster brought a lawsuit against Tickets.com for "deep linking" internal event pages, and mining them for information about event times, venues, and ticket prices. *Ticketmaster Corp. v. Tickets.com, Inc.* (2000 WL 1887522). Both Ticketmaster and Tickets.com were brokers for tickets to various performance events, but Tickets.com's larger function was as a clearinghouse for information about when and where such events were taking place. To obtain this information, Tickets.com would use a "webcrawler" to automatically search Ticketmaster's internal event pages, obtaining and later displaying pertinent event information on the Tickets.

com website. That site would also refer visitors to the Ticketmaster website if Tickets.com was not brokering a particular event. Though Ticketmaster attempted to prevent Tickets.com from such linking using both technological and legal measures, both ultimately failed. The court held that Tickets.com's use of Ticketmaster's internal links was designed to obtain information that was not protected by copyright, and was therefore a fair use.

In *Ticketmaster,* and in the nearly contemporaneous case of *eBay, Inc. v. Bidder's Edge, Inc.* (100 F.Supp.2d 1058), the court discussed the possible impact automated "web crawlers" might have upon the overall performance or profitability of the linked website. The court held that a web crawler electronically trespassed on another's site if its activity resulted in additional unanticipated traffic, or otherwise permitted competitors to encroach upon the linked website's business. In *eBay*, the court held that a web crawler that repeatedly searched the eBay auction database harmed the plaintiff, since it reduced the overall responsiveness of the eBay website. The *eBay* trespass theory was rejected in *Ticketmaster*, however, since the defendant's attempts to access Ticketmaster's databases were a relatively small percentage of the total traffic passing through the Ticketmaster website, and thus did not impact the site's performance.

The Dangers of Secondary Infringement

The increasing proliferation of broadband Internet connectivity has breathed new life into the principles of secondary infringement of copyright. Secondary, or indirect infringement occurs when one party facilitates copyright infringement by others. The theory is designed to give a remedy to copyright holders when it would be futile to pursue tens, hundreds, or millions of direct infringers. It allows an aggrieved party to instead sue a "gatekeeper" who has created a system or environment that permits others to infringe copyrights en masse. Quite often, such "gatekeepers" are the developers of new and popular technologies who defend lawsuits against established right holders. However, these theories may also trip up web developers who post infringing content on their websites, or link to such content directly. Hence, it is worth examining some of the cases in this area.

An early manifestation of the secondary infringement problem came in the form of Sony's Betamax video tape recorder. This now venerable technology was an incarnation of the soon-to-be ubiquitous VCR. The advent of Betamax in the late 1970s and early 1980s was troubling to media companies, who feared that millions of consumers would use the devices to unlawfully tape copyrighted television content. Realizing that suing television viewers at large would be nearly impossible, one media company instead decided to sue Sony, the manufacturer and distributor of the Betamax. In the ensuing case of *Sony Corporation of America v. Universal City Studios* (464 U.S. 417), the U.S. Supreme Court held that Sony was not contributorily liable for the infringing acts of its customers. The Court recognized a number of uses for the Betamax that did not infringe the plaintiff's copyrights, and used these substantial non-infringing uses to carve out a "safe harbor" that spared Sony from being held indirectly liable for mass infringement by thousands of Betamax owners.

The Supreme Court revisited the *Sony* safe harbor almost two decades later, when it was confronted with the problem of Internet based file sharing. The first wave of file sharing cases came to the lower court the early 2000s. At this time, the emergence of peer-to-peer file sharing networks, combined with the widespread adoption of fast Internet connections at home, resulted in an explosion of mass copyright infringement. Among the earliest and most famous of these peer-to-peer networks was Napster, a vast community of globally connected file sharers whose content could be searched using a freely downloadable, intuitively usable client software. Though Napster brought copyright infringement to the global mainstream for a few brief years, it was eventually found liable for indirect infringement, and effectively shut down. Though Napster argued that its software and underlying peer-to-peer network had substantial non-infringing uses, much akin to the Betamax in *Sony*, the court did not allow Napster to take refuge in *Sony's* safe harbor. The court noted a key difference between Napster and Sony; while Sony could not directly control the acts of Betamax purchasers in their homes, Napster actively monitored traffic across its network, and could easily have filtered infringing content. *A&M Records, Inc. v. Napster, Inc.* (284 F.3d 1091).

After "the lights went out" at Napster, a number of companies sought to replace it. These companies deliberately structured their peer-to-peer networks in a way that would allow them to avoid liability under then-existing law. One such company, Grokster, developed peer-to-peer client software that operated on a completely decentralized network that was impossible to centrally monitor or filter. Media companies soon brought an indirect infringement suit against Grokster, whose software was enabling copyright infringement on a colossal scale. Grokster, in turn, hoped that its lack of control over user activity, coupled with the software's potential for exchanging non-infringing files, would allow the company to take shelter in the *Sony* safe harbor.

The Supreme Court decided, however, that Grokster was not protected by *Sony's* safe harbor, because the company actively encouraged its users to infringe copyrights. Even though Grokster could not control its users, the Court noted several proposed advertisements and promotional materials that demonstrated how useful the software was for finding and downloading copyrighted content. *Metro-Goldwyn-Mayer Studios v. Grokster*, (545 U.S. 913). The decision effectively limited the scope of the *Sony* safe harbor, though as the following discussion shows, Congress responded to the growth of the Internet by creating a few "safe harbors" of its own.

Secondary Infringement and the Digital Millennium Copyright Act

In addition to the many important court cases shaping the law of indirect infringement, Congress has passed legislation that specifically affects Internet service providers, and other large online communities. Though other aspects of the landmark Digital Millennium Copyright Act of 1998 are discussed later in the chapter, this section focuses on how the law changed the largely court-developed doctrines of indirect infringement. Though the Federal Copyright Act does not discuss the issue of secondary liability, the amendments added in the Digital Millennium Copyright Act, or DMCA, create new "safe harbors" that exempt certain Internet operators from secondary liability.

Basically, any online marketplace, forum, or Internet provider that takes active efforts to prevent its users from posting infringing materials is insulated from liability for indirect infringement. In *Ellison v. Robertson* (357 F.3d 1072), a federal court held that such efforts must include an effective means for aggrieved parties to inform an Internet operator that users are posting infringing materials on the network. In the *Ellison* case, for example, AOL.com's failure to furnish an effective infringement notification was fatal to its ability to shelter in a DMCA safe harbor.

In addition to such notification procedures, the DMCA safe harbor requires any network or online community seeking its protection to inform users of their anti-infringement policy, and the operators must have a procedure for terminating repeat infringers of copyright. These issues were cast in sharp relief in the case *Corbis v. Amazon.com* case. (351 F.Supp.2d 1090).

Corbis is a stock photo agency that complained about how many vendors on Amazon.com's Marketplace (zShops) were posting or selling photographs copyrighted by Corbis. Corbis notified Amazon.com of this activity, and Amazon responded by terminating the user accounts of the infringing members. Because Amazon's terms of use specifically warned all Marketplace (zShop) members to not post copyrighted content, and because Amazon properly responded to Corbis's complaints of infringement by Marketplace users, the court determined that Amazon qualified for DMCA's safe harbor from indirect infringement liability.

The Protection of Typefaces

Though typeface designs are creative in their own right, they are not protected by copyright law. Interestingly, copyright *does* protect the source code for software containing typeface information. In spite of this modicum of legal protection, however, unlawful copying of font and typeface software is quite commonplace. One group that seeks to educate the public about this problem is Atypi, an international nonprofit organization of type designers, manufacturers, and educators. At one point, Atypi launched a Font Software Anti-Piracy Campaign to reduce the extensive copying of software containing typeface designs.

In a sense, this piracy of font software is simply an aspect of the larger problem of software piracy in general. Sales of PC software generally amounted to $88 billion in 2008, but industry sources estimate that up to 41 percent of all installed software is pirated. With

respect to type designs, the former president of Atypi, Ernst-Erich Marhencke, states that "Conservative estimates put illegal copying of font software at six times for each package sold." Another Atypi member has done research indicating that in some cases the illegal copying might be as high as twenty times for each package sold.

The Departments of Justice and Education have jointly issued a report to encourage the teaching of ethical use of computers and information technology in the nation's schools. This emphasis is certainly not misplaced with respect to students in the visual arts. In one class, I posed the following hypothetical to undergraduate art students: "You have just purchased a computer program with unusual typefaces. A friend who has done you many favors asks you to make a copy of the program and give it to him so he can use the fonts. Will you do this for your friend?"

While some students argued that the creativity of the typeface designer merited respect, most felt that they would copy the font software and give it to the friend. The irony, of course, is that these same students would be outraged if anyone copied their designs. Why should there be any difference?

Perhaps the ease of copying software dulls the copier to the amount of creativity embodied in the creation of a typeface. There is also the fact that typeface designs are not copyrightable. Thus, the Copyright Office, in its final regulation on "Registrability of Computer Programs that Generate Typefaces," stated that the Office will not "register copyright claims in typeface designs as such, whether generated by a computer program, or represented in drawings, hard metal type, or any other form." The noncopyrightability of typefaces is embedded in the history of the current copyright law and has been upheld in the courts.

What Is Protected

On the other hand, computer programs certainly are copyrightable "whether or not the end result of intended use of the computer program involves uncopyrightable elements or products." The Copyright Office concluded that "the creation of scalable font output programs to produce harmonious fonts consisting of hundreds of characters typically involves many decisions in drafting the instructions that drive the print. The expression of these decisions is neither limited by the unprotectable shape of the letters nor functionally mandated. This expression, assuming it meets the usual standard of authorship, is thus registrable as a computer program."

Nonetheless, the Copyright Office will scrutinize closely the nature of the work claimed to be protectable in the copyright applications. When registering font software, the work to be protected should not be described as "entire work," "entire computer program," or "entire text," but rather a description such as "computer program" should be used.

This clarification by the Copyright Office strengthened the hand of typeface designers, manufacturers, and educators to launch their anti-piracy initiative. Atypi members—including Agfa Corp., Bitstream, ITC, Linotype-Hell Co., and Monotype Typography Ltd.—agreed to the following policy statement regarding font software piracy:

The use of a package of font software is governed by a license agreement. When font software is purchased, the rights the user has licensed do not include the right to make unauthorized copies of the type design or of the font software that embodies the design. If copies of the font are made to give away or resell, everyone involved in the creation of the font software, including the typeface designer, will be prevented from being properly rewarded for the hard work involved in its creation. This could discourage the creation of new typefaces, hinder font software development, and reduce the ability of manufacturers to make new products available.

If the typeface designers are not rewarded for the work that they do because of piracy, there will be an impoverishment of the creativity that can be brought to bear in making new typefaces. Imagine that I had posed a somewhat different hypothetical to that same undergraduate class: "A client will pay you to do your design work, but a thief will steal a significant portion of your fee. Do you have the same motivation to work as you would if you received all of your fee?" If the answer is obvious, why are designers and other people in the creative community stealing the copyright-protected font software created by type designers who are also part of that same creative community?

One might like to say that only desktop publishers with no design background are part

of this widespread theft, but that simply isn't so. Otherwise reputable designers and companies seem unable to see the serious nature of this piracy. Perhaps the size of some of the companies involved in the creation and distribution of font software gives thieves a rationalization, but this is at best a rationalization. It is both illegal and unethical to steal regardless of the size of a company. Moreover, that theft is affecting the income of individual designers and must eventually place boundaries on the outflow of their creative energies.

The Dangers of Infringement

Atypi points out that "Infringement is defined as impermissible copying, or copying not allowed by the licensing agreement....In the world of font software, this means copying the disk in any form (except the permitted single copy back-up), including through the use of conversion programs." Such infringement carries severe penalties under the copyright law. Each instance of infringement makes the infringer liable for damages that can be as high as $150,000 if shown to be willful, as these infringements certainly appear to be, or $30,000 if not shown to be willful. In addition, the infringer can be liable for court costs and attorneys' fees.

Since copyright infringement actions may be brought until three years after the time the infringement is discovered (or should have been discovered), an infringer is creating an ongoing potential liability of substantial proportions. If appeals to ethics and legality fail to move some infringers, perhaps the bottom line considerations of the cost of paying for font software compared to the potential infringement damages will deter piracy.

Atypi plans to support all of its members who pursue infringers. By raising the public awareness through its anti-piracy campaign and also increasing the risks to infringers, Atypi's former president and current honorary president Mark Batty believes that his organization will make inroads against font software piracy: "a problem of tremendous proportions [that] is greatly affecting the viability of the font industry."

Does the Client Own the Disk or File?

Another problem presented by the digital revolution involves ownership of the disk containing a file with artwork. The reasoning of this discussion applies to the ownership of files as well, which is important since so many transmissions of files are now by e-mail rather than by the delivery of a disk (or, in the old days, of a physical mechanical). In a typical scenario, a designer completes a project to the satisfaction of the client, delivers mechanicals to their clients (either on a disk or attached to an e-mail), and the pieces are printed. Later, when the client wants to revise the projects, the client fails to ask the designer to do the revision but instead plans to use a different designer or the clients' in-house design staffs.

The designer is outraged and concerned, but the contract does not say anything about who owns the mechanicals. Certainly the contract could have been black-and-white: it could have stated that the designer or the client owns the disks and files. That would have given a clear answer. But, as so often happens, the situation presents shades of gray.

Applying the Copyright Law

The copyright law does not fully clarify such a conundrum. The copyright is composed of a number of rights, including the right to reproduce a work in copies, the right to make the first sale of a copy of the work, and the right to make works derived from the work (such as a painting derived from a photograph). The designer would own the copyright in the design unless a written contract transferred rights to the client. If there were no written contract, it would be assumed that the client at least obtained the rights contemplated by the nature of the project (but this is, obviously, vague). In any case, if nothing is written, the client would only obtain nonexclusive rights (which means the designer could give other clients the right to use the design—not a very likely scenario). But would a court construe the intention of the parties as allowing the client to make derivative works on a nonexclusive basis? This can't be answered with certainty, which points to the importance of carefully drafted, written contracts.

Protecting Electronic Rights

In September of 1995, "The Report of the President's Working Group on Intellectual Property Rights" recommended legislation "to accommodate the new technologies of the rapidly expanding digital environment" and to further clarify the application of copyright protection in the Cyberspace of the Internet. The report found that:

Creators, publishers and distributors of works will be wary of the electronic marketplace unless the law provides them the tools to protect their property against unauthorized use Just one unauthorized uploading could have devastating effects on the market for the work.

The result, according to the report, is that investment, both creative and economic, will not flow into the Information Infrastructure unless adequate protections for the products of that investment are put in place.

In response to the Working Group's recommendations, a bill known as the National Information Infrastructure Copyright Protection Act of 1995 was introduced in both the United States Senate and House of Representatives. The purpose of the bill was to increase and clarify the scope of copyright protection as an incentive for copyright owners to make their works available on the Internet, for the benefit of the public at large. To that end it clarified that a transmission of a publication is a part of the distribution right for purposes of copyright protection. A transmission was defined in the bill as something that was distributed by any device or process whereby a copy or phonorecord of the work was fixed beyond the place from which it was sent. In addition, the bill banned de-encryption devices because of the important role encryption plays in protecting transmitted copyrighted content.

The legislation proposed in 1995 actually failed to pass, because opposition developed from a coalition of groups representing libraries, educational institutions, and high technology. Of particular concern to these groups was the possibility that the bill might narrow the fair use defense. Closely related to the fair use issue was the objection to making illegal the use of anti-encryption devices, since breaking through such devices allows a person browsing the Internet, for example, to gain access to information in digital form. Fair use is only of value if there can be access to the information that might be used. In October, 1998, the Digital Millennium Copyright Act was enacted after compromises that alleviated these concerns. In handling the illegality of using anti-encryption devices, the Act provides, "Nothing in this section shall affect rights, remedies, limitations, or defenses to copyright infringement, including fair use, under this title." In addition, an exemption states, "A nonprofit library, archives, or educational institution which gains access to a commercially exploited copyrighted work solely in order to make a good faith determination of whether to acquire a copy of that work for the sole purpose of engaging in conduct permitted under this title shall not be in violation" There are several restrictions on this exemption, such as the fact that the exemption is only available "with respect to a work when an identical copy of that work is not reasonably available in another form." The general prohibition automatically took effect in 2000, subject to certain exceptions for activities such as testing computer security, research on encryption, certain software development, protection of privacy, and the monitoring of children's Internet usage. This area of the law continues to evolve, as the Librarian of Congress and the Copyright Office are permitted to carve out new exceptions, and have actually done so for a number of situations. The important point, however, is that modern copyright law unambiguously protects digital information, and most efforts to encrypt that information.

The Legacy of Copyright

No doubt we live in an interesting time. As the foundations shift beneath us, we must pay attention to what is fundamental. The efforts to educate students, recent graduates, and, in fact, everyone in the field, about rights and ethical practices must continue. If some day the larger community will appropriate and own the images created by its artists, then some mechanism must be provided to support those artists in their creativity and also preserve our democratic institutions. Until that day comes, the copyright law offers the best approach for achieving the delicate balance between the rights of the creator, the user, and the community. Observing that law and following the ethical standards developed from long experience in the field offer us the best hope for a fruitful future.

7 MORAL RIGHTS

The Visual Artists Rights Act ("VARA"), landmark legislation creating moral rights for artists in the United States, was enacted on December 1, 1990, as an amendment to the copyright law and took effect on June 1, 1991. Copyright, the power to control reproduction and other uses of a work, is a property right. Moral rights are best described as rights of personality. Even if the artist has sold a work and the accompanying copyright, the artist would still retain rights of personality.

Prior to the enactment of VARA, the protections for American artists had been limited and often unsatisfactory. While some legal commentators argued that American laws relating to unfair competition, trademarks, right to privacy, protection against defamation, right to publicity, patents and copyrights amounted to a satisfactory equivalent of moral rights, the better view was that this mélange did not at all approach the protections offered to creative people and their work under specially designed moral-rights provisions. Many artists' groups recognized moral rights as an important issue and urged the enactment of legislation to guarantee this protection. A number of states responded by enacting pioneer moral rights laws, a trend that helped develop momentum for the enactment of VARA. This chapter will explore the provisions of VARA, compare it to foreign and state laws, and then review other legal theories that protect artists.

The Visual Artists Rights Act

Drafted and shepherded to passage by Senator Edward Kennedy, VARA gives a narrow definition of a work of visual art as "a painting, drawing, print or sculpture." VARA covers unique works and consecutively numbered limited editions of two hundred or fewer copies of either prints or sculptures, as long as the artist has done the numbering and signed the edition (or, in the case of sculpture, placed another identifying mark of the artist on the work). The limited edition provision also applies to "still photographic images" as long as an edition of two hundred copies or fewer is consecutively numbered and signed by the artist.

This narrow definition limits the effectiveness of VARA. Explicitly excluded from protection under VARA are posters, applied art, motion pictures, audiovisual works, books, magazines, data bases, electronic information services, electronic publications, merchandising items, packaging materials, any work made for hire, and any work which is not copyrightable. While VARA protects traditional fine art, it appears that it will have no impact at all on commercial art, which is created for the purpose of reproduction. Of course, one can imagine that a unique painting might be altered before reproduction, in which case the provisions of VARA might apply even though the intention in creating the art was to reproduce it in large quantities.

VARA gives an artist the right to claim authorship of his or her work, to prevent the use of his or her name on the works of others, and to prevent use of his or her name on mutilated or distorted versions of his or her own work, if the changes would injure his or her honor or reputation. In addition, the artist has the right to prevent the mutilation or distortion itself if it will damage the artist's reputation.

If the artist wants to prevent the destruction of a work, it must be of "recognized stature." This test for recognized stature is

like that under the California law, which is discussed later in this chapter. However, the statute wisely gives artists rights in their own work regardless of recognized stature and reserves the stature test for works that should be preserved for the culture. As cases are decided under VARA, it will be interesting to see where the boundary is drawn to divide works considered to be of recognized stature from those which are not.

The moral rights of the artist cannot be transferred. However, VARA does allow the artist to waive these rights in a written instrument signed by the artist. The wisdom of allowing waivers is certainly open to question in view of the disparity of bargaining strength so often present when artists deal with larger entities. The written instrument of waiver must identify the work and the uses to which the waiver applies, and the waiver is limited to the work and uses specified. For a work created by more than one artist, any of the joint artists has the power to waive the rights for all the artists. The waiver of moral rights does not transfer any right of ownership in the physical work or copies of that work. Nor does the sale of a physical work, a copyright, or any exclusive right of copyright, transfer the artist's moral rights, which must be exercised by the artist.

For art incorporated in or made part of buildings, VARA seeks to balance the rights of the building owner against those of the artist. If the art would be destroyed or altered by its removal, then the artist has a right to prevent such destruction or modification unless either (1) the art was installed in the building before the effective date of the law, or (2) the artist and owner signed a written instrument in which they specified that the work may be subject to destruction or modification due to removal. On the other hand, if work can be removed without destruction or mutilation, the artist shall have the right to prevent mutilation or destruction unless either the owner makes a "diligent, good faith attempt" to notify the artist of the owner's intended action or, if the owner succeeds in notifying the artist, the artist does not either remove the work or pay for its removal within 90 days of receiving such notice. Of course, an artist objecting to the destruction of a work incorporated in a building would have to show that the work was of recognized stature.

VARA exempts from its coverage changes in a work of art due to the passage of time, the inherent nature of the work's materials, conservation or public display.

The term of protection for works created after the effective date of VARA is the artist's life. This certainly invites the criticism that the term should have been the same as the term of copyright protection. For works created before VARA's effective date, the artist will have moral rights in works to which he or she holds title, and such moral rights shall last as long as the copyright in the work. This means that works created prior to June 1, 1991, and in which the artist holds title will have a longer term of moral rights protection (the artist's life plus seventy years) than those works created on or after June 1, 1991. The term of moral rights protection when a work is created jointly by more than one artist is the life of the last surviving artist. All moral rights run to the end of the calendar year in which they would expire.

VARA also requires that a Visual Arts Registry be created in the Copyright Office. The Copyright Office regulations (section 201.25) allow either an artist or building owner to give and update relevant information with respect to art incorporated in buildings, such as the name and address of the artist or owner, the nature of the art (including documenting photographs), identification of the building, contracts respecting the art, and any efforts by the owner to give notice regarding removal of the art. The Copyright Office does not provide a form for giving such information. The fee is $105 for one title and an additional $30 for each group of not more than ten titles.

The enactment of VARA at least extends to visual artists, if not other creators, rights similar to those contained in the Berne Copyright Convention, which provides that "the author shall have the right to claim authorship of the work and to object to any distortion, mutilation or other modification of, or other derogatory action in relation to, the said work, which would be prejudicial to his honor or reputation."

To understand how VARA will apply to particular situations, and to what degree the law of the United States has been changed by VARA, it is helpful to examine a number of European and American cases illustrating the likely impact of VARA.

Right of Attribution

VARA gives the artist the right to claim authorship of the artist's work and to disclaim authorship of works by others. Known as the right of attribution (or paternity), this should prevent enforcement of a contractual provision by which an artist agrees to create work under a pseudonym. In a French case decided in 1967, for example, a painter named Guille agreed to deliver to his dealer his entire output for ten years. These works would either be unsigned by Guille or signed under a pseudonym. The court held the contract invalid, since it violated the painter's right of attribution.

A limit to the right of attribution is shown in a bizarre 1977 case involving the Surrealist Giorgio de Chirico. He filed suit in France when a painting titled *The Ghost* and attributed to him was displayed at the Musée des Arts Décoratifs. He claimed that the attribution was false and demanded the painting be destroyed. The court insisted that he pay an expert's fee to examine the painting for authenticity. When de Chirico refused to do this and failed to prove by other means that the painting was a fake, the court not only refused to grant the relief requested but also required de Chirico to pay fifty thousand francs to the woman who owned the painting. The right of attribution would permit an artist to prevent false attribution of a painting, but it would not allow the artist to stop the exhibition of a painting that is correctly attributed.

It is open to question whether VARA would have changed the result in the famous American case involving the artist Alberto Vargas and *Esquire* magazine. Vargas created a distinctive series of drawings of women over which *Esquire* acquired complete ownership by contract. For more than five years, *Esquire* had given Vargas credit as creator of the illustrations, although the contract itself did not provide for him to receive any such credit. After Vargas and *Esquire* had a falling out in 1946, the magazine changed the title on the remaining drawings it owned to "Esquire Girls" and gave no credit line at all to Vargas. Vargas sued, but the court decided that Vargas could not claim an implied right to receive authorship credit, because the contract specifically transferred all rights to *Esquire*. It stated, "What plaintiff [Vargas] in reality seeks is a change in the law of this country to conform to that of certain other countries...we are not disposed to make any new law in this respect." (*Vargas v. Esquire, 164 F.2d 522*.) Whether VARA would afford any relief in a Vargas-like case today might depend on whether the magazine altered the physical work or not. If the magazine scanned the physical work and left it intact, but altered the digitized image, it seems unlikely that VARA would apply.

Interview with Alberto Vargas

Laws granting moral rights may seem arcane to artists who have never experienced a denial of authorship credit or defacement of an artwork. What do such laws mean in terms of human emotions and the impulses governing creativity? Two cases from the 1940s were invariably cited as authority for the fact that artists in the United States lack moral rights and must protect their reputation and their art by contract. But how did these cases affect the artists, Alberto Vargas and Alfred Crimi, who dared seek legal recourse in vain attempts to gain moral rights? How might moral rights laws affect other artists who find themselves involved in such disputes in the future? To learn the answers to questions such as these, I interviewed both Crimi and Vargas in 1979, more than three decades after the cases that had made their names an enduring part of our legal history. The Crimi interview appears later in this chapter.

Alberto Vargas, well known for his portraits of women, became a pioneer in the field of artist's rights by waging his famous legal battle against *Esquire*. While the Vargas decision is known to many artists and lawyers with an interest in the field of creator's rights, the struggle between Vargas and *Esquire* is not known.

No problems developed between Vargas and *Esquire* under his first contract with the magazine, which lasted from June, 1940 through May, 1944. On May 23, 1944, however, Vargas entered into a new contract with Esquire that required fifty-two drawings each year for a period of ten and a half years. The contract provided, "The drawings also furnished, and also the name 'Varga', 'Varga Girl', 'Varga Esq.,' and any and all names, designs or materials used in connection therewith, shall forever belong exclusively to *Esquire*, and *Esquire* shall have all rights with respect thereto..."

In February, 1946, Vargas sued in federal court to have the contract canceled. The court decided the contract had been fraudulently obtained and granted Vargas the cancellation, but *Esquire* later obtained a reversal in the appellate court. In March, 1946, after cancellation of the contract, *Esquire* began calling the Varga Girl drawings by the title of the Esquire Girls. Vargas's name did not appear with his drawings at all. Vargas then sued to prevent the reproduction of any more of his work by *Esquire* because *Esquire* was not giving him credit as the artist for the drawings. But the court refused to grant Vargas his right to receive credit for his work, stating instead that moral rights were not recognized in the United States.

Vargas briefly related his background, speaking with a slight accent, in a conversation frequently punctuated by laughter. Born in Peru's second largest city, Arequipa, in 1896, Vargas came to New York City in 1916 and had immediate success when Florenz Ziegfield, creator of the fabulous Follies, commissioned him to paint nearly twenty portraits for an exhibition at the Ziegfield opening in June, 1916. The fee would be $200 for each portrait; they sealed this agreement by shaking hands. Vargas remained with Ziegfield until the Follies closed in 1931. He called the experience, "the most fantastic thing in my life. From then I was on my way."

After the closing of the Follies, Vargas worked for a time in Hollywood but in 1939 was blackballed by all the studios for joining in a union walkout. In 1940, Vargas returned to New York City and began working for *Esquire Magazine*. After leaving *Esquire*, of course, he was to meet Hugh Hefner and go on to great success in the pages of *Playboy Magazine*.

The interview with Alberto Vargas took place by telephone on April 9, 1979. Mr. Vargas was at his home in West Los Angeles, California, and I was in New York City. An excellent recounting of Vargas's life and work is *Vargas* by Alberto Vargas and Reid Austin (published by Harmony House).

CRAWFORD: You didn't have a lawyer for the first or second contract?

VARGAS: No, I never had a lawyer. Do you know who my lawyer was? My right hand...

CRAWFORD: Tell me a little bit more about the lawsuit itself. You began to have some troubles with *Esquire* about the credit for the pictures?

VARGAS: Yes, first of all, he [the *Esquire* executive] said, "You know, Alberto, I like the work you're doing, but we must do something about your name."

I said, "What's wrong with my name?"

He said, "It's not phonetic. The Vargas Girl is no good, you have to drop the s."

I didn't know why he was doing this. I learned it later to my discomfort. I did the worst thing in the world to let him change my name...

CRAWFORD: Did he think you were getting too much money?

VARGAS: Yes...

CRAWFORD: How long did you go along doing this?

VARGAS: In 1946 he couldn't stand it anymore. He had a backlog of about two hundred pictures, so he could go on for three or four years without me.

CRAWFORD: So he fired you at that point?

VARGAS: Yes.

CRAWFORD: Was it then that they started changing the name from Varga Girls to Esquire Girls?

VARGAS: Not only that. He began to cut the name in pieces. I couldn't sign this, I couldn't put the name *Esquire* in the circle of my name, the signature of my drawing. My wife and I were bewildered. We didn't know what he was up to...

CRAWFORD: Then he took your name completely off the pictures?

VARGAS: Yes. He took it off entirely and called it the Esquire Girls.... [When my lawyer read the second contract] he said, "My God, you signed your death warrant."

I said, "What do we do now?"

"Well, you have to fight now," he answered. "You haven't any money, but I'll take it on the provision that if you get some, I get some. Otherwise I don't see how to rescue you."

CRAWFORD: Did you think that generous on the lawyer's part?

VARGAS: Yes, he was honest, this lawyer, because he said, "He has put something on you that no man on earth can ever comply with. It said you are going to give him fifty pictures and he only had five. So you broke the contract," that's what he said. That I broke the contract for not producing fifty, only five. That was the whole thing.... He thought he had destroyed me then. But it wasn't so,

because we went and fought him. The lawyer went to work and he said, "There's no way that I can do it, but I have to try at least." But he [*Esquire*] had a slew of lawyers defending himself...

CRAWFORD: In what way did you win? What did the judge decide?

VARGAS: He decided that he [*Esquire*] had cheated me, that he had changed my name, that he had made up his mind to destroy me because no man on earth can have that—I don't care what artist he had work at top speed. And he had three lawyers. I had none. [This refers to the suit for cancellation of the contract.]

CRAWFORD: But the decision that was finally published said that *Esquire* had won, because it said that in the United States there are no moral rights the way there are in Europe. Even though *Esquire* had taken your name off the work, they were not going to punish *Esquire* in any way...

VARGAS: The judge said, "This is a contractual matter. This has nothing to do with law. Nothing unlawful has been done to him. It is a contract that he has to live up to..." He [*Esquire*] saw the interest the other magazines had in me and he said, "My God, they are going to have what I just threw away." Then he appealed.... He licked me also in the second court.

So I asked my attorney, "What can I do now? I cannot use my name. I have no money..."

"Oh, well, I tell you, Alberto," [the lawyer answered], "you can go and dig ditches. That you can do without any name."

CRAWFORD: He was being ironic?

VARGAS: Yes, purely. Then [the lawyer] was driving me to his home because his wife and my wife were waiting there for lunch when the decision came. And he was driving me and in the big yellow envelope was the decision. When we were six or seven blocks from the house, I said, "Do me a favor please. You go and give the bad news to Anna [Mrs. Vargas] and tell her that I'm coming later. I don't want to face her. I don't want to go and have to tell her, because this is awful."

"And what are you going to do?" [the lawyer asked.]

"I'm going to kill that s.o.b."

He said, "Are you kidding?"

I said, "Look in my eyes. Do you think I'm kidding?"

He said, "Don't do anything foolish."

I said, "That's not foolish, that's a pleasure. I got the idea just how to do it too..."

CRAWFORD: I'd like to thank you for this interview.

VARGAS: Will you send me your article on "Moral Rights and the Artist?" That is wonderful. Anytime that you need me, I would walk to Chicago or New York to help the cause because it's my own... I want to help all the other artists. My time is passed already, but the newcomers are the ones that need a lot of help, believe me.

CRAWFORD: Thank you again.

VARGAS: The pleasure has been mine.

Right of Integrity

The artist's right to object to any distortion, mutilation or alteration of art is known as the right of integrity. This right is illustrated by a leading French case involving six panels of a refrigerator painted by Bernard Buffet. It was Buffet's intention that the refrigerator be exhibited as a whole. Accordingly, he only signed one of the six panels. Within six months of the first auction, however, one of the panels was offered for sale at a second auction under the description of a painting on metal by Buffet. He brought suit to prevent the sale of the panel separately and to have the entire work returned to him. In 1962, the court upheld him to the extent that it refused to allow the panels to be sold separately in either a public or private sale, but the private owner was allowed to keep the work. Buffet also received one franc as a symbolic vindication, the right to have the court's decision published in three art journals of his choice at the defendant's expense and the court costs.

On the other hand, prior to VARA, artists in the United States have not been notably successful in preventing the circulation and display of their work in altered or distorted form. Carl Andre, for example, lent a work to the Whitney Museum in New York City for its 1976 exhibition, "Two Hundred Years of American Sculpture." Because the work was displayed near a bay window and a fire exit, Andre claimed these distractions distorted it and withdrew it from the exhibition. The Whitney Museum simply substituted another work by Andre from its permanent collection. Andre objected again, this time because

the substitute work had been misinstalled by placing rubber backings under the copper floor pieces. He found, however, that he had no recourse against the owner of the work, whether the owner was a private person or an institution. While Minimal Art may test the understanding of courts, it would seem that an artist in Andre's position today would be likely to be protected by VARA.

A recent case shows the interplay between VARA and state moral rights laws. Philip Pavia, an artist, sued defendants whom he claimed were improperly displaying his sculptural work. The work, titled *The Ides of March* and consisting of four separate parts, had been commissioned for a hotel but was later moved to a warehouse where only two of the four parts were displayed *(Pavia v. 1120 Avenue of the Americas Associates*, 901 F. Supp. 620). The court concluded that the sculpture's four parts formed a single work that would be considered a "work of visual art" and therefore protected by VARA, but that VARA did not give the artist the right to stop post-enactment display of sculptural work mutilated before VARA's enactment. On the other hand, VARA did not preempt the artist's claim under the New York moral rights law for improper display of his sculpture occurring before VARA's effective date and the artist's allegations did state a claim under the New York law. In addition, the three-year limitations period applicable to artist's claims under the New York law commenced to run each day artist's sculpture was improperly displayed in the commercial warehouse, rather than when the sculpture was first disassembled.

Destruction of Art

Prior to VARA, in the United States nothing prevented the owner of an artwork from destroying it completely. For example, in 1937, the muralist Alfred Crimi was selected by competition to create a fresco mural painting thirty-five by twenty-six feet for the Rutgers Presbyterian Church in New York City. The contract stated that the mural would be permanently affixed to the wall and that the church would also own the copyright. In 1938, Crimi completed the mural, but already some members of the congregation objected to it, complaining that the degree to which Christ's chest was exposed emphasized his physical rather than his spiritual qualities. This protesting segment apparently increased

so that in 1946 the mural was painted over in the course of redecorating the church. A black-and-white photograph of the mural is reproduced here.

Crimi sued, demanding that the mural either be restored, removed from the wall at the church's expense and given to him or that he receive an award of damages as compensation. The court held against Crimi, stating, "The time for the artist to have reserved any rights was when he and his attorney participated in the drawing of the contract with the church." *(Crimi v. Rutgers Presbyterian Church*, 194 Misc. 570, 89 N.Y.S. 2d 813) In the view of the

Figure 10. Mural for the Rutgers Presbyterian Church by Alfred Crimi.

court, the mural was merely property and could be destroyed at its owner's whim.

VARA would likely change the result if such a case arose today. If the artist and owner have not signed a written instrument stating that the work may be subject to destruction or mutilation by reason of removal, then the artist would have the right to prevent the mutilation of the work if the artist's reputation would be damaged. The artist would also have the right to prevent total destruction if the work were of recognized quality. With respect to Crimi's mural, there can be little doubt that the work would have been found to be of recognized quality. In addition to protecting art incorporated into buildings, VARA would also protect a privately displayed work from destruction if the work were of recognized quality.

Interview with Alfred Crimi

My interview with Alfred Crimi took place in his studio in Greenwich Village on February 3, 1979. He had contacted me more than a year earlier because of an article I had written on the subject of moral rights for *American Artist*. I stated that, "It is clear that in the United States nothing prevents the owner of an artwork from destroying it completely. For example, in 1937 a mural painter named Alfred Crimi was selected by competition to create a fresco mural painting thirty-five by twenty-six feet for the Rutgers Presbyterian Church in New York City..." Crimi's letter chided me as follows: "I am Alfred Crimi who painted that fresco mural back in 1936, and so you touched a sore spot. [You say], 'for example, in 1936 a mural painter named Alfred Crimi, etc.'-- you made it sound mythical and remote. I gather you are not acquainted with my status in the profession, except for what you have read in the law records. I can understand that. However, some research in the Who's Who might have been appropriate. It behooves me, therefore, to identify and update myself from the remote to the living..."

Alfred Crimi looked far younger than his seventy-eight years. When we met he wore a white gown for painting and was neatly dressed in a black beret, grey flannel trousers, a pinstriped shirt, a sweater, and a bow tie. His manner was vigorous and, in addition to continuing to paint, he was writing his autobiography, which was published in 1987 and titled *A Look Back–A Step Forward* (The Center for

Migration Studies, Staten Island, New York). He explained that he had achieved substantial success as a muralist, but had withdrawn from the world of galleries and dealers in 1959 so that he would not have to be a "peddler" as he pursued his own innovative "multidimensional" style (explained in his book, *The Art of Abstract Dimensional Painting*, published by Grumbacher Library). This withdrawal interested me, since it placed Crimi in the situation of many artists today, whether by choice or not, of pursuing art without connecting it to commerce. Crimi still felt the injustice of what had happened to his mural, and the interview began without my having to ask a question.

CRIMI: ...Most of the traditionalist architects and archaeologists believe that a fresco is not good in the United States. It won't hold out in the weather, in our climatic conditions. This was the challenge for me [in doing the mural at the Rutgers Presbyterian Church].... So I would go every three or four months to check [the mural]. This time I was on vacation, it was right after the war and I spent a whole summer out of town in the country. I came back...and met a friend of mine I hadn't seen in years...

He said, "By the way, do you know such and such a man?"—whose name I don't remember.

"Why, what about him?" I said, "I don't know him."

"Well, he's a member of the Board of Trustees of the Rutgers Church. He wants to know from me what kind of paints you used because they tried to wash it off and it won't come out."

So that put a bug in my head... I went up to Seventy-Second Street [on his way to visit his friend, the sculptor Carl Schmitz, in whose building he hoped to find a studio]. When I got there I decided to get off and I went to the Rutgers Church. For the first time they wouldn't let me in.

CRAWFORD: Who was there?

CRIMI: The sexton.

"I'm sorry, Mr. Crimi," [he said], "We've been given orders not to allow anybody in the church."

I said, "Well, can I see Dr. Russell?"— who was the minister.

He said, "Dr. Russell had retired."

I said, "Well, who is the minister now?"

He said, "Dr. Key."

I said, "Can I see Dr. Key?"

"Well, I'll go upstairs and see."

Dr. Key naturally had to be gracious and receive me. He said, "I'm very sorry, Mr. Crimi, the mural has been painted over."

"What?" I said. I couldn't believe it. "Painted over. What for?"

He said, "Well, the main objection was the nakedness of the chest of Christ."

I said, "You mean to say in the twentieth century they are so prudish? Even if he were naked, you could have called me and advised me and I could have done something about it. But instead you destroyed the mural. It's an offense to me, because you are destroying my name which is there.... May I see the mural?"

He said, "I'm sorry, Mr. Crimi, but we cannot allow anybody there until the decorations are over."

So naturally I went over to him and said, "I want to see under what shroud you buried this corpse."

[Crimi went to see Carl Schmidt. They contacted Dr. Frankfurter, the editor for Art News, who suggested they obtain an injunction to prevent the Church from going ahead with its destruction of the mural. Press coverage was highly favorable to Crimi throughout his struggle to save the mural. Carl Schmitz helped Crimi find a lawyer, Milton Morrison, to take the case.]

CRAWFORD: How did he take the case?

CRIMI: Without any charge. He thought the case was a rare case, an unusual case, and he took it.

CRAWFORD: What was his background as a lawyer? What kind of cases did he usually handle?

CRIMI: I have no idea. I was green myself. I was a babe in the woods, you see. I was grown up but I didn't know anything about legality. And I wasn't looking for trouble so I was unprepared for anything like that...

CRAWFORD: After what has been done to the mural, can it be restored?

CRIMI: I don't know. It might be possible with an oil detergent, but it would be a very delicate operation because of the coat of aluminum bronze.

[Crimi said that the mural itself was to be a last gesture by Dr. Russell as a surprise for the parish before he retired. In discussing the history of how he was chosen to paint the mural, Crimi explained that he won an open competition sponsored by the National Society of Mural Painters in 1936 for the commission to do the mural. After he won the competition, he met all twenty or twenty-five of the Church's Board of Trustees and the five or six members of the Decorations Committee to discuss his sketches for the mural. He pointed to the photograph of the mural as he recapitulated to me his explanation of the mural's imagery.]

...I have a triangle here which is the Trinity. And the all-seeing eye, an old Egyptian symbol that was taken over by the Christians. And this is the Holy Ghost, the dove.

Now there was a lady there, one of the officer's wives. And she said, "Mr. Crimi, is this a Communist symbol?"

[The woman pointed to the all-seeing eye. Crimi told them to look on the Church's baptismal fountain where the same symbol appeared. This demonstration that it was not a Communist symbol cleared the way for his work to begin. But it also showed a bias against the mural that certain of the officers felt from the start of the project. Dr. Russell, who supported Crimi and the mural, wrote on September 18, 1946 to Crimi that:

I did everything in my power to prevent what has happened, but what I could do was practically nothing as the committee took council with no one and none save the committee know even now what is to go on the wall.... I am sorry beyond words that you have been so hurt. I've been hurt quite a lot myself. I try to remember One who said: `Father forgive them for they know not what they do.'" [Dr. Russell died of a heart attack three months after writing this letter.]

CRIMI: When I went back to the Church with my lawyer, we had a meeting with their lawyer. Their lawyer must have been an Irish Catholic. He didn't know anything about it. He said, "Mr. Crimi, what is the problem?" And I told him that I was told that because of the nakedness of the chest of Christ, they had destroyed the mural. He said, "Oh, no, Mr. Crimi, that isn't it. If you know the background of the Presbyterians, they don't believe in murals."

"The Presbyterians wanted the mural," [I replied], "Why don't they believe in it now?

This is a contradiction."

Then Mr. Etherington, the culprit [the President of the Board of Trustees], came to the rescue and he said, "Mr. Crimi, that isn't it. To be honest, Dr. Key said that the mural interfered with his work during services."

CRAWFORD: How could it have done that?

CRIMI: He was a poor speaker to begin with and the acoustics were not so very good.... So that the people were looking at the mural instead of listening to his sermons.... Now, when we sued, we didn't sue for money. We sued for moral rights.... Eventually we also had to sue for money. That's as far as the Church controversy got until we went to court.

CRAWFORD: There were no more negotiations? In other words, it has been painted over and after your meeting with the Church's lawyer you had to sue?

CRIMI: That's right...

CRAWFORD: Were you represented by a lawyer when you signed the contract to do the mural in 1936?

CRIMI: I had no lawyer, the Church had a lawyer when the contract was signed. And he really manifested the prejudice that had already been created. [Crimi's statement contradicts the court's decision referring to Crimi "and his attorney." I checked this important point again with Crimi who assured me that he did not have a lawyer represent him when he signed the contract.]

CRAWFORD: How would you describe the nature of the congregation in 1936?

CRIMI: Hypocritical...

CRAWFORD: These were well-to-do people?

CRIMI: Yes...

CRAWFORD: Can you describe the trial?

CRIMI: The judge was retired and they called him in for this case. The judge was very much interested in this case. And he was like a young boy. He got up from the bench and he came down and he fed the slides into the projector himself. I could see that his attitude was all for the artist. At the end...he asked the two lawyers to come into his chambers. In the chambers he told the lawyers to come to some settlement. If the judge said, "Come to some settlement," he must have seen that I had some rights to be settled, otherwise he wouldn't have said it. But the other lawyer stuck to the letter of the law. He didn't have any compassion for the artist at all. And I

think this is a damnation throughout the history of art in America and will continue to be.

CRAWFORD: So there were no settlement offers made at any time?

CRIMI: None. Then I got disgusted. You see, we didn't believe it would ever go on the calendar at all, because my lawyer knew the law.... Our intention was to create enough publicity that...it would get support... [After losing the case, Crimi said that he couldn't appeal because he had no money and didn't feel he could ask the lawyer to continue working for free.]

CRAWFORD: But you wanted to present a bill in Washington?

CRIMI: Yes, we wanted to do that.... It was my own experience. I thought there should be a bill for the profession...and I believe there should be a bill for the profession on the inheritance tax...but I'm sort of a loner. I don't participate anymore, since the 1950s. In 1959 I withdrew from the rat race on Madison Avenue. I haven't given a one-man show on Madison Avenue since 1959.

CRAWFORD: What prompted you to make that decision?

CRIMI: Because I know that they're a bunch of crooks. They are opportunists. They treat an artist like a peddler. An artist is not a peddler, he's someone who anticipates the future...

CRAWFORD: When you withdrew from the art world, did you feel a kind of freedom?

CRIMI: Yes, because I've been painting to please myself. I never paint a picture on commission, unless it's a mural. I never paint to sell. My paintings are good or bad or indifferent. They are an expression of myself. I believe it's a sincere expression. It's not for the public to judge...

CRAWFORD: In 1946, when you found out what was going on, did other artists rally to support you?

CRIMI: In the beginning, some of them did.

[Crimi relates that the Salmagundi Club membership wanted to support him, but were dissuaded by a lawyer member. Instead of taking a moral position, they followed the lawyer's strictly legalistic conclusion that Crimi had no chance to win in court. At the beginning, he received support from the National Society of Mural Painters, but they withdrew their backing from fear of preventing other churches from having murals

painted. After this support ended, the National Sculptors Society and other artists' groups also fell silent. Only the editors of the arts magazines gave unstinting support to Crimi throughout his struggle.]

CRAWFORD: What happened after the lawsuit was over and the publicity had quieted down?

CRIMI: Every now and then there was an article...on artist's rights... But I was glad that I did sue them, because if I hadn't I would never touch a brush again. I was so frustrated...

CRAWFORD: What do you feel is the lesson for people, artists today, who are thinking about moral rights and these kinds of issues to draw from your own experience?

CRIMI: I blame the artists because they're not willing to fight for their rights.

In November, 1988, the newsletter of the Rutgers Presbyterian Church ran a lengthy article about the dispute and excerpted from one of my essays about its battle with Crimi. The article, accompanied by photographs of the mural and Alfred Crimi, concluded, "Was it really only a 'tempest in a teapot' or a valid moral rights case? You be the judge." If this was some vindication of Crimi and his mural, the best vindication was to come in 1991 with the passage of VARA. Crimi had testified in favor of both the New York State moral rights law and the federal legislation that ultimately became VARA. Senator Kennedy praised Crimi, a courageous pioneer whose legal struggle helped point the way toward the legislation needed to improve the rights of artists.

A Test of VARA

The protections offered artists by VARA with respect to the destruction of art were the focus of *Carter et. al. v. Helmsley-Spear* (71 F.3d 77, *cert. denied*, 517 U.S. 1208). Three artists worked under contract to create an environmental sculpture permanently affixed to the defendant's building. When the defendant decided that it wanted to remove or destroy the art, the artists brought a lawsuit seeking a preliminary injunction to project the work.

In creating the art the artists worked under contract with the defendant, though the defendant argued that the artists had done work-for-hire. In support of this, the defendant offered proof that it "provided plaintiffs

with some tools, required that plaintiffs work on the Work for a minimum number of hours weekly, paid plaintiffs via a weekly check, paid some of plaintiff's assistants, provided plaintiffs with some health insurance benefits for a portion of the time they worked on the Work, and withheld taxes from weekly checks issued to plaintiffs." However, while the federal District Court concluded that the work was not for hire, the Court of Appeals for the Second Circuit reversed due to its determination that the defendant had correctly defined the relationship as work for hire. While this narrow determination removed the art from the protection of VARA, it is worthwhile to follow the reasoning of the District Court since such reasoning is likely to apply to similar cases in the future when the artists are clearly not employees of the commissioning party.

The district court made a factual finding that the art was installed in the building in such a way that it would be destroyed if it were removed. This led to the issue of whether the art was a work of recognized stature under VARA, and whether its destruction would be prejudicial to the honor or reputation of the artists. Several experts testified in the artists' favor on these points, leading the court to decide that serious issues existed that would make the artists' claims worthy of being litigated. The existence of such serious issues is a threshold test in the granting of a preliminary injunction.

Next the court concluded that defendant's arguments against the constitutionality of VARA—primarily on the ground that VARA allows an unconstitutional taking of property interests—were not likely to succeed. So the court granted a preliminary injunction to the artists to prevent the destruction or removal of the art.

However, the decision of the Court of Appeals makes the reasoning of the district court merely instructive rather than dispositive. Barring subsequent appeals by the artists, it appears that a landmark interpretation of VARA will have to wait for a future case.

Two interesting cases have been decided in the wake of the *Carter* decision. In *Martin v. City of Indianapolis* (982 F. Supp. 625), the Court found a violation of VARA when the city contracted to have a stainless steel sculpture destroyed after acquiring the land on which it was located. Because the art was created on the artist's own time as a personal

project, the Court determined that the sculpture was not work for hire subject to exclusion from the protection of VARA. The Court also held that, although the sculpture was completed four years before VARA became effective, it was still protected because the artist established that he maintained title during the time between completion and enactment of VARA and beyond the effective date of VARA.

In the second case, *English v. BFC & R East 11ᵗʰ Street LLC* (1997 WL 746444), a group of six artists had created artwork in a community garden on East 11ᵗʰ Street in New York City. The artwork consisted of approximately five murals and five sculptures that the artists saw as a single work of art. The artists described the garden as "a large environmental sculpture encompassing the entire site and comprised of thematically interrelated paintings, murals, and individual sculptures of concrete, stone, wood, metal, and plants." The lot, however, was owned by the City and was sold for development in May of 1997. The artists, hoping to stop the development and protect the sculpture garden, brought this action.

The Court, in refusing to extend VARA's protection to the works in question, held that moral rights encompasses two specific rights: integrity and attribution. Integrity is at issue here because the critical determination is whether the Garden in question should be conceived as a single work of visual art, hence falling within the scope of VARA, or whether each mural and sculpture should be seen as an independent work and therefore not fall within VARA's scope, as each work could be moved without being physically destroyed or mutilated. The Court held the works to be independent and therefore not protected under VARA. Perhaps most importantly, the Court held that VARA does not apply to artwork that is illegally placed on the property of others without their consent, when such artwork cannot be removed from the site in question.

Yet, even when an artist creates work at the behest of a property owner, courts are reluctant to treat the location of the work as inherent to the overall integrity of the art. In other words, relocating a sculpture or mural does not trigger VARA protections, even if the artist insists that the location is essential to appreciating the work. One case that illustrates this point is *Phillips v. Pembroke Real Estate* (459 F.3d 128). In that case, David Phillips, a sculptor well known for his "environmental" sculpture, tried to prevent a developer from moving his artwork. Phillips's sculptures were part of Boston's Eastport Park, and were deeply interwoven into the overall layout and structure of that park. In 2003, Pembroke Real Estate sought to totally redesign the park layout, and their plans called for moving a number of Phillips's sculptures. Phillips sought an injunction, arguing that the location of the sculptures was an important element of the overall work, and that any attempt to shift or move the pieces would violate his rights of artistic integrity as protected by VARA. The court of appeals rejected this argument, however, holding that VARA did not protect the "site specific" quality of a particular work. Similarly, the Massachusetts State Court also held that Massachusetts' moral rights protections did not protect the site-specific character of an artist's work. These holdings reaffirm a pre-VARA decision in which a separate federal appellate court refused to recognize any right to artistic integrity in the particular location of an "environmental" sculpture. *See Serra v. United States General Administration*, 847 F.2d 1045 (2d Cir. 1988). Hence, while VARA may protect individual, standalone pieces from mutilation, alteration, or destruction, it does *not* protect the artist's right to have those works remain in any particular place.

Right of Disclosure

In France, the moral right of disclosure gives the artist sole power to determine when a work is completed and ready to be disclosed to the public. This has led to some interesting decisions in French courts. In the Whistler case in 1900, the artist was dissatisfied with a portrait he had done on commission. Lord Eden, who had commissioned the portrait, was satisfied and demanded delivery of the work. Application of the right of disclosure gave Whistler the right not to deliver the work until such time as he considered the work completed, despite the fact that the work had been publicly exhibited. The Camoin case in 1931 involved a painter who had slashed and discarded several canvases. The slashed canvases were found and restored by another person who sought to sell the works. The painter intervened, based upon his right of disclosure, and the French court seized and destroyed the canvases in accordance with the artist's original intent.

The Rouault case in 1947 was a dispute between the artist and the heirs of the artist's dealer. The artist had left 806 unfinished canvases in a studio in a gallery of the dealer. Rouault, who had a key to the room and would occasionally work on the paintings, had agreed to turn over all his work as created to the dealer. The dealer died and the heirs of the dealer claimed to own the 806 works. The court held that Rouault owned the works, because the right of disclosure required the artist himself determine the work to be completed before any disclosure of the work to the public by sale could occur. Any agreement to the contrary would be invalid. Finally, the Bonnard case ultimately resolved that paintings only become community property upon completion to the artist's satisfaction. The estate of an artist's wife would, therefore, have no right in works the artist had chosen not to disclose. The right of disclosure, like the other moral rights, was enacted as legislation in France on March 11, 1957.

VARA does not deal with the moral right of disclosure. While it may be argued that our copyright laws provide similar protection, it is not clear that copyright or other laws would, for example, protect unfinished artworks from the demands of a bankrupt artist's creditors or from a spouse in divorce proceedings in a community property state.

Duration and Enforcement

Moral rights in a country such as France are perpetual. If the moral rights are perpetual, the question arises who will enforce such rights after the artist's death. In France, the right of disclosure is enforced by the artist's executors, descendants, spouse, other heirs, general legatees and finally by the courts. The rights of attribution and integrity can be transmitted to heirs or third parties under the artist's will for enforcement.

VARA is an amendment to the copyright law, which provides for damages, injunctions, court costs, and attorney's fees if a copyright infringement claim is successfully prosecuted. However, the criminal penalties that can be visited upon a copyright infringement defendant are not available to punish those who violate an artist's moral rights. VARA also provides that copyright registration need not be made by an artist in order to bring a lawsuit for the violation of moral rights. In addition, registration prior to the violation is not required for the artist to be eligible for an award of attorney's fees or statutory damages in a moral rights case.

State Moral Rights Laws

Prior to the enactment of VARA, a number of states pioneered by enacting their own moral rights statutes. While the copyright law preempts state laws that cover the same subject matter, certain aspects of the state laws that are beyond the scope of VARA will presumably be found to remain in force. There are now eleven states with moral rights laws in force: California, Connecticut, Massachusetts, Louisiana, Maine, Nevada, New Jersey, Mew Mexico, New York, Pennsylvania and Rhode Island. Utah has enacted moral rights for works commissioned under its percent-for-art law. These state laws tend to be modeled on either the moral rights laws in California or New York.

Moral Rights in California

Former State Senator Alan Sieroty acted as a great friend to artists in California. He sponsored almost all of the art legislation that has made California the preeminent state in protecting its artists. His sagacity and concern for the artist is evidenced by the Art Preservation Act that he guided to passage in 1979 and which took effect on January 1, 1980.

The law protects, "...an original painting, sculpture, or drawing, or an original work of art in glass, of recognized quality, but shall not include work prepared under contract for commercial use by its purchaser." The fine artist is protected by this law, but the commercial artist is not. Under the California law, art is recognized to have quality based "...on the opinions of artists, art dealers, collectors of fine art, curators of art museums, and other persons involved with the creation or marketing of fine art." Presumably a similar determination will be made as to recognized quality for purposes of VARA.

California does not focus its protection on the artist, but protects art of a certain quality. Thus, the law does not necessarily connect the artist to his or her art, but instead preserves for society certain pieces of art that have an agreed- upon significance.

Only an artist may alter, deface or destroy his or her art (provided, of course, that not even the artist may do this unless he or she owns the art). The artist retains, "...at all times the right to claim authorship, or, for a just and valid reason,

to disclaim authorship of his or her work of fine art." However, the California law allows the artist to waive these moral rights by an express written instrument signed by the artist.

The protections in the law last for the artist's life plus fifty years. After the artist's death, these rights may be enforced by the artist's heir, legatee or personal representative. (such as an executor or administrator).

A special provision of the law deals with art affixed to buildings. If the owner of the building intends to remove art that can be removed without substantial harm, the artist has rights to the art if the owner intends to alter, deface or destroy it. In such a case, the owner would have to make a diligent effort to give notice or actually give written notice of the planned removal to the artist or the artist's successor-in-interest. If the artist fails within ninety days of receipt of notice to remove the art at the artist's own expense, the owner may alter, deface or destroy it. An artist who removes or pays to remove art from a building in this situation becomes the owner of the art.

On the other hand, if substantial harm will of necessity be caused to the art by its removal, the artist must obtain a written instrument signed by the owner of the building and providing for the protection of the art. This instrument must be recorded, presumably in a registry where other real estate documents such as deeds would be recorded, in order to be binding. Otherwise the artist will have no rights in the art and it may be destroyed by the owner.

An action under the law must be brought within the longer of either three years from the act complained of, or one year from the artist's discovering that act.

The artist's remedies include injunctive relief, actual damages, punitive damages, reasonable attorneys' and expert witness fees and such other relief as the court considers appropriate. Since punitive damages are awarded to punish wrongful acts rather than compensate the artist, any punitive damages awarded under the law are paid to an organization selected by the court to be used for charitable or educational activities involving the arts in California.

The California law appears to be pre-empted in large part by VARA. However, a crucial aspect that ought not be preempted is the extra fifty years of protection afforded by the California law, since its term is life plus fifty years while VARA's term is, in general, only the life of the artist. It is instructive to contrast the provisions of the California law with those of the New York law described in the next section.

Moral Rights in New York

On January 1, 1984, a landmark law benefiting artists took effect in New York State. Due to the passage of VARA, an issue now exists as to whether or to what degree the New York law may have been pre-empted by the passage of VARA. One case, *Board of Managers of Soho International Arts Condominium* v. *City of New York* (2003 WL 21403333), held that the New York law is pre-empted, but this decision is controversial. For VARA to pre-empt a state moral rights law, the rights granted in that law must be the same or equivalent to the rights granted in VARA. As the court observed in the *Pavia* case, "[W]hether the rights conferred by VARA are equivalent to those of [New York's moral rights statute] will occupy courts for years to come." In view of this, it is interesting to explore the history and scope of the New York law, especially the ways in which the statute is more extensive than VARA and therefore should not be pre-empted. The following discussion assumes that at least some parts of the New York law are not pre-empted.

Sponsored by Assembly Majority Leader Richard Gottfried and known as the Artists' Authorship Rights Act, this law entitles artists to name credit when their work is displayed or reproduced and protects artists against alterations or mutilations of their work (but not against complete destruction). Working closely together, the Assembly's Committee on Tourism, Arts and Sports Development, the Graphic Artists Guild, and the American Society of Magazine Photographers brought about the passage of the law. As the main author (along with Wendy Feuer of the Committee's staff) of the original draft of the New York bill, I sought to broaden the scope of protection to include reproductions of art, photography, and design, even if these reproductions were prepared under a contract for commercial use. After much lobbying and numerous revisions, the New York law protects "any original work of visual or graphic art of any medium," including reproductions of such art. However, the law does not protect works prepared under contract for advertising or trade use. Thus, the art or photography for a point of purchase display

or product packaging would not be protected. Art prepared for magazines, books, and other public interest uses would be covered.

No one, other than the artist or a person acting with the artist's permission, may publish or display an original work or a reproduction in an altered or defaced form if damage to the artist's reputation is reasonably likely to occur. If a violation takes place, the artist has the right to have his or her name removed from the work. If a work is published without the artist's name, the artist has the right to insist that his or her name accompany the work.

By protecting the reputation of the artist, the law protects the integrity of the art itself. Cropping for publication will undoubtedly become an issue. Is the cropping done in such a way that damage to the artist's reputation is reasonably likely to result? This test is flexible, so that unobjectionable cropping can continue. However, if a user fears that cropping or other alteration might damage the artist's reputation, it would be best to obtain permission from the artist for the form of the image to be disseminated. Other changes in the art, such as additions or deletions to the image, may risk violating the law and require the precaution of obtaining the artist's consent.

The law's name credit provisions would have affected the result of the famous *Esquire v. Vargas* case. Under the law in New York, Vargas would have had a much better chance to win his case. The law does not appear to permit a waiver by the artist of the right to claim or disclaim authorship credit, since it states, "...the artist shall retain at all times the right to claim authorship or, for just and valid reasons, to disclaim authorship of his or her work of fine art."

A limitation in the law provides that, "a change that is an ordinary result of the medium of reproduction does not by itself create a violation..." For example, a reproduction of a painting that appears in a magazine will not be identical to the painting itself, but the law will not be violated if the alterations are those that ordinarily accompany such a change of medium. At what point changes are no longer "ordinary" will have to be decided on a case-by-case basis.

The law does not apply unless a work is "knowingly displayed in a place accessible to the public, published or reproduced in this state." The work must be made public before a violation occurs. A painting defaced in a private home or an unprinted template or layout file containing an altered image are not violations until the work reaches the public. Also, a person who does not know an image has been altered will not be liable for making it public, since the violation would not have been done "knowingly."

The law applies to any work published or displayed in New York. However, the true impact of the law is national. Since most published works eventually are sold in New York, the law will undoubtedly affect publishers in other states. Compliance with the law will be a necessity for publishers who plan to market in New York.

For original art, conservation is not a violation of the law unless it is done negligently. Also, changes caused to originals by "the passage of time or the inherent nature of the materials" will not be a violation of the law, unless such changes were the result of gross negligence in protecting or maintaining the art. Gross negligence is an intentional failure to perform a required duty with utter disregard for the consequences.

The protection of the law lasts for the artist's lifetime. The right is personal to the artist, who is the only person who may sue to rectify violations. Any lawsuit must be brought within three years after the violation occurs or within one year after the artist should have found out about the violation, if that would be a longer time period.

If an artist's rights have been violated under the law, he or she may sue for damages. The amount of the damages will be based on the nature of the injury suffered. Expert testimony about the significance of a good and growing reputation for success in the field will probably aid in establishing the amount of damages. The law allows for a suit to prevent a potential violation from taking place as well as to prevent any existing violation from continuing.

The New York law is preempted in large part by VARA. However, the New York law protects art in books, magazines, and other public interest uses, while VARA does not extend to published works. So with respect to these and other rights not similar to those protected by VARA, the New York law may continue in force and extend the scope of protection provided by VARA.

The fact that so many states enacted moral rights laws suggests the wisdom of VARA, which will ensure uniformity of treatment (except insofar as some parts of the state statutes are not preempted by VARA). In addition to rights granted by VARA, the artist in the United States can also seek additional protection by the use of avenues such as unfair competition, trademarks, trade dress, the right to privacy, protection against defamation, the right to publicity, and patents. Each of these is considered separately in the next chapter.

CHAPTER

8 OTHER PROTECTIONS FOR ARTISTS

Protections in addition to the Visual Artists Rights Act ("VARA") discussed in chapter 7 are especially important for artists whose work will not be covered by VARA, so the other protections reviewed in this chapter are germane to many artists and a vast body of art. Often these protections will overlap one another, so a lawsuit may rely on a variety of them as well as asking for relief under the copyright law.

Unfair Competition

"The essence of an unfair competition claim is that the defendant assembled a product which bears so striking a resemblance to the plaintiff's product that the public will be confused as to the identity of the products.... The test is whether persons exercising 'reasonable intelligence and discrimination' would be taken in by the similarity." (*Shaw v. Time-Life Records*, 38 N.Y. 2d 201)

The application of the theory of unfair competition can be even broader than this definition indicates. In proper factual situations, it can prevent the artist from being presented as the creator of works the artist in fact did not create; prevent the artist from being presented as the creator of distorted versions of the artist's own works; prevent another person from claiming to have created works in fact created by the artist; protect titles which, although not usually copyrightable, may become so well recognized that use of the title again (such as *Gone With the Wind*) would create confusion of the new work with the original work; and generally prevent the competitors of an artist from confusing the public to benefit unfairly from the reputation for quality of the artist's work. Thus, although copyright does not protect an artist's style, copying style may in some cases prove to be unfair competition.

An example of the application of the theory of unfair competition involved the "Mutt and Jeff" comic strip, which the cartoonist first sold to a San Francisco newspaper and then to a New York City newspaper. When the cartoonist signed an exclusive agreement with the San Francisco newspaper, the newspaper in New York City hired another cartoonist for a competitive "Mutt and Jeff" strip. However, the court stated, "No person should be permitted to pass off as his own the thoughts and works of another," and granted an injunction to prevent the New York City newspaper from continuing to produce a "Mutt and Jeff" comic strip. (*Fisher v. Star Co.*, 231 N.Y. 414, *cert. denied* 257 U.S. 654)

Trademarks and Trade Names

A trademark is a distinctive motto, symbol, emblem, device or mark that a manufacturer places on a product to distinguish in the public mind that product from the products of rival manufacturers. Trademarks are usually registered with the Patent Office for federal protection and with the appropriate state office for state protection, although even an unregistered mark can have protection under the common law. An artist who is exploiting work commercially—for example, posters, jewelry or clothing—might wish to seek trademark protection for a distinctive logo or motto. Also, the artist would wish to be certain that any chosen trademark did not infringe an already registered trademark in commercial use.

A trademark can be licensed, as long as the artist giving the license ensures that the quality of goods created by the licensee will be of the same quality that the public associates with the

trademark. Trademarks are entitled to protection in foreign countries under treaties executed by the United States. The effect of having a trademark is like unfair competition in that others are prevented from using the trademark where confusion to the public would result. While trademarks are used for products, or in some cases for services, the artist should at least be aware of the existence of this type of protection.

An important revision of the trademark law took effect on November 16, 1989. Trademarks may now be registered before use, whereas previously they could only be registered after use. The application must include a bona fide "intent to use" statement. Every six months an "intent to use" statement must be filed again and additional fees paid, and in no event can such a preregistration period exceed three years.

Trade names are closely related to trademarks. Such a name may not technically be a trademark (because it is not affixed to marketed goods or is not capable of exclusive use by anyone), but may designate a particular business establishment, the location of a business or a class of goods. Artists operating under a trade or fictitious name should register the name with the local authority in charge of registration (such as the county clerk). Partnerships will also be required to make such a registration. In this way, a record exists of the names under which a business is being conducted. The registration fee is not expensive, and failure to obtain a certificate of registration may make it impossible to open a bank account and, in some cases, may foreclose the exercise of certain legal rights. When a business operating under a dba (doing business as) name ceases, a certificate of discontinuance may be filed with the local authority.

Occasionally artists wish to include a trademark in an artwork. For example, an artist may paint a street scene that includes a sign with a company logo. Use of the trademark in this way should not be a problem for the artist, except in the unlikely case in which the public might be confused by the painting and imagine it was created by or was a product of the company depicted in the painting.

Trade Dress

Trade dress has special relevance for designers and other artists who create the look of products for sale to consumers. Trade dress claims arise under section 43(a) of the Lanham Act, a federal statute. A leading case, *Hartford House Ltd. v. Hallmark Cards* (647 F. Supp. 1533), shows the criteria for evaluating whether a claim for trade dress is likely to succeed. Hartford House, doing business under the name Blue Mountain Arts, created enormously successful lines of greeting cards intended to express strong emotions. Their major lines, Airebrush Feelings and Watercolor Feelings, came on the market in 1981 and 1983, respectively. Hallmark created its own Personal Touch line of cards to blunt Blue Mountain's market penetration, but failed at first. In 1986, Hallmark redesigned the Personal Touch line to be so similar to Airebrush Feelings and Watercolor Feelings that Blue Mountain commenced legal action.

The court pointed out that a plaintiff has to prove three elements to win a trade dress claim:

1) That the features of the trade dress are primarily non-functional; 2) That the trade dress has secondary meaning; and 3) That the competing products' respective trade dresses are confusingly similar, thus giving rise to a likelihood of confusion among consumers as to their sources.

Non-functionality applies to the design, not to the card. On this point the court decided the design was non-functional, stating, "A non-functional feature is one whose primary value is to identify the source of the particular goods or services.... the Airebrush and Watercolor Feelings cards have an inherently distinctive and recognizable look attributable to their source, Blue Mountain."

Next the plaintiff has show "that the Airebrush and Watercolor Feelings 'look' possesses a secondary meaning. To establish secondary meaning, a manufacturer must show that, in the minds of the public, the primary significance of a product's feature is to identify the product's source rather than the product itself." Adding that distinctive trade dress is proof of secondary meaning, the court found the Blue Mountain cards sufficiently distinctive to establish secondary meaning, especially in view of Hallmark's internal memoranda showing that Hallmark considered the trade dress of the card designs to be highly distinctive.

The final factor is the likelihood of public confusion due to the similarity of the trade dress. Here a variety of factors

are considered, including "(1) similarity of products, (2) identity of retail outlets and purchasers, (3) identity of advertising media, (4) strength of trade dress, (5) defendant's intent, (6) similarity of design, (7) presence of actual confusion, (8) degree of care likely to be exercised by purchasers, and (9) other evidence showing that consumers are likely to be confused." All of these factors were against Hallmark, especially in view of two consumer surveys showing that seventy to 80 percent of consumers confused the Blue Mountain and Hallmark cards.

Most trade dress cases involve a request by the plaintiff for a preliminary injunction to stop the other party from continuing to distribute the competing product while the trade dress lawsuit is litigated. The court looks to four factors in deciding whether to grant a preliminary injunction: (1) whether the plaintiff is likely to win the case; (2) whether not giving the injunction will cause irreparable injury to the plaintiff; (3) whether the damage to the plaintiff if the injunction is not given outweighs the damage to the defendant if the injunction is given; and (4) that the injunction is not against the public interest. Applying these factors, the court issued the preliminary injunction against Hallmark Cards.

Similarity between book covers has given rise to interesting trade dress cases. In one case, Harlequin Enterprises, the largest publisher of paperback romances in the world, sued to stop Simon and Schuster from publishing a Silhouette Romance series. Simon and Schuster had been Harlequin's distributor and, after the distribution arrangement was terminated, Simon and Schuster started the Silhouette Romance series. The court concluded that the Harlequin romances had acquired secondary meaning and that public confusion was likely to result from the sale of the Silhouette Romance series. In issuing a preliminary injunction, the court noted:

Moreover, the substantial similarity between the "Silhouette Romance" and "Harlequin Presents" covers noted above did not result from accident or inadvertence. A Simon and Schuster executive appears to have selected the cover design now in use from some twenty cover designs proffered by the Art Director, many of which would have unquestionably been non-infringing. Indeed, the one selected appears to have been that which most closely resembles the "Harlequin Present" cover. (Harlequin Enterprises Limited v. Gulf and Western Corporation, 503 F. Supp. 647, aff'd 644 F.2d 946)

Another trade dress case involving book covers added a novel element to the defense: that the intentional similarity should be allowed because it was intended as parody. In *Cliff's Notes, Inc. v. Bantam Doubleday Dell Publishing Group* (718 F. Supp. 1159), *Spy Magazine* created Spy Notes, which sought to parody some popular urban novels of the 1980s. Spy Notes admittedly was designed to look like Cliff's Notes, which are a line of study guides. So Spy Notes copied from Cliff's Notes the yellow and black diagonal stripes, the format and type style of the titles, and a picture of a clay model that is in the lower right hand corner.

The trial court issued a preliminary injunction against Spy Notes on the grounds that public confusion was likely to ensue as to whether Cliff's Notes might be the source of Spy Notes. "Parodies, as a form of political, social or artistic impression, generally enjoy the protections of the free speech clause of the first amendment," the court stated, adding that "While it is true that trademarks may be parodied, the Court disagrees with defendant's general theory that the first amendment gives the parodist unbridled freedom to use a registered trademark as part of a parody or satire." The court concluded that the defendant had copied the cover in order to sell more of its own product, rather than copying only enough to evoke that cover in the consumer's mind as a necessary step in doing parody.

The decision was vacated on appeal, however, with the Court of Appeals for the Second Circuit ruling that the public interest in free expression outweighed the risk of consumer confusion presented in the case.

Another trade dress case involved a calendar manufacturer who selected twelve images created by Andy Warhol to make into a calendar., Neither the Warhol estate nor Warhol's Foundation for the Visual Arts owned copyrights to the images used, but they nonetheless sought a preliminary injunction based on a trade dress violation. However, the court pointed out that there "is no such thing as property in a trademark except as a right appurtenant to an

established business or trade in connection with which the mark is employed..." *Hughes v. Design Look, Inc.*, 693 F.Supp 1500 (S.D.N.Y. 1988). While no one questioned that Warhol created the images, the court said the proper test for plaintiffs to prevail was "not that these images have come to signify Andy Warhol as the artist, but plaintiffs as the source of the product—the calendars." Since plaintiffs produced no similar products, they could not show that they possessed a product with trade dress that had acquired secondary meaning.

The plaintiffs had, at most, a desire to produce calendars in the future, so no public confusion could develop from the immediate circulation of the defendant's calendar. In addition, the defendants proposed to include the following disclaimer with their calendar: "Neither Andy Warhol, the Estate of Andy Warhol, Andy Warhol's Foundation for the Visual Arts, nor Andy Warhol Enterprises, Inc., are the origin or source of the Design Look Pop Art calendar, nor have they sponsored, sanctioned, or approved its publication." Based on all these considerations, the court refused to issue a preliminary injunction and the defendant was allowed to distribute its Warhol calendar.

Protection for Domain Names

Internet domain names have become important properties as the Internet has become a prominent vehicle for marketing and for generally disseminating information. The success of any Internet venture depends, in no small part, upon obtaining a domain name that effectively represents a given company, individual, group, or business activity to hundreds of millions of Internet users worldwide. Indeed, many Internet entrepreneurs have discovered that even the most fanciful of domain names may nonetheless be catchy or memorable enough to creep into the consciousness of the Internet using public. Sometimes, a nascent company's identity may itself emerge from the original domain name under which its founders conducted Internet based activities.

A domain name itself is nothing more than a combination of letters that is associated, through a Domain Name Server (DNS), to a numerical Internet Protocol (IP) address. IP addresses are unique, assigned to a single Internet-enabled computer at any given time. Domain names act as a proxy for arcane IP addresses, making it easier for Internet users to access content hosted on remote computers. For example, a web-surfer looking to access a news website, such as *The New York Times*, could simply type in *www.nytimes.com*, rather than memorize the multi-digit IP address of the server hosting the site.

A domain name can be registered through any of a number of private registration companies, the largest of which is *www.godaddy.com*. Most registrars will ask for the registrant's actual name, billing information, and Domain Name Server (DNS) settings. Registrants should beware of unscrupulous registrars that do not require registrant information; these companies often grant paying customers administrative access to a domain name, but take title and possession of the domain itself. Where this occurs, it is often difficult for registrants to wrest control of domains they had paid for from a recalcitrant registrar.

Unregistered names can be "rented" for a one-year term, after which they lapse back into the public space. Most registrars offer multi-year purchase options, wherein the registrar automatically re-registers a given domain name before it lapses.

In an effort to stem the inevitable confusion that could result from multiple private registrars assigning domain names all over the globe, the Internet Corporation for Assigned Names and Numbers (ICANN, or *www.icann.com*) was formed in 1998. This not-for-profit corporation regulates how domain names are assigned, in effect ensuring that every combination of domain name and DNS addressing is unique.

ICANN is one product of a world where just about everyone recognizes the importance of having a distinct and recognizable Internet presence. However, in the early days of Internet, some companies were slow to recognize the significance of the World Wide Web as a business tool. This significance was not lost upon many domain name "speculators," who realized that these descriptive virtual addresses could become quite valuable as Internet use expanded. Speculators, or "cybersquatters," registered certain domain names, believing that a company or organization might pay a substantial sum to acquire that domain name in the future. Such cybsersquatters would usually purchase domain names that either contained certain trademarks, or bore a

striking resemblance to existing trademarks. Cybersquatters would sit on domain name properties, and later charge handsomely to sell them to organizations that had come to realize a domain name's commercial value.

Cybersquatting soon became the target of federal legislation. In 1999, Congress passed the Anticybersquatting Consumer Protection Act. (15 U.S.C. § 1125(d)). The law requires a cybserquatter to surrender any domain name that, at the time it was registered, contained or could be confused with a trademark, famous mark, or distinctive mark, including personal names. The party seeking to dislodge a cybersquatter must prove that the registrant had a bad-faith motive to profit from the domain. A number of factors are considered in determining bad faith, including whether the registrant had any legitimate relationship to the domain name, the registrant's use of the domain name, and the extent to which the domain name actually contains a trademark, famous mark, or other protected intellectual property.

An early case leveraging this law was *People for the Ethical Treatment of Animals* (PETA) *v. Doughney*, wherein PETA was able to force Michael Doughney to relinquish the domain name *www.peta.org*. (263 F.3d 359) In 1995, Michael Doughney registered this domain, and operated a site entitled "People Eating Tasty Animals." Contrary to PETA's more compassionate view towards animals, Doughney's site was "a resource for those who enjoy eating meat, wearing fur and leather, hunting, and the fruits of scientific research." PETA first sought a voluntary transfer of the domain name in 1996, and then sued for, among other things, trademark infringement and cybersquatting. The District Court granted PETA's request, forcing a transfer of the domain name from Doughney to PETA.

Though parties have enjoyed some success in using the courts to dislodge cybersquatters, federal court litigation is an expensive, time-consuming process. Moreover, it cannot reach cybersquatters operating outside the jurisdiction of American courts. A less costly and farther-reaching alternative is ICANN's Uniform Dispute Resolution Procedure (UDRP). Complainants looking to dislodge a cybersquatter (Respondent) may file an electronic complaint against the squatter through one of ICANN's pre-approved "dispute resolution service providers," listed at www.icann.org/ udrp/approved-providers.htm. The complaint must state (1) the manner in which the domain name(s) is/are identical or confusingly similar to a trademark or service mark in which the Complainant has rights; and (2) why the Respondent (domain-name holder) should be considered as having no rights or legitimate interests in respect of the domain name(s) that is/are the subject of the complaint; and (3) why the domain name(s) should be considered as having been registered and being used in bad faith. These proceedings only rarely require oral hearings; they are typically decided by panels of one or three arbitrators. Further details on the expedited UDRP can be found on ICANN's website, at *www.icann.org/en/dndr/udrp/uni-form-rules.htm.*

Right to Privacy

The right to privacy is the right to be free from unwanted and unnecessary publicity, or from interference that could injure the personal feelings of the artist or present the artist in a false light before the public. The right is recognized in varying forms by almost every state. New York's Civil Rights Law Section 50, for example, prohibits using "for advertising purposes, or for the purposes of trade, the name, portrait or picture of any living person without having first obtained the written consent of such person." Under Section 51, however, this right is specifically not applicable to use of "the name, portrait or picture of any...artist in connection with his...artistic productions which he has sold or disposed of with such name, portrait or picture used in connection therewith."

The right to privacy is personal, which means that only the living artist may use it, not assignees or heirs. The right to privacy diminishes as the artist gains stature as a public figure, particularly as to those areas of the artist's life in which the public has a legitimate interest. The New York statute limits violations to uses for "advertising purposes" or "purposes of trade," but exhibitions of work, especially if by a private collector or a museum, would not appear to be for such uses. In *Neyland v. Home Pattern Company* (65 F.2d 363, *cert. denied* 290 U.S. 661), an artist recovered for invasion of privacy when an unauthorized use of the artist's name accompanied the sale of pillows designed in imitation of the artist's work. But, in *Geisel v. Poynter Products, Inc.* (295 F. Supp. 331), after the artist's sale of all

rights in a cartoon, a magazine was able to use the artist's name in manufacturing and selling dolls based on the cartoon without an invasion of the artist's privacy. While theoretically the right to privacy might be used to protect the artist against distortions of the artist's work, the practical effect of the right to privacy in this area would seem quite limited.

Protection Against Defamation

Defamation is an attack on the reputation of another person. Both libel and slander are forms of defamation, libel being expressed by print, writing, pictures or signs, and slander being expressed by spoken words. For an artist to bring an action for defamation, the defamatory material must have reached the public. Also, the defamatory material must be false, since the truth of the alleged defamatory material will be a defense to a lawsuit based on defamation.

The effect of showing or publishing an artist's work in a distorted form while attributing the work to the artist would be damaging to the artist's reputation. Protection against defamation is, therefore, a possible method for an artist to use in preventing violations of the integrity of the artist's work. Defamation is discussed in more detail on pages 93–94.

Right to Publicity

The right to publicity is a relatively new right independent of the right to privacy. The right of publicity states that a person with a public reputation has the right to benefit from the commercial value associated with that person's name or picture. Sports figures, for example, have the right to financial benefits from the use of their names and pictures on baseball cards or in a baseball game. But the right to publicity will be of little value to the artist who is not famous. Among the states that protect a celebrity's right to control his or her public image are Arizona, California, Georgia, Massachusetts, Missouri, Illinois, Pennsylvania, New Jersey, New York, Tennessee, and Texas.

The right to publicity does not prevent advertising uses of a well-known person's name and picture if such uses are incidental to a legitimate news article. For example, Joe Namath was the subject of many newsworthy articles on football in Sports Illustrated. However, when Sports Illustrated used photographs from the articles to illustrate advertising,

Namath contended that his right to publicity had been violated. The court concluded that the use of the name and photographs of Namath were only uses incidental to establishing the quality and news content of Sports Illustrated. To allow damages might well violate the First Amendment guarantees of freedom of speech and press, so Namath lost the case (*Namath v. Sports Illustrated*, 48 A.D.2d 487, *aff'd* 39 N.Y.2d 897).

In 1984, California enacted a celebrity rights law. A number of other states have followed California's lead. The basic approach of these laws is to protect the publicity rights of deceased people for up to fifty years after their death. This applies to people whose name, voice, signature or likeness had commercial value at the time of death, whether or not that commercial value had been exploited during life. Prohibited uses cover commercial exploitation to sell merchandise or services, including advertising. Typical exemptions from the coverage of the law would include works in the public interest, material of political or newsworthy value, and single and original works of fine art.

These celebrity rights laws impinge on the freedom of expression guaranteed to artists by the First Amendment. Since creative works are likely to be disseminated nationally, it may be that the most restrictive celebrity rights law will govern whether the artist must seek permission from the people to whom the decedent has transferred the celebrity rights or, if no transfer has been made, the heirs of the decedent.

Also, valuable as this right of publicity may be to well-known artists, the right will at present neither protect artists from being denied authorship credit when a contract is silent as to such credit, nor protect artworks from distorting changes.

Patents

Artworks protected by copyright can sometimes also be protected by patent. While a copyright can be obtained for original work, a patent requires a far more difficult test of invention. A utility patent, which might be relevant for some conceptual works, can be obtained for a work that is useful, new and nonobvious to persons skilled in the discipline. A utility patent has a non-renewable term of seventeen years if issued before June 8, 1995.

If the patent issued after this date, it is valid for twenty years following the date the earliest application was filed.

The more common patent protection for artworks would be a design patent, which has a term of fourteen years from the date the patent was issued. Such a patent is granted on an article of manufacture, for example a statue used as a lamp base, if its design is new, original, ornamental and nonobvious. The test for a design patent is whether the object when viewed as a whole by an ordinary observer makes an impression of uniqueness of character.

Unlike copyright protection, which attaches at the moment that the work is fixed in a tangible means of expression, patent protection does not attach until the United States Patent Office grants the patent. Such patents issue only after lengthy requirements are fulfilled, and multiple fees are paid. For this reason patent protection is difficult and expensive to obtain and, for the most part, requires the aid of a patent attorney.

Patent protection prevents others from exploiting the patented article regardless of whether the copying necessary for copyright infringement can be shown. However, patents are not designed to provide protection similar to moral rights. For further information contact the United States Department of Commerce, Patent and Trademark Office, Washington, D.C. 20231.

Protections for Artists

VARA and the state moral rights laws represent an enlightened approach to protecting the reputations of artists and the integrity of their art. However, because of the limitations of VARA and the state moral rights law, artists may seek redress under many different doctrines. While these doctrines do offer protection, there are still substantial risks that the artist may either go unacknowledged as a creator or have no recourse to prevent the alteration or destruction of the artist's work. Only by contract can the artist attempt to create the fullest protection and ensure the satisfaction of all parties. Hence, understanding the benefits of contracts, which are discussed in depth starting with chapter 10, is integral to the artist's success.

9 RISKS IN THE CONTENT AND CREATION OF ART

The First Amendment of the United States Constitution provides guarantees of freedom of expression which apply to artists and their works, but such guarantees are not unlimited. Copyright, patent, trademark, trade dress, the doctrine of unfair competition, the rights of privacy and publicity, and protection from defamation safeguard not only the artist but the artist's competitors as well. Significantly, other private citizens also have rights protecting them from invasion of privacy or defamation, which the artist must consider when creating work. Since violation of the right to publicity is a risk faced by the artist, the discussion of the right to publicity on pages 94–97 should also be reviewed. In addition, the public at large, through law enforcement agencies, may seek to suppress works which are considered either obscene or a desecration of a governmental symbol.

Defamation

Defamation is an attack on a person's reputation by print, writing, pictures or spoken words. The defamatory material must reach the public, since damage to reputation is a requirement for an action for defamation. While the truth of an alleged defamatory statement would be a defense to such an action, the burden of proving truthfulness is on the person who asserts truth as a defense. Generally, everyone who participates in publishing or exhibiting defamatory material will be liable to the defamed person.

The artist who attacks a person's reputation, for example, by representing a person as involved in unethical or criminal conduct, as physically deformed in an unnatural or obscene way, or as lacking manners or intelligence, may face a libel suit. The person defamed need not be mentioned by name, as long as the depiction will be recognizable to those acquainted with the person's reputation.

In a recent case, a painting titled The Mugging of the Muse showed three knife-wielding men about to attack a woman scantily covered by a red garment. Two artists sued, stating they had been depicted as the assassins of the Muse. The court agreed that these two artists were indeed so depicted. However, it concluded that this was not the statement of a false fact, but rather the expression of an opinion protected by the First Amendment. The court stated:

The picture could not be intended, viewed by any reasonable person, as an accusation by defendant that either plaintiff had actually participated in an assault or related crime such as attempted homicide, or had any intention of so doing.... In the context provided by the factual background and the use of the word "Muse," that figure could be representative only of the arts; therefore, the painting states that plaintiffs' artistic beliefs and activities are destructive of the arts. It says nothing more. Far worse commentary is written almost daily by newspaper and magazine critics of every aspect of the arts and is deemed to be no more than an expression of opinion. (Silberman v. Georges, 91 A.D.2d 520)

The artist must be aware of this important distinction between defamation and criticism. An artist who places work before the public invites criticism of the work. That criticism, no matter how hostile or fantastic or extravagant, is not by itself defamatory. However, if untrue statements are made disparaging the work,

or if the artist is attacked personally in some way unconnected with the work, the critic may well have crossed the border into the area of defamation.

Another case, also involving a dispute between artists, illustrates a personal attack that was defamatory. One of the leading sculptors of the Pacific Northwest had created a thirteen-foot work of art titled Rock Totem which was displayed at the Seattle World's Fair in 1962. A younger sculptor, who was studying for his master's degree in sculpturing and had seen Rock Totem, was commissioned to do a piece for a bank. His piece stood eight feet high and was titled Transcending.

The older sculptor went to the architects who commissioned the work and called Transcending a copy of Rock Totem. At the bank, he called the younger artist a thief. Prior to suing the younger artist for this alleged copying, the older artist wrote a letter in which he said: "When a thief robs openly from a creative spirit no bit of talk around a legal table can quietly settle the issue. Is it not more important that the art student recognize his desire for money has guided his hand in his path of plagiarism." (*Fitzgerald v. Hopkins*, 70 Wash.2d 924, 425 P.2d 920)

The court concluded no copying had taken place and dismissed the older artist's infringement claim. In defending the lawsuit, the younger artist counterclaimed for damages for defamation. The court determined that calling someone a thief and a plagiarist is neither criticism nor a protected form of opinion. These are personal attacks, beyond the scope of fair comment, and entitled the younger artist to collect damages.

Of course, a depiction may not in itself be defamatory, but may become so because of accompanying written material. For example, an unobjectionable picture of a man might be accompanied by a caption calling him a thief, which is actionable if not true. In such a case, the creator of the original picture should not be liable for defamation if he or she had nothing to do with adding the words that, in combination with the picture, became actionable.

The First Amendment does limit the extent to which actions for defamation can successfully be pursued. The right of a public figure, in particular, to sue for libel is limited to false statements made with actual malice or reckless disregard of the truth. The term public figure is itself subject to definition. For example, a woman successfully sued a magazine for unfavorably misreporting the grounds of her divorce decree. Although the woman was often mentioned in society columns and actually gave news conferences because of the widespread reporting of her divorce proceedings, the Supreme Court reasoned she was not a public figure because she had no major role in society's affairs and had not voluntarily joined in a public controversy with an intention to influence the outcome. (*Firestone v. Time, Inc.*, 424 U.S. 448)

Similarly, when a magazine accused a prominent lawyer of having framed a policeman as part of a Communist conspiracy to discredit the police, the attorney was determined not to be a public figure. The United States Supreme Court stated, "The communications media are entitled to act on the assumption that public officials and public figures have voluntarily exposed themselves to increased risk of injury from defamatory falsehoods concerning them. No such assumption is justified with respect to a private individual." (*Gertz v. Robert Welch*, 418 U.S. 323)

The Supreme Court determined that the states should have discretion to determine the standard of liability for defamation when a private individual is involved in a matter of public interest, as long as the states require some negligence or fault on the part of the person accused of the defamation. Thus, when a matter of public interest is involved, a public figure will have to show actual malice or reckless disregard for the truth to recover for defamation, while a private individual will only have to show negligence. When a private person is defamed on a matter not of public interest, there is no requirement even to show an intent to defame. Recovery in such a case is allowed on the basis of the defamation alone. Malice or reckless disregard for the truth are only relevant in determining whether extra damages, known as punitive damages, should apply. Retraction or correction of a libel will often be a factor in reducing damages.

Privacy

The right to privacy, as discussed in relation to the artists, is the right to live free from unwanted or unnecessary publicity or interference that would injure a person's feelings or present the person in a false light before the public.

Onassis v. Galella

The First Amendment again operates to reduce the right of privacy protecting public figures. A dramatic example is the litigation involving Ronald Galella, a photographer, and Jacqueline Onassis. Galella's role as a paparazzo pursuing Jacqueline Onassis for photographs created a substantial and unwanted interference with her life. The Federal Court of Appeals described Galella jumping into the path of John Kennedy's bicycle to take a picture, and also stated:

Galella on other occasions interrupted Caroline at tennis, and invaded the children's private schools. At one time he came uncomfortably close in a power boat to Mrs. Onassis swimming. He often jumped and postured around while taking pictures of her party.... He followed a practice of bribing apartment house, restaurant and nightclub doormen as well as romancing a family servant to keep him advised of the movements of the family. (Galella v. Onassis, 487 F.2d 986)

The court indicated that such activities could not be tolerated, whether as an invasion of privacy or as harassment. But the final order of the court, mindful of Galella's First Amendment rights, merely restricted the photographer from approaching within twenty-five feet of Jacqueline Onassis, blocking her movement in public places, or harassing or endangering her.

However, in 1982, Onassis brought a new action against Galella on the grounds that he had violated the 1975 court order on at least twelve occasions. Although the First Amendment protected the photographer's right to take photographs of a public figure, the contempt citations might still have resulted in Galella being imprisoned and paying heavy fines (*Galella v. Onassis*, 533 F. Supp. 1076). To avoid this, Galella agreed never to photograph Mrs. Onassis or her children again.

Anti-Paparazzi Legislation

A law enacted in California after Princess Diana's death seeks to protect people subject to media attention from news gathering techniques that would be offensive to a reasonable person. If a person is engaging in personal or familial activity and someone trespasses to obtain visual images or sound recordings in a way that would be offensive to a reasonable

person, the law is violated. "Personal and familial activity" is defined in the law and "includes, but is not limited to, intimate details of the plaintiff's personal life, interactions with the plaintiff's family or significant others, or other aspects of plaintiff's private affairs or concerns."

Even without a physical trespass, the law is also violated if images or sound recordings are obtained that would, but for the use of visual or auditory enhancing devices, have required a trespass into a place where a person had a reasonable expectation of privacy. Anyone who violates the act, including an employer or someone who causes others to violate the act, is liable for three times the amount of general and special damages caused by the violation and may also be liable for punitive damages. If the violation was for commercial purposes, which are defined as "any act done with the expectation of a sale, financial gain, or other consideration," the violator may be required to pay any gains as additional damages.

While such a law might seem to risk objections to its constitutionality in view of the First Amendment protections bestowed on news gatherers, this law remains in force and, in fact, was amended in 2009 to make punishable dissemination of images if the person doing the dissemination had actual knowledge that the images had been obtained in violation of the law. Also, to put this in perspective, when paparazzi Ron Galella harassed Jacqueline Onassis, the court found no constitutional impediment to creating a twenty-five foot buffer around the former First Lady. Perhaps that buffer had constitutional justification on the grounds that harassment had already occurred, while the California law contemplates the prevention of future harassment by paparazzi. Federal anti-paparazzi legislation was also introduced after the death of Princess Diana, but that legislation did not pass.

The Arrington Case

The artist will often, however, deal with a person who is not a public figure. The right of privacy—such as that granted under the New York Civil Rights Law Sections 50 and 51, prohibiting the advertising or trade use of an individual's name, portrait or picture without consent—would apply in full force. One exception is that Section 51 specifically permits a photographer to display portraits at

the photographer's place of business unless the person portrayed objects in writing. Also, a factual account or portrayal of a matter of current newsworthy or legitimate public interest will not be an invasion of privacy. For example, a professional musician who spontaneously performed before four hundred thousand people at the Woodstock Festival in 1969 could not object to the distribution without his consent of a film of his performance. This was because the Woodstock Festival was an occurrence of great public interest and remained newsworthy long after the end of the festival.

Arrington v. The New York Times (55 N.Y.2d 433, cert. denied 459 U.S. 1146) arose from more troubling facts. Clarence Arrington, an African-American, was photographed without his knowledge while walking along a street in New York City. This photograph was then used on the cover of the *New York Times Magazine* in connection with an article titled "The Black Middle Class: Making It." This widely circulated article probed the issue of whether middle-class blacks felt divorced from the problems affecting less fortunate blacks. Arrington, a financial analyst at the time the photograph was taken, was indeed a member of the middle class. However, he had never consented to the use of his image; indeed, he was never asked by the *New York Times* for his consent. Although he was not mentioned by name in the article, he felt the article degraded not only the black middle class but himself as its apparent exemplar. He did not share the views expressed in the article and also said that his acquaintances assumed that he had at least partly changed his vocation to that of a professional model.

New York's highest court, the Court of Appeals, reiterated its other decisions that a picture illustrating an article on a matter of public interest is not considered used for the purposes of trade or advertising unless it has no real relationship to the article. If the picture had no real relationship to the article, it could not serve the public interest and would be simply a disguised advertisement.

The Court of Appeals concluded that the photograph of Arrington was related to the article about the black middle class. In the struggle between freedom of the press and the individual's right to privacy, the press emerged victorious. However, the *New York Times* had not been the only defendant in the suit. Other defendants included Gianfranco Gorgoni, the freelance photographer who took the photograph on assignment for the *New York Times*; Contact Press Images, Inc., the photographic agency that handled the sale from Gorgoni to the *New York Times* and Robert Pledge, the president of Contact. If liability were found, the corporate shield would not protect an officer from being personally at risk.

In a decision that caused great concern among visual communicators, the Court of Appeals stated that the case against the *New York Times* was properly dismissed but reasoned that the defendants might be found to have made a sale of the photograph without Arrington's consent. Not being publishers, the photographer and his agency might be liable, despite the fact that the *New York Times* was protected by the First Amendment. When the case would be sent back to a lower court to determine the facts, that lower court might well find that the defendants, operating independently from the publisher, had commercialized the photograph by the transfers leading to the publication by the *New York Times*.

This ill-reasoned decision could have led to an absurd result. A freelance photographer working for a publisher would be liable for an invasion of privacy in this situation when the publisher would not be. Likewise, a freelance photographer might be liable for an invasion when an employee of a publisher taking the same photograph would have no liability. The employee-photographer would be protected by his or her employer's First Amendment freedom of the press. Not only would this decision place freelancers in a precarious position, it would constrict the flow of imagery to the media. Indirectly, it would inhibit freedom of the press.

Publishers and visual communicators joined forces to lobby for a bill to overturn this aspect of the Arrington decision. The American Society of Media Photographers and the Graphic Artists Guild played important roles as this coalition formulated draft legislation and a strategy for guiding the legislation through both houses of the New York legislature.

The Arrington Bill

The bill took the form of an amendment to the privacy statute in New York State. The amendment provided that if a use protected by the First Amendment is the purpose of the sale or

transfer of an image from a photographer to an agent or an agent to a publisher, then all the parties in the chain of transfers will be protected by the First Amendment.

No opposition formed against the bill. In one year it passed both the Assembly and Senate and was signed into law by Governor Cuomo. So freelance photographers and their agents now enjoy the same protection that publishers and employee-photographers enjoy with respect to the Arrington factual pattern.

Right to Create Art

Courts rigorously protect an artist's First Amendment right to creatively express themselves. One example of the judiciary's willingness to defend such rights is *Tunick v. Safir* (228 F.3d 135). Photographer Spencer Tunick sought to capture a photograph involving 75-100 nude models posed in a residential Manhattan neighborhood. The City, relying on New York's statutory ban on public nudity, tried to prevent the shoot from taking place. Tunick then took his case to federal court, arguing that New York's ban irreparably interfered with his right to freely express himself as an artist, and asking the court to enjoin the city from interfering with his shoot. Judge Baer, agreeing with Tunick, issued a preliminary injunction preventing the NYPD from stopping Tunick's shoot. Though the city appealed the ruling, the Court of Appeals for the Second Circuit upheld the injunction and allowed Tunick to complete his shoot. They held that the ban on public nudity, as applied to Tunick's expressive act, ran afoul of his First Amendment Rights.

Trademarks

Occasionally artists wish to include a trademark in an artwork. For example, an artist may paint a street scene that includes a sign with a company logo. Use of the trademark in this way should not be a problem for the artist, except in the unlikely case where the public might be confused by the painting and imagine it was created by or was a product of the company depicted in the painting.

In a twist on this idea, the Rock and Roll Hall of Fame argued that it had a trademark in the unique shape of its building and, therefore, photographer Charles Gentile should be prevented from selling his posters of the Rock and Roll Hall of Fame. The court agreed that the building, designed by I. M. Pei, was unique and

distinctive with "a large, reclining triangular facade of steel and glass, while the rear of the building, which extends out over Lake Erie, is a striking combination of interconnected and unusually shape, white buildings." Gentile's posters sold for $40 and $50 dollars, while the Hall of Fame's own poster sold for $20, but the photographs in the posters were very different treatments of the building. The court concluded that the building, while fanciful, was not fanciful in the way that a trademark identifies a company as the source of goods or services to the public and that, indeed, there had been no showing that the public might have come to associate the building's design as a trademark connected to products or services offered by the Hall of Fame. In what the court admitted to be an unusual case, Gentile was allowed to sell his posters. Even Gentile's use on his poster of the words "ROCK 'N ROLL HALL OF FAME," was considered by the court to be likely to be a fair use of the Hall of Fame's registered service mark since it was merely descriptive of what was photographed. (*The Rock and Roll Hall of Fame and Museum, Inc. v. Gentile Productions*, 134 F.3rd 749)

In another case, Mattel used a similar argument to try and show that photographer Tom Forsyth's parodic photographs of various Barbie dolls infringed Mattel's intellectual property rights. (*Mattel v. Walking Mountain Productions*, 353 F.3d 792). Forsyth's photographs, which the artist himself described as the work of an "absurdist," sought to "critique...the conventional beauty myth and the societal acceptance of women as objects because this is what Barbie embodies." Mattel tried to show that Forsyth's use of the images infringed on trade-dress protections it owned in the Barbie doll, but the court rejected these arguments. In so doing, the court noted that there was little chance that a person viewing Forsyth's photography would conclude that Mattel either commissioned the images, or that the photos were in any way affiliated with Mattel.

Releases

The user of images must always keep in mind the individual's right to privacy. Publisher, advertising agency, corporation, graphic designer, illustrator, art director, photographer and agent all risk liability in a suit brought for an invasion of privacy. In common commercial

situations, releases are used as a matter of course. However, the Arrington case points to the borderline area where distinctions blur between what is a use for private gain and what is a use for the public interest. In such situations, the only safe course to adopt is the securing of a release.

An appropriate form of personal release is set forth below. A release should provide space for the date, the consideration (usually some payment of money, even one dollar, to the model), the subject matter, the extent of the release, who other than the artist may benefit from the release, the signature of the individual giving the release and the guardian's consent if the person giving the release is a minor. The artist who is provided with a release, perhaps by an agency, should request indemnification against lawsuits based on invasion of privacy if the release appears inadequate to protect the artist. Although some states allow oral releases, New York requires that a release be written. In any case, it is always best to have a written release. The release should also specify what use of the art is permitted. Actual usage should not exceed this. Alterations or distortions in using art may open the risk of an invasion of privacy lawsuit even if a release has been obtained.

Model Release Form

In consideration of $_____,
receipt of which is acknowledged,
I, _____, do hereby
give _____, his (her) assigns,
licensees and legal representatives the irrevocable right to use my name (or any fictional name), picture, portrait, or photograph in all forms and media and in all manners, including composite or distorted representations, for advertising, trade or any other lawful purposes, and I waive any right to inspect or approve the finished product, including written copy, that may be created in connection therewith. I am of full age.* I have read this release and am fully familiar with its contents.

Witness: _____ Signed: _____

Address: _____

Address: _____

Date: _____, 19 ___

Consent (if applicable)

I am the parent or guardian of the minor named above and have the legal authority to execute the above release. I approve the foregoing and waive any rights in the premises.

Witness: _____ Signed: _____

Address: _____

Address: _____

Date: _____, 20 ___

* Delete this sentence if the subject is a minor. The parent or guardian must then sign the consent.

The artist may wonder whether a release might be necessary to portray a building, an animal, or some other type of property. This is not a privacy issue, since the right of privacy basically only protects living people. Normally, no release would be necessary to use the image of a public building. Of course, the artist should not trespass and should obtain any permits which are necessary from local authorities. Similarly, a private building used as a background in a public place or thoroughfare would not require a release, although advertising agencies are likely to be especially cautious and require property releases when using the image of a house. A private building, or a public building where admission is charged, might require a release, particularly since a subsequent advertising use might create a question regarding unfair competition. In addition, many states have laws forbidding the photographing of performances without the permission of the management of the theater.

A recent case pitted the owners of a building against R. J. Reynolds Tobacco Company, the maker of Camel cigarettes. The building had a side-wall facing the street on which advertising could have been placed. A photograph was taken of the building and then an ad for Camels was added to the photograph, so that it appeared the side of the building had a large ad for Camels painted on it. Since the owners had never rented the side of the building for advertising and no such ad had ever appeared there, the owners sued for damages. The court, however, concluded that the owners had not shown a sufficient likelihood

of commercial injury and dismissed the case (*Cecere v. R. J. Reynolds Tobacco Company*, 1998 WL 665334).

In general, the reason to obtain a release when using images of someone's private property is to have the release act as a contract. No questions can then arise as to whether the artist offered to pay, what the amount of payment might be or what the intended usage is. For example, an image of a model's hands does not require a release unless the model is identifiable. However, a release would probably be obtained simply to clarify the contractual arrangement with the model. It is not, however, necessary from the standpoint of a right to privacy.

Child Models

Laws regarding the employment of minors vary from state to state. Parental consent and work permits are often required. Depending on the age of the model, supervision of the modeling session may also be necessary. The quickest way to find out the relevant state law is to check with the state departments of labor, employment or education.

For example, the New York statute provides:

1. It shall be unlawful to employ, use, exhibit or cause to be exhibited a minor as a model unless: (a) A child model work permit has been issued as hereinafter provided; and (b) Such employment, use or exhibition is in accordance with the rules and regulations promulgated by the commissioner of education as hereinafter provided.(Arts and Cultural Affairs Law, section 35.05)

The California law requires the written consent of the Labor Commission for a minor under the age of sixteen to work as an advertising or photographic model. The consent of the Labor Commissioner is based on the following factors:

(a) The environment in which the performance, concert, or entertainment is to be produced is proper for the minor; (b) The conditions of employment are not detrimental to the health of the minor; (c) The mino's education will not be neglected or hampered by his or her participation in the performance, concert, or entertainment. The Labor Commissioner may require the authority charged with the issuance of age and schooling certificates to make the necessary investigation into the conditions covered by this section. (California Labor Code, section 1308.6)

Obscenity

The laws regulating obscenity have been the focus of much controversy and concern. What the artist creates for aesthetic reasons may not be perceived in the same way by viewers in the general public. The United States Supreme Court has given the following guidelines to determine what is obscene:

*(a) whether"'the average person, applying contemporary community standards" would find that the work, taken as a whole, appeals to the prurient interest, (b) whether the work depicts or describes, in a patently offensive way, sexual conduct specifically defined by the applicable state law, and (c) whether the work, taken as a whole, lacks serious literary, artistic, political, or scientific value.(*Miller v. California, 413 U.S. 15*).*

These guidelines hardly seem to offer more guidance than the subjective reaction of the ordinary citizen as to what may be obscene. Also, the guidelines specifically refer to community standards and state laws. This means that standards for judging what is obscene will vary not only from state to state depending on the state laws, but also from community to community depending on the local standards. The United States Supreme Court has clarified that community standards apply to clauses (a) and (b) in the test for obscenity, but that a reasonable man standard is to be used for clause (c). (*Pope v. Illinois*, 481 U.S. 497) The reasonable man standard, while still difficult to ascertain objectively, is a national standard which should not vary from one community to another.

The artist can hardly be certain, therefore, when and where a work, upon exhibition or publication, may be found to be obscene. At the least, if the artist keeps the work in the privacy of the studio, no violation of the obscenity laws will occur. But the obscenity laws, if applicable, can cover such uses of the work as possession for sale or exhibition, sale, distribution, mailing and importation through customs. The manner in which the material is offered to the public may be important in a determination

of obscenity. If there is an emphasis solely on the sexual aspects of the works, this factor will make more likely a determination that the work is obscene. If minors have access to the material, an even higher standard than that applicable to pornography may be applied by the states without violating the First Amendment.

The First Amendment, however, offers important procedural safeguards to the artist whose work risks being challenged as obscene. Law enforcement agencies cannot simply seize such materials upon their belief the materials are obscene. The exhibitor of work must be given notice of a hearing to determine whether the work may be seized as obscene. At the hearing the exhibitor can be represented by a lawyer to argue that the works are not obscene. The judge must consider all relevant evidence, such as the works, the manner of publicizing the exhibit and the degree to which the general public may view the works. Law enforcement officers who testify the works are obscene must actually have attended the exhibition. Only after such a hearing can the works be seized or the exhibition prohibited. The Supreme Court has also made clear that even under racketeering laws there can be no seizure of art or books without an adversarial hearing.

The artist or exhibitor may find that law enforcement agents have chosen to seize work without a prior adversary hearing. In such a case, the law enforcement officials should not be resisted in any way, but merely advised that they are acting in violation of the First Amendment procedural safeguards and may be liable for damages for their actions. In no event should consent be given to the conduct of the law enforcement officials, since consent might be a waiver of the procedural safeguards necessitated by the First Amendment.

In 1988 and 1990 Congress enacted laws to protect children from being used in pornographic materials, so artists should exercise special care if minors are to be portrayed nude. The law requires anyone producing images of sexual activity or "sexually explicit conduct" to maintain records giving the model's name, including stage names and nicknames, and keeping a cross-indexing system so that any name can be retrieved by the title or other identifying feature of the film or book. These records were required to be kept for adults as well as for minors. Other tools to combat child pornography include the criminalization

of possession with intent to distribute obscene materials that have crossed state lines, applying racketeering statutes to child pornography, and making illegal the taking of a minor across state lines for use in child pornography.

The constitutionality of these enactments was challenged in *American Library Association v. Barr* (33 F.3d 78, cert. denied 115 S.Ct. 2610) on the grounds that the producer's freedom of expression would be unduly limited. In one interesting passage, the court observed:

One example of how the Act's requirements would impose virtually insurmountable burdens on protected expression is in the case of "appropriationist" artists.... These artists create their works by photographing sexually explicit materials from other sources and combining those pictures with other images to portray those images in new and different ways.... These artists have no contact with the primary producer or model. Moreover, they often produce strong feminist or political messages which might be critical of that producer so that it would be extremely difficult for these artists to be able to meet the Act's strict record keeping requirements and avoid committing a felony.

The court concluded that the required record keeping was unconstitutional as to producers and distributors of materials containing images of adults. So the law may not be applied to those "who use due diligence to satisfy themselves that the subjects in these images are over eighteen years of age." However, the law's constitutionality was upheld with respect to its record-keeping requirements for those who are minors.

Obscenity is a complex legal area. The artist who either fears an obscenity issue may arise or faces such an issue must consult a lawyer for assistance in proving the work is not obscene and should not be suppressed.

Flag Desecration

The United States Code provides: "Whoever knowingly casts contempt upon any flag of the United States by publicly mutilating, defacing, defiling, burning, or trampling upon it shall be fined under this title or imprisoned for not more than one year, or both." The definition of United States flag includes "any flag of the United States, or any part thereof, made of any substance, of any size,

in a form that is commonly displayed." The Supreme Court struck down this law in 1990, holding that Congress could not so infringe the First Amendment rights to free expression (*United States v. Eichman*, 496 U.S. 310).Though the states and the District of Columbia have enacted legislation similar to the Congressional law, the Supreme Court has proved to be quite hostile to any legislation that targets flag desecration.

Hence, the First Amendment does offer protection to artists who use the flag in creating their work, particularly where the purpose of the work is political protest as opposed to a commercial use. For example, in 1966, an artist named Marc Morrel exhibited in the Radich Gallery in New York City "an object resembling a gun caisson wrapped in a flag, a flag stuffed into the shape of a six-foot human form hanging by the neck from a yellow noose, and a seven-foot cross with a bishop's mitre on the head-piece, the arms wrapped in ecclesiastical flags and an erect penis wrapped in an American flag protruding from the vertical standard," as well as other works which used a Vietcong flag, a Russian flag, a Nazi swastika and a gas mask. (*U.S. ex rel Radich v. Criminal Court of City of New York*, 385 F. Supp. 165)

The gallery owner, Stephen Radich, was charged with desecration of the flag and began a seven-year odyssey through the courts. Radich was finally vindicated on the basis of a two-part judicial test. First, the court determined whether the activity, in this case the exhibition, had such elements of communication as to be protected by the First Amendment. Morrel's work was found to have such elements of communication, so the court proceeded to the second part of the test: whether the state had interests which were more compelling than the individual's. The interests of New York State—such as preservation of the flag as a symbol, avoiding breaches of the peace and protecting the feelings of passers by—were found less important than the interests of the artist and gallery owner in freely expressing the political protest conveyed by the exhibition.

The divergent state laws and complexity of the area of flag desecration will make consultation with a lawyer a necessity for the artist who wishes to determine whether the First Amendment will provide adequate protection for given works of art using a motif of the state or federal flag.

Other Governmental Symbols

Flags are not the only symbols protected by the federal or state governments. Federal law places restrictions on symbols such as the great seal of the United States, military medals or decorations, the Swiss Confederation coat of arms, the Smokey Bear character or name and the Woodsy Owl character or name or slogan. While the prohibited uses vary, they often include advertising, product packaging or uses that might mislead the public. For an artist to use such an emblem, insignia or name may require legal advice or obtaining an opinion from the appropriate government agency as to whether the use is allowed.

These restrictions may be found unconstitutional if their enforcement would limit the First Amendment rights of citizens and the government cannot show a compelling reason for such limitations. For example, an environmental group created and published a political advertisement depicting a chainsaw-wielding Smokey Bear. The advertisement was critical of the Forest Service's management of public land. Portraying Smokey Bear with the chainsaw partially concealed behind his back, the advertisement included the caption, "Say it ain't so, Smokey."

The Chief of the Forest Service warned the environmental group that the Service would seek an injunction if the group continued to use Smokey in this way. The group then sued the Service to clarify its rights. The court concluded:

By ruling that the [law and regulation] are unconstitutional as applied to LightHawk the Court by no means intends to create an open season on Smokey Bear. While the question is not before the Court the government can likely regulate commercial uses of Smokey Bear.... Those portions of the regulatory scheme addressing solely commercial uses remain intact. However, the statute and regulation, which impose content-based restrictions on non-commercial uses, cannot be applied to Lighthawk's purely expressive political speech. (LightHawk v. Robertson, *812 F. Supp. 1095*)

Coins, Bills, and Stamps

The artist may also wish to use either United States currency or stamps as part of a work. Certain uses, however, are prohibited by federal statutes. For example, advertising on either real

or imitation currency is forbidden and punishable by fines up to $500. Mutilation of currency with an intent to make such currency unfit to be reissued is punishable by fines up to $100 or six months in jail, or both. Also, anyone who makes or possesses a likeness of a United States coin for use in any manner is subject to a fine up to $100, but the likeness must be such as to create some possibility that the coin could be mistaken as minted by the United States.

The federal laws on counterfeiting had, however, made specific provisions to allow paper money and stamps to be printed and published, "for philatelic, numismatic, educational, historical, or newsworthy purposes in articles, books, journals, newspapers, or albums." Advertising uses were restricted to legitimate coin or stamp dealers in trade publications. Time Magazine challenged this purposes limitation as part of a lawsuit to permit it to publish images of currency without being subject to either the purposes or size and color limitations. Because the United States Supreme Court struck down the purposes limitation, the Department of Treasury made the following announcement on February 22, 1985:

The Treasury Department today announced a new enforcement policy concerning reproductions. The Department will henceforth permit the use of photographic or other likenesses of United States and foreign currencies for any purposes, provided the items are reproduced in black and white and are less than three-quarters or greater than one-and-one-half times the size, in linear dimension, of each part of the original item. Furthermore, negatives and plates used in making the likenesses must be destroyed after their use.

The policy is consistent with the Supreme Court's decision of July, 1984, in the case of Regan v. Time, Inc., *and was made with the concurrence of the Department of Justice. This decision will, for the first time, permit the use of currency reproductions in commercial advertisements, provided they conform to these size and color restrictions.*

Under the new policy, the Treasury Department expects to increase enforcement efforts against color currency reproductions and against black-and-white reproductions that do not conform to the size restrictions.

As the announcement stated, the illustrations of paper money must be black and white and either less than 3/4 or more than 1 ½ times the size of the original. The size requirements apply to stamps which are in color, but not to black-and-white or canceled colored stamps. The negatives and plates must be destroyed after being used for the illustrations. Also, paper money and stamps may be used in films, microfilm and slides as long as no prints or reproductions are made that violate the foregoing restrictions. These size and color requirements were also considered by the Supreme Court in the case brought by Time Magazine, but the Supreme Court upheld the validity of these restrictions (*Regan v. Time, Inc.*, 468 U.S. 641).

Photographs or printed illustrations, slides or films of United States and foreign coins may be made in any size and color and used for any purpose, including advertising. This is because such reproductions of coins raise no dangers with respect to passing off counterfeit money.

The counterfeiting laws are enforced by the United States Secret Service, which will give an opinion as to whether a particular use is a violation of any federal statute. However, such an opinion does not prevent a later prosecution by either the Department of Justice or any United States Attorney. To obtain an opinion, the address is: Office of the Director, United States Secret Service, Department of the Treasury, Washington, D.C. 20223.

The guidelines for reproducing money are discussed in *Know Your Money*, a free publication available from the Secret Service. Interestingly, certain imaging software, such as Adobe Photoshop, has incorporated internal monitoring features that prevent users from effectively scanning American, European, and Japanese bank notes.

Dangerous Art

Neither the First Amendment nor the any entitlement to create art gives an artist the right to endanger others or violate the law. When an artist placed a "bomb" on top of a tower of the Brooklyn Bridge, he was arrested and charged with criminal possession of a weapon, a felony for which sentences can be as long as seven years. Two years later the Manhattan District Attorney's Office finally requested that the charges be dropped. Explosives experts had testified that the device was not dangerous. From the artist's point of view, it had been an attempt to create an environmental sculpture to

illuminate the city skies. If he had succeeded in detonating the fireworks in the explosive device, he would at most have created entertainment and not danger for the public.

In the craft area, the artist must be aware of the risk of lawsuits based on a defect in a product sold to the public. If a customary or foreseeable use of a defective product causes injury, the artist will be held responsible for resulting injuries and be liable for damages. Careful quality control, development of the product to be safe even if misused, giving clear instructions to prevent injurious uses, and obtaining product liability insurance will mitigate the risks in this area.

The Consumer Product Safety Commission oversees the Consumer Product Safety Act, the Flammable Fabrics Act and other laws relating to consumer safety. The artist creating clothing, furnishings or other products may wish to contact the Commission and determine whether regulations or instructions exist for a particular item: Consumer Product Safety Commission, 4330 East West Highway, Bethesda, MD 20814, 800-638-2772.

Penalties for Graffiti Art
Though graffiti adorns much of America's urban landscapes, many states have taken a hard statutory line on this spontaneous and nearly ubiquitous form of visual communication. In New York, a law has been proposed to criminalize graffiti art-making. In that law, graffiti is defined as the unpermitted "etching, painting, covering, drawing upon or otherwise placing of a mark upon public or private property with intent to damage such property." Similar laws are in force in California, where the graffiti artist and certain art suppliers can be held criminally liable. For example, any person or corporation who sells spray paint to a minor without attempting to run an "age check" could be held criminally liable.

Labeling
Artists working with wool, fur and other textiles should be aware of labeling requirements under various laws. While these laws are not for consumer safety, they do safeguard the consumer by requiring that information be provided which may include the materials in, processes used to create and appropriate uses of covered items.

The Federal Trade Commission enforces these laws and can provide further information: Federal Trade Commission, 600 Pennsylvania Avenue, NW, Washington, District of Columbia, 20580.

Protecting Animals and Plants
It is forbidden to kill certain protected species or use or sell any parts of such species, although regulations may exist for certain exemptions and Native Americans may receive special treatment in certain cases. The United States Department of the Interior administers these programs through its Fish and Wildlife Office. Up-to-date lists of covered animals and plants and other information may be obtained by writing: Office of Endangered Species, United States Fish and Wildlife Service, Main Interior, 1849 C Street NW, Room 3238 Washington, District of Columbia 20240-0001.

Right to Sell Art
Courts staunchly defend artists' rights to sell their art under the First Amendment. In *Bery v. City of New York*, artists challenged New York City's regulation requiring them to obtain a license before selling their art in public spaces (97 F.3d 689). These artists argued that the license requirement infringed on their Constitutional right of free expression. On appeal, the Court enjoined the City ordinance, noting that a municipality could not prevent the sidewalk display or sale of expressive artwork.

Protected Expression
In certain expressions of creativity and opinion, artists are protected by the First Amendment with respect to acts that might otherwise be grounds for a civil or criminal suit. Generally, however, artists are subject to the law in the same way as any citizen and should be careful not to violate public laws or private rights.

10 CONTRACTS: AN INTRODUCTION

A contract is an agreement creating legally enforceable obligations between two or more parties. The artist is constantly entering into contracts with collectors, dealers, agents, exhibitors, publishers, ad agencies, landlords, and others. While a lawyer should usually be consulted when the artist is given a contract to sign, the artist's knowledge of the different negotiable points in each contract can assist a lawyer in reaching the contract best suited to the artist's individual needs. This chapter develops a background of the law relating to contracts in order to make subsequent chapters on specific types of contracts more helpful.

In negotiating contracts, artists will find the following series of books by Tad Crawford very helpful: *Business and Legal Forms for Fine Artists, Business and Legal Forms for Illustrators, Business and Legal Forms for Graphic Designers* (co-authored with Eva Doman Bruck), *Business and Legal Forms for Photographers*, and *Business and Legal Forms for Crafts*. All of these books contain explanations of various contracts, negotiation checklists that can be used even when the other party prepares the contract, and model contracts ready to be used. Published by Allworth Press, the forms in each book are also available on computer disk for ease of modification.

Negotiation Skills

Negotiation is integral to the process of making a contract. The terms of the contract are those reached by the negotiation. A few basic observations will help the artist negotiate successfully.

The purpose of negotiation is not to defeat the other party. Rather, both parties should benefit and feel satisfied that their needs have been met. Prior to beginning any negotiation, the artist should have his or her goals clearly in mind. These goals certainly include money, but reach beyond this to issues of artistic control, authorship credit and other factors that may also have importance for the artist.

Of course, the other party has its goals. The artist should gather as much information as possible about the other party, including its resources and goals. For example, what advances and royalty rates has a publisher given to other artists? What provisions did it strike out of its standard contract? What commission rate has a gallery agreed to with other artists? Did a magazine agree to buy first North American serial rights or insist on more? This kind of information shows what an artist may expect in a negotiation. It also indicates what the other party must have in order to be satisfied with the business arrangement.

It is wise to keep records of both negotiators' strategies, including preparing written notes on all discussions. This will enable the artist to keep current on the nuances of the negotiation. It will also prepare the way for future negotiations, since the artist may be able to predict the other party's patterns while avoiding falling into patterns that give the other party an advantage.

Offers should be put in writing. This avoids disputes as to what the offer was. Generally, the first offer is not the best. In this way there is room for give and take in the negotiation. The more time and effort invested in a negotiation, the more both parties will want a successful conclusion by reaching an agreement.

After an agreement is signed, both parties should feel the contract will be mutually beneficial, not that one party or the other won.

The telephone is, of course, one of the chief instruments of negotiation. Since negotiations must be prepared in order to be successful, it follows that no phone call should be made without adequate preparation. The artist should be aware of which party talks the most, since listening often produces more information and therefore better results. The artist should be certain the call will not be interrupted and that no distractions will divert attention from the negotiation. If a call to the artist catches him or her off guard, the best approach is to call back after taking the time to prepare properly.

The artist must be willing to lose a deal in order to negotiate from strength. It is also wise for any negotiator to ask for all he or she wants and something extra that can be sacrificed. Not to make demands because the artist fears rejection can only be self-defeating. If the artist makes the demands of a professional, he or she is far more likely to be treated as a professional.

Governing Laws

Every state has enacted the Uniform Commercial Code, a statute governing the sale of goods. For example, the Uniform Commercial Code applies when an artist contracts to sell a finished work or to create a specific work for a purchaser. The Uniform Commercial Code does not apply, however, when the artist's services are employed in a project such as the creation of a mural. Such a contract for services is governed by the case law of the various states, although general principles of the case law can be described.

Offer and Acceptance

An offer is a proposal to enter into a contract. It is a promise inviting acceptance in the form of a return promise or, less usually, an acceptance by performance based on the terms of the offer. If a collector says to an artist, "I want to buy your painting, *Doves of Peace*, for $2,500," an offer has been made. The collector has promised in definite terms that can be accepted by the artist's return promise to sell the painting.

If the collector says, "This painting would look wonderful in my office," or, "This painting will be worth a fortune soon," or, "I want to borrow this painting to try for a few weeks," no offers have been made. If the collector says, "You paint my portrait and we'll agree later about the price," or, "You paint my portrait and

I'll pay you as I see fit," no offers have been made because a material term, the price, has been omitted.

However, if the collector says, "Paint my portrait and I will pay you $2,500 if satisfied," a valid offer has been made. The artist should beware of such an offer, because the collector may be able to reject the finished portrait. The courts generally rule that a satisfaction clause means that a dissatisfied collector may reject the work, even if the collector reasonably should have been satisfied. But the artist certainly does not want to deal with vagueness of this nature and should either avoid satisfaction clauses or require step-by-step approval from the collector, as shown in the Commission Agreement on pages 121–123.

The exhibition of a painting with a price is not an offer. The reason for this is that advertising to the public at large does not create an offer. If a collector is willing to meet the asking price, it is the collector who makes an offer that the artist may then accept or refuse.

The person making an offer can usually revoke the offer at any time prior to acceptance. Another way in which an offer can be terminated is by limiting the time for acceptance. An example of this would be, "I will purchase your painting for $2,500, if you will sell it to me within the next ten days." This offer would terminate at the end of ten days. If no such time limit is set, the assumption is made that the offer ends after a reasonable amount of time has passed. An offer is also terminated by a counteroffer. For example, if the collector offers $2,500 for a painting and the artist demands $5,000, the original offer of $2,500 is no longer effective.

Acceptance is usually accomplished by agreeing to the offer. If the collector offers to pay $2,500 for a portrait, the artist can accept by stating, "I agree to paint your portrait for $2,500." The less usual method of acceptance would be by conduct indicating acceptance to the offer. The artist could simply begin painting the portrait, which would be implied acceptance of the collector's offer. The best way, however, is to accept by giving a promise in return instead of merely performing according to the terms of the offer.

The end result of the process of offer and acceptance is a meeting of the minds, a mutual understanding between the parties to the contract.

Consideration

Every contract, to be valid, must be based on consideration, which requires each party to give something of value to the other. The consideration each party to a contract receives is what induces entry into the contract. When the collector promises to pay $2,500 for a portrait, which the artist promises to paint, each party has received value from the other. The consideration must be bargained for at the time of entry into the contract. If a collector says, "I'm enjoying my portrait you painted so much, I'm going to pay you an extra $2,500 even though I don't have to," the collector is not obliged to pay. The artist has already painted the portrait and been paid in full, so the promise to pay an additional $2,500 is not supported by consideration.

The one situation in which consideration is not required occurs when a person relies on a promise in such a way that the promise must be enforced to avoid injustice. If a collector makes a promise which one reasonably should know an artist will rely on, such as offering $2,500 as a gift for the artist to buy art supplies, the collector cannot refuse to pay the money after the artist has in fact relied on the promise and purchased the supplies.

Competency of the Parties

The law will not enforce a contract if the parties are not competent. The rationale is that there can be no meeting of the minds or mutual understanding in such a situation. A contract entered into by an insane person is not enforceable. Similarly, contracts entered into by minors will, depending on the law of the specific state, be either unenforceable or enforceable only at the choice of the minor. The age of majority has traditionally been twenty-one, but many states such as New York and California have now lowered the age of majority to eighteen years of age.

Legality of Purpose

A contract for a purpose that is illegal or against public policy is not binding. Thus, a contract to smuggle pre-Columbian art into the United States would not be valid because a federal statue prohibits such importation without the permission of the country where the art is found. Similarly, a contract between an unethical art dealer and an art forger to create and sell old masters could not be enforced by either party in court.

Written and Oral Contracts

A common fallacy is that all contracts must be written to be enforced. While this is not always true, it is certainly wise to insist on having contracts in writing. The terms of a contract may come into dispute several years after the creation of the contract. At that time, reliance on memory to provide the terms of the contract can leave much to be desired, especially if no witnesses were present and the parties disagree as to what was said.

A written contract need not even be a formal document. An exchange of letters can create a binding contract. Often a letter of agreement is signed by one party, and the party completes the contract by also signing at the bottom of the letter beneath the words "Agreed to." Both parties may not have signed an agreement, but a memorandum signed by the party against whom enforcement is sought can be found to constitute a valid contract. Even when the parties merely show, from their conduct, an intention to agree, a contract—called an implied contract—can come into existence. But when part of a contract is in writing, the artist should not rely on an oral agreement to the effect that compliance with all the written provisions will not be insisted upon. Courts are reluctant to allow oral evidence to vary the terms of a written contract, except in cases in which the written contract is procured by fraud or under mistake, or is too indefinite to be understood without the additional oral statements.

The Uniform Commercial Code also requires written evidence whenever goods of a value of more than $500 are to be sold. This simple rule, however, is subject to several important exceptions. If the contract provides for goods to be specially created for purchasers—photographs of a specific place, for example—an oral contract for more than $500 will be valid, if the artist has made a substantial start on the work. If the artist receives and accepts payment or if the purchaser receives and accepts the work, the oral contract will be valid despite being for more than $500. Also, merchants who have made an oral contract for more than $500 will have a valid contract if one merchant then writes a note binding against that merchant and the other merchant doesn't give written objection to the contents of the note within ten days of receipt. Merchant is a special term under the Uniform Commercial

Code, defined to mean a person who deals in goods or practices involved in the transaction. A gallery or publisher would be a merchant, and at least some artists may also come within the definition.

There are provisions, however, in statutes other than the Uniform Commercial Code which also require certain contracts to be in writing. For example, the original Statute of Frauds enacted in 1677 in England required contracts that could not be performed within one year to be in writing. This is still the law in almost every state. Unlike the Uniform Commercial Code, which only requires evidence for sales of goods, this provision applies to contracts for services as well and requires that the writing contain all of the essential terms of the contract. If an artist agrees to sell a collector two paintings each year for three years at $200 per painting, the contract cannot be performed within one year and must be in writing to be valid. Similarly for services, if a muralist is hired by a church to paint a mural during the next fifteen months, that contract will take longer than a year to perform and must be in writing. If completion of the mural were only to take eleven months but the church's payments would be over a two-year period, the contract would again not be performable within one year and would have to be in writing to be valid.

The wisest course is to use only written contracts, but, particularly if the contract is for the sale of goods worth more than $500 or will take more than one year to perform, the artist should generally insist on a written contract.

What about the sale of reproduction rights as opposed to the sale of physical art or a contract for services? As mentioned in the discussion of copyright, the copyright law requires that any transfer of a copyright or an exclusive right in a copyright must be evidenced by a writing. While this would cover many of an artist's transactions, it does not apply to nonexclusive licenses. It also would not apply to literary property which might not be copyrightable—for example, an idea. However, the Uniform Commercial Code might still apply, requiring written evidence—indicating price and subject matter and signed by the party against whom enforcement is sought—of a contract for the sale of intangible personal property if the amount being paid exceeds $5,000.

Warranties

Caveat emptor—let the buyer beware—expressed the traditional attitude of the courts toward the protection of purchasers of goods. More and more, especially under the Uniform Commercial Code, warranties are created with contracts of sale for the purchaser's protection. Warranties can be created orally, even if the contract must be written, and can be made during negotiations, when entering into a contract, or, in some cases, after the contract is effective.

One implied warranty guarantees that the seller—for example, an artist—has title or the right to convey title in the artwork to the purchaser. Another implied warranty is that the artwork will be fit for the particular purpose for which sold, if the artist is aware of the particular purpose and the purchaser relies on the artist's skill or judgment in furnishing the work. If, for example, a sculpture, particularly purchased for a fountain, cracked because of the effect of water on the materials composing the sculpture, this warranty would be breached. This warranty would not apply when goods are put to a customary use, presumably including most forms of exhibition in the case of artworks.

An express warranty is created when the artist asserts either facts or promises relating to the work or describes the work in such a way that the purchaser relies on the facts, promises or description as a basis for making the purchase. Describing the work as being constructed of certain materials, for example, would be an express warranty if the purchaser considered that a basis for purchasing the work. However, sales talk or opinions as to the value or merit of the work by the artist will not create warranties. If, for example, the artist speculates that the work will be worth a fortune in a few years, the purchaser cannot rely upon such an opinion and no warranty is created.

One express warranty which the artist may wish to make is that a work is either unique (one of a kind) or original (one of a limited number). This is particularly true where the work could be easily duplicated, such as photographs, found objects, collages, much pop art, and the manufactured geometric shapes created by some of the minimal artists. While the beauty of the work would not seem diminished by identical pieces, the value for most collectors would be greatly impaired. Painters benefit from the myth that all paintings are unique,

but artists whose work can be duplicated must inspire faith in the purchaser that a unique work is unique and that an original work exists in no more than a given number of copies. For example, a photographic work might exist in color in black and white, as well as having versions with a greater or smaller number of photographs. Although the artist and the purchaser may differ as to what uniqueness is in an artwork, the artist can avoid the purchaser's having any cause for complaint by placing a warranty like the following on the back of the work:

Model Warranty

This art work, titled *Doves of Peace*, and briefly described as doves flying against a background of clouds, is an original work consisting of six numbered panels of thirty-by-forty inches in dimension with no more than three other identical originals and no more than four other originals in black and white consisting of three panels of the dimension of fifteen-by-twenty inches.

Date:_____
Artist:_____

The artist would place this notice on the back of each panel, but sign only panel one to avoid the possibility of the work being split up. The notice can easily be adapted to suit the details of different artworks. The purchaser will be pleased by this reassurance as to the scarcity of the work, and the artist will benefit from the increased trust created by such a demonstration of integrity. If the work were unique, the notice could simply be shortened to state the work's uniqueness. The artist who creates one work with several different parts, such as a sculpture in three separate pieces, might want the purchaser to expressly warrant that the pieces would always be exhibited and sold as a single work.

A fuller discussion of unique art and limited editions appears in chapter 13.

Assignments of Contracts

Sometimes one party to a contract can substitute another person to take over the burdens or rewards of the contract. This is not true, however, for contracts based upon the special skills of one party to the contract. When such personal ability is crucial to the contract—for example, in a contract for the creation of an artwork—the artist may not delegate the contractual duties for performance by another artist. But even though the artist is unable to delegate the performance of the artist's duties, the artist will still be able to assign to another person the artist's right to receive money due or to become due under the contract. A well-drafted contract will state the intention of the parties as to the assignment of rights or delegation of duties under the contract.

Nonperformance Excused

There are a variety of situations in which the artist's failure to perform contractual obligations will be excused. The most obvious case is that the death of the artist is not a breach of contract that would permit a lawsuit against the artist's estate. Similarly, because the artist's work is personal, unforeseen disabling physical or mental illness will excuse performance by the artist. Also, payment by the party contracting with the artist will be excused if the continued existence of a particular person is necessary to the contract being performed—for example, if a portrait was commissioned but the person to be portrayed died prior to commencement of the work.

Grounds other than the personal nature of the artist's work will also permit the artist to refuse to perform. If the other party waives the artist's performance or if both parties have agreed to rescind the contract, no performance will be necessary. If the artist is prevented by the other party from performing, perhaps by a person refusing to sit for a portrait, performance will be excused and the artist will have an action for breach of contract. Similarly, no performance is required when performance would be impossible, as in the case of a muralist who cannot paint a mural because the building has burned. Also, performance is excused if it would be illegal due to a law passed after the parties entered into the contract.

Remedies for Breach of Contract

A party who refuses to perform a contract can be liable for damages. There must, however, be some detriment or loss caused by a breach of contract before the recovery of damages will be allowed. The damages will generally be the amount of the reasonably foreseeable losses

(including out-of-pocket costs and lost profits) caused by the breach. Also, the injured party must usually take steps to minimize damages.

The artist may wonder what happens when performance under a contract is either nearly completed or is completed but varies slightly from what was agreed on. Unless the contract specifies that strict compliance is necessary if the artist is to be paid for performing pursuant to the contract, the artist will usually be able to recover the contract price less the costs necessary to pay for the defects in performance. For example, when an artist created stained-glass windows in substantial compliance with the designs except that less light came through the windows than one of the parties had apparently intended, the court stated:

Where an artist is directed to produce a work of art in accordance with an approved design, the details of which are left to the artist, and the artist executes his commission in a substantial and satisfactory way, the mere fact that, when completed, it lacks some element of utility desired by the buyer and not specifically contracted for, constitutes no breach of the artist's contract. (Wagner-Larshield Co. v. Fairview Mausoleum Co., *190 Wis. 357, 208 N.W. 241)*

The question, however, of what constitutes substantial performance is an area in which litigation is likely. The reason for this is another rule: that part performance under a contract will not allow recovery based on the price specified in the contract for full performance. Moreover, such part performance will not, in most states, even be paid for on the basis of reasonable value unless the part performance is of substantial benefit to the other party who accepts and retains the benefits of such performance. This rule would not apply, of course, if one party prevented the other from performing. Also, if one part of a contract can be separated from another part, such as a number of payments for a number of different sets of photographs, recovery will usually be permitted for the partial contract price specified for each partial performance.

In some situations, damages may be adequate to compensate for the loss caused by a breach of contract. If a famous artist is retained to paint a portrait of unique emotional value, the artist's refusal to honor the contract might be difficult to value in money damages. But since involuntary servitude is prohibited, the artist cannot be forced to create the portrait. On the other hand, if a painting with unique value is already in existence, a purchaser might well be able to require specific performance of a contract of sale. This would mean that a court would order the seller, whether an artist or a dealer or a collector, to transfer to the purchaser the specific painting for which the purchaser had contracted. Specific performance may only be used, however, when the payment of money would not be sufficient remedy.

The Dangers of Disks

An artist described a troubling experience in which the allocation of blame and financial loss proved quite difficult. This episode illustrates both how valuable it would have been to have a written contract and how important it is to be flexible in trying to achieve a fair result when a problem arises. An old and valued client had asked to have a corporate brochure designed. In addition, the client asked that the artist suggest a printer for the 200,000 copies needed of this colorful brochure. After giving approvals at a variety of stages, the client agreed that the brochure was ready to be printed. At this point, the client had seen a 300-dpi printout of the textual portions of the brochure. This printout had been proofed and found to be accurate.

The artist recommended a printer with whom the artist had an established and very positive relationship. As a final step before printing, the artist sent a disk for the job to a prepress house and received back film and a blue line. The blue line was sent to the client for a final check. After the client approved the blue line, the artist went on press to ensure that the brochures would be printed to the highest possible standard. In fact, the client was delighted with the printing.

To this point, the job hardly sounds like the nightmare that it soon became. The artist and the printer had performed at levels pleasing to the client and the 200,000 brochures were ready to be delivered. However, when the client reviewed the sample copies of the brochures that had been sent to it from the print run, the art director was shocked to discover a typographical error. A "t" had been omitted from "this," leaving instead the word "his" and ruining the sense of the sentence. The client could not live with this kind of error in its brochure, so the 200,000 brochures would have to be discarded.

Before trying to decide who should bear the financial burden, we have to understand how this could have happened at all. The client approved the laser printout and the blue line. Unfortunately, the blue line did not conform to the laser printout. The laser printout had the correct word—"this" —while the blue line had the incorrect word—"his."

The artist could not understand why the disk given to the prepress house contained that erroneous change, but it did. Perhaps the artist was to blame or perhaps the fault belonged to the prepress house. To this day, the artist cannot explain how the error was introduced. In any event, the artist did not check the blue line against the laser printout to compare for accuracy. Should the artist have proofed the text of the blue line—or is such checking the task of the client?

The client had not checked the blue line against the laser printout. How easy it is to rely on the mechanical nature of the process. If the disk is correct, how can anything on it change as the image on the computer screen or printout is simply moved by the prepress house to higher dpi output or film? Unfortunately, such a change had occurred.

The question of who would bear the loss turned, to a large extent, on who would be blamed for what had gone wrong. The artist had to admit that in all likelihood the artist was responsible for the mistake (although it could have been a software flaw for which the software company was responsible, or a problem at the prepress house). If the client had proofed the blue lines and found the mistake, the artist would have had to correct the error without any charge.

However, the client had the responsibility to proof the blue lines. Failing to do this, the client presumably should take responsibility for any errors that the client did not correct. This would mean that the client would have to bear the full loss from the 200,000 brochures that could not be used. This might be a satisfactory legal result, but would probably end the artist's long-term relationship with the client and thus would be a complete failure in terms of customer relations.

Another ominous possibility would be for the client to refuse to pay the printer, thus jeopardizing the artist's relationship with the printer. While the printer had certainly done nothing wrong, the artist had referred the client to the printer. If the client wished to force the printer to sue and then, in turn, sue the artist, the waste of time and legal fees could do great damage to all parties.

Fortunately, the parties made the best of a bad situation. The client agreed to pay for the first printing and for the cost of reprinting a corrected version. The printer agreed to take no profit on the reprint and the artist agreed to waive the fee for the job.

All of the parties suffered, and it can certainly be argued that the final arrangement was not completely fair. Nonetheless, it is difficult to say what would be fairer. If the artist takes the position that the job was done correctly and the client is solely at fault for failing to proof, the artist will probably never receive another job from the client. Also, the artist clearly did make a mistake, but a mistake that the client should have seen. However, at least there was a cure, unlike the damage that can sometimes be caused by a virus being conveyed on a disk to a client's computer system.

Until we work with computers, we imagine them to be infallible. But anyone who has experienced the crash of a hard drive—or lost data in other ways that seem to fall on a scale ranging from unjust to cruel—knows how vulnerable these systems can be. One constant danger is the introduction of a virus into a healthy system. If that system does not have anti-virus safeguards, it may be damaged or completely destroyed.

If an artist is providing a disk to a client, what is the artist's responsibility to make certain that the disk contains no virus? Or, if an artist gives a disk containing a virus to a client, what will be the artist's liability if the client's system crashes and data is lost? In a less usual case, the client might supply the artist with a disk containing a virus. What liability would the client then have to the artist? Though the direct transmission of files and content over the Internet alleviates these problems somewhat, the possibility of inadvertently passing viruses between clients, artists, and printers remains a very real possibility.

The risk of liability suggests that artists may want to have any clients receiving a disk or other "digitized" content sign a waiver of the artist's liability. Such a waiver might recite that: "The Client accepts the risk of and shall hold the Artist harmless from and against any

loss, expense, or damage occasioned by any claim, demand, suit, or recovery against the Artist arising out of viruses or other defects contained in computer disks or other electronically transmitted data supplied by the Artist to the Client or to other parties at the Client's request."

Viruses and the other ailments that—often mysteriously—afflict computers suggest the need for innovations in contracts and ethical practices as well as in the design of chips and programs. Realizing that these sophisticated servants are vulnerable and taking appropriate business precautions is certainly a step in the right direction.

Statutes of Limitation

A statute of limitation sets forth the time within which an injured party must bring suit to have the injury remedied. After the limitation period has passed, no lawsuit can be maintained. The limitation period for actions based on contracts for the sale of goods under the Uniform Commercial Code is four years from the time of breach. The limitation period for actions based on breach of contract for services varies from state to state (for example, six years in New York). The limitation period in many states is longer for written contracts than for contracts that are oral, partly in writing, or implied. The artist contemplating legal action is well advised to seek redress promptly so that no question will arise regarding statutes of limitation.

Protection of Ideas

Ideas are denied copyright protection but can still be protected by contract. The idea may be a format, a campaign, a style, a game and so on. The problem comes upon submission of the idea, since the artist must feel assured of payment if the idea is used.

At the outset, it should be noted that many potential purchasers of ideas will have release forms which must be signed by persons submitting ideas before any consideration will be given to the submission. Such release forms bar any claims by the artist based upon a subsequent use of similar material by the potential purchaser. In addition, if the artist should be able to sue and recover despite the release form, the maximum reasonable value of the material is stipulated (for example, $200) and

the total recovery possible is limited to such an amount. These provisions are accompanied by a recital from the artist, such as "I recognize that there is always a likelihood that this material may be identical with, like or competitive to material which has or may come to you from other sources. Identity or similarity of material in the past has given rise to claims and disputes between various parties and has caused misunderstandings. You have advised me that you will refuse to examine or consider material unless you obtain for yourself complete protection from me against the possibility of any such claims." The artist can expect to be bound by such provisions, so caution should be exercised before signing a release form in order to submit an idea or manuscript.

The artist will be best served by an express contract providing for payment in the event the purchaser does use the idea. This is likely to be difficult to obtain, but the artist who simply volunteers an idea is basically at the mercy of the other party. The express contract should specify the consideration and other details of the transaction. If a standard price is paid for such material, it should be stated. Otherwise, a reasonable standard of value should be required as compensation. The submission agreement need not be complex, although it must suit the individual circumstances. For example, the artist might use a brief letter:

Model Idea Submission Letter

Dear _____:

I understand it is your practice to entertain or receive ideas or suggestions for (specify the market). I have developed such an (indicate what will be submitted) for submission and would like to disclose this to you. I understand that if you use it you will pay me a reasonable compensation based on current industry standards. Please advise me if I should send this to you.

 Sincerely yours,
 Jane Artist

It is not uncommon, however, for the artist to disclose ideas without having thought to obtain an express contract. Recovery may still be possible under a variety of doctrines

which will only be mentioned here: implied contract (which occurs when the parties indicate by their conduct that a contract exists), confidential relationships (applicable to some cases in which the party with less bargaining power trusts in the other party's good faith and discloses the idea), and quasi-contract (in which the law implies an obligation that the party receiving the idea pay for the benefits conferred). Especially for a confidential relationship or quasi contract, however, the courts may require that the idea be concrete, elaborated, or novel before recovery will be allowed. A written, express contract is by far the best way for an artist to protect an idea.

Lecture Agreements

Artists are frequently invited to lecture at schools and universities. The rewards of such appearances are both psychic and financial. However, the artist does run the risk that the host organization may not be set up to pay fees quickly. This can mean that expenses and time are invested by the artist, who must then wait before any compensation is received. A good way to deal with this problem is by having a written agreement that specifies when payment will be made, as well as detailing the exact nature of services the artist is to perform and what other reimbursements, such as for travel and other expenses, the artist will receive. An alternative to breaking down the expenses is to provide that the school will be responsible for all expenses, with a stipulated amount paid in advance and the balance paid while the artist is at the school or as soon as the artist can send in a statement detailing all the expenses.

If artwork is to accompany the artist's visit, insurance and risk of loss will also have to be resolved. And the artist may wish to retain the right to copyrights in any recordings or transcripts that are made in the course of the visit.

A relatively informal contract is shown here in the form of a letter from the artist to the university, which the university is to countersign and return a copy of to the artist. In fact, the exchange of letters between the artist and university can also serve as a contract as long as the terms of their understanding are clearly delineated.

Model Lecture Agreement
[Artist's Letterhead]
[Date]

Dear _____:

I am delighted by your invitation to address your group and would like this letter to serve as our contract with respect to the details of my visit. I will travel to (specify the location) on (specify the date or dates) and perform the following services: _____. In return you agree to pay my round-trip travel expenses in the amount of $_____ fourteen days prior to the date of my visit, to pay me at the end of my first day of services an honorarium of $_____, and to pay me additional expenses in the amount of $_____ on or before _____ for food, lodging, and the following other expenses: _____.
No recordings or transcripts of my visit or any art of mine shall be made without my express written consent, and all copyrights in such recordings or transcripts shall belong to me. If I provide examples of my art, you agree to bear any risk of loss or damage and to provide wall-to-wall insurance for said artwork in the amounts agreed to in a rider to this contract. You will also pay for any shipping and packing expenses necessary to bring the artwork to the University and return it to me. This contract is complete and can be modified only in writing. It will be governed by the laws of the State of_____.

Please sign both copies of this letter beneath the words "Consented and Agreed" to make this a binding contract between us, and return one copy to me for my files.

Sincerely yours,
The University

Consented and Agreed:

By: _____
Name and official title

Artist

Electronic Contracting

A number of legal frameworks ensure that electronic records of contract formation are the legal equivalent of traditional paper documents. The Uniform Electronic Transactions Act (UETA) is a form of "model legislation" that holds electronic communications to be the legal equivalent of paper records. The UETA is a form of "model" legislation enacted by every state, with the exception of Georgia, New York, Illinois, and Washington. Yet even these four states are covered by the federal Electronic Signatures in Global and National Commerce Act, or E-SIGN. (15 U.S.C. § 7001).

Both E-SIGN and the UETA guarantee that any electronic communication bearing an electronic signature has the same legal effect as a hand-signed, physical document. Signatures are broadly defined, and may bind a party if they adequately indicate the party's intent to be bound by a promise. Typing one's name at the end of an email, or leaving a voicemail message, may constitute an electronic signature. Indeed, even "unsigned" communications can give rise to a binding agreement. The critical element is "the intention to execute or adopt the sound or symbol or process for the purpose of signing the related record." This means that the simple act of clicking on a box that designates agreement to the terms of an electronic agreement is a valid signing.

Both laws also ensure that no electronic writing can be denied legal effect solely on account of its "electronic" character.

11 ORIGINAL ART: SALES, COMMISSIONS, AND RENTALS

The last chapter developed a background of contractual law in order to prepare for a discussion of the particular contracts into which an artist may enter. The artist's sale of an artwork directly to a purchaser, whether of an already completed work or of commissioned work, will be explored in this chapter along with the less common arrangement in which art is rented.

Basic Contractual Terms

If a purchaser decides to purchase a work, the artist should at least insist on a simple written contract in a form such as the Model Bill of Sale on page 116. It can be a brief form stating no more than the artist's name, the purchaser's name, the date, the title and description of the piece sold, the price, the sales tax due, if any, and the total amount payable. By including this basic information, the bill of sale is useful as a record of the transaction in at least two ways. First, it helps keep track of sales for income tax purposes, since all the prices paid are recorded. The artist need only transfer the amounts from the bills of sale to the ledger for income. Second, it can help in maintaining an overall inventory of work and keeping track of who owns the artist's work at any given moment. Again, the artist will want to transfer the information from the bill of sale to a ledger, file or slide book in which all the works created are recorded.

The bill of sale can also be expanded to deal with various contingencies that may occur in a given transaction. These may arise from the nature of the work, the manner of payment, or the artist's desire to enforce certain standards of treatment for the work after sale.

Such additional clauses can be added under Terms of Sale.

For example, the artist is the owner of copyright from the moment of creation of a work. However, the artist may still wish to express this in the bill of sale so the purchaser has no misunderstanding about his or her right to make reproductions. At the same time, the artist might want to permit limited reproductions that fall into the category of "fair use." Such a provision might read as follows:

The Artist hereby expressly reserves all rights whatsoever to copy or reproduce the work to the Artist, his or her heirs, executors, administrators, and assigns. The Artist has placed copyright notice in his or her name on the Work. The Artist shall not unreasonably refuse permission to reproduce the Work for catalogs and other publicity purposes incidental to public exhibition of the Work, provided all such reproductions bear appropriately placed copyright notice in a form identical to that appearing on the Work.

The risk of loss passes to the purchaser on delivery of the work as discussed on pages 128–129. If the purchaser is to pick up the work at the artist's studio, the risk of loss passes to the purchaser at such time as the purchaser could reasonably have been expected to pick up the work. The bill of sale can alter the time that risk of loss will pass to the purchaser. Of course, the passage of the risk of loss from one party to another should, ideally, be determined in view of the insurance coverage that each party has. This clause might read: "The risk of loss shall pass to the Purchaser on the _____ (specify when the risk of loss shall pass, such as 'on the date hereof')."

The bill of sale might include acknowledgment of receipt of the work by the purchaser and receipt of payment by the artist if these events occurred.

It is not uncommon for purchasers to make installment payments in order to purchase a work. Such a clause might provide: "The price shall be paid in _____ equal monthly installments, commencing on the _____ day of _____, 20_____, and ending on the _____ day of _____, 20_____."

If installment payments are used, the artist should consider retaining a security interest in the work until full payment has been made. Such a security interest would require the filling out and filing of Uniform Commercial Code Form 1 with the Secretary of State or local agency for filing, such as the County Clerk. This would protect the artist's interest in the work from other creditors of the buyer until such time as the artist has been paid in full. Form 1 is available at any stationery store that carries legal forms. It is easy to fill out, since it requires a limited amount of information. This includes the name and address of the debtor (the buyer is the debtor until all payments are made), the name and address of the secured party (who is the artist), and a description of the art that is covered. When signed by the artist and filed with the proper agency, the artist has precedence over any other creditor who might seek to assert a claim over the art or proceeds from the sale of the art. In general, the debtor must also sign Form 1 unless a separate security agreement has already been signed by the debtor.

Provisions relating to the integrity of the work, non-destruction, restoration, a right to exhibit and an art resale proceeds right are discussed in relation to the Projansky contract.

Instead of using a bill of sale, the terms of sale could also be set forth in a brief letter to the purchaser. The artist would sign the letter and the purchaser would sign beneath the words "Agreed to."

Projansky Contract

The Projansky contract, or The Artist's Reserved Rights Transfer and Sale Agreement, was drafted by New York City attorney Bob Projansky to rectify a common problem for artists, whereby they often lose their control over, and ability to profit from, artwork after it is sold. It seeks to create, by contract, rights that are somewhat similar to moral rights and art resale proceeds legislation. In reading over the provisions of the contract, reproduced on page 117, the artist should remember that not all of the proposed provisions need to be used for every sale and some sales will require provisions not present in the contract. The actual terms will vary, depending on the bargaining power of the parties, but the Projansky contract will aid the artist in developing an awareness of what can be demanded.

Model Bill of Sale
Artist's Letterhead

Date:_____

Purchaser:
(Name)
(Address) _____

Description of work: _____
Price: _____
Sales tax (if applicable): _____
Balance due: _____
Terms of sale: _____

Artist

Purchaser

AGREEMENT OF ORIGINAL TRANSFER OF WORK OF ART

fill in names, addresses of parties

Artist: _____ address: _____

Purchaser: _____ address: _____

WHEREAS Artist has created that certain Work of art ("the Work"):

fill in data identifying the Work

Title: _____ dimensions: _____

media: _____ year: _____ and

WHEREAS the parties want the Artist to have certain rights in the future economics and integrity of the Work. The parties mutually agree as follows:

fill in agreed value

1. **SALE:** Artist hereby sells the Work to Purchaser at the agreed value of $ _____
2. **RETRANSFER:** If Purchaser in any way whatsoever sells, gives, or trades the Work, or if it is inherited from Purchaser, or if a third party pays compensation for its destruction, Purchaser (or the representative of his estate) must within 30 days

(a) Pay Artist 15% of the "gross art profit," if any, on the transfer; and

(b) Get the new owner to ratify this contract by signing a properly filled-out "Transfer Agreement and Record" (TAR); and

(c) Deliver the signed TAR to the Artist.

(d) "Gross art profit" for this contract means only: "Agreed value" on a TAR less the "agreed value" on the last prior TAR, or (if there hasn't been a prior resale) less the agreed value in Paragraph 1 of this contract.

(e) "Agreed value" to be filled in on each TAR shall be the actual sale price if the Work is sold for money or the fair market value at the time if transferred any other way.

3. **NON-DELIVERY:** If the TAR isn't delivered in 30 days, Artist may compute "gross art profit" and Artist's 15% as if it had, using the fair market value at the time of the transfer or at the time Artist discovers the transfer.

4. **NOTICE OF EXHIBITION:** Before committing the Work to a show, Purchaser must give Artist notice of intent to do so, telling Artist all the details of the show that Purchaser then knows.

5. **PROVENANCE:** Upon request Artist will furnish Purchaser and his successors a written history and provenance of the Work, based on TAR's and Artist's best information as to shows.

6. **ARTIST'S EXHIBITION:** Artist may show the Work for up to 60 days once every 5 years at a nonprofit institution at no expense to Purchaser, upon written notice no later than 120 days before opening and upon satisfactory proof of insurance and prepaid transportation.

7. **NON-DESTRUCTION:** Purchaser will not permit any intentional destruction, damage or modification of the Work.

8. **RESTORATION:** If the Work is damaged, Purchaser will consult Artist before any restoration and must give Artist first opportunity to restore it, if practicable.

9. **RENTS:** If the Work is rented, Purchaser must pay Artist 50% of the rents within 30 days of receipt.

10. **REPRODUCTION:** Artist reserves all rights to reproduce the Work.

11. **NOTICE:** A Notice, in the form below, must be permanently affixed to the Work, warning that ownership, etc., are subject to this contract. If, however, a document represents the Work or is part of the Work, the Notice must instead be a permanent part of that document.

12. **TRANSFEREES BOUND:** If anyone becomes the owner of the work with notice of this contract, that person shall be bound to all its terms as if he had signed a TAR when he acquired the Work.

13. **EXPIRATION:** This contract binds the parties, their heirs, and all their successors in interest, and all Purchaser's obligations are attached to the Work and go with ownership of the Work, all for the life of the Artist and Artist's surviving spouse plus 21 years, except the obligations of Paragraphs 4, 6, and 8 shall last only for Artist's lifetime.

14. **ATTORNEYS' FEES:** In any proceeding to enforce any part of this contract, the aggrieved party shall be entitled to reasonable attorneys' fees in addition to any available remedy.

fill in date both sign

Date: _____

Artist

Purchaser

TRANSFER AGREEMENT AND RECORD

fill in data identifying the Work

Title: _____ dimensions: _____

media: _____ year: _____

fill in date

Ownership of the above Work of Art has been transferred between the undersigned persons, and the new owner hereby expressly ratifies, assumes and agrees to be bound by the terms of the Contract dated _____ between:

fill in names, addresses of parties

Artist: _____ address: _____ and

Purchaser: _____ address: _____

Agreed value (as defined in said contract) at the time of this transfer: $ _____

do not FILL in anything between these lines

Old owner: _____ address: _____

New owner: _____ address: _____

Date of this transfer: _____

fill in date fill in names of parties and Artist's address on both Notices

SPECIMEN NOTICE	cut out, affix to Work NOTICE
Ownership, transfer, exhibition and reproduction of this Work of Art are subject to a certain Contract dated _____ between:	Ownership, transfer, exhibition and reproduction of this Work of Art are subject to a certain Contract dated _____ between:
Artist: _____	Artist: _____
Address: _____ and	Address: _____ and
Purchaser: _____	Purchaser: _____
Artist has a copy.	Artist has a copy.

◄ 99 ►

117

Basic Terms

The Projansky contract, like the bill of sale, starts by setting forth the names and addresses of the parties. The "whereas" clauses explain the motives of the parties and prepare a rationale for the duties and rights under contract. The first whereas clause states that the artist has created a work of art which is described by the title, dimensions, medium, and year. The next "whereas" clause embodies the fundamental goal of the Projansky contract; it states that, "the parties want the Artist to have certain rights in the future economics and integrity of the Work." An earlier edition of the Projanksy contract set forth a more detailed basis for such rights: (1) that the value of the artwork sold would be affected by subsequent works created by the artist; (2) that the value of the work would, in fact, increase; (3) that the artist should share in any such increase in value; and (4) that the artist's intention in creating the work should be recognized by giving the artist a certain control over the work.

The Artist's Economic Benefits

The Projansky contract requires each work to have a permanently affixed notice showing that future transfers are subject to the contract (Article 11; Specimen Notice and Notice). Exchanges, gifts, inheritances, receipt of insurance proceeds, and similar transfer transactions relating to the work are covered by the contract as well as sales (Article 2). Depending on the nature of the transaction, either price or value is entered under Article 1 and used to calculate gross art profit, which is simply the excess of the present transfer value or price over the previous transfer value or price (Article 2 [d]). The purchaser agrees to have anyone who purchases the work sign a Transfer Agreement and Record (abbreviated as TAR, as required by Article 2 [b] and shown with the contract) and each subsequent purchaser is bound by all the terms of the original agreement (Article 12). Each time the work is sold, the seller within thirty days must file a current TAR signed by the new purchaser (Article 2 [b], [c]) and pay 15 percent of gross art profit to the artist (Article 2 [a]). The artist also reserves all reproduction rights in the work (Article 10) and has a right to receive 50 percent of any rentals received by the purchaser (Article 9).

The term of the economic benefits would be for the lives of the artist and spouse, plus an additional twenty-one years (Article 13).

The provisions can be illustrated by an example. In 2012 the artist sells a work for $3,000, subject to the Projansky contract. In 2015 the work is sold for $4,500. The owner who sells in 2015 must, within thirty days, file a current TAR and pay 15 percent of the $1,500 profit to the artist. If, in 2015, the artist had transferred ownership of the work through gift or barter, the Projansky contract could still be used. Similarly, if in 2015 the owner transfers the work by a method other than sale, the 15 percent of gross art profit would still have to be paid to the artist. If the party who purchases in 2015 for $4,500 resells in 2019 for $6,500, the artist will be entitled to receive 15 percent of $2,000 and a new TAR must be filed with the artist.

The Artist's Control

The artist also gains substantial control over the work after sale under the Projansky contract. Of course, reproduction rights are reserved to the artist (Article 10), which offers aesthetic control as well as economic benefits. The purchaser must give written notice to the artist of any intended exhibition (Article 4). The earlier edition of the contract had a much stronger provision that allowed the artist to either give advice or veto any proposed public exhibition. Upon showing satisfactory proof of insurance and prepaid transportation, the artist is entitled to borrow the work back from the purchaser for a sixty-day period every five years for exhibition at a nonprofit institution. The purchaser agrees not to "permit any intentional destruction, damage, or modification of Work," (Article 7), rights which the artist would not have in most states in the absence of a specific contractual provision. If the work is damaged, the purchaser must consult with the artist prior to making repairs and, if possible, use the artist to do the repairs (Article 8). The term of the contract is limited to the life of the artist as to notice of the purchaser's exhibitions, the artist's right to possession once every five years, and the artist's right regarding restorations. Lastly, any party forced to bring suit for a breach of the contract may demand reasonable lawyer's fees as well as other remedies (Article 14).

Benefits to the Purchaser

The Projansky contract might seem to favor only the artist, raising the question whether any but the most successful artist would have the bargaining power to persuade a purchaser to use the contract. However, there are benefits to the purchaser, the most important of which is the right to receive the artist's written certification of the work's provenance and history (Article 5). Also, the purchaser can feel more assured that the work is being treated as the artist would wish.

Arguments against the Projansky Contract

The merits of the Projansky contract have been warmly debated, although the contract has not come into wide use. Some argue that use of copyright by artists would provide much of the economic benefit sought by the Projansky contract. A difficult problem for the artist would be enforcement of the provisions requiring the filing of a current TAR and the payment of 15 percent of gross art profit. Since artworks as an investment may not be easily salable, the purchaser might be quite reluctant to accept a work that could only be resold if the new purchaser agreed to the substantial obligations of the Projansky contract. The purchaser may additionally be deterred by the prospect of work burdened by the Projansky contract passing through the purchaser's estate.

Also, there must be an increase in the value of the work for the artist to benefit economically. For many artists, who are fortunate simply to sell their work, this increase may not occur. The contract, therefore, will benefit artists whose work does not increase in value only by giving such artists some control over the work at the expense of negotiating a more complex contract. Since the artist will not have to pay purchasers if the work decreases in value, the contract is argued to be unfair. In any case, appreciation of a work may be caused by inflation, in which case the appreciated value is merely an illusion. But still the 15 percent must be paid back to the artist. Some collectors even argue that increases in the value of the artist's work are due to the collector giving the work prestige by the collector's ownership of the work. And if the artist's work sells for such high prices, why can't the artist create more pieces for a sale at the new price levels?

Arguments for the Projansky Contract

The best argument for the Projansky contract may simply be that it is an equitable proposal. Artists should receive part of the appreciation in value of work and maintain certain controls over the work after sale. The purchaser who refuses to purchase a work under such conditions fails to respect the integrity of either the artist or the artist's work. Copyright laws are most beneficial for works that are intended for mass production and sale, not for unique or original works which may well not be reproduced during the artist's lifetime. Also, since the payment back to the artist need only be made if the work appreciates in value, the purchaser will necessarily have made a profit each time such a payment must be made. And, frequently, an artist's early work represents the crucial period during which the artist's sensibility developed. Such work will always have a special aesthetic value to both the artist and the public. Often that aesthetic value will be translated into a substantial discrepancy between the prices such work brings compared to prices for later work. This would certainly be the case, for example, with an artist like de Chirico, whose early Surrealist work was crucial to an entire movement while his later work received no acclaim.

A Compromise

The use of the Projansky contract will depend on bargaining power. Any artist who can persuade a purchaser to use the contract would certainly be justified in doing so. Even greater restrictions could be required by the artist— for example, that the work not be resold by the purchaser for a certain period of time. However, many artists will wish to modify the Projansky contract in ways that are more favorable to the purchaser. Bob Projansky suggests, for example, placing a higher value for the work in Article 1 so the gross art profit is initially less. Another alternative Projansky proposes is to have the 15 percent of gross art profit be used as a credit against the purchase of additional works from the artist. But it is possible to go beyond Projansky's proposals for modification. For example, the 15 percent of gross art could be changed to a lower figure. Or the contract might require that only the first purchaser, but not subsequent purchasers, be bound to pay the 15 percent of appreciated value. The artist might be willing to go even

further and completely omit any requirement for payment of a part of appreciated value, but keep the requirements giving the artist privileges of control after the work is sold.

The issues raised by the Projansky contract penetrate to a deeper level than mere contractual negotiations. In fact, the very concept that art is to be treated as a commodity like other commodities is brought into question. Each artist will find a personal answer to either the fairness or the practicality of the Projansky contract, but there can be no doubt of the value of this innovative contract in bringing such issues to the attention of both artists and the public.

Commission Agreement

The crucial terms of a contract for a commissioned work must attempt to ensure that the purchaser will be satisfied with the finished work, while letting the artist be certain that the work in progress is, in fact, satisfactory. Of course, the artist should never agree to satisfy the purchaser, except perhaps to agree to create a work that reasonably should satisfy the purchaser. A subjective approach to measuring a purchaser's ultimate "satisfaction" is far more dangerous. A capricious purchaser might use a subjective satisfaction clause as an escape hatch, declining to purchase a perfectly good painting or sculpture that a hard-working artist completed in good faith. On the other hand, satisfaction must be the artist's goal. The more opportunities provided for consultation and approval in the process of creation, the better the likelihood of success in the regard.

The preliminary design provides the first opportunity to see whether the artist and purchaser mutually understand one another with regard to the intention and execution of the work (see Model Commission Agreement, Paragraph 1). The approximate budget, size of the finished work, materials, construction, scope of the artist's work, and responsibilities of the purchaser, such as posing or providing work-space, should all be specified (Paragraphs 1 and 2). The preliminary design fee must be paid upon signing the agreement. A completion date for the design is specified and the purchaser must notify the artist within two weeks of any proposed changes in the design. In the event of changes, the artist is entitled to receive additional compensation on an hourly basis. If the purchaser decides not to have the work

created, the artist retains the design fee and all rights in the designs remain the property of the artist (Paragraphs 5 [A] and 6).

Having specified the rights of the parties at the earliest stage of their relationship, the commission agreement then looks to the satisfactory completion of the designs and the continuation of work (Paragraph 2). In order to be certain the parties are in agreement as to the satisfactory progress of the work, a sequence of three progress payments is used. The first payment is made upon the purchaser's giving written approval of the preliminary design, the second when the work is one-third completed and the final payment, with any sales tax, upon completion of the work (Paragraph 2).

The issue of satisfaction is resolved by giving the artist the power to determine when the work is completed. Since the artist is "a recognized professional artist" and the purchaser wants the art created "in artist's own unique style," it is reasonable to allow the artist to determine completion of the work and deviate from the preliminary design if necessary (Paragraph 2). If, at any stage, the purchaser is dissatisfied, the agreement may be terminated (Paragraph 5). If this happens, the artist is entitled to a fee based on the degree of completion and owns the work, but the purchaser is freed of any further obligations to pay for completion of the work (Paragraph 5 and 6). Of course, the purchaser might negotiate in the contract for the return of some or all payments in the event of termination, but this will depend on the relative bargaining strengths of the parties.

A date is provided for completion and final delivery of the work, but the artist shall not be liable for damages in the event of delays (Paragraph 3, and 5 [D]). If the artist cannot finish the work within ninety days of the delivery date, the artist must return all progress payments to the purchaser but retains all rights in the work (Paragraph 5 [E]). The purchaser might well insist either that the specific reasons, such as illness or acts of God, be given to excuse delays or that the purchaser have an option to accept the partially completed work rather than merely to receive back the payments to date. Also, it is wise to specify where the work is to be received, any installation that may be necessary, and who will pay for insurance and the costs of transportation (Paragraph 4). Since the artist is excused from any penalties other than return of payments if

the work is not completed, the purchaser might also object that it is harsh to charge interest on unpaid progress payments and at the same time to give the purchaser no rights in the work until the final payment is made (Paragraph 2).

Other provisions cover the artist's ownership of copyright, the purchaser's agreement not to destroy or alter the work, the purchaser's obligation to maintain the work properly and the artist's rights to make repairs, if practical, and borrow the work for exhibition (Paragraphs 7, 9, 10, 11). If the work is a portrait, the purchaser waives his or her right of privacy. This is important if the artist becomes the owner of the work because of a termination or wishes to exploit the work in multiples. Obviously the artist should obtain the purchaser's approval of any plans to reproduce the work.

The commission agreement may be simpler or more sophisticated depending on the work. If the work will be of very long duration, more than three progress payments would be reasonable. The purchaser may require the artist to maintain insurance on the work in progress so that the work can be replaced at no cost to the purchaser in the event of damage or theft (Paragraph 4). Also, a provision should definitely be included governing the effect of the death of either the artist or the purchaser while the work is in progress. If the artist dies, a fair provision might be to have the work, in whatever stage of progress, belong to the purchaser, while the payments to the date of death remain in the artist's estate (Paragraphs 5 [F] and 6). The same provision would be reasonable if the death of the purchaser makes further performance impossible—for example, a portrait. Otherwise the estate of the purchaser should be required to perform as if the purchaser were living (Paragraph 13).

These are not all the possible terms of an agreement for a commissioned work, but knowledge of the more important terms and general approach will enable the artist to negotiate fair and effective agreements for commissions.

Model Commission Agreement

Agreement dated as of the _____ day of _____, 20_____, between _____ ("the Artist"), whose address is _____ _____, and _____ ("the Purchaser"), whose address is _____.

Whereas the Artist is a recognized professional artist; and

Whereas the Purchaser admires the work of the Artist and wishes to commission the Artist to create a work of art ("the Work") in the Artist's own unique style; and

Whereas the parties wish to have the creation of this work of art governed by the mutual obligations, covenants and conditions herein,

Now, Therefore, in consideration of the foregoing premises and the mutual covenants hereinafter set forth and other valuable considerations, the parties hereto agree as follows:

1. Preliminary Design. The Artist hereby agrees to create the preliminary design for the Work in the form of studies, sketches, drawings, or maquettes described as follows:_____ _____ _____ in return for which the Purchaser agrees to pay a fee of $_____ upon the signing of this Agreement. The Artist agrees to develop the preliminary design according to the following description of the Work as interpreted by the Artist:

 Title:

 Materials:

 Dimensions:

 Description:

 Price:

 The Artist shall deliver the preliminary design to the Purchaser within _____ days of the date hereof. The Purchaser may, within two weeks of receipt of the preliminary design, demand changes, and the Artist shall make such changes for a fee of _____ per hour; provided, however, that the Artist shall not be obligated to work more than _____ hours making changes.

2. Progress Payments. Upon the Purchaser's giving written approval of the preliminary design, the Artist agrees to proceed with construction of the Work, and the Purchaser agrees to pay the price of _____ for the Work as follows: one-third upon the giving of written approval of the preliminary design; one-third upon the completion of one-third of the construction of the Work; and one-third upon the completion of the Work. The Purchaser shall also promptly pay the following expenses to

be incurred by the Artist in the course of creating the Work: _____. The Purchaser shall pay the applicable sales tax, if any, with the final progress payment. Completion of the Work is to be determined by the Artist, who shall use the Artist's professional judgment to deviate from the preliminary design as the Artist in good faith believes necessary to create the Work. If, upon the Artist presenting the Purchaser with written notice of any payment being due, the Purchaser fails to make said payment within two weeks of receipt of notice, interest at the prime interest rate for banks in _____ shall accrue upon the balance due. The Purchaser shall have a right to inspect the Work in progress upon reasonable notice to the Artist.

3. Date of Delivery. The Artist agrees to complete the Work within _____ days of receiving the Purchaser's written approval of the preliminary design. This completion date shall be extended for such period of time as the Artist may be disabled by illness preventing progress of the Work. The completion date shall also be extended in the event of delays caused by events beyond the control of the Artist, including but not limited to fire, theft, strikes, shortages of materials and acts of God. Time shall not be considered of the essence with respect to the completion of the Work.

4. Insurance, Shipping, and Installation. The Artist agrees to keep the Work fully insured against fire and theft and bear any other risk of loss until delivery to the Purchaser. In the event of loss caused by fire or theft, the Artist shall use the insurance proceeds to recommence the making of the Work. Upon completion of the Work, it shall be shipped at the expense of _____ to the following address specified by the Purchaser: _____. If any special installation is necessary, the Artist shall assist in said installation as follows:_____.

5. Termination. This Agreement may be terminated on the following conditions:

(A) If the Purchaser does not approve the preliminary design pursuant to Paragraph 1, the Artist shall keep all payments made and this Agreement shall terminate.

(B) The Purchaser may, upon payment of any progress payment due pursuant to Paragraph 2 or upon payment of an amount agreed in writing by the Artist to represent the pro rata portion of the price in relation to the degree of completion of Work, terminate this Agreement. The Artist hereby agrees to give promptly a good faith estimate of the degree of completion of the Work if requested by the Purchaser to do so.

(C) The Artist shall have the right to terminate this Agreement in the event the Purchaser is more than sixty days late in making any payment due pursuant to Paragraph 2, provided, however, nothing herein shall prevent the Artist bringing suit based on the Purchaser's breach of contract.

(D) The Purchaser shall have the right to terminate this Agreement if the Artist fails without cause to complete the Work within ninety days of the completion date in Paragraph 3. In the event of termination pursuant to this subparagraph, the Artist shall return to the Purchaser all payments made pursuant to Paragraph 2, but shall not be liable for any additional expenses, damages or claims of any kind based on the failure to complete the Work.

(E) The Purchaser shall have a right to terminate this Agreement if, pursuant to Paragraph 3, the illness of the Artist causes a delay of more than six months in the completion date or if events beyond the Artist's control cause a delay of more than one year in the completion date, provided, however, that the Artist shall retain all payments made pursuant to Paragraphs 1 and 2.

(F) This Agreement shall automatically terminate on the death of the Artist, provided, however, that the Artist's estate shall retain all payments made pursuant to Paragraphs 1 and 2.

(G) The exercise of a right of termination under this Paragraph shall be written and set forth the grounds for termination.

6. Ownership. Title to the Work shall remain in the Artist until the Artist is paid in full. In the event of termination of this Agreement pursuant to Subparagraphs (A), (B), (C) or (D) of Paragraph 5, the Artist shall retain all rights of ownership in the Work and shall have the right to complete, exhibit and sell the Work if the Artist so chooses. In the event of termination of this Agreement pursuant to Paragraph 5 (E) or (F), the Purchaser shall own the Work in whatever degree of completion and shall have the right to complete, exhibit and sell the Work if the Purchaser so chooses. Notwithstanding anything to the contrary herein, the Artist shall retain all rights of ownership and have returned to the Artist the preliminary design, all incidental works made in the creation of the Work and all copies and reproductions thereof and of the Work itself, provided, however, that in the event of termination pursuant to Paragraph 5 (E) or (F) the Purchaser shall have a right to keep copies of the preliminary design for the sole purpose of completing the Work.

7. Copyright. The Artist reserves all rights of reproduction and all copyrights in the Work, the preliminary design, and any incidental works made in the creation of the Work. Copyright notice in the name of the Artist shall appear on the Work, and the Artist shall also receive authorship credit in connection with the Work or any reproductions thereof.

8. Privacy. The Purchaser gives to the Artist permission to use the Purchaser's name, picture, portrait, and photograph, in all forms and media and in all manners, including but not limited to exhibition, display, advertising, trade, and editorial uses, without violation of the Purchaser's rights of privacy or any other personal or proprietary rights the Purchaser may possess in connection with reproduction and sale of the Work, the preliminary design, or any incidental works made in the creation of the Work.

9. Non-Destruction, Alteration, and Maintenance. The Purchaser agrees that the Purchaser will not intentionally destroy, damage, alter, modify, or change the Work in any way whatsoever. If any alteration of any kind occurs after receipt by the Purchaser, whether intentional or accidental and whether done by the Purchaser or others, the Work shall no longer be represented to be the Work of the Artist without the Artist's written consent. The Purchaser agrees to see that the Work is properly maintained.

10. Repairs. All repairs and restorations which are made during the lifetime of the Artist shall have the Artist's approval. To the extent practical, the Artist shall be given the opportunity to accomplish said repairs and restorations at a reasonable fee.

11. Possession. The Purchaser agrees that the Artist shall have the right to possession of the Work for a period not to exceed sixty days for the purpose of exhibition of the Work to the public, at no expense to the Purchaser. The Artist shall provide proof of sufficient insurance and prepaid transportation. The Artist shall have such right of possession for one period not to exceed sixty days every five years.

12. Non-Assignability. Neither party hereto shall have the right to assign this Agreement without the prior written consent of the other party. The Artist shall, however, retain the right to assign monies due to the Artist under the terms of this Agreement.

13. Heirs and Assigns. This Agreement shall be binding upon the parties hereto, their heirs, successors, assigns, and personal representatives, and references to the Artist and the Purchaser shall include their heirs, successors, assigns, and personal representatives.

14. Integration. This Agreement constitutes the entire understanding between the parties. Its terms can be modified only by an instrument in writing signed by both parties.

15. Waivers. A waiver of any breach of any of the provisions of this Agreement shall not be construed as a continuing waiver of other breaches of the same or other provisions hereof.

16. Notices and Changes of Address. All notices shall be sent to the Artist at the following address:_____ and to the Purchaser at the following address:_____. Each party shall give written notification of any change of address prior to the date of said change.

17. Governing Law. This Agreement shall be governed by the laws of the State of _____.

Artist:_____

Purchaser:_____

Rental Agreement

Under this agreement, the purchaser has the right to purchase the artwork and apply rental payments to the purchase price (see Model Rental Agreement, Paragraph 12). The agreement is not meant to be adopted as is, but to be modified and adapted to the artist's needs. The artist will have to decide, for example, how much to charge (museums frequently charge about 5 percent of the sales price per month, but the artist might want to charge a little more) and how long the artist wishes the renter to be able to lease the work. The artist will also have to set a policy on who must pay for shipping and insurance while the work is in transit. Although it is obviously to the artist's advantage to have the renter pay these costs, the artist may be willing to absorb them if there is a good chance the rental will result in a sale. In Paragraph 4 a blank has been left for the amount for which the artwork is to be insured.

Since the artist continues to own the rented work, it is particularly important that it be protected. The use is limited to personal use by the renter and any reproductions must be approved by the artist (Paragraphs 6 and 9). Maintenance of the work is determined by the artist (Paragraph 7). The location of the work is also restricted and the artist is given a right of access to the work (Paragraph 8). In the event of sale, the artist has continuing rights to borrow the work and repair the work while the purchaser agrees not to destroy or damage the work (Paragraph 12). A security interest retained by the artist allows the artist to file Uniform Commercial Code Form 1 with the Secretary of State or a local agency such as the County Clerk to gain priority over any creditors of the Renter that might try to seize the rented work (Paragraph 13 and see pages 125–126). Since the artist is far more likely to have to sue than the renter, a provision regarding attorney's fees is included (Paragraph 14).

Model Rental Agreement

Agreement dated as of the _____
day of _____, 20____, between
_____ (the "Artist"),
whose address is _____,
and _____
(the "Renter"), whose address is
_____.

Whereas the Artist is a recognized professional artist who creates artworks for rental and sale; and

Whereas the Renter admires the work of the Artist; and

Whereas the Renter wishes to rent and have the option to purchase certain works by the Artist; and

Whereas the parties wish to have the rentals and any purchases governed by the mutual obligations, covenants, and conditions herein,

Now, Therefore, in consideration of the foregoing premises and the mutual covenants hereinafter set forth and other valuable considerations, the parties hereto agree as follows:

1. Creation and Title. The Artist hereby warrants that the Artist created and possesses unencumbered title to the works of art listed and described on the attached Schedule of Artworks ("the Schedule").
2. Rental and Payments. The Artist hereby agrees to rent the works listed on the Schedule at the rental fees shown thereon and the Renter agrees to pay said rental fees as follows:_____ _____.
3. Delivery and Condition. The artist shall be responsible for delivery of the works listed on the Schedule to the Renter by the following date: _____. All costs of delivery (including transportation and insurance) shall be paid by _____. The Renter agrees to make an immediate written objection if the works upon delivery are not in good condition or appear in any way in need of repair. Further, the Renter agrees to return the works in the same good condition as received, subject to the provisions of Paragraph 4.
4. Loss or Damage and Insurance. The Renter shall be responsible for loss of or damage to the rented works from the date of delivery to the Renter until the date of delivery back to the Artist. The Renter shall insure each work for the benefit of the Artist up to _____ percent of the Sale Price shown in the Schedule.
5. Term. The term of this Agreement shall be for a period of _____ months, commencing as of the date of the signing of the Agreement.
6. Use of Work. The Renter hereby agrees that the rental under this Agreement is

solely for personal use and that no other uses shall be made of the work, such other use including but not being limited to public exhibition, entry in contests and commercial exploitation.

7. Framing, Cleaning, Repairs. The Artist agrees to deliver each work ready for display. The Renter agrees not to remove any work from its frame or other mounting or in any way alter the framing or mounting. The Renter agrees that the Artist shall have sole authority to determine when cleaning or repairs are necessary and to choose who shall perform such cleaning or repairs.

8. Location and Access. The Renter hereby agrees to keep the works listed on the Schedule at the following address:_____ _____, which may be changed only with the Artist's written consent, and to permit the Artist to have reasonable access to said works for the purpose of taking photographs of same.

9. Copyright and Reproduction. The Artist reserves all reproduction rights, including the right to claim statutory copyright, on all works listed on the Schedule. No work may be photographed, sketched, painted or reproduced in any manner whatsoever without the express, written consent of the Artist. All approved reproductions shall bear the following copyright notice: © by (Artist's name) _____ (Year).

10. Termination. Either party may terminate this Agreement upon fifteen (15) days written notice to the other party. This Agreement shall automatically terminate in the event of the Renter's insolvency or bankruptcy. Upon termination, the Artist shall refund to the Renter a pro rata portion of any prepaid rental fees allocable to the unexpired rental term, said refund to be made after the works have been returned to the Artist in good condition.

11. Return of Works. The Renter shall be responsible for the return of all works upon termination of this Agreement. All costs of return (including transportation and insurance) shall be paid by _____.

12. Option to Purchase. The Artist hereby agrees not to sell any works listed on the Schedule during the term of this Agreement. During the term the Renter shall have the option to purchase any work listed on the Schedule at the Sale Price shown thereon. This option to purchase shall be deemed waived by Renter if he or she fails to make timely payments pursuant to Paragraph 2. If the Renter chooses to purchase any work, all rental fees paid to rent that work shall be applied to reduce the Sale Price. Any purchase under this paragraph shall be subject to the following restrictions:_____ _____.

(A) The Artist shall have the right to borrow any work purchased for up to sixty (60) days once every five years for exhibition at a nonprofit institution at no expense to the Renter-Purchaser, provided that the Artist gives 120 days advance notice in writing prior to the opening and offers satisfactory proof of insurance and prepaid transportation.

(B) The Renter-Purchaser agrees not to permit any intentional destruction, damage, or modification of any work.

(C) If any work is damaged, The Renter-Purchaser agrees to consult with the Artist before restoration is undertaken and must give the Artist the first opportunity to restore the work, if practicable.

(D) The Renter-Purchaser agrees to pay the Artist any sales or other transfer tax due on the full Sale Price.

(E) The Renter agrees to make full payments of all sums due on account of the purchase within fifteen days after notifying the Artist of the Renter's intention to purchase.

13. Security Interest. Title to, and a security interest in, any works rented or sold under this Agreement is reserved in the Artist. In the event of any default by the Renter, the Artist shall have all the rights of a secured party under the Uniform Commercial Code and the works shall not be subject to claims by the Renter's creditors. In the event of purchase of any work pursuant to Paragraph 12, title shall pass to the Renter only upon full payment to the Artist of all sums due hereunder. The Renter agrees not to pledge or encumber any works in his or her possession, nor to incur any charge or obligation in connection therewith for which the Artist may be liable.

14. Attorney's Fees. In any proceeding to enforce any part of this Agreement, the aggrieved party shall be entitled to reasonable attorney's fees in addition to any available remedy.

15. Non-Assignability. Neither party hereto shall have the right to assign this Agreement without the prior written consent of the other party. The Artist shall, however, retain the right to assign monies due to him or her under the terms of this Agreement.

16. Heirs and Assigns. This Agreement shall be binding upon the parties hereto, their heirs, successors, assigns, and personal representatives, and references to the Artist and the Renter shall include their heirs, successors, assigns, and personal representatives.

17. Integration. This Agreement constitutes the entire understanding between the parties. Its terms can be modified only by an instrument in writing signed by both parties.

18. Waivers. A waiver of any breach of any of the provisions of this Agreement shall not be construed as a continuing waiver of other breaches of the same or other provisions hereof.

19. Notices and Changes of Address. All notices shall be sent to the Artist at the following address:_____ _____, and to the Renter at the following address: _____ _____ _____. Each party shall give written notification of any change of address prior to the date of said change.

20. Governing Law. This Agreement shall be governed by the laws of the State of _____.

Artist:_____

Renter:_____

Schedule of Artworks
Rental Sale

Title	Medium	Size	Fee	Price
1.				
2.				
3.				
4. [Etc.]				

12 ORIGINAL ART: OWNERSHIP, INSURANCE, SUBMISSIONS, AND RESALE PROCEEDS

O f course the artist owns whatever original art he or she creates, subject to the "work-for-hire" exception discussed on pages 39–40. This art owned by the artist must be protected against unintentional transfers when reproduction rights are sold as well as against loss, damage, or theft. When submitted either for the purpose of selling the original art or reproduction rights in that art, the submission form must provide for the safe return of the art.

As discussed in chapter 7, moral rights connect the artist to original art after sale. In a similar way, France and other countries give the artist a right to share in the proceeds from certain sales of art. California has used this concept as the basis to enact an art resale proceeds law which gives artists a right to share in profitable resales of the art.

Issues pertaining to original art are discussed throughout this book. However, this chapter focuses on certain unique or novel issues of significance to the artist.

Ownership When Selling Rights

California, Georgia, Nevada, New York, and Oregon have enacted statutes to protect the artist's ownership of original art when reproduction rights are sold. This addresses the problem of a client who buys reproduction rights but also believes the original art is being sold without an additional fee. The state laws will force the parties to discuss this issue and reach agreement about it. This is especially important in view of the fact that the client making reproductions is in possession of the art. In states without such laws, the artist might be found to have sold the art by an oral or implied contract.

The California and Oregon laws resolve any ambiguity as to what reproduction rights are transferred in favor of the artist. I originally drafted this bill for presentation to the National Conference of State Legislatures. The support of the Graphic Artists Guild and the American Society of Media Photographers was crucial to the enactment of these laws. The California law reads as follows:

988. Ownership of physical work of art; reservation upon conveyance of other ownership rights; resolution of ambiguity (a) For the purpose of this section: (1) The term "artist" means the creator of a work of art. (2) The term "work of art" means any work of visual or graphic art of any media including, but not limited to, a painting, print, drawing, sculpture, craft, photograph, or film. (b) (b) Whenever an exclusive or nonexclusive conveyance of any right to reproduce, prepare derivative works based on, distribute copies of, publicly perform, or publicly display a work of art is made by or on behalf of the artist who created it or the owner at the time of the conveyance, ownership of the physical work of art shall remain with and be reserved to the artist or owner, as the case may be, unless such right of ownership is expressly transferred by an instrument, note, memorandum, or other writing, signed by the artist, the owner, or their duly authorized agent. (c) Whenever an exclusive or nonexclusive conveyance of any right to reproduce, prepare derivative works based on, distribute copies of, publicly perform, or publicly display a work of art is made by or on behalf of the artist who created it or the owner at the time of the conveyance, any ambiguity with respect to the nature or extent

of the rights conveyed shall be resolved in favor of the reservation of rights by the artist or owner, unless in any given case the federal copyright law provides to the contrary. (Civil Code, section 988)

This law bolsters the protection for the artist provided by the copyright law and offers a model that can be enacted in other states.

Ownership of Negatives

Photographers will want to know about an unusual feature of the law relating to physical negatives. If the photographer works independently, of course, all rights in the copyright and all negatives will belong to the photographer, unless a contract transfers rights. If the photographer works for hire, the person hiring the photographer will own the copyright. This means that the photographer cannot sell or distribute any copies of those photographs without the permission of the copyright owner. But the photographer may be deemed to own the negatives, unless the photographer agrees otherwise. The increasing dominance of digital photography does nothing to diminish the importance of owning "negatives." For example, many digital photographers shoot and store images in an uncompressed "RAW" file format that retains the maximum amount of information a digital camera's sensor can capture. While subsequent publications of the image generally require some additional processing of a "digital negative," the original RAW files are generally retained by the photographer. The photographer becomes, in essence, a warehouse, storing negatives or RAW files to meet requests for photographs from former clients. (*Corliss v. E. W. Walker*, 64 F. 280) The question of whether RAW could be treated the same as negatives is not one that courts have yet addressed. However, there is widespread consensus within the digital photography community that RAW is the digital equivalent of physical negative. To that end, many influential photographers have thrown their support behind an "open RAW" initiative that would encourage standardization of RAW file formats, and prevent camera manufacturers from imposing proprietary standards on what photographers believe to be the "direct equal to film negatives."

The rule may have ramifications for fine artists who employ photographers to make a photographic record of work. For example, the photographer Paul Juley was hired by portrait artist Everett Raymond Kinstler to photograph Kinstler's paintings. After Juley's death, an issue arose as to the ownership of the negatives which Juley had retained. Kinstler said Juley had orally agreed that the negatives belonged to Kinstler and Juley kept the negatives only for convenience. Juley, however, had bequeathed the negatives with the rest of his work to the Smithsonian Institution. Kinstler, presumably barred by rules of evidence from giving self-serving testimony regarding a contract with a man no longer living, found that the general rule applied giving ownership of the negatives to the photographer. So the negatives today belong to the Smithsonian Institution. The moral is, once again, to use written agreements.

Insurance and Risks of Loss

The artist may wish to insure original art in order to receive insurance proceeds in the event of its loss or destruction. The artist should seek an agent who is familiar with insuring art works. Such insurance may cover art only when in the artist's studio or may extend to cover art that is in transit. Valuation can be difficult with art, and the artist might even have to incur the extra expenses of an appraisal. The fact that an insurance company has the artist pay premiums based on a certain valuation of the art does not necessarily mean the company will not dispute that valuation in the event of a claim. Inquiry should be made of the agent regarding this issue.

The artist should ascertain whether certain risks are excluded from coverage, such as losses caused by war, faulty film processing, or mysterious disappearances. Also, once the artist has insurance, exact records as to the art subject to the insurance become crucial in order to document claims. If the artist's premises or work may be dangerous, the artist should consider liability coverage to pay for possible accidents.

If the artist has no insurance and the work is damaged or stolen while in the artist's studio, the artist simply loses the work. But if the artist has sold the work, when does the risk of loss pass to the purchaser? The general rule is that if a work must be shipped, the risk of loss passes to a purchaser upon delivery. Thus, the artist would normally bear the risk of loss while the work was being shipped to a purchaser.

However, if the purchaser buys the work at the artist's studio and leaves the work to be picked up later, the purchaser bears the risk of loss. This is because a sale by a non-merchant seller under the Uniform Commercial Code passes the risk of loss to the purchaser after such notification as would allow the purchaser a reasonable opportunity to pick up the work. For example, when a bronze sculpture was sold along with the contents of a house, it was not reasonable to expect the purchaser to take possession of the sculpture within twenty-four hours of being given the keys. The risk of loss remained on the seller, but might have shifted to the purchaser if the purchaser had a longer period in which to pick up the sculpture (*Deitch v. Shamash*, 56 Misc.2d 875, 290 N.Y.S.2d 137). The contract of sale offers the artist an opportunity either to shift any risk of loss to the purchaser or to provide for insurance on the works sold.

Bailment

A bailment is a situation in which one person allows his or her lawfully owned property to be held by another person. For example, an artist might lend a work to a museum, leave a painting for framing, drop off a portfolio at an advertising agency, or leave film to be developed at a film lab. In all of these relationships, when both parties benefit from the bailment, the bailee (the person who takes the artist's property) must exercise reasonable care in safeguarding the work. If that person is negligent and the work is damaged or lost, the artist (as the bailor) will recover damages. Even if the work has no easily ascertainable market value, damages would still be awarded based on the intrinsic value of the work to the artist.

However, the reasonable standard of care required in a bailment can be changed by contract. Often, for example, film labs will require an artist to sign a receipt which limits the liability of the lab to the cost of replacing film which is ruined. This is so despite the great value that may exist in the images recorded on the film. Similarly, a museum, a frame maker, an advertising agency and so on might seek to limit liability, perhaps to the extent of requiring the artist to sign a contract under which the artist would assume all risks of injury to the work.

The artist should seek just the opposite— that is, to have the other party agree to act as an insurer of the work. This would mean that the other party would be liable if the work were damaged for any reason, even though reasonable care might have been exercised in safeguarding the work. Even if the artist signs a limitation on the liability of a lab or other bailee, the artist should document how any loss occurs. If the bailee is extraordinarily negligent, it may be that the limitation will be invalid. At least, the language of the limitation should be closely examined before the artist decides whether or not to make a claim.

A technical issue that arises is whether all of the artist's bailments are for mutual benefit or whether certain bailments would either be for the sole benefit of the bailor or the sole benefit of the bailee. If the bailment is for the sole benefit of the bailor, the bailee will only be liable for gross negligence. If the bailment is for the sole benefit of the bailee, the bailee can be liable even though reasonable care is taken with the goods. A bailment for mutual benefit will usually be found when the bailee takes possession of the goods as an incident to the bailee's business, even if no consideration is received.

Submission/Holding Forms

Rather than relying on the law pertaining to bailment, artists may wish to protect their art by use of a submission/holding form. The following discussion should be prefaced by the observation that the concern about loss of physical art and damages for such loss will be far less significant if the photography or other art is in digital form,

The American Society of Media Photographers (ASMP) developed a delivery memo for its members to have signed by the recipient of photographic positives or transparencies. The contract provides for the recipient to have the liability of an insurer as to submitted materials while either in the recipient's possession or in transit. Other provisions require that the recipient: make any objections to the terms of the delivery memo within ten days; pay a fee for the recipient's keeping materials beyond fourteen days; not use the materials without an invoice transferring rights in the work; pay a specified amount per transparency in the event of loss or damage (often set at $1,500 per transparency); not project any transparencies; and submit to arbitration.

The setting of damages in advance is a frequent practice to avoid the necessity of extensive

proofs to establish proper damages at trial. The courts will normally enforce such provisions for damages, known as liquidated damages, as long as damages would be difficult to establish and the amount specified is not unreasonable or a penalty. Rather than using $1,500 as a standard minimum figure, it would be wise to list a value for each photograph. This will avoid any risk of a court concluding that the $1,500 figure is excessive as to some transparencies.

In any case, other artists may wish to follow the lead of ASMP whenever work leaves their hands. Certainly, however, the artist entering into a bailment relationship should avoid a contract that lowers the reasonable care usually required to safeguard the artist's work.

Model Submission/Holding Form

This model form can be adopted by any artist for use when work is to be submitted to and held by a client.

Model Submission/Holding Form

Artist's Letterhead

Date:_____

Client's name:_____
address:_____

Art enclosed Value
(Describe by subject
and type of art)
1.
2.
3.
4.
5.
6.
7.
8.
9.
10.

Subject to all terms and conditions on reverse side.

[Model Holding/Submission Form -- reverse side]

Terms and Conditions

The submitted art is original and protected under the copyright law of the United States. This art is submitted to the client in confidence and subject to the following terms and conditions:

1. Acceptance. Client accepts the listing and value of art submitted as accurate if not objected to in writing by immediate return mail. Any terms of this form not objected to in writing within ten days shall be deemed accepted.

2. Copyright. Client agrees not to copy or modify directly or indirectly any of the art submitted, nor will client permit any third party to do any of the foregoing. Reproduction shall be allowed only upon Artist's written permission specifying usage and fees.

3. Return of Art. Client agrees to assume responsibility for loss, theft or damage to the art while held by Client. Client further agrees to return all art by bonded messenger, air freight, or registered mail. Reimbursement for loss, theft, or damage to each piece of art shall be in the amount of the value entered for that piece. Both Client and Artist agree the specified values represent the value of the art.

4. Holding Fees. Art held beyond _____ days incurs the following daily holding fees :_____
 [Enter the holding fees for each piece art of for the categories of art submitted.]

5. Arbitration. Client and Artist agree to submit all disputes hereunder in excess of $_____ [Enter the maximum amount which can be sued on in Small Claims Court, since this is usually the quickest remedy.] to arbitration in _____ [Enter the Artist's city and state.] under the rules of the American Arbitration Association. The arbitrator's award shall be final and judgment may be entered on it in any court having jurisdiction thereof.

Accepted for Client

Company Name
By:_____

Authorized Signature

Name and Title

Droit de Suite

The artist who sells original art seldom benefits from appreciation of the art in the future. Because of this, in 1920, France created the *droit de suite*, a right of artists to share in the proceeds from sales of their work. The legislation was prompted in part by a Forain drawing showing two children dressed in rags looking into an expensive auction salesroom and saying, "Look! They're selling one of daddy's paintings."

The measure, later incorporated in the copyright provisions under the law of March 11, 1957, was a response to the stereotyped image of the artist living in penury while works created earlier sold for higher and higher prices. The droit de suite lasts for the term of the copyright, during which time the proceeds benefit the artist's spouse and heirs. The droit de suite applies to original works when sold either at public auction or through a dealer, although the extension of the droit de suite to dealers by the law of March 11, 1957, appears not to have been followed or enforced. The droit de suite is collected when the price is over ten thousand francs. The rate is 3 percent upon the total sales price, not merely the profit of the seller. Artists utilize *S.P.A.D.E.M. (Société de la Propriété Artistique, des Dessins et Modèles)*, an organization like ASCAP, to collect proceeds due under the droit de suite. *S.P.A.D.E.M.*, by reciprocal agreements with similar organizations, also receives proceeds due its artists from sales of work in Belgium and West Germany.

The droit de suite is payable to a foreign artist if a French artist could collect a similar payment in the country of the foreign artist. Despite some commentary to suggest that United States artists should be able to collect the droit de suite in France, it appears that United States artists are not entitled to the droit de suite because the United States offers no such right to foreign artists. Foreign artists can collect the French droit de suite in any case if such artists have resided in France for five years, not necessarily consecutively, and have contributed to the French life of the arts. This survey covers only the French law, of course, and the laws of other countries with rights similar to the droit de suite can vary significantly. A right to such proceeds exists in some form in countries as diverse as Algeria, Belgium, Brazil, Chile, Congo, Costa Rica, Equador, Germany, Guinea, Holy See, Hungary, Italy, Ivory Coast, Luxembourg, Madagascar, Mali, Morocco, Peru, Philippines, Portugal, Senegal, Spain, Tunisia, Turkey, and Uruguay.

Resale Proceeds Right

The French droit de suite has at least been discussed for the United States under the designation of a resale proceeds right. Such a right would require the payment back to the artist of a certain percentage of either proceeds or profits from subsequent sales of the artist's work. The Visual Artists Rights Act required the Register of Copyrights, in consultation with the Chair of the National Endowment for the Arts, to conduct a study on the feasibility of implementing resale royalties. That report did not strongly support resale royalties, so national resale royalty legislation appears unlikely at this time.

California has taken the lead in this area by enacting a 5 percent resale proceeds right for artists. Whenever an original painting, sculpture, drawing or original work of art on glass is sold in California or sold anywhere by a seller who resides in California, the artist must be paid 5 percent of the gross sale price within ninety days of the sale. This right may not be waived by the artist, although a percentage higher than 5 percent may be used. For resale proceeds to be payable, however, the sale must be at a profit and the price must be $1,000 or more. Also, the artist must be either a citizen of the United States or a two-year resident of California at the time of the resale. The sale must take place during the artist's life or within twenty years after the artist's death, if the artist dies after January 1, 1983.

The law excludes from coverage a resale by an art dealer to a purchaser for a period of ten years after the initial sale by the artist to the dealer. This would also exclude intervening resales between dealers. Also, stained glass incorporated in a building is not considered resold when the building is sold.

Monies due the artist for resale proceeds are protected from the dealer's creditors. If the seller cannot locate the artist within ninety days to make payment, the proceeds are deposited with the California Arts Council. After seven years, if the council has been unable to locate the artist, the proceeds are used to acquire fine art for the Art in Public Buildings program. The law took effect on January 1, 1977, and

applies to works sold after that date regardless of when the works were created or first sold. If the seller does not make payment, the artist has the right to bring suit for damages within three years after the date of sale or one year after discovery of the sale, whichever period is longer. The winning party in any suit is entitled to reasonable attorney's fees as determined by the court.

Challenge to Resale Rights

When the California law was enacted, many people wondered if it might be unconstitutional. A number of arguments were proposed as to why the law should be invalid. Finally, a dealer sold two paintings subject to the provisions of the law and then brought a lawsuit challenging the law's constitutionality. He argued that the law: (1) is pre-empted by the copyright law; (2) violates due process; and (3) violates the contracts clause of the Constitution.

The federal district court rejected these assertions and found the law to be valid, stating:

Not only does the California law not significantly impair any federal interest, but it is the very type of innovative lawmaking that our federalist system is designed to encourage. The California legislature has evidently felt that a need exists to offer further encouragement to and economic protection of artists. That is a decision which the courts shall not lightly reverse. An important index of the moral and cultural strength of a people is their official attitude towards, and nurturing of, a free and vital community of artists. The California Resale Royalties Act may be a small positive step in such a direction. (Morseburg v. Balyon, *201 U.S.P.Q. 518, aff'd 621 F.2d 972, cert. denied 449 U.S. 983*)

Resale Rights Contracts

Private contract can also create an art proceeds right. If an artist and collector agree that there will be a payment back to the artist on subsequent resales, the artist would be able to gain by private bargaining what French artists possess by national legislation. But the Projansky contract, which provides for such an art proceeds right as well as attempting to create moral rights for United States artists, has not been widely adopted. The Projansky contract appears on page 117 and is discussed on pages 118–120..

13 UNIQUE ART AND LIMITED EDITIONS

The pricing of art has none of the abstract purity of supply and demand curves intersecting on a graph. Factors such as aesthetic impact, the reputations of the artist and art dealer, vogue and general market conditions, all influence an often mystifying process of which price is the end product. Even when artists have evolved apparently unmarketable art, receptive dealers have adeptly priced this art (or art object surrogates, such as conceptualist documentation) for sale to equally receptive collectors. From Marcel Duchamp's ready-made to Lawrence Weiner's words which have no specific tangible form, the market has absorbed every manner of art object and even the absence of such an object. When Ian Wilson's discussions are sold, the collector is given a paper indicating that a discussion in fact took place on a certain date. And a word piece by Weiner will, at the collector's request, be accompanied by a letter placing the piece within the collector's responsibility.

Scarcity and Price

Scarcity, however, is a crucial determinant of price and affects even a marketplace open to innovation. Scarcity, in the present context, is the limited quantity of a work offered for sale. A unique work (one of a kind) is the ultimate in scarcity and, in terms of salability, is preferable to a work that is not unique (even if it is one of a very small number). Traditionally, editions of fine prints and sculpture castings have resolved issues relating to scarcity with a simple and accepted marking system—1/8, 2/8, 3/8 and so on. These markings are a device of the law, a method of promising the collector that only a limited number of prints or castings have been

made. But this system is inadequate to deal with the issues relating to uniqueness posed by much contemporary art.

Ideally, one might imagine an equation that would elucidate all issues relating to price:

$A^2 + U = V$
A = assimilation into the art context
U = uniqueness
V = value

This equation implies that A is of greater importance than U in determining V. But, in fact, recent art movements have made uniqueness an especially problematic marketing factor. Andy Warhol could exactly duplicate a Brillo box or Campbell Soup can. Dan Flavin can repeat an arrangement of standard, commercially produced fluorescent lights as many times as he wishes. Dennis Oppenheim's photographic documentation of *Canceled Crop* or his other earthwork projects can be reproduced in unlimited quantity. Appropriation artists value their power to take what they want— exact copies without limitation, artistic style, even the life style of the copied artist. The increasing popularity of the digital medium exacerbates the problem of uniqueness, since digital files are infinitely duplicable in either digital or printed forms.

Yet, for the collector, limitation is an important factor in valuing work for purchase. It is intriguing to speculate whether collectors would care about scarcity if art could not be bought and sold, since uniqueness should have no bearing on aesthetic appreciation. If, for example, five collectors owned an identical work that each collector believed unique, would enjoyment of the work diminish upon learning of the existence of the other copies?

In fact, even collectors who knew their work existed in a small number of copies were upset when faced with another collector's copy of the work. The relationship between a collector and his or her art can be as intense, and irrational, as sexual jealousy.

Of course, duplication of art has always been possible in varying degrees, although the idea that paint on canvas necessarily produces uniqueness is still a popular myth. Robert Rauschenberg's *Factum I* and *Factum II*, two nearly identical abstract paintings, were probably prompted in part by a desire to demythify and deromanticize (as to Abstract Expressionism specifically) the uniqueness of paint on canvas. The Photo Realists could, if they wished to take the time, reproduce work in paint on canvas as closely as one photograph can duplicate another.

The Issue of Uniqueness

Uniqueness is not a new issue, therefore, but rather one that has assumed far greater importance and subtlety. Sol LeWitt, for example, can produce two unique works that appear identical. His intention in creating the work resides in his choice of materials, wood for one work and metal for the other. As LeWitt states in Sentences on Conceptual Art, "If an artist uses the same form in a group of works and changes the material, one would assume the artist's concept involved the material."

But a variation in materials would not create unique works if the artist's intention

Figures 11. *Factum I* and *Factum II* by Robert Rauschenberg.

Figures 12. *Factum I* and *Factum II* by Robert Rauschenberg.

were directed toward a different kind of content. Lawrence Weiner is concerned with the communicative content expressed by his word pieces, so for him a unique object is unimportant. Regardless of variation in the materials, size, or even the medium of expression, there is no unique object—only a single unique content. But the artist's intention toward the work may not always involve the issue of uniqueness. An artist working with narrative, for example Peter Hutchinson whose work includes the *Alphabet* series, is concerned with appearance as well as written content. Is a new visual content, such as taking a color photograph and reproducing it in a smaller black and white version, going to create a new unique work when the written content remains unchanged? Endless variations of media, material, size, color, arrangement, and the number of objects composing a piece are possible. Especially when photographs or other easily duplicated materials are used, and when content is the central issue, both the artist and collector may wonder whether a version changed in form is unique. This is directly in conflict with formalistic painting, in which a change in a single brush stroke or color makes a new unique work.

The Artist's Intent

Nor can the artist's concept of what is unique solely govern the matter. It might be contended that any legal definition of uniqueness should conform to the artist's intent or the opinion of experts such as art historians and critics. But a court determining the uniqueness of a work would consider statements by an artist or experts as merely factors in reaching a decision. Constantin Brancusi's statement that his *Bird in Space* was an art work (which could be brought duty free into the United States) did not dispose of that lawsuit, although an enlightened decision ultimately did find *Bird in Space* a "pleasing to look at and highly ornamental" art work rather than dutiable scrap metal.

A legal determination of an art issue can vary considerably from the consensus of art opinion, even in those cases in which a consensus could be obtained. As Hilton Kramer stated, after testifying as an expert in the flag desecration case involving art protesting the Vietnam War, "Suddenly complicated questions of aesthetic intention and artistic realization ... were cast into an alien legalistic vocabulary that precluded the very possibility of a serious answer."

If the artist transferred the copyright to a collector, then the collector might object to the artist making other versions of the work on the grounds that these versions infringed the collector's copyright. Artists selling physical art should reserve ownership of the copyright, or allow the collector only limited rights to reproduce the work. However, issues as to duplication arise even when the artist has reserved the copyright.

For example, the artist Frank Stella painted three versions of a painting titled *Marquis de Portago*. The first version was done with ordinary aluminum paint, the second with alumichrome, and the third with clear liquitex paint in which aluminum particles were suspended. The first version was traded to another artist, while the second version was sold to a collector. When the second version was damaged, Stella replaced it with the third version. When the collector was going to auction his version of the painting, he learned of the existence of the first version. This caused the reserve price to fall from $35,000 to $17,000, and the collector sued Stella for not disclosing the existence of the first version. Another issue was Stella's intention to restore the second version, using new and improved restoration techniques.

Although the collector had not asked if a duplicate work existed, the court decided that: "An artist has a duty to a purchaser of his work to inform the purchaser of the existence of a duplicate work which would materially effect [sic] the value or marketability of the purchased work." Nonetheless, the court awarded no damages because of its conclusion that: "There is no credible evidence that the auctioned painting would have brought a higher price at auction had not the existence of the other Marquis de Portago been disclosed." The court also noted that: "The use of different paint made a discernable difference," leaving us to wonder whether an award of damages would have been more likely had the copying been exact. In any event, *Stella v. Factor* (Sup. Ct. L.A. County, No. C58832, 1978) dramatizes why all parties should understand whether a work is unique.

Computers make duplication of art even easier. The file containing a digitized image can be exactly duplicated without any generational

loss of quality. How can the artist who works with computers assure the collector that a work will be unique or a limited edition? Short of transferring the copyright to the collector, or destroying all copies of the files containing the work after outputting a single copy, the artist must incorporate into the transaction some guidelines on which the collector is willing to rely.

Warranty of Uniqueness

Trust between the artist, dealer, and collector usually will make uniqueness the art issue which it should be. If the work is one of several identical pieces, the artist will indicate this by the traditional designation—1/3, 2/3, 3/3. This numbering, in legal terms, is a warranty as discussed on pages 108–109. In any sale, a warranty is an express or implied fact on which a purchaser can rely. The artist can create a warranty by a marking such as 1/5, a writing, or even a verbal statement. If a collector requests reassurance that a work is unique, the artist's statement is a warranty upon which the collector can rely. Dan Flavin puts warranties to a significant use by signing a certificate which must accompany the components to make them into a work of art (a drawing showing the arrangement of the components is also provided). This protects collectors, since it removes any incentive for copying of Flavin's work by someone who might simply purchase and arrange the components after seeing an exhibition. Jan Dibbets warrants that the negatives for his work will be held at the Stedelijk Museum so that print replacements can be made in the event of any fading of color.

The uniqueness warranty is a valuable device if the nature of the work would easily permit duplication. It reaffirms the trust a collector must give the artist. But the warranty is perhaps most useful if a changed version might be argued by the collector to be merely a copy, despite the artist's belief that each version is unique. The artist should not have to risk legal penalties if a court at some future time were to disagree with the artist's aesthetic evaluation as to uniqueness. Here the artist can, simultaneously with the giving of the warranty, disclose the basis of one work's uniqueness (for example, a change in materials) in relation to other unique works. This essentially offers the artist the opportunity to fix his or her aesthetic evaluation into the legal matrix of the transaction.

Uniqueness in art is hardly a new issue, but it is an issue that has assumed greater significance with the reproducible nature of the art of recent movements. Ideally, the sensibility and intention of the artist should control the issue of whether a work is unique. Thus, the collector must have a clear understanding of the artist's intention. The artist's warranty, coupled with a disclosure of similar works that the artist considers unique, will enable a collector to make an informed decision in an atmosphere of mutual trust. And, by a legal mechanism, uniqueness will remain the art issue that it should be, instead of becoming the legal issue that it should not be.

Fine Prints

Fine prints have offered an opportunity for people of moderate means to enjoy art that is original but not unique. The growing enthusiasm for fine prints has been remarkable. To avoid unethical selling practices as a wider public began to purchase fine prints, California, New York, and Illinois each enacted legislation governing the sale of fine prints. These states were later joined by Arkansas, Georgia, Hawaii, Iowa, Maryland, Michigan, Minnesota, Oregon, South Carolina, and Wisconsin. In addition to having familiarity with this legislation, the artist must also be able to negotiate the contracts necessary for the publication of fine prints.

California Legislation

In 1971 California became the first state to enact legislation regulating the sale of fine prints. This statute was extensively amended in 1982, including extending its coverage to multiples other than fine prints. The statute starts by defining fine art multiple, fine print, master, artist, signed, unsigned, art dealer, limited edition, proofs, written instrument and person. A fine art multiple is "...any fine print, photograph (positive or negative), sculpture cast, collage or similar art object produced in more than one copy."

The statute limits its application to any sale of a multiple for a price of $100 or more, exclusive of the cost of framing. When an art dealer sells such a multiple in California, a written instrument must be provided to the purchaser (or intermediate seller, in the case of a consignment) that sets forth certain information regarding the multiple. An artist, although

not otherwise considered an art dealer, must also provide this information whether selling or consigning a multiple. If the artist does this, he or she will not be liable to the final purchaser of the multiple. This information includes the name of the artist, whether the artist signed the multiple, a description of the process by which the multiple was produced, whether the artist was deceased at the time the master image was created or the multiple was produced, whether there have been prior editions and in what quantity, the date of production, the total size of a limited edition (including how many multiples are signed, unsigned, numbered, or unnumbered and whether proofs exist), and whether the master has been canceled after the current edition. The requirements vary depending on whether the multiple was produced before 1900, from 1900 to 1949, or from 1950 to the present. In giving the name of the artist (for years after 1949) and the other information, the art merchant is held to have created express warranties on which the purchaser may rely.

An art dealer regularly engaged in the sale of multiples must conspicuously post the following sign: "California law provides for the disclosure in writing of certain information concerning prints, photographs, and sculpture casts. This information is available to you, and you may request to receive it prior to purchase." A dealer may disclaim knowledge of any required information, but such a disclaimer must be specific as to what is being disclaimed. Also, the dealer may still be liable if reasonable inquiries would have produced the required information. A charitable organization selling multiples may post a sign disclaiming knowledge of the required information (and include such a disclaimer in any catalog for the sale or auction). In such a case, the charitable organization would not have to provide the required information, unless it used an art dealer as its selling agent.

The penalties for violating the law may include refunding the cost of the multiple plus interest (if the multiple is returned to the dealer), damages of triple the cost of the multiple if the violation is willful, and damages or other available remedies. If the purchaser wins, he or she may receive court costs together with reasonable attorney's and expert witnesses' fees. However, if the court determines the purchaser started the lawsuit in bad faith, it

may award expenses to the dealer. Injunctions may be obtained by private purchasers or law enforcement officials to prevent violations of the multiples law.

The California law was amended in 1988 to require a certificate of authenticity (instead of a written instrument) when an art dealer sells a multiple into or from the state. A certificate of authenticity is defined as "a written or printed description of the multiple which is to be sold, exchanged, or consigned by an art dealer." The law requires every certificate to contain the following statement: "This is to certify that all information and the statements contained herein are true and correct."

New York Legislation

New York originally enacted legislation in 1975 to prevent deceptive acts in the sale of fine prints and posters. This legislation was replaced in 1982 when New York enacted a law governing visual art multiples, which include "prints, photographs (positive or negative), and similar art objects produced in more than one copy and sold, offered for sale, or consigned in, into, or from this state for an amount in excess of one hundred dollars exclusive of any frame." In structure, this new law is similar to California's. Certain information must be disclosed or specifically disclaimed by art merchants selling multiples. The purchaser may generally rely on these disclosures as express warranties. Violations may be enjoined or be the basis for damages (including triple damages) and the award of court costs and reasonable fees for attorneys and expert witnesses.

New York broke new ground with a 1990 amendment extending the multiples law to sculpture. Effective January 1, 1991, sculpture, even if unique, that is made in New York must have a mark identifying "the foundry or other production facility at which such sculpture was made, and the year that such sculpture was made." In addition, the producer must keep records for twenty-five years that detail such information as the name of the artist, the title of the sculpture, the foundry, the medium, the dimensions, the year produced, the number of castings, whether the sculptor was deceased at the time of the casting, and whether the sculpture is authorized by the artist or the artist's estate. As to sculpture in limited editions, the information must include whether and how the sculpture and edition

is numbered, the size of the edition (including prior versions), and whether any castings exist beyond the size of the edition. For copies of sculpture, the information must indicate how the copy was made, whether the copy was authorized by the artist or the estate, and whether the copy is of the same size and material as the master. Unauthorized sculptures, which are those made without the written permission of the artist, can only be sold legally if the phrase "This is a reproduction" accompanies the identifying mark and date affixed to the sculpture.

This information is in written form and accompanies the sculpture when sold. The law makes the giving of such written information create express warranties, thereby protecting the purchaser in the event any of the information is inaccurate. See page 108–109 regarding warranties.

Contracts for Limited Editions

Contracts for limited editions can vary greatly with the particular situation of the artist. This section discusses the relevant considerations for editions of fine prints, but the same principles apply to limited editions of sculpture.

First, the fine prints must be printed. The artist may undertake this, either personally or by contracting with a printer, and then either sell the fine prints directly to purchasers or enter into a distribution agreement with a gallery. Alternatively, the gallery, as a publisher, may agree with the artist for the creation of one or more editions of the prints, which the gallery would finance and distribute.

If the artist must use a printer, the artist should ensure that the printer's work will be satisfactory. The best way to accomplish this is to specify materials and methods for the printing as well as to require the artist's approval at various stages of the printing process. In the case of digital artists printing content developed on a computer, calibration of color profiles for both display and output hardware is essential towards obtaining predictable and consistent results. Many professional labs will print in accordance with custom color profiles used by the artist, which more or less ensures that the ultimate print will reflect the image seen onscreen. Many artists also purchase their own printing equipment, given the plummeting costs and skyrocketing quality of home and small business printers.

Once the artist has the fine prints, sales can be made either directly to purchasers or through a gallery. If sales are made directly, the artist should review the coverage of sales of artworks in chapter 11, since the same considerations apply. If a gallery is to act as the artist's agent, the artist should consult chapter 14 as to sales by galleries.

The gallery might, however, act as publisher as well as distributor of the edition or editions of fine prints, as in the sample agreement shown on page 139. Now the gallery is paying the costs of producing the fine prints and will want certain concessions from the artist. The degree to which the artist meets the gallery's demands will of course depend on the bargaining strength of the two parties.

The gallery's most extreme demand would be to own all rights in the fine prints. This would include ownership of the fine prints, ownership of the plate or other image used for the printing, and ownership of the copyright. The artist would receive a flat fee and artist's proofs, but would not receive income from sales of the fine prints by the gallery.

The artist should bargain for an arrangement in which the artist owns the prints, which are held by the gallery on consignment. Because the gallery has paid the costs of making the prints, however, the gallery might demand that these costs be deducted from sales receipts prior to any payments to the artist. If the gallery and the artist split sales receipts on an equal basis, the artist would receive 50 percent of sales receipts after subtraction of production costs. The artist might not agree to the subtraction of such costs or might demand a higher percentage than 50 percent. Any advance of money to the artist against future receipts from sales should be stated to be non-refundable.

Both the gallery and the artist will want to agree regarding the size limits of each edition, the number of prints to be kept by the artist, the number to be consigned to the gallery, and whether the prints will be signed. The artist should usually seek a short term for the contract, perhaps one year, with a provision for the equal division of all unsold prints consigned to the gallery at the end of the contract's term. If the gallery defaults under the contract, all the prints should be returned to the artist. The artist should remain the owner of all prints, and title should pass directly from the artist to any purchaser.

The price at which the gallery will sell the prints should be specified, but the artist should resist any effort to set the same price for sales of the prints owned by the artist. If the contract will cover more than one edition, a schedule can be annexed at the end of the contract to cover the additional editions. The artist should, however, remain free to create competing prints without offering the gallery any option rights to such prints. If the gallery insists on such exclusivity, of course, the artist may have to make concessions in this regard.

The artist should be willing to warrant the originality of the prints. By this same token, the artist should have full artistic control over production. If the gallery is to choose the printer, the artist should insist on the right to approve the gallery's choice. The artist should not agree to any provisions subjecting the prints to the approval or satisfaction of the gallery. The artist should retain the copyright, and copyright notice in the artist's name should be placed on the prints. The printer should be required to give the artist certification of the cancellation of the plate or other image.

The remaining considerations in sales of prints through galleries are basically the same as with sales of any artwork. Provision must be made for periodic accountings and payments, inspection of the gallery's books, insurance, responsibility for loss, termination, and the other terms fully discussed in chapter 14.

Print Contract with Gallery

Dear Artist:

This letter is to be the agreement between you and Pisces Gallery regarding the publication of a suite of six of your woodcuts of fish in paper size 9 ½ by 13 inches. The works selected are as follows: sunfish, trout, eel, bass, carp and whale. You shall create one hundred (100) impressions of each woodcut, which are to be signed and numbered accordingly by you. You may print ten (10) additional proofs for your personal use, and these are to be signed as artist's proofs. You shall affix copyright notice in your name to all prints and all copyrights and rights of reproduction shall be retained by you upon sales to purchasers. You shall provide Pisces Gallery with certification of the cancellation of the blocks after completion of the printing.

Pisces Gallery shall be solely responsible for and pay all costs of the printing. Pisces Gallery shall prepare the title page, descriptive material and justification page.

Nonrefundable advances of $1,000 shall be paid to you upon delivery of each one hundred (100) prints. The minimum selling price of each suite shall be $500. Pisces Gallery shall exercise best efforts to sell the suites and shall receive 50 percent of all sales revenues as its commission. The balance due you, after subtraction of any advances paid to you, shall be remitted on the first day of each month along with an accounting showing the sale price and number of prints sold and the inventory of prints remaining. Title to all work shall remain in you and pass directly to purchasers. Pisces Gallery shall insure all work for at least the minimum sale price and any insurance proceeds shall be equally divided.

The term of this agreement shall be one (1) year. After one (1) year, this agreement shall continue unless terminated upon either party giving sixty (60) days written notice of termination to the other party. Upon termination the inventory remaining shall be equally divided between Pisces Gallery and you. Your share shall be promptly delivered to you by Pisces Gallery at its expense. If, however, termination is based upon a breach or default by Pisces Gallery under this agreement, all inventory remaining shall be promptly delivered to you at Pisces Gallery's expense. You agree to sign such papers as may be necessary to effectuate this agreement.

Kindly return one copy of this letter with your signature below.

Sincerely yours,
John Smith

President, Pisces Gallery

CONSENTED AND AGREED TO:

Artist

Print Documentation

Reproduced here by permission of Gemini G.E.L. is the front (in reduced size) and back of their form giving both print documentation and terminology.

CHAPTER

14 SALES BY GALLERIES AND AGENTS

The artist will often seek professional assistance in selling work. Relationships with galleries and other agents can take numerous forms. Arrangements are frequently oral, although the artist should insist on written agreements whenever possible. This chapter details many of the considerations involved in such agreements, but the artist should, as always, consult a lawyer for individual advice when such agreements are being negotiated. Helpful books include *The Artist-Gallery Partnership* by Tad Crawford and Susan Mellon and *The Law (in Plain English)®* *for Galleries* by Leonard DuBoff (Allworth Press).

Consignment or Sale

The usual agreements in the United States involve work consigned to a gallery that has either a limited agency to represent only that particular work or an exclusive agency to represent all of the artist's work. The artist remains the owner of the work, and the gallery receives a commission on sale or rental.

If agreements are informal and unwritten, questions can arise whether a work has been consigned or sold to a gallery. New York, California, and a majority of the other states have enacted statutes providing that any fine art left with an art gallery or dealer is held on consignment in trust for the artist. Generally, the gallery will hold any money from sales of such work in trust for the artist. Even if a the gallery subsequently purchases consigned work, the work remains trust property held for the artist until full payment has been made. The gallery's creditors have no right to make claims against the work or funds held in trust for the artist, even if the artist's rights to the

work or funds have not been protected from creditors by filings of the financing statements required under the Uniform Commercial Code. Any waiver of these favorable rights by the artist will be invalid. The New York statute does allow the artist to give up his or her rights to have sale proceeds considered trust funds. This applies only to sales proceeds greater than $2,500 per year. The waiver must be written and, in any case, will not apply to works initially on consignment that are purchased by the gallery. The California statute requires first payment of the trust funds to the artist unless the artist agrees otherwise in writing.

Other jurisdictions with statutes governing consignments are Alaska, Arizona, Arkansas, Colorado, Connecticut, District of Columbia, Florida, Georgia, Idaho, Illinois, Iowa, Kentucky, Maryland, Massachusetts, Michigan, Minnesota, Missouri, Montana, New Hampshire, New Jersey, New Mexico, North Carolina, Ohio, Oregon, Pennsylvania, Rhode Island, Tennessee, Texas, Washington, and Wisconsin. *The Artist-Gallery Partnership* by Tad Crawford and Susan Mellon (Allworth Press) has a helpful appendix offering details about the coverage of these statutes.

The artist must consider the wide variations in the specific coverage and provisions of these statutes. What types of art are covered, whether the art or funds created by the sale of the art are trust funds, whether any rights can be waived by the artist, and whether the art and proceeds from sales are protected against the claims of creditors of the gallery are among the many issues on which the statutes vary. To take one example, California defines the fine art protected under the law as including "a painting, sculpture, drawing, work of graphic

art (including an etching, lithograph, offset print, silk screen, or a work of graphic art of like nature), a work of calligraphy, or a work in mixed media (including a college, assemblage, or any combination of the foregoing art media)" while the New York law protects, "a work of fine art, craft or a print of [the artist's] own creation," each of which terms has its own definition. The way to find out if a particular state has enacted such a law—and, if so, the provisions of the law—is to contact the state legislature or an attorney in that state.

Artists should take warning if their states do not have such statutes. Written consignment agreements are a necessity to protect the artist by showing the artist's ownership of the work.

A simple consignment agreement, in which the gallery's agency is only for the sale of a given work or works, would specify the gallery's receipt on consignment of certain works which would be listed by title, medium, size, retail selling price, and the gallery's commission percentage on each work. The agreement would also state when payment must be made to the artist and indicate that the artist remains owner of the work until title passes to a purchaser. The agreement should provide for the return of the work upon the artist's request. Also, it would be specified that the agreement was not a general agency and that the artist would have no responsibility to pay commissions on works other than those consigned.

Model Consignment Agreement
[Artist's Letterhead]
[Date]

Dear _____:

You hereby confirm receipt on consignment of my artworks as follows:

Title Medium Size Retail Price Commission
1.
2. _____
3. _____
4. _____
5. _____

I reserve title to the works until sale, at which time title shall pass directly to the purchaser. You shall remit to me the retail price of each work less your commission within thirty days after sale. This consignment applies only to works consigned under this agreement and does not make you a general agent for any works not so consigned.

At any time before sale of the works you will return the works to me immediately upon my request.

Sincerely yours,
Artist

Consented and Agreed to:
XYZ Gallery
By: _____

A simple consignment agreement appears on page 147–148, but this agreement could encompass many more aspects of the relationship between the artist and dealer. This chapter will focus on agreements under which the gallery represents all or most of an artist's output over a period specified in the contract. But many of the provisions relevant to such representation agreements can be used in the simple consignment as dictated by the given transaction.

The less common arrangement of outright purchase by the gallery might involve a situation in which the gallery would wish to be the exclusive seller of the artist's work. Alternatively, the gallery might require either a given portion of the artist's output or a right of first refusal on all work. The gallery might also want to fix the prices at which the artist could make private sales. The outright purchase arrangement is rare, however, and this chapter will concentrate on representation agreements in which work is consigned in an ongoing relationship of representation between the artist and the gallery.

A model form of artist-gallery agreement appears on pages 147–148 and its provisions are referred to in order to illustrate points covered in the text.

Parties to the Agreement

When a gallery serves as agent for an artist, the representation agreement creates a bond of trust and an obligation of good faith dealing on the part of the gallery. Often the gallery will be required to exercise best efforts to sell the artist's work, although this clause is difficult to enforce. In addition to assurance of certainty that the gallery deals only for the artist's interest, the artist will also want the gallery to keep

confidential any information about its business dealings for the artist.

The artist will be especially reassured that the gallery will live up to this fiduciary role, however, when the artist personally knows and trusts the gallery personnel. The artist might well wish to provide for termination of the agreement in the event of the death of a trusted dealer, a change of personnel, a transfer of ownership of the gallery, or even a change in the legal form of the gallery (see model agreement, Article 2). The model agreement also deals with this by prohibiting assignment by the gallery of the agreement (Article 12). The artist might also want to be certain that the location of the gallery would remain the same and, perhaps, that all artwork consigned would be kept at that location.

The gallery may in turn request certain assurances of fair dealing by the artist. These might be in the form of warranties that the artist is the creator of the work and has title to the work.

Scope of the Agency

The artist may choose, in a number of ways, to circumscribe the gallery's authority as agent.

The geographic extent of the agency could be limited to a single city or country, instead of the entire world (model agreement, Article 1).

The duration of the contract should be limited and provision made for the return of work and costs of return at the end of the term (model agreement, Article 2). The artist should probably hesitate to enter into an agreement for more than two years, unless the contract provides the artist with a right of termination—for example, on thirty or sixty days notice (model agreement, Article 2). A shorter term could also be extended by options to renew.

The provision describing the kinds of work covered is important (model agreement, Article 1). The gallery may want to receive a commission even on work the artist sells (model agreement, Article 4). If the gallery sells only the artist's paintings, it must be resolved whether the gallery will receive commissions on the artist's sales of work in other media, such as drawings or graphics. Also, will the gallery be entitled to a percentage when the artist is commissioned for a work (model agreement, Article 4), gives away a work either to a family member or to a charity, or barters a work to pay dentist's or accountant's bills?

The gallery may demand a right to a percentage when the artist sells work created before the agency relationship was established or after the agency terminates. One possible resolution would be to exempt a certain number of works or dollar value of sales by the artist from the requirement of the gallery's commission. This approach is particularly feasible when the artist is not located closely enough to the gallery to be competitive. Or the artist might simply wish to limit the proportion of output that the gallery would have a right to demand. This raises a related issue of the gallery's right to inspect the artist's studio to see work, but, in fact, the artist would normally welcome such interest on the part of the gallery.

Few contracts will provide for all the possible contingencies discussed, yet the artist must be aware of the different limitations which can be placed upon the gallery's authority as agent.

Exhibitions

The artist will want to be guaranteed an exhibition each year (model agreement, Article 3). The dates (during the exhibition season), duration, space, and location of the exhibition should all be specified. Also, the costs of the opening, advertisements, catalogs, announcements, frames (and ownership of the frames after the exhibition), photographs of the work, shipping either to purchasers or for return to the artist, storage, and any other costs should all be detailed as either the gallery's or the artist's responsibility (model agreement, Article 3).

The artist may demand a specific budget, especially for publicity and advertising. The artist should avoid any situation in which the gallery might later seek to place a lien on the work, perhaps refusing to return it, for costs incurred under the agreement. The artist may also wish a specific provision ensuring the confidentiality of the artist's personal mailing list. The artist will usually be required, and want, to consent to the use of the artist's name, biography, and picture in the publicizing of the exhibition. The artist might also want the gallery to use best efforts in seeking museum exhibitions for the artist. In return, the gallery might request complimentary credit on any loan by the artist to museums or in any magazine articles displaying the artist's work.

Another important consideration in exhibitions is artistic control (model agreement,

Article 3). The artist will wish to avoid inclusion in a group exhibition without the power to prevent inappropriate work being shown in the same exhibition. Also, the artist should control the choice of work in either a solo or group exhibition. At the same time, the protection of the artist's reputation may require control over the publicity and advertising relating to the exhibition. An extreme form of control would be the power to prevent any given purchaser from buying a work. Or the artist might simply insist by an appropriate clause in the representation agreement that a contract specified by the artist (such as the Projansky contract) be used for all sales.

Gallery's Commission

There are two ways in which a gallery may take compensation on the sale of consigned work. The net price method specifies an amount—for example, $1,000—that will be paid to the artist in the event of sale. The gallery may then sell the work at any price, $1,500 or $4,000, and pay the artist the $1,000 originally agreed to. The net price method is not common, especially if the artist lacks control over the gallery's selling price, because of its possible unfairness.

The commission method, in which the gallery takes a percentage of the sale price, is much more common (model agreement, Article 4). The percentage varies greatly, but 25 to 50 percent would be the usual limits of the range. A relatively high commission rate may be justified by the gallery's expenses and effort on behalf of an artist, such as extensive promotion, travel abroad to sell work, and expensive gallery installations. Each situation must be evaluated on its own special facts.

If the gallery's commission is one third, a sale of a $3,000 work will yield the artist $2,000. A risk that the artist faces here is the computation of the value to be assigned a given work when a global invoice—that is, an invoice including many works—is used. If ten paintings are sold for $20,000, the artist who owned one of the works might find the value assigned that work—$1,000 or $2,000 or $3,000—is arbitrary. The artist can prevent this problem by specifying a sale price in advance.

An artist whose work is expensive to construct might request that the cost of materials be subtracted from the sale price before the commission of the gallery is taken. Or the artist might request different commission rates for works done in different media. A sliding scale based on the amount of sales would be another possible commission arrangement. Also, the problem of double commissions, when one gallery consigns a work to a second gallery, must be resolved.

The right of the gallery to rent work to potential purchasers will be determined by the agreement. If this is permitted, a commission rate against such rental income must be specified. Also, the agreement will then need certain additional articles detailing rental rates, copying restrictions, and, especially, insurance. The representation agreement should also indicate whether the gallery will receive any commission on lecture fees, copyright royalties, or similar income received by the artist.

Pricing

Both gallery and artist will generally wish to control prices (see model agreement, Article 5). The gallery may wish to sell more cheaply to maintain a volume of sales, while the artist may wish to keep prices higher for the enhancement of reputation which accompanies steadily rising values for an artist's work. Usually, prices are set by consultation between the artist and the gallery. The agreed-upon prices may then be set forth in a schedule attached to the agreement (model agreement, Record of Consignment). The agreement may well give the gallery the power to vary prices slightly—for example, 10 percent—for flexibility. Also, the agreement will have to provide for the discounts customarily given to certain purchasers, such as museums. If the gallery has complete power to set prices, the artist should beware of sales at low prices to dummies, people who seem to buy the work when, in reality, they are holding the work for the gallery to sell later at higher prices.

The artist may want to restrict the gallery as to the prices placed on works of the artist to be sold by the gallery for its own account or for other galleries or collectors. Also, if the gallery has the right to sell works at auction, the artist may want the gallery to guarantee receipt of an acceptable fair market price at auction. If the gallery sells through other galleries, the artist should require that the other galleries maintain the prices set in the agreement with the original gallery.

Accounting

The artist will want the gallery to regularly record all business transactions in books that the artist may inspect. Periodically, perhaps every three or six months, statements of account indicating sales, commissions, and proceeds due the artist should be sent out by the gallery (model agreement, Article 7). The artist will wish to receive the names and addresses of all purchasers, which most galleries will be willing to provide. If the gallery objects, a compromise might be to have a list of purchasers held by a third party so the artist will not be cut off from the work, but the gallery will have its market protected.

Payments

The artist must feel confident that the gallery will meet payment obligations with reasonable promptness (model agreement, Article 6). The gallery may want corresponding assurances as to payments of commissions based on sales made by the artist. If credit is extended to a purchaser, the risk of loss should be the gallery's. The artist should be paid even if the purchaser defaults or, at least, have a right to the first proceeds received by the gallery from the purchaser (model agreement, Article 6). If the gallery has the right to accept works in payment for the artist's works sold, a fair method of valuation must be agreed to. The respective percentages for the artist and gallery would then be applied to this valuation instead of to a sales price. When work may be sold in foreign countries, the artist would be well advised to require payment in United States dollars. A provision regarding losses due to delays in converting foreign currencies might also be included in the agreement.

Payments are sometimes made to artists in the form of a monthly stipend. This is an advance given by the gallery regardless of whether or not sales have been made. The artist should insist that such advances are nonrefundable. Often the gallery will have the right, if the advance is nonrefundable, to purchase at year-end that amount of the artist's work which will pay off the artist's debt to the gallery. The artist must be certain that the work will be purchased at fair prices, such as the prices set forth in the model agreement's Record of Consignment. The gallery would receive a discount, of course, equal to its normal commission.

Purchases of a substantial amount of an artist's work by a gallery can create an unfortunate tension in the relationship between gallery and artist. While the gallery is an agent, bound to deal in good faith for the interest of the artist, the gallery may promote and sell its own inventory instead of those works the artist has given on consignment. The artist may find the gallery has become an alter ego, competing with the artist instead of remaining a loyal agent. But this risk will have to be balanced in each case with the advantages of the regular income provided by a monthly stipend.

Copyright

The artist should require that the gallery reserve all copyrights to the artist upon sale and also take steps to protect the artist's copyrights (model agreement, Article 11).

Creditors of the Gallery

The statutes of New York, California, and a number of other states (see pages 43–44) protect the artist from claims by creditors of the gallery against works on consignment. Title to art is transferred directly from the artist to any purchaser. The funds received by the gallery become trust funds and must be paid first to the artist regardless of creditors' claims.

The absence of such provisions in the laws of many states should alert artists to the complex legal entanglements that may occur if a gallery's creditors claim rights to consigned works after the gallery has become bankrupt. For this reason, the artist should try to establish the financial stability of any gallery prior to consigning works. However, an agreement might also provide for termination in the event the gallery's financial condition becomes untenable, as shown by bankruptcy, insolvency, an assignment of assets for the benefits of creditors, a lien or attachment against the gallery not vacated within reasonable time, or appointment of a receiver or trustee for the gallery or its assets (model agreement, Article 2). The gallery would be required in such circumstances to return immediately all work as well as money held for the artist. The agreement might also specify that the work and any proceeds from sales would be held in trust for the artist and not subject to the claims of creditors of the gallery, but the legal efficacy of these provisions is questionable.

The Uniform Commercial Code states that creditors have rights against consigned goods.

These rights can be cut off if the person consigning the goods, such as an artist, complies with certain filing provisions to gain a secured interest in the consigned work. The filing of Uniform Commercial Code Form 1, discussed on pages 106–108, is not difficult. Compliance with these provisions, however, is a problem for the artist who finds galleries rarely willing to agree to such a filing. This approach should certainly be considered, however, as the safest alternative where works of great value are being consigned.

The creditor's rights are also cut off if the artist could prove the gallery was known to its creditors as being substantially engaged in the sale of goods of others. This raises a burden of proof that may be difficult for the artist to satisfy. For artists in states lacking special consignment protection laws, the safest course may be simply to make a close examination of the financial stability of the gallery before consigning any work.

Damage, Loss, Theft, Insurance

The Uniform Commercial Code requires return of consigned work to be at the gallery's "risk and expense." This imposes a far higher standard on the gallery than a bailment would. The artist should still require a provision stating that the gallery is responsible for the safekeeping of the work and, in the event of loss, damage, or theft, will pay the artist as if the work had been sold (model agreement, Article 9). In case of damage the artist might seek either the right to compensation for any restoration done by the artist or control over restoration done by any other party.

The gallery should be required to insure the work so there will definitely be money to pay the artist in the event of loss, damage, or theft (model agreement, Article 10). The artist should, if possible, be named as a beneficiary of the insurance policy. The insurance may not be for the retail value of the work, but must be sufficient to pay what the artist would normally receive upon sale. The artist might wish to take a separate policy to increase coverage on the work to 100 percent of retail value. Also, the work should be insured while in the artist's possession or in transit to the gallery if not covered by the gallery policy. The artist whose works may be dangerous to either people or property may want insurance for injuries or damages caused by the work itself. The artist and gallery should agree as to the payment of the premiums in such a case.

Customs

If the gallery will be selling work abroad, the artist will want to be certain the gallery complies with customs regulations. Many countries place no duty on original works of art but require a bond to be posted upon entry to the country in case the work is sold. Upon sale, the bond will guarantee payment of a value added tax, but otherwise the bond is returned when the works are taken from the country. When countries do place duties on original works, the work may have to be declared valueless and shipped without insurance to avoid paying duties. In such cases, the artist would want the gallery to take responsibility for loss, damage, or theft of the work. The consulates of each country can provide assistance to both the gallery and the artist seeking to comply with customs regulations.

Arbitration

The parties will often agree to arbitrate disagreements (model agreement, Article 14). The arbitration provision in the model agreement allows the parties to select a suitable arbitrator who has familiarity with the art world. The model agreement also provides that either party may refuse to arbitrate if the dispute is less than a specified dollar amount. This amount should be the maximum acceptable in the local small claims court, since this may be an even easier forum for settling disputes than arbitration. The disadvantage of small claims court might be a lack of knowledge regarding the special trade customs in the visual arts field.

Other Provisions

The artist will have to decide whether the artist's death should terminate the agreement or whether the gallery should continue to sell the consigned work and pay the proceeds to the artist's estate (model agreement, Article 2). This provision will have to correspond to the plan developed for the artist's overall estate. If a crucial person at the gallery dies or the gallery goes out of business, the agreement should require an accounting, payment to the artist for all funds due and a return of all works (model agreement, Articles 2 and 7).

The agreement will provide for modification to be in writing (model agreement, Article 14), that a waiver of a right is not permanent and affects no other rights under the agreement, that if one provision of the contract is invalid

the rest of the agreement will remain in effect and that the law of a specific state will govern the agreement (model agreement, Article 15).

No agreement between an artist and a gallery is likely to contain all these possible provisions, but the artist's familiarity with the potential scope and details of such an agreement will enable the artist to forge more effectively the artist's relationship to a gallery.

Model Artist-Gallery Agreement

Agreement entered into this _____ day of _____, 20_____, between_____(hereinafter referred to as the "Artist"), residing at _____, and ____ _____(hereinafter referred to as the "Gallery"), located at _____.

Whereas, the Artist is a professional artist of good standing; and

Whereas, the Artist wishes to have certain artworks represented by the Gallery; and

Whereas, the Gallery wishes to represent the Artist under the terms and conditions of this Agreement;

Now, Therefore, in consideration of the foregoing premises and the mutual covenants hereinafter set forth and other valuable consideration, the parties hereto agree as follows:

1. Scope of Agency. The Artist appoints the Gallery to act as Artist's exclusive agent in the following geographic area:_____ _____ for the exhibition and sales of artworks in the following media:_____ _____. This agency shall cover only artwork completed by the Artist while this Agreement is in force. The Gallery shall document receipt of all works consigned hereunder by signing and returning to the Artist a Record of Consignment in the form annexed to this contract as Appendix A.

2. Term and Termination. This Agreement shall have a term of two years and may be terminated by either party giving sixty days written notice to the other party. The Agreement shall automatically terminate with the death of the Artist; the death or termination of employment of _____ with the Gallery; if The Gallery moves outside of the area of _____; or

if the Gallery becomes bankrupt or insolvent. On termination, all works consigned hereunder shall immediately be returned to the Artist at the expense of the Gallery.

3. Exhibitions. The gallery shall provide a solo exhibition for the Artist of _____ days between September and May in the exhibition space located at _____ which shall be exclusively devoted to the Artist's exhibition for the specified time period. The Artist shall have artistic control over the exhibition of his or her work and the quality of reproduction of such work for promotional or advertising purposes. The expenses of the exhibition shall be paid for in the respective percentages shown below:

Exhibition Expenses	Artist	Gallery
Transport work to gallery (including insurance and packing)	_____	_____
Advertising	_____	_____
Catalogs	_____	_____
Announcements	_____	_____
Frames	_____	_____
Special installations	_____	_____
Photographing work	_____	_____
Party for opening	_____	_____
Shipping to purchasers	_____	_____
Transporting work back to artist (including insurance and packing)	_____	_____
All other expenses arising from the exhibition	_____	_____

After the exhibition, the frames, photographs, negatives and any other tangible property created in the course of the exhibition shall be the property of_____.

4. Commissions. The Gallery shall receive a commission of ____ percent of the retail price of each work sold. In the case of discount sales, the discount shall be deducted from the Gallery's commission. In the event of studio sales by the Artist that fall within the scope of the Gallery's exclusive agency, the Gallery shall receive a commission of _____ percent of the retail price for each work sold. Works done on a commissioned basis by the Artist shall/shall not be considered studio sales on which then Gallery may be entitled to a commission.

5. Prices. The Gallery shall sell the works at the retail prices shown on the Record of Consignment, subject to the Gallery's right to make customary trade discounts to such purchasers as museums and designers.

6. Payments. The Gallery shall pay the Artist all proceeds due to the Artist within thirty days of sale. No sales on approval or credit shall be made without the written consent of the Artist and, in such cases, the first proceeds received by the Gallery shall be paid to the Artist until the Artist has been paid all proceeds due.

7. Accounting. The Gallery shall furnish the Artist with an accounting every six months, the first such accounting to be given on the ____ day of ____, 20___. Each accounting shall state for each work sold during the accounting period the following information: the title of the work, the date of sale, the sale price, the name and address of the purchaser, the amounts due the Gallery and the Artist, and the location of all works consigned to the Gallery that have not been sold. An accounting shall be provided in the event of termination of this Agreement.

8. Inspection of Books. The Gallery shall maintain accurate books and documentation with respect to all transactions entered into for the Artist. On the Artist's written request, the Gallery will permit the Artist or the Artist's authorized representative to examine these books and documentation during normal business hours of the Gallery.

9. Loss or Damage. The Gallery shall be responsible for loss or damage to any consigned artwork from the date of delivery to the Gallery until the work is returned to the Artist or delivered to a purchaser. In the event of loss or damage that cannot be restored, the Artist shall receive the same amount as if the work had been sold at the retail price listed in the Record of Consignment. If restoration is undertaken, the Artist shall have a veto power over the choice of the restorer.

10. Insurance. The Gallery shall insure the work for _____ percent of the retail price shown in the Record of Consignment.

11. Copyright. The Gallery shall take all steps necessary to insure that the Artist's copyright in the consigned works is protected, including but not limited to requiring copyright notices on all reproductions of the works used for any purpose whatsoever.

12. Assignment. This Agreement shall not be assignable by either party hereto, provided, however, that the Artist shall have the right to assign money due him or her hereunder.

13. Arbitration. All disputes arising under this Agreement shall be submitted to binding arbitration before _____ [specify a suitable arbitrator] and the arbitration award may be entered for judgment in any court having jurisdiction thereof. Notwithstanding the foregoing, either party may refuse to arbitrate when the dispute is for a sum of less than _____ dollars. [Note: Insert the jurisdictional amount of the local small claims court. This will provide an even easier forum than arbitration for settling disputes.]

14. Modifications. All modifications of this Agreement must be in writing and signed by both parties. This Agreement constitutes the entire understanding between the parties hereto.

15. Governing Law. This Agreement shall be governed by the laws of the State of _____.

In Witness Whereof, the parties hereto have executed this Agreement on the day and year above set forth.

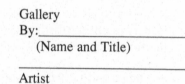

Gallery
By:_____
 (Name and Title)

Artist

Record of Consignment (Appendix A)

This is to acknowledge receipt of the following works of art on consignment:

Title	Medium	Description	Retail Price
1._____	_____	_____	_____
2._____	_____	_____	_____
3._____	_____	_____	_____
4._____	_____	_____	_____
5._____	_____	_____	_____
6._____	_____	_____	_____

Gallery
By:_____
 Name and Title

Cooperative Galleries

Cooperative galleries often provide a welcome outlet for the artist who has difficulty in establishing a relationship with a commercial gallery. A group of artists normally contribute funds to establish and maintain the gallery in which their own work will be shown.

Some cooperative galleries have sought status as federal tax-exempt organizations by making their primary function the service of the public through educational activities such as lectures, workshops, employment information, and exhibitions of the work of both members and nonmembers without offering the work for sale. If the work of members was offered for sale, however, the cooperative gallery would probably not qualify for tax exemption. Such exemption was denied where "the cooperative gallery... engaged in showing and selling only the works of its own members and is a vehicle for advancing their careers and promoting the sale of their work. It serves the private purpose of its members, even though the exhibition and sale of paintings may be an educational activity in other respects." (Rev. Rul. 71-395, 1971-2 Cum. Bull. 228; Rev. Rul. 76-152, I.R.B.4 1976-17) But, regardless of tax status, many artists would value the promotion.

It is important, however, to remember that the cooperative gallery is a legal entity separate from the artists who compose its membership. Thus, the artist should anticipate that nearly all the problems of dealing with commercial galleries may arise when the artist joins a cooperative gallery.

Agents

Photographers and illustrators may use agents for sales of work. Most illustrators' agents represent the illustrator individually in selling work and seeking assignments. Photographers may be represented individually and also use a stock agency maintaining exclusive sales rights over the photographs submitted to the agency by many photographers. Conceptually, the concerns of the illustrator or photographer with respect to agents are much the same as those of the fine artist. The parties to the agreement, scope of the agency, promotion of the work, commission rates for the agent, prices, accountings, payment, risks of loss or theft or damage, insurance, and responsibilities for expenses incurred will have to be considered and specified in the agreement. A good sample agreement to consult is the Graphic Artists Guild's Artist-Agent Agreement that appears on pages 150–152. Both the American Society of Media Photographers and the Society of Photographer and Artist Representatives (abbreviated as "SPAR") also have model agreements worth comparing to the Guild's version.

One good source for finding an agent for both illustrators and photographers is the list of agent-members of SPAR. SPAR's address appears on page 262; their Web site is at *www.spar.org/*. Along with the list of agents who are members, artists might also request SPAR's "Policy Statement to Clarify Urgent Problems and Stem Growing Abuses." In most cases artist and agent are on the same side in seeking fair industry practices for the creators of artwork that will be reproduced. The model contract shown here favors the artist, but is not unreasonable in view of current practices between agents and artists.

The gallery is selling a finished work of art, while the agent is usually obtaining an assignment for the illustrator or photographer to undertake. The Guild's agreement requires the agent to use best efforts to secure assignments, but allows the artist to reject assignments with unacceptable terms (Article 1). The artist and agent share the cost of promotions (Article 2). This is often shared equally or in proportion to how proceeds are divided, but varies with the specific situation. Since the agent probably has reproductions for samples, loss or damage is not as serious as in the case of original art. The agreement states that the agent will only be liable if he or she is negligent in causing loss or damage. If valuable original art or transparencies are to be in the hands of the agent, this provision should be reconsidered. In such an event, it would be wise to provide a valuation for the original work and require insurance coverage sufficient to protect the artist.

The standard commission rate is 25 percent (Article 4). Some agents charge a slightly higher rate for out-of-town assignments. House accounts are those the artist brings to the agent. The house accounts should be listed, as in Schedule A, to avoid confusion. The commission rate on house accounts is 10 percent. The agreement provides that the

commission shall be payable on the artist's actual profit from the assignment, so expenses are excluded for that computation. The agent usually handles billing, but in some cases the artist may do so (Article 5). In any case, payment should be made immediately on receipt of payments from the client (Article 6). Accountings and the inspection of books and records should also be covered (Articles 7 and 8).

The term and termination provisions are among the most important in the agreement (Articles 3 and 9). The artist doesn't want to be bound to an agent who isn't selling; the agent doesn't want to build an artist's career only to have the artist find another agent. The result is that the agent will want commissions for assignments obtained by the artist after termination from clients originally secured by the agent. The duration of this after-termination right to commissions, the commission percentage and whether house accounts are included are all subject to negotiation. If the after-termination right continues for too long a period, it will be both costly to the artist and make finding a new agent more difficult.

Each party relies on the other party to render personal services, so the agreement is not assignable. However, sums of money due under the contract would be assignable.

Textile designers might seek the following special restrictions on the scope of the agency and the agent's right to employ or represent other designers:

The Agent agrees to represent no more than _____ designers.

The Agent agrees not to represent conflicting hands, such hands being designers who work in a similar style to that of the Designer.

The Agent agrees to have no designers as salaried employees.

The Agent agrees not to sell designs from his or her own collection of designs in competition with the Designer's work.

The Agent agrees to employ _____ full time and _____ part time salespeople.

I drafted the following contract for the Graphic Artists Guild. It is reproduced here with their permission.

Model Artist-Agent Agreement

Agreement, this _____ day of _____, 20_____, between _____

(hereinafter referred to as the "Artist"), residing at _____, and

_____ _____ (hereinafter referred to as the "Agent"), residing at _____.

Whereas, the Artist is an established artist of proven talents; and

Whereas, the Artist wishes to have an agent represent him or her in marketing certain rights enumerated herein; and

Whereas, the Agent is capable of marketing the artwork produced by the Artist; and

Whereas, the Agent wishes to represent the Artist.

Now, Therefore, in consideration of the foregoing premises and the mutual covenants hereinafter set forth and other valuable consideration, the parties hereto agree as follows:

1. Agency. The Artist appoints the Agent to act as his or her exclusive representative:

 (A) in the following geographical area:

 _____.

 (B) for the markets listed here (specify publishing, advertising, etc.):

 _____.

 The Agent agrees to use his or her best efforts in submitting the Artist's work for the purpose of securing assignments for the Artist. The Agent shall negotiate the terms of any assignment that is offered, but the Artist shall have the right to reject any assignment if he or she finds the terms thereof unacceptable.

2. Promotion. The Artist shall provide the Agent with such samples of work as are from time to time necessary for the purpose of securing assignments. These samples shall remain the property of the Artist and be returned on termination of this Agreement. The Agent shall take reasonable efforts to protect the work from loss or damage, but shall be liable for such loss or damage only if caused by the Agent's negligence. Promotional expenses, including but not limited to promotional mailings and paid advertising, shall be paid _____ percent by the Agent and _____ percent by the Artist. The Agent shall bear the expenses of shipping, insurance, and similar marketing expenses.

3. Term. This Agreement shall take effect on the _____ day of _____,

20_____, and remain in full force and effect for a term of one year, unless terminated as provided in Paragraph 9.

4. Commissions. The Agent shall be entitled to the following commissions: (A) On assignments obtained by the Agent during the term of this Agreement, twenty-five (25%) percent of the billing; and (B) On house accounts, ten (10%) percent of the billing. For purposes of this Agreement, house accounts are defined as accounts obtained by the Artist at any time, or obtained by another agent representing the Artist prior to the commencement of this Agreement, and are listed in Schedule A attached to this Agreement.

Both parties understand that no commissions shall be paid on assignments rejected by the Artist or for which the Artist fails to receive payment, regardless of the reason payment is not made. Further, no commissions shall be payable in either (A) or (B) above for any part of the billing that is due to expenses incurred by the Artist in performing the assignment, whether or not such expenses are reimbursed by the client. In the event that a flat fee is paid by the client, it shall be reduced by the amount of expenses incurred by the Artist in performing the assignment, and the Agent's commission shall be payable only on the fee as reduced for expenses.

5. Billing. The ____Artist ____Agent shall be responsible for all billings.

6. Payments. The Party responsible for billing shall make all payments due within ten (10) days of receipt of any fees covered by this Agreement. Late payments shall be accompanied by interest calculated at the rate of _____ percent per month thereafter.

7. Accountings. The party responsible for billing shall send copies of invoices to the other party when rendered. If requested, that party shall also provide the other party with semi-annual accountings showing all assignments for the period, the clients' names, the fees paid, expenses incurred by the Artist, the dates of payment, the amounts on which the Agent's commissions are to be calculated and the sums due less those amounts already paid.

8. Inspection of the Books and Records. The party responsible for the billing shall keep the books and records with respect to commissions due at his or her place of business and permit the other party to inspect these books and records during normal business hours on the giving of reasonable notice.

9. Termination. Either party may terminate this Agreement by giving thirty (30) days written notice to the other party. If the Artist receives assignments after the termination date from clients originally obtained by the Agent during the term of this Agreement, the commission specified in Paragraph 4(A) shall be payable to the Agent under the following circumstances. If the Agent has represented the Artist for six months or less, the Agent shall receive a commission on such assignments received by the Artist within ninety (90) days of the date of termination. This period shall increase by thirty (30) days for each additional six months that the Agent has represented the Artist, but in no event shall such period exceed one hundred eighty (180) days.

10. Assignment. This Agreement shall not be assigned by either the parties hereto. It shall be binding on and inure to the benefit of the successors, administrators, executors or heirs of the Agent and Artist.

11. Arbitration. Any disputes in excess of $_____ (maximum limit for small claims court) arising under this Agreement shall be submitted to binding arbitration before the American Arbitration Association or other mutually agreed upon arbitrator pursuant to the rules of the American Arbitration Association. The arbitrator's award shall be final and judgment may be entered in any court having jurisdiction thereof. The Agent shall pay all arbitration and court costs, reasonable attorney's fees, and legal interest on any award or judgment in favor of the Artist.

12. Notices. All notices shall be given to the parties at their respective addresses set forth above.

13. Independent Contractor Status. Both parties agree that the Agent is acting as an independent contractor. This Agreement is not an employment agreement, nor does

it constitute a joint venture or partnership between the Artist and Agent.

14. Amendments and Merger. All amendments to this Agreement must be written. This Agreement incorporates the entire understanding of the parties.

15. Governing Law. This Agreement shall be governed by the laws of the State of _____.

In Witness Whereof, the parties have signed this Agreement as of the date set forth above.

Artist

Agent

House Accounts (Schedule A)

Date:

1. _____
 (name and address of client)
2. _____
3. _____
4. _____
5. _____
6. _____
7. _____
8. _____
9. _____

15 SALES OF REPRODUCTION RIGHTS

Commercial artists earn their livelihood by selling reproduction rights to clients. The art is often created on assignment for the client. Nonetheless, the artist will own the copyright (unless the assignment is work-for-hire) and the original art. What rights will the artist transfer to the client and what contractual protections will the artist require?

The artists' professional organizations have created model forms for use in selling reproduction rights. This chapter includes model forms for photographers, illustrators, graphic designers, and textile designers that can be adapted to sell art to any market. In addition, syndication and other forms of commercial exploitation are covered. A contract for Web site design is also included. Sophisticated contracts for the sale of reproduction rights include the book publishing contract discussed in chapter 16, the video broadcast agreement discussed in chapter 17, and the multimedia contracts discussed in chapter 18.

Battle of the Forms

One pitfall to be avoided is the oft-encountered battle of the forms. An art director sends a purchase order that has one set of terms. The artist sends back a confirming letter (or form) with different terms, but starts work immediately because the assignment is on a deadline. When the assignment is billed, the artist's invoice follows the terms of the confirming letter. But the client's check has terms stamped on the back that conform to the terms of the client's original purchase order. When all is said and done, neither party knows the actual terms of the transaction.

As the chapter on contracts pointed out, agreement must be two-sided. The moment a potential disagreement arises, the artist must deal with it. If a purchase order has unacceptable terms, it becomes especially important to obtain a signed contract with terms acceptable to both parties (or a client's response accepting the terms of the confirmation form). If deadlines are tight, faxes or overnight delivery services can be used to speed the reaching of agreement. To continue working when agreement has not been reached is to invite disputes.

Such disputes can be avoided by using the model contracts at the end of the chapter, all of which cover certain basic terms.

Assignment Description and Due Date

There must be a description of the assignment and a due date. If the client is to provide reference material or take other steps that are necessary for the artist to perform, any delay caused by the client should extend the artist's time for performance.

Fee

A basic fee should be specified for the assignment. For photography this might be a day, shot, or hourly rate, in which case any minimum guarantee as to the amount of time or number of shots should be specified. Alternatively, event photographers may charge by the event, estimating the price for all on-site and post processing work in advance. For sales to magazines the day rate will normally be an advance against the space rate in the magazine. For an advertising assignment, usage fees may be paid in addition to the day rate if a number of images are used, and sometimes even if a single image is used.

If work beyond the original assignment is required, such as overtime on a shoot for which

the fee is modest or many additional sketches on an illustration, an hourly rate or per sketch fee may sometimes be agreed upon. Days spent on travel and preparation should be compensated, as should days on which it is impossible to work due to the weather, if that is relevant. Travel and weather days may be paid for at half the regular day rate, although this is negotiable. Payment for extensive amounts of preparation time is also becoming more common.

The surface/textile designer estimate and confirmation form provides a breakdown of estimated prices for different categories of work.

Cancellations

If an assignment is canceled, a cancellation fee should be paid. A cancellation fee is often referred to as a "kill fee," though some artists consider "kill fee" to be pejorative, since it may reflect on the artist's work. Of course some assignments are canceled prior to work even commencing. In this case, it is unusual to receive a cancellation fee, except that photographers may negotiate for such a fee if reasonable notice (such as forty-eight hours) of the cancellation is not given prior to the time the assignment was to start.

The contract for graphic designers requires payment for cancellation based on the contract price in relation to the degree of completion of the work, while the illustrators' contract allows the filling in of percentages to be paid if cancellation is after sketches (perhaps 25 to 50 percent of the fee) or finishes (perhaps 50 to 100 percent of the fee). If the cancellation is due to dissatisfaction with the art, the fee will usually be lower than if the cancellation is for reasons unrelated to the art (such as a decision not to do the project).

In the event of cancellation, the artist would seek to retain the rights in the art that has been created. Cancellation implies that the client has no use for that art, so retention of the rights by the artist appears reasonable.

Usage

The fee is often based on usage. This makes it important to specify what use of the art is anticipated. The photographer's contract does this by specifying category, media, and title. The contractual terms then give the following definitions: "'Category' means advertising, corporate, editorial, etc.; 'Media' means brochure,

magazine, hardcover book, billboard, etc.; 'Title' means publication or product name." By carefully limiting usage to the client's needs at the time of entering into the contract, the fee can then be based on that usage. If the client later wishes to make greater usage, reuse fees can be agreed on (if such fees are not specified in the original contract).

The illustrator's estimate and confirmation form limits usage in the same way, as does the graphic designers' contract. However, these contracts contain additional limitations, since the geographic area of use, the time period of use, number of uses or the edition of a book can also be specified.

Most magazines purchase only first North American serial rights (sometimes called first rights), the right to be the first magazine to publish the work in North America. After such publication, the artist is free to sell the work elsewhere. A variation of first serial rights would be first North American serial rights, whereby the artist conveys to the client the right to be the first magazine publisher of the work in North America. Another grant of rights would be second serial rights—the right to publish artwork that has appeared elsewhere. A different grant of rights would be one-time rights—the right to use the work once but not necessarily first and certainly not exclusively. Another way of expressing this could be the grant of simultaneous rights: granting the right to publish to several magazines at once.

The artist should keep in mind the possibility of limiting the grant of rights with regard to exclusivity, types of uses, duration, and geographical scope. The artist who wishes can define exactly the nature of the permitted publication. If possible, the artist should avoid selling all rights (sometimes called exclusive world rights in perpetuity), which would mean the artist retained no rights to the work. Prior to 1978, magazines sometimes purchased all rights with the understanding that certain rights would be transferred back to the artist after publication. In such a case, the artist should have had a written contract setting forth precisely which rights the magazine would transfer back to the artist. Since 1978, this trust arrangement has become obsolete because contributions are protected by the magazine's copyright notice (although it is best to have copyright notice for the contribution in the artist's name).

The surface/textile designer's estimate and confirmation form leaves the limitation of rights to be filled in under special comments, but the approach to limiting rights is the same as in the other contracts.

It is important to state that only the specified usage is granted to the client. A more formal approach would be to recite, "All rights not hereby transferred are reserved to the Artist." Usage should also be limited to images actually purchased. Many photographers, for example, profit by using out takes from assignments to create stock files for sale. This is an accepted practice as long as the photographer does not sell the out takes to a company competitive with the original client.

Electronic Rights

Electronic rights cover many of the ways in which images will almost certainly be marketed in the future. The ability to digitize images, store vast numbers of images, and deliver such images into homes and offices around the world, is part of the electronic revolution. While multimedia contracts are discussed in chapter 18, the artist working for print or other nonelectronic media should not sell electronic rights. The value of these rights can be difficult to determine, since this is a rapidly evolving frontier. Nonetheless, the growth of the Internet makes it especially important to retain rights to profit from it. As with any right the client does not intend to use, and therefore is unlikely to be paying for, the artist should reserve electronic rights to him- or herself. Conversely, if electronic rights are being licensed, nonelectronic rights should be reserved to the artist. In addition, the nature of the electronic license should be carefully spelled out as to type of use, medium of use, duration of use, territory, and similar limitations. The artist should try to negotiate out of any contractual provision that seeks rights in media that don't as yet exist but may be discovered in the future.

Advances and Expenses

Photographers and designers are paid for their expenses as a routine matter. An issue arises as to whether these expenses should be marked up. For example, should a 15 or 20 percent charge be added to the expenses when billing the client? The justification for such a charge is the bookkeeping cost involved, the overhead expense to make such outlays on behalf of the client and the cost (in lost interest) of paying money for the client and then having to wait to be reimbursed. There is no general rule, but some photographers and virtually all designers markup expenses when billing the client.

Illustrators often do not bill for expenses because the expenses are minimal. If such expenses are not minimal, the illustrator is certainly justified in requesting a reimbursement (perhaps, for example, if the assignment requires hiring a model).

Sometimes, an advance against expenses can be negotiated. Such an advance provides part or all of the money estimated for the expenses. When an advance is paid, the justification for marking up expenses is lessened. The artist is no longer in effect lending money to the client, although extra overhead costs are still incurred in keeping track of the expenses and billing them to the client.

Changes and Reshoots

If changes are necessary, the artist should be given the first opportunity to make such changes. If the changes are due to a change in the assignment, of course, additional fees should be paid. Likewise, a reshoot might be done on the basis of expenses plus half the regular fee when the client changes the assignment.

Authorship Credit and Copyright Notice

The contracts provide for such credit when the use of the art is editorial (such as for magazines or books). If the art is for corporate or advertising use, authorship credit is less common and would have to be added into the contract form.

Copyright notice does not accompany art unless the artist requires such notice. Often the name credit can simply be elaborated by adding the copyright symbol and the year date. A common mistake in magazines had been a photograph with a copyright notice that lacked the year date. Such a notice would have been acceptable prior to 1978, but from January 1, 1978 until March 1, 1989, a notice lacking a date was the same as no notice as all. Of course, the notice in the front of the magazine protected all contributions (except for advertisements which require their own notice), but the photographer's protection was reduced because a person who received a license from

the magazine to use the photograph would have a defense against the photographer (who would be able to collect from the magazine).

After March 1, 1989, no copyright notice is required, so a copyright notice without a year date should not present any problems. Copyright notice in the name of the magazine will protect contributions in the sense that innocent infringers will not be eligible to ask for mitigation of damages due to the infringer's reliance on the absence of copyright notice for a contribution. In addition, the infringer's having obtained a license from the magazine in reliance on the absence of copyright notice with the contribution will no longer be a defense.

Return of Originals and Samples

Original art should be specified to remain the property of the artist. After the art has been used for reproduction, it should be returned to the artist. If clients expect to keep originals and are paying a sufficient fee, this should be stated. For photography, the client may expect to keep shots that are used, but not out takes. Stock sales for photographers and sales of originals for illustrators depend on the proper retention of ownership of rights and art. These can provide yet another source of residual income (in addition to reuses by the client beyond the usage originally agreed on and paid for). Also, if art is never used by the client, the contract may specify that after a certain amount of time passes, the original art and any rights granted will revert to the artist.

The artist will also want copies of the art in its reproduced form. So the contract should provide that a certain number of copies of the art as reproduced will be provided free of charge to the artist. These samples are helpful for updating portfolios and related promotion.

In addition, the textile designers' contract requires that the client provide insurance covering the fair market value of the art when it is being shipped.

Releases

If the client is supplying reference materials, the client should guarantee that use of these materials will neither violate anyone's right of privacy nor infringe any copyright. If this guarantee (called a warranty) is breached, the client should agree to pay any judgment as well as legal fees and court costs resulting from a lawsuit. Artists may also be asked to give warranties and indemnities for images they create,

as is discussed with respect to book publication contracts on page 178.

Payment

The contract must state a time for payment, usually within thirty days of the submission of an invoice (although some clients take sixty or even ninety days to pay). Some artists include a contractual term charging interest for late payment. While rarely enforced by the artist due to the desire to keep the client's good will, such provisions may encourage timely payment. Some magazines pay on publication, rather than on acceptance of a contribution. This is not a desirable practice, since the artist is simply loaning money to the publisher. It also raises the risk that there will be no payment, since the magazine is under no obligation to publish the contribution. Payment on acceptance is best, but certainly payment should be required if publication does not occur with a reasonable time (such as six months after acceptance).

Estimates

If an estimate is given for an assignment, it should be specified whether or not the estimate is binding. For example, the contract could state than any estimate is a minimum only. If this were done, the contract might also provide that the billing may not be increased more than a certain percentage above the estimate without the client's approval. Any estimate must leave flexibility unless the scope of the work can be very precisely delineated.

Modifications

It would be ideal to have any modifications be written, but to keep work progressing smoothly oral modifications may be unavoidable. Such changes should be promptly confirmed in writing, especially if the fees or expenses will be increased due to the change.

The contracts can require that the client object to terms either immediately on receipt or within ten days of receipt. If the client complies with this, it will help to achieve a meeting of the minds.

Invoices

The form for photographers is designed to serve as an estimate, confirmation, or invoice. On the other hand, the forms for illustrators, graphic designers, and surface/textile designers

are only for use as estimates or confirmations and require separate invoices that track along the terms of the estimate or confirmation. Only invoices for illustrators have been included with the forms at the end of the chapter as a sample of how an invoice differs from an estimate and confirmation form. One of the invoices is basic and quite simple; the other is more detailed and tracks the terms of the confirmation of assignment.

An estimate is used in seeking an assignment, a confirmation after an assignment has been received and an invoice after the assignment has been completed. The invoice specifies the fee and includes most of the terms that appeared on the confirmation form, including the payment terms. It usually accompanies delivery of the finished assignment or is sent on acceptance of the assignment. If extra charges have been incurred that did not appear in the confirmation form, the invoice can include such charges. The invoice would also bill for the sales tax, if any were payable.

Syndication Agreements

A syndicate gathers marketable features for distribution on a regular basis to markets, such as newspapers. Cartoon strips are commonly syndicated. The basic considerations are similar to those of the book contract discussed in the next chapter, but the creation of unique characters can have some special implications. For example, the creators of Superman sold all their rights and benefited hardly at all from the phenomenal success of Superman as a comic strip and as a character in numerous other commercial ventures.

The Cartoonists Guild in their *Syndicate Survival Kit* (now out of print) states that the artist selling greater rights (such as "all rights" instead of only "first North American rights") should receive a greater payment. But the Guild strongly urges that the term be limited to no more than one or, at most, two years. This is to enable the artist either to negotiate a better contract, if the comic strip is a success, or to stop working on an unprofitable venture, if the comic strip is not popular. Since automatic renewal would defeat the purpose of a short term, the artist should refuse any such renewal provision.

The artist is normally paid in the form of a percentage of the receipts earned by the strip. But again, the artist should be careful that the percentage is taken against gross receipts, not net receipts (which might also be phrased as "gross receipts less expenses"). The Guild suggests 50 percent of gross receipts is usually fair payment to the artist, but indicates a minimum payment should always be specified. The Guild urges the artist to reserve a fair percentage of gross receipts—75 percent, perhaps—from all subsidiary rights, particularly since book, television, radio, periodical, and novelty rights can be so valuable when cartoon characters are successful.

The Guild suggests that the artist retain copyright in the work, in which case copyright notice should appear in the artist's name. The artist should require powers of consultation and approval with regard to any changes to be made in submitted material. Also, the original artwork should be returned to the artist.

The Guild stresses the importance of promotion for the success of a cartoon strip. The promotional plan should, ideally, be agreed upon in advance. The burden of promotional costs and the rights to use the work for promotion without additional payments should be resolved at this stage too.

The artist should have a right to periodic accountings showing the source of all receipts and the exact nature of any expenses. The artist should be able to inspect the books of the syndicate. Package deals, in which several features are sold together, should be forbidden. Each feature should stand on its own merit and be paid for individually. The Guild also suggests that legal fees and liabilities should be equally divided between the artist and the syndicate.

The artist must not relinquish the right to sell other creative work. The syndicate has received a license with regard to the comic strip at issue, so work that is too similar will infringe that license. But the artist should not agree even to refrain from marketing similar work because of the problem of defining what may be similar. Any option provision giving rights over future work of the artist to the syndicate should also be struck from the contract.

The Guild suggests that, in the event of the artist's death, controls be present in the contract that ensure payments for the comic strip will continue to be made to the artist's estate. One possible way to do this would be to require minimum payments to the estate after the artist's death. Another way might be to have the estate pay for a replacement artist, who would continue the comic strip.

Licensing and Merchandising

Commercial exploitation through the reproduction of artwork can take the form of jewelry, t-shirts, posters, prints, and even useful household objects (such as lamps with decorative bases). The artist who is offered an opportunity to exploit copyrighted or patented work can limit the rights licensed with regard to use, duration and geographical scope. The artist will want to be certain that the entrepreneur seeking the license is financially stable, respected for honesty, and capable of creating and distributing quality products.

The entrepreneur would normally bear the cost of reproducing the work, possibly under a binding schedule for production. The artist would want the right to approve the quality of the product at the various stages of manufacture. Promotional budgets and approaches might be specified in advance along with channels of distribution. Appropriate copyright, trademark, and patent notice; the right to artistic credit; the artist's ownership of the original work; the artist's right to free copies; and any warranties given by the artist would all be included in the contract.

The artist might be paid either a flat fee or a royalty. If a royalty is to be paid, the issue of gross and net receipts again becomes significant. The artist will want a stated percentage of the gross receipts, not the net receipts (or gross receipts less certain expenses). Nonetheless, the typical deal is to give the artist 5 to 12 ½ percent of the net wholesale price received by the manufacturer from its distributors. The artist would want the right to both periodic accountings and inspection of the entrepreneur's books.

The entrepreneur might request that the artist either refrain from creating competing works or offer an option on the artist's next commercial creation to the entrepreneur. The artist should not agree to these provisions, however, for the same reasons discussed in the next chapter with regard to book contracts.

The contract should provide for termination in the event the entrepreneur fails to exploit the work or becomes bankrupt or insolvent. The rights would then revert to the artist who might be entitled to purchase stock on hand at the cost of the stock to the entrepreneur.

The commercial exploitation of art is merely a more general application of the principles that guide the artist in the specific exploitation of art involved in a publication contract. For the artist considering such a commercial venture, the principles discussed for the book contracts will be a helpful guide. An excellent guide to this area is *Licensing Art and Design* by Caryn Leland (Allworth Press).

Model Contracts

The photographer's assignment estimate/confirmation/invoice form is reproduced here by permission from *Business and Legal Forms for Photographers* by Tad Crawford (Allworth Press). The illustrator's confirmation of assignment, invoice, and basic invoice are reproduced here by permission from Business and Legal Forms for Illustrators by Tad Crawford (Allworth Press). The surface/textile designer's estimate and confirmation form was drafted by Tad Crawford for the Graphic Artists Guild and is reproduced here by permission of the Guild. The graphic designer's project confirmation form and website design contract are reproduced here by permission from *Business and Legal Forms for Graphic Designers* by Tad Crawford and Eva Doman Bruck (Allworth Press).

< Photographer's Letterhead >

Assignment Estimate/Confirmation/Invoice

Client _____ Date_____

Address _____ ❑ Estimate

_____ ❑ Confirmation

Client Purchase Order Number_____ ❑ Invoice

Client Contact _____ Job Number_____

Assignment Description _____

_____Due Date _____

Grant of Rights. Upon receipt of full payment, Photographer shall grant to the Client the following exclusive rights:

For use as _____

For the product, project, or publication named _____

In the following territory _____

For the following time period or number of uses_____

Other limitations _____

This grant of rights does not include electronic rights, unless specified to the contrary here_____

in which event the usage restrictions shown above shall be applicable. For purposes of this agreement, electronic rights are defined as rights in the digitized form of works that can be encoded, stored, and retrieved from such media as computer disks, CD-ROM, computer databases, and network servers.

Credit. The Photographer ❑ shall ❑ shall not

receive adjacent credit in the following form on reproduction _____

Fee/Expenses. The Client shall pay the Balance Due, including reimbursement of the expenses as shown below, within thirty days of receipt of an invoice. A reuse fee of $_____ shall be paid in the following circumstances:_____

Expenses		Fees	
Assistants	$_____	Photography fee	$_____
Casting	$_____	Other fees	
Crews/Special Technicians	$_____	Preproduction $_____/day;	$_____
Digital Processing	$_____	Travel $_____/day;	$_____
Equipment Rentals	$_____	Weather days $_____/day	$_____
Film and Processing	$_____	Space or Use Rate (if applicable)	$_____
Insurance	$_____	Cancellation fee	$_____
Location	$_____	Reshoot fee	$_____
Messengers/Shipping	$_____	Fee subtotal $_____	
Models	$_____	Plus total expenses $_____	
Props/Wardrobe	$_____	Subtotal $_____	
Sets	$_____		
Styling	$_____	Sales tax $_____	
Travel/Transportation	$_____	**Total** $_____	
Telephone	$_____		
Other expenses	$_____	Less advances $_____	
subtotal $_____			
(Plus ____% markup) $_____		**Balance due** $_____	
Total expenses $_____			

Client_____

Company Name

Photographer_____ By_____

Authorized Signatory, Title

Subject to All Terms and Conditions Above and on Reverse Side

Terms and Conditions

1. **Payment.** Client shall pay the Photographer within thirty days of the date of Photographer's billing, which shall be dated as of the date of delivery of the Assignment. The Client shall be responsible for and pay any sales tax due. Time is of the essence with respect to payment. Overdue payments shall be subject to interest charges of _____ percent monthly.

2. **Advances.** Prior to Photographer's commencing the Assignment, Client shall pay Photographer the advance shown on the front of this form, which advance shall be applied against the total due.

3. **Reservation of Rights.** Unless specified to the contrary on the front of this form any grant of rights shall be limited to the United States for a period of one year from the date of the invoice and, if the grant is for magazine usage, shall be first North American serial rights only. All rights not expressly granted shall be reserved to the Photographer, including but not limited to all copyrights and ownership rights in photographic materials, which shall include but not be limited to digital files, transparencies, negatives, and prints. Client shall not modify directly or indirectly any of the photographic materials, whether by digitized encodations or any other form or process now in existence or which may come into being in the future, without the express, written consent of the Photographer.

4. **Value and Return of Originals.** All photographic materials shall be returned to the Photographer by registered mail or bonded courier (which provides proof of receipt) within thirty days of the Client's completing its use thereof and, in any event, within _____ days of Client's receipt thereof. Time is of the essence with respect to the return of photographic materials. Unless a value is specified for a particular image either on the front of this form or on a Delivery Memo given to the Client by the Photographer, the parties agree that a reasonable value for an original transparency is $1,500. Client agrees to be solely responsible for and act as an insurer with respect to loss, theft, or damage of any image from the time of its shipment by Photographer to Client until the time of return receipt by Photographer.

5. **Additional Usage.** If Client wishes to make any additional uses, Client shall seek permission from the Photographer and pay an additional fee to be agreed upon.

6. **Authorship Credit.** Authorship credit in the name of the Photographer, including copyright notice if specified by the Photographer, shall accompany the photograph(s) when it is reproduced, unless specified to the contrary on the front of this form. If required authorship credit is omitted, the parties agree that liquidated damages for the omission shall be three times the invoiced amount.

7. **Expenses.** If this form is being used as an Estimate, all estimates of expenses may vary by as much as ten (10%) percent in accordance with normal trade practices. In addition, the Photographer may bill the Client in excess of the estimates for any overtime which must be paid by the Photographer to assistants and freelance staff for a shoot that runs more than eight (8) consecutive hours.

8. **Reshoots.** If Photographer is required by the Client to reshoot the Assignment, Photographer shall charge in full for additional fees and expenses, unless (a) the reshoot is due to Acts of God or is due to an error by a third party, in which case the Client shall only pay additional expenses but no fees; or (b) if the Photographer is paid in full by the Client, including payment for the expense of special contingency insurance, then Client shall not be charged for any expenses covered by such insurance in the event of a reshoot. The Photographer shall be given the first opportunity to perform any reshoot.

9. **Cancellation.** In the event of cancellation by the Client, the Client shall pay all expenses incurred by the Photographer and, in addition, shall pay the full fee unless notice of cancellation was given at least _____ hours prior to the shooting date, in which case fifty (50%) percent of the fee shall be paid. For weather delays involving shooting on location, Client shall pay the full fee if Photographer is on location and fifty (50%) percent of the fee if Photographer has not yet left for the location.

10. **Releases.** The Client shall indemnify and hold harmless the Photographer against any and all claims, costs, and expenses, including attorney's fees, due to uses for which no release was requested or uses which exceed the uses allowed pursuant to a release.

11. **Samples.** Client shall provide the Photographer with two copies of any authorized usage.

12. **Assignment.** Neither this Agreement nor any rights or obligations hereunder shall be assigned by either of the parties, except that the Photographer shall have the right to assign monies due hereunder. Both Client and any party on whose behalf Client has entered into this Agreement shall be bound by this Agreement and shall be jointly and severally liable for full performance hereunder, including but not limited to payments of monies due to the Photographer.

13. **Arbitration.** All disputes shall be submitted to binding arbitration before _____ in the following location _____ _____ and settled in accordance with the rules of the American Arbitration Association. Judgment upon the arbitration award may be entered in any court having jurisdiction thereof. Disputes in which the amount at issue is less than $_____ shall not be subject to this arbitration provision.

14. **Miscellany.** The terms and conditions of this Agreement shall be binding upon the parties, their heirs, successors, assigns, and personal representatives; this Agreement constitutes the entire understanding between the parties; its terms can be modified only by an instrument in writing signed by both parties, except that the Client may authorize additional fees and expenses orally; a waiver of a breach of any of its provisions shall not be construed as a continuing waiver of other breaches of the same or other provisions hereof; and the relationship between the Client and Photographer shall be governed by the laws of the State of _____.

Confirmation of Assignment

AGREEMENT entered into as of the _____ day of _____, 20___, between _____ (hereinafter referred to as the "Client"), located at _____,' and _____ (hereinafter referred to as the "Illustrator"), located at _____,' with respect to the creation of certain illustrations (hereinafter referred to as the "Work").

WHEREAS, Illustrator is a professional illustrator of good standing;

WHEREAS, Client wishes the Illustrator to create certain Work described more fully herein; and

WHEREAS, Illustrator wishes to create such Work.

NOW, THEREFORE, in consideration of the foregoing premises and the mutual covenants hereinafter set forth and other valuable considerations, the parties hereto agree as follows:

1. **Description.** The Illustrator agrees to create the Work in accordance with the following specifications:

 Subject matter _____

 Number of illustrations in color _____ Number of illustrations in black and white _____

 Size of illustrations _____ Medium for illustrations _____

 Other specifications _____

 Client purchase order number _____ Job number _____

2. **Due Date.** The Illustrator agrees to deliver sketches within _____ days after the later of the signing of this Agreement or, if the Client is to provide reference, layouts, or specifications, after the Client has provided same to the Illustrator. Finished art shall be delivered _____ days after the approval of sketches by the Client.

3. **Grant of Rights.** Upon receipt of full payment, the Illustrator grants to the Client the following rights in the finished art:

 For use as _____

 For the product or publication named _____

 In the following territory _____

 For the following time period _____

 Other limitations _____

 With respect to the usage shown above, the Client shall have ❏ exclusive ❏ nonexclusive rights.

 If the finished art is for use as a contribution to a magazine, the grant of rights shall be for first North American serial rights only unless specified to the contrary above.

 This grant of rights does not include electronic rights, unless specified to the contrary here _____ in which event the usage restrictions shown above shall be applicable. For purposes of this Agreement, electronic rights are defined as rights in the digitized form of works that can be encoded, stored, and retrieved from such media as computer disks, CD-ROM, computer databases, and network servers.

4. **Reservation of Rights.** All rights not expressly granted hereunder are reserved to the Illustrator, including but not limited to all rights in sketches, comps, or other preliminary materials.

5. **Fee.** Client agrees to pay the purchase price of $_____ for the usage rights granted. Client agrees to pay sales tax, if required.

6. **Additional Usage.** If Client wishes to make any additional uses of the Work, Client agrees to seek permission from the Illustrator and make such payments as are agreed to between the parties at that time.

7. **Expenses.** Client agrees to reimburse the Illustrator for the following expenses: ❏ Messengers ❏ Models ❏ Props ❏ Travel ❏ Telephone ❏ Other _____.

 At the time of signing this Agreement, Client shall pay Illustrator $_____ as a nonrefundable advance against expenses. If the advance exceeds expenses incurred, the credit balance shall be used to reduce the fee payable or, if the fee has been fully paid, shall be reimbursed to Client.

8. Payment. Client agrees to pay the Illustrator within thirty (30) days of the date of Illustrator's billing, which shall be dated as of the date of delivery of the finished art. In the event that work is postponed at the request of the Client, the Illustrator shall have the right to bill pro rata for work completed through the date of that request, while reserving all other rights under this Agreement. Overdue payments shall be subject to interest charges of _____ percent monthly.

9. Advances. At the time of signing this Agreement, Client shall pay Illustrator _____ percent of the fee as an advance against the total fee. Upon approval of sketches, Client shall pay Illustrator _____ percent of the fee as an advance against the total fee.

10. Revisions. The Illustrator shall be given the first opportunity to make any revisions requested by the Client. If the revisions are not due to any fault on the part of the Illustrator, an additional fee shall be charged. If the Illustrator objects to any revisions to be made by the Client, the Illustrator shall have the right to have his or her name removed from the published Work.

11. Copyright Notice. Copyright notice in the Illustrator's name ❑ shall ❑ shall not be published with the Work.

12. Authorship Credit. Authorship credit in the name of the Illustrator ❑ shall ❑ shall not accompany the Work when it is reproduced. If the finished art is used as a contribution to a magazine or for a book, authorship credit shall be given unless specified to the contrary in the preceding sentence.

13. Cancellation. In the event of cancellation by the Client, the following cancellation payment shall be paid by the Client: **(A)** cancellation prior to the finished art being turned in: _____ percent of fee, **(B)** cancellation due to finished art being unsatisfactory: _____ percent of fee, and **(C)** cancellation for any other reason after the finished art is turned in: _____ percent of fee. In the event of cancellation, the Client shall also pay any expenses incurred by the Illustrator and the Illustrator shall own all rights in the Work. The billing upon cancellation shall be payable within thirty (30) days of the Client's notification to stop work or the delivery of the finished art, whichever occurs sooner.

14. Ownership and Return of Artwork. The ownership of original artwork, including sketches and any other materials created in the process of making the finished art, shall remain with the Illustrator. All such artwork shall be returned to the Illustrator by bonded messenger, air freight, or registered mail within thirty days of the Client's completing its use of the artwork. The parties agree that the value of the original finished art is $_____.

15. Permissions and Releases. The Client agrees to indemnify and hold harmless the Illustrator against any and all claims, costs, and expenses, including attorney's fees, due to materials included in the Work at the request of the Client for which no copyright permission or privacy release was requested or uses that exceed those allowed pursuant to a permission or release.

16. Arbitration. All disputes arising under this Agreement shall be submitted to binding arbitration before _____ in the following location _____ and settled in accordance with the rules of the American Arbitration Association. Judgment upon the arbitration award may be entered in any court having jurisdiction thereof. Disputes in which the amount at issue is less than $_____ shall not be subject to this arbitration provision.

17. Miscellany. This Agreement shall be binding upon the parties hereto, their heirs, successors, assigns, and personal representatives. This Agreement constitutes the entire understanding between the parties. Its terms can be modified only by an instrument in writing signed by both parties, except that the Client may authorize expenses or revisions orally. A waiver of a breach of any of the provisions of this Agreement shall not be construed as a continuing waiver of other breaches of the same or other provisions hereof. This Agreement shall be governed by the laws of the State of _____.

IN WITNESS WHEREOF, the parties hereto have signed this Agreement as of the date first set forth above.

Illustrator _____ Client _____
 Company Name

 By _____
 Authorized Signatory, Title

< Illustrator's Letterhead >

Invoice

Client _____ Date _____

Address _____

Client Purchase Order Number _____ Job Number _____

Fee.. $_____

Expenses.............................. $_____

Revisions................................. $_____

Advances............................... ($_____)

Balance.................................. $_____

Sales tax................................. $_____

Balance due........................... $_____

This Invoice is subject to the terms and conditions that follow.

1. Description. The Illustrator has created and delivered to Client _____ illustrations for the following project _____.

2. Delivery Date. The finished art was delivered on _____, 20____.

3. Grant of Rights. Upon receipt of full payment, Illustrator shall grant to the Client the following rights in the finished art:

For use as _____ For the product or publication named _____

In the following territory _____ For the following time period _____

Other limitations _____

With respect to the usage shown above, the Client shall have ❑ exclusive ❑ nonexclusive rights.

If the finished art is for use as a contribution to a magazine, the grant of rights shall be first North American serial rights only, unless specified to the contrary above.

This grant of rights does not include electronic rights, unless specified to the contrary here_____ in which event the usage restrictions shown above shall be applicable. For purposes of this Agreement, electronic rights are defined as rights in the digitized form of works that can be encoded, stored, and retrieved from such media as computer disks, CD-ROM, computer databases, and network servers.

4. Reservation of Rights. All rights not expressly granted are reserved to the Illustrator, including but not limited to all rights in sketches, comps, or other preliminary materials.

5. Fee. Client shall pay the purchase price of $_____ for the usage rights granted. Client shall also pay sales tax, if required.

6. Additional Usage. If Client wishes to make any additional uses of the Work, Client shall seek permission from the Illustrator and pay an additional fee to be agreed upon.

7. Expenses. If Illustrator incurred reimbursable expenses, a listing of such expenses is attached to this Invoice with copies of supporting documentation. Illustrator has received $_____ as an advance against expenses.

8. Payment. Payment is due to the Illustrator within thirty (30) days of the date of this Invoice, which is dated as of the date of delivery of the finished art. Overdue payments shall be subject to interest charges of _____ percent monthly.

9. Advances. Illustrator received $_____ as an advance against the total fee.

10. Revisions. The Illustrator shall be given the first opportunity to make any revisions requested by the Client. If the revisions are not due to any fault on the part of the Illustrator, an additional fee shall be charged. If the Illustrator objects to any revisions to be made by the Client, the Illustrator shall have the right to have his or her name removed from the published Work.

11. Copyright Notice. Copyright notice in the name of the Illustrator ❑ shall ❑ shall not accompany the Work when it is reproduced.

12. Authorship Credit. Authorship credit in the name of the Illustrator ❑ shall ❑ shall not accompany the Work when it is reproduced. If the finished art is used as a contribution to a magazine or for a book, authorship credit shall be given unless specified to the contrary in the preceding sentence.

13. Cancellation. In the event of cancellation by the Client, the amount charged to the Client as the fee in this Invoice has been computed as follows based on the fee originally agreed upon: **(A)** cancellation prior to the finished art being turned in: ____ percent of fee, **(B)** cancellation due to finished art being unsatisfactory: ____ percent of fee, and **(C)** cancellation for any other reason after the finished art is turned in: ____ percent of fee. In the event of cancellation, the Client shall pay any expenses incurred by the Illustrator and the Illustrator shall own all rights in the Work. The Invoice upon cancellation is payable within thirty (30) days of the Client's notification to stop work or the delivery of the finished art, whichever occurs sooner.

14. Ownership and Return of Artwork. The ownership of original artwork, including sketches and any other materials created in the process of making the finished art, shall remain with the Illustrator. All such artwork shall be returned to the Illustrator by bonded messenger, air freight, or registered mail within thirty (30) days of the Client's completing its use of the artwork. A reasonable value for the original, finished art is $_____.

15. Permissions and Releases. The Client shall indemnify and hold harmless the Illustrator against any and all claims, costs, and expenses, including attorney's fees, due to materials included in the Work at the request of the Client for which no copyright permission or privacy release was requested or uses which exceed the uses allowed pursuant to a permission or release.

16. Arbitration. All disputes shall be submitted to binding arbitration before _____ in the following location _____ and settled in accordance with the rules of the American Arbitration Association. Judgment upon the arbitration award may be entered in any court having jurisdiction thereof. Disputes in which the amount at issue is less than $_____ shall not be subject to this arbitration provision.

17. Miscellany. This Invoice shall be governed by the laws of the State of _____.

Illustrator _____

< Illustrator's Letterhead >

Basic Invoice

Client _____ Date _____

Address _____

Client Purchase Order Number _____ Job Number _____

Assignment Description _____

Fee.. $_____

Expenses................................ $_____

Revisions................................ $_____

Advances................................ ($_____)

Balance................................... $_____

Sales tax................................. $_____

Balance due............................ $_____

This Invoice is subject to the terms and conditions set forth in the Confirmation of Assignment dated _____.

Surface/Textile Designer's Estimate and Confirmation Form

FRONT
Designer's Letterhead

TO

Date_____

Pattern Number_____

Due Date_____

ESTIMATED PRICES

Sketch_____

Repeat_____

Colorings_____

Corners_____

Tracings_____

Other_____

DESCRIPTION OF ARTWORK

Repeat_____

Size_____

Colors_____

Type of Printing_____

1/2 Drop_____ Yes _____ □No

SPECIAL COMMENTS

BACK

TERMS

1. Time for Payment
Because the major portion of the above work represents labor, all invoices are payable 15 days net. A 1 1/2% monthly service charge is payable on all unpaid balances after this period. The grant of textile usage rights is conditioned on receipt of payment.

2. Default of Payment
The Client shall assume responsibility for all collection of legal fees necessitated by default in payment.

3. Estimated Prices
Prices shown above are minimum estimates only. Final prices shall be shown in invoice.

4. Payment for Changes
Client shall be responsible for making additional payments for changes requested by Client in original assignment.

5. Expenses
Client shall be responsible for payment of all extra expenses rising from assignment, including but not limited to mailings, messengers, shipping charges, and shipping insurance.

6. Sales Tax
Client shall assume responsibility for all sales taxes due on this assignment.

7. Cancellation Fees
Work canceled by the client while in progress shall be compensated for on the basis of work completed at the time of cancellation and assumes that the Designer retains the project, whatever its stage of completion. Upon cancellation, all rights, publication and other, revert to the Designer. Where Designer creates corners that are not developed into purchased sketches, a labor fee will be charged, and ownership of all copyrights and artwork is retained by the Designer.

8. Insuring Artwork
The client agrees when shipping artwork to provide insurance covering the fair market value of the artwork.

9. Uniform Commercial Code
The above terms incorporate Article 2 of the Uniform Commercial Code.

10. Warranty of Originality
The Designer warrants and represents that to the best of his/her knowledge, the work assigned hereunder is original and has not been previously published, or that con-sent to use has been obtained through the undersigned from third parties is original or, if previously published, that the consent to use has been obtained on an unlimited basis; that the Designer has full authority to make this agreement; and that the work prepared by the Designer does not contain any scandalous, libelous, or unlawful matter. This warranty does not extend to any uses that the Client or others may make of the Designer's product that may infringe on the rights of others. Client expressly agrees that it will hold the Designer harmless for all liability caused by the Client's use of the Designer's product to the extent such use infringes on rights of others.

11. Limitation of Liability
Client agrees that it shall not hold the Designer or his/her agents or employees liable for any incidental or consequential damages that arise from the Designer's failure to perform any aspect of the Project in a timely manner, regardless of whether such failure was caused by intentional or negligent acts or omissions of the Designer or a third party.

12. Dispute Resolution
Any disputes in excess of $_____ (*maximum limit for small-claims court*) arising out of this Agreement shall be submitted to binding arbitration before a mutually agreed-upon

arbitrator pursuant to the rules of the American Arbitration Association. The Arbitrator's award shall be final, and judgment may be entered in any court having jurisdiction thereof. The Client shall pay all arbitration and court costs, reasonable attorney's fees, and legal interest on any award of judgment in favor of the Surface/Textile Designer.

13. Acceptance of Terms

The signature of both parties shall evidence acceptance of these terms.

Consented and agreed to:

Designer's signature/date_____

Authorized signature/date_____

Client name and title_____

Project Confirmation Agreement

AGREEMENT as of the _____ day of _____, 20 _____, between _____, located at _____ (hereinafter referred to as the "Client") and _____, located at _____ (hereinafter referred to as the "Designer") with respect to the creation of a certain design or designs (hereinafter referred to as the "Designs").

WHEREAS, Designer is a professional designer of good standing;

WHEREAS, Client wishes the Designer to create certain Designs described more fully herein; and

WHEREAS, Designer wishes to create such Designs;

NOW, THEREFORE, in consideration of the foregoing premises and the mutual covenants hereinafter set forth and other valuable considerations, the parties hereto agree as follows:

1. **Description.** The Designer agrees to create the Designs in accordance with the following specifications:
 Project description_____
 Number of finished designs_____
 Other specifications_____
 The Designs shall be delivered in the form of one set of finished ❏ camera-ready mechanicals ❏ electronic mechanicals, more fully described as_____
 Other services to be rendered by Designer_____

 Client purchase order number_____Job number_____

2. **Due Date.** The Designer agrees to deliver sketches within _____ days after the later of the signing of this Agreement or, if the Client is to provide reference, layouts, or specifications, after the Client has provided same to the Designer. The Designs shall be delivered _____ days after the approval of sketches by the Client.

3. **Grant of Rights.** Upon receipt of full payment, Designer grants to the Client the following rights in the Designs:
 For use as_____
 For the product or publication named_____
 In the following territory_____
 For the following time period_____
 Other limitations_____
 With respect to the usage shown above, the Client shall have ❏ exclusive ❏ nonexclusive rights.
 This grant of rights does not include electronic rights, unless specified to the contrary here _____
 _____, in which event the usage restrictions shown above shall be applicable. For purposes of this agreement, electronic rights are defined as rights in the digitized form of works that can be encoded, stored, and retrieved from such media as computer disks, CD-ROM, computer databases, and network servers.

4. **Reservation of Rights.** All rights not expressly granted hereunder are reserved to the Designer, including but not limited to all rights in sketches, comps, or other preliminary materials created by the Designer.

5. **Fee.** Client agrees to pay the following purchase price: $_____ for the usage rights granted. Client agrees to pay sales tax, if required.

6. **Additional Usage.** If Client wishes to make any additional uses of the Designs, Client agrees to seek permission from the Designer and make such payments as are agreed to between the parties at that time.

7. **Expenses.** Client agrees to reimburse the Designer for all expenses of production as well as related expenses including but not limited to illustration, photography, travel, models, props, messengers, and telephone. These expenses shall be marked up ____ percent by the Designer when billed to the Client. At the time of signing this Agreement, Client shall pay Designer $_____ as a nonrefundable advance against expenses. If the advance exceeds expenses incurred, the credit balance shall be used to reduce the fee payable or, if the fee has been fully paid, shall be reimbursed to Client.

8. **Payment.** Client agrees to pay the Designer within thirty days of the date of Designer's billing, which shall be dated as of the date of delivery of the Designs. In the event that work is postponed at the request of the Client, the Designer shall have the right to bill pro rata for work completed through the date of that request, while reserving all other rights under this Agreement. Overdue payments shall be subject to interest charges of ____ percent monthly.

9. Advances. At the time of signing this Agreement, Client shall pay Designer ____ percent of the fee as an advance against the total fee. Upon approval of sketches Client shall pay Designer ____ percent of the fee as an advance against the total fee.

10. Revisions. The Designer shall be given the first opportunity to make any revisions requested by the Client. If the revisions are not due to any fault on the part of the Designer, an additional fee shall be charged. If the Designer objects to any revisions to be made by the Client, the Designer shall have the right to have his or her name removed from the published Designs.

11. Copyright Notice. Copyright notice in the name of the Designer ❏ shall ❏ shall not accompany the Designs when reproduced.

12. Authorship Credit. Authorship credit in the name of the Designer ❏ shall ❏ shall not accompany the Designs when reproduced.

13. Cancellation. In the event of cancellation by the Client, the following cancellation payment shall be paid by the Client: **(A)** Cancellation prior to the Designs being turned in: ____ percent of the fee; **(B)** Cancellation due to the Designs being unsatisfactory: ____ percent of fee; and **(C)** Cancellation for any other reason after the Designs are turned in: ____ percent of fee. In the event of cancellation, the Designer shall own all rights in the Designs. The billing upon cancellation shall be payable within thirty days of the Client's notification to stop work or the delivery of the Designs, whichever occurs sooner.

14. Ownership and Return of Designs. Upon Designer's receipt of full payment, the final electronic files delivered to the Client shall become the property of the Client. The ownership of removable electronic storage media and of original artwork, including but not limited to physical and electronic concepts and any other materials created in the process of making the Designs as well as illustrations or photographs, shall remain with the Designer. Any such physical materials delivered by Designer to Client with the electronic files shall be returned to the Designer by bonded messenger, air freight, or registered mail within thirty days of the Client's completing its use of the final electronic files. The parties agree that the value of original design, art, or photography is $_____, and these originals are described as follows

15. Releases. The Client agrees to indemnify and hold harmless the Designer against any and all claims, costs, and expenses, including attorney's fees, due to materials included in the Designs at the request of the Client for which no copyright permission or privacy release was requested or uses which exceed the uses allowed pursuant to a permission or release.

16. Arbitration. All disputes arising under this Agreement shall be submitted to binding arbitration before _____ in the following location _____ and settled in accordance with the rules of the American Arbitration Association. Judgment upon the arbitration award may be entered in any court having jurisdiction thereof. Disputes in which the amount at issue is less than $_____ shall not be subject to this arbitration provision.

17. Miscellany. This Agreement shall be binding upon the parties hereto, their heirs, successors, assigns, and personal representatives. This Agreement constitutes the entire understanding between the parties. Its terms can be modified only by an instrument in writing signed by both parties, except that the Client may authorize expenses or revisions orally. A waiver of a breach of any of the provisions of this Agreement shall not be construed as a continuing waiver of other breaches of the same or other provisions hereof. This Agreement shall be governed by the laws of the State of _____.

IN WITNESS WHEREOF, the parties hereto have signed this Agreement as of the date first set forth above.

Designer_____
Company Name

Client_____
Company Name

By_____
Authorized Signatory, Title

By_____
Authorized Signatory, Title

Website Design Agreement

Agreement as of the _____ day of _____, 20 ___, between _____ (hereinafter referred to as the "Client"), located at _____ and _____ (hereinafter referred to as the "Designer"), located at _____ with respect to the creation and licensing of a website (hereinafter referred to as the "Website").

WHEREAS, Designer is a professional designer with experience in the design of websites; and

WHEREAS, the Client wishes to develop a Website in furtherance of the Client's activities; and

WHEREAS, Designer wishes to create such a Website for Client;

NOW, THEREFORE, in consideration of the foregoing premises and the mutual covenants hereinafter set forth and other valuable considerations, the parties hereto agree as follows:

1. **Scope of Work**. The Designer agrees to perform the following work with respect to the Website as indicated by the checked boxes:

 ❏ **Prototype**. Designer shall provide Client with an initial prototype for approval, which shall consist of:

 ❏ home page, described as _____

 ❏ ____ subsection web pages, described as _____

 ❏ ____ additional sample web pages, described as _____

 ❏ navigational flow chart

 ❏ special features, described as _____

 The web pages shall show the look and feel of the Website, including type style, colors, navigational devices, illustrative/photographic styles, buttons, and related design elements.

❏ **Website Delivery and Testing.** Upon Client's approval of the initial prototype and receipt of the necessary assets (including but not limited to text, visual, and sound elements) from the Client, the Designer shall create a fully functional Website consisting of ____ web pages and reasonably conforming to the initial prototype. If the assets provided by Client cause the Website to exceed ____ web pages, the due date specified in Paragraph 2 and fee specified in Paragraph 5 shall be adjusted as provided in those paragraphs. After creation of the functional Website, the Designer shall test the Website in a Beta version. In consultation with the Client, the Designer shall make necessary corrections in the functionality before uploading the final version of the Website to the Client's web server or otherwise delivering the final version to the Client as follows

❏ **Website Maintenance.** Designer shall maintain the Website and incorporate new assets as Client gives such assets to the Designer. The maintenance process is more fully described as _____

2. **Due Dates.** The Designer shall meet the following due dates:

❏ **Prototype.** The initial prototype shall be presented to the Client on or before _____, 20___.

❏ **Website Delivery and Testing.** The functional Website shall be provided in a Beta version to the Client within ____ days of Client's approval of the prototype and receipt of the necessary assets from Client. If the quantity of assets delivered by Client causes the Website to exceed ____ web pages, the deadline for Website Delivery shall be extended by ____ days for every ____ additional web pages. After consultation with Client, the Designer shall make any corrections and upload or deliver the final version of the Website within ____ days of receipt of Client's corrections.

❏ **Website Maintenance.** Designer shall incorporate new assets into the Website as agreed between the parties at the time of receipt by Designer of said assets.

The Designer's time for performance shall be extended by any delays caused by the Client, including but not limited to delays arising from the failure to deliver assets or advise the Designer as to corrections.

3. **Grant of Rights.** Upon receipt of full payment, Designer shall grant to the Client exclusive world website usage rights for the business, nonprofit organization, project, product, or publication named _____ for the following time period _____. The Client shall be the owner of the Website but shall have the right to use the Website design for this particular Website only. In addition, the Client shall have the right to use assets supplied by the Designer only for the Website. The html files, images files, animations, JAVA scripts, CGI programs, and related assets supplied by the Designer may not be used by the Client apart from their use on the Website. The Designer retains the right to make portfolio use of the Website or parts thereof after the Website has been placed on Client's web server.

4. **Reservation of Rights.** All rights not expressly granted shall be reserved to the Designer.

5. **Fee.** Client agrees to pay the following fees:

❏ **Prototype.** A fee of $_____ shall be paid for the prototype, ____ percent on the signing of this Agreement, ____ percent when half the prototype is completed, and ____ percent when the prototype is provided to the Client.

❏ **Website Delivery and Testing.** A fee of $_____ shall be paid for Website Delivery and Testing, ____ percent on commencement, ____ percent when half the work is completed, and ____ percent on the uploading or delivery of the final version. Alternatively, the fee may be paid in installments as follows _____ _____

If the quantity of assets delivered by Client causes the Website to exceed ____ web pages, the fee for Website Delivery and Testing shall be increased by $_____ for every ____ additional web pages.

❏ **Web Maintenance.** A fee of $_____ shall be paid for web maintenance. The fee shall be $____ per hour or shall be computed as follows _____ _____.

These compensation provisions for web maintenance shall be in effect for ____ months after the date of this Agreement and then shall be subject to renegotiation.

6. Additional Usage. If Client wishes to make any additional uses, Client shall seek permission from the Designer and pay an additional fee to be agreed upon.

7. Expenses. Client agrees to reimburse the Designer for all expenses of production as well as related expenses including but not limited to illustration, photography, travel, messengers, telephone, and unreturned electronic storage media. These expenses shall be marked up _____ percent by the Designer when billed to the Client to cover overhead and carrying expenses.

8. Payment. Designer shall invoice Client as fees are due and Client shall pay within ____ days of receipt of each invoice. Overdue payments shall be subject to interest charges of _____ percent monthly.

9. Advances Against Expenses. At the time of signing this Agreement, Client shall pay Designer $_____ as a non-refundable advance against expenses. If the advance exceeds expenses incurred, the credit balance shall be used to reduce the fee payable or, if the fee has been fully paid, shall be reimbursed to Client.

10. Revisions. The Designer shall be given the first opportunity to make any revisions requested by the Client. If the revisions are not due to any fault on the part of the Designer, additional compensation shall be paid as follows _____ _____

11. Copyright Notice. Copyright notice for the Website shall appear in the name of the Client, unless specified to the contrary _____. Other copyright notices, such as for photography, illustration, and music, shall be included as required in the relevant releases.

12. Authorship Credit. Authorship credit in the name of the Designer shall appear on the Website in the following location _____ along with the Designer's email address. If Client alters the Website design, the Designer shall have the right to have Designer's name removed from the Website.

13. Cancellation. In the event of cancellation by the Client, the Client shall pay all expenses incurred by the Designer as well as fees based on the degree of completion of the Website. Special provisions regarding cancellation are as follows _____ _____

14. Client Responsibilities and Confidentiality. Any and all assets that Client is to supply for the Website shall be delivered to the Designer by _____, 20___, in electronic format (delivered on removable storage media or

transmitted via the Internet), and such supplied assets shall be in final form and ready for Website use. Client shall proofread and edit such assets prior to delivery to Designer, and any additional work due to corrections of such assets, file conversions, or scanning of text or images shall be billed additionally to the fee specified in Paragraph 5. The Designer agrees that any asset supplied by Client, whether for the Website or in relation to the business purposes for its development, shall be treated as confidential and neither disclosed to third parties nor used in any way other than for the development of the Website. At the completion of work, the Designer shall return to Client the assets supplied by Client.

15. Releases. The Client warrants that it has the right to enter into this Agreement and that Client owns or has obtained appropriate Website usage rights for any assets supplied by the Client to the Designer. The Client shall indemnify and hold harmless the Designer and its subcontractors against any and all claims, lawsuits, costs, and expenses, including reasonable attorney's fees, arising in connection with the Website. This indemnification shall extend to assets obtained by the Designer on the Client's behalf if the Designer has secured either exclusive or nonexclusive world Website usage rights.

16. Arbitration. All disputes shall be submitted to binding arbitration before _____ in the following location _____ and settled in accordance with the rules of the American Arbitration Association. Judgment upon the arbitration award may be entered in any court having jurisdiction thereof. Disputes in which the amount at issue is less than $_____ shall not be subject to this arbitration provision.

17. Miscellany. Neither this Agreement nor any rights or obligations hereunder shall be assigned by either of the parties, except that the Designer shall have the right to assign monies due hereunder. Both Client and any party on whose behalf Client has entered into this Agreement shall be bound by this Agreement and shall be jointly and severally liable for full performance hereunder, including but not limited to payments of monies due to the Designer. The terms and conditions of this Agreement shall be binding upon the parties, their heirs, successors, assigns, and personal representatives. This Agreement constitutes the entire understanding between the parties; its terms can be modified only by an instrument in writing signed by both parties, except that the Client may authorize additional fees and expenses orally. A waiver of a breach of any of this Agreement's provisions shall not be construed as a continuing waiver of other breaches of the same or other provisions hereof. The relationship between the Client and Designer shall be governed by the laws of the State of _____.

IN WITNESS WHEREOF, the parties hereto have signed this Agreement as of the date first set forth above.

Designer _____
Company Name

Client _____
Company Name

By_____
Authorized Signatory, Title

By_____
Authorized Signatory, Title

CHAPTER

16 PUBLISHING CONTRACTS

One of the most sophisticated contracts for the sale of reproduction rights is the book publishing contract. A book of illustrations, photographs, or any art will require the negotiation of the same type of contract offered to an author. Even if an artist and author collaborate, each will usually negotiate such a contract with the publisher. If the artist and author are co-authors, it is important to enter into a collaboration agreement to avoid misunderstandings as to rights, royalties, and a myriad of other issues.

This chapter examines the standard clauses in the author's book contract to determine how each of the provisions should be negotiated. The Authors Guild has published the Authors Guild Trade Book Contract, which recommends terms the author or artist should seek. The provisions of a collaboration agreement are also examined.

A model contract appears at the end of the chapter and its terms are referred to in the discussion of the various provisions. Any professional publishing house will have its own contract, but the terms of the model contract may be used for comparison. Also, artists are sometimes asked by non-professional book publishers to illustrate a book. For example, a charity or chamber of commerce might want to do a book of special local interest. If neither party has any publishing background, the model contract could be adapted for this purpose. Certain clauses, such as the subsidiary rights clause, have been eliminated because they would not pertain to this kind of venture. However, the contract covers all the areas that the artist and the other party might want to deal with in an agreement.

Many of the provisions will require negotiation, and the terms that have been filled in

are only suggestions. This agreement would be considered generally favorable to the artist. For artists who wish to delve more deeply into publishing agreements, *Business and Legal Forms for Authors and Self-Publishers* by Tad Crawford (Allworth Press) offers helpful coverage. This book includes a collaboration agreement and negotiation checklists.

The complexity of book contracts makes the advice of an agent or lawyer especially valuable.

Grants of Rights

After setting out the names of the parties and the date, a book contract will detail the rights granted by the artist to the publisher (model agreement, Paragraph 1). "All rights" would be the transfer of all the rights possessed by the artist to the publisher. This would mean the publisher, and no one else, could exploit the work as a book or in any other medium without any limitation as to either territory or time (although it might be argued that even "all rights" only means "all publishing rights"). If, for example, the publisher wished to exploit the work on t-shirts, posters, jewelry, or dolls, the artist would not have any right to prevent such uses. Nor could the artist prevent the publisher from exploiting the material electronically, such as over the Internet or on a CD-ROM. Artists who create designs for book covers may find that the design is subsequently used for advertising or paperbacks. If the artist has not negotiated a contractual right to additional payments or reserved all rights not expressly granted, the artist may have no right to additional payments.

The grant of rights can be limited as to uses that can be made of the artwork, the time

during which the work can be used in book form, and the territory in which the book can be sold. Simply specifying that the work can only be used in a book would prevent licensing applications, and specifying that the grant is non-electronic would prevent use on a CD-ROM.

The rights not conveyed in the grant of rights provision, however, might still be conveyed as subsidiary rights.

Subsidiary Rights

Subsidiary rights cover many of the uses not permitted by the grants of rights, such as abridgments, anthologies, book clubs, reprints by another publisher, first and second serializations (which are magazine rights before and after book publication), syndication, advertising, novelty uses, translation and foreign language publications, motion pictures, dramatic, radio, television, mechanical rendition or recording uses, and electronic rights. The definition of these rights can vary in different contracts.

The publisher often has the exclusive power to dispose of the subsidiary rights. The division of income between publisher and artist is specified as to each subsidiary right. Often the division of subsidiary rights income is shared equally by author and publisher. However, the terms of Authors Guild contract suggest that only publishing rights should be granted in a publishing contract. This means that the author would not grant to the publisher any control over, or benefits from, non-publishing subsidiary rights, such as stage, record, radio, motion picture, television, audiovisual, and electronic rights. The artist might particularly seek to reserve all rights to advertising, licensing, and electronic uses. For each subsidiary right, the artist should consider demanding the power either to control the right or to veto exercises of the right by the publisher. At the least, however, the artist should receive copies of any licenses for subsidiary rights granted by the publisher.

Reservation of Rights

The grant of rights and the subsidiary rights provisions will normally cover all the conceivable uses of the artist's work. However, the artist should anticipate un-thought of, or even un-invented, uses. This is done by insisting on a simple clause stating: "All rights not specifically granted to the publisher are reserved to the artist," (model agreement, Paragraph 2). Just as the CD-ROM or the Internet are recent innovations, the likelihood of further inventions is great and must be anticipated in the contract. If the artist does want to allow electronic versions of the work to be published and sold, a typical royalty at the present time would be 25 percent of receipts.

Delivery of Manuscript

The contract will require the artist to deliver a manuscript on or before a specified date (model agreement, Paragraph 3). Many publishers are now requiring that computer disks also be delivered. If the contract specifies that the manuscript be in "content and form satisfactory to the publisher," the artist should at least have the word "reasonably" inserted before "satisfactory." A less likely solution would be to allow the publisher to reject a manuscript deemed unsatisfactory, but not allow the publisher to demand back advances given to the artist (model agreement, Paragraph 20). If the publisher has seen either completed work or work in progress, the provision should be modified to indicate such work as satisfactory. Also, the artist should have a grace period for illness and similar eventualities that may cause the work to be delivered late.

The contract may require the artist to deliver a manuscript consisting of more than just artwork. The artist may be responsible for the title page, preface or foreword, table of contents, index, charts, all permissions (including payments for such permissions), and a bibliography (model agreement, Paragraphs 4 and 5). If the artist does not supply these materials, the publisher will normally have the right to pay for them and deduct the cost from the artist's royalties.

Royalties

The artist may sell artwork for a flat fee, in which case no royalties would be payable. However, royalties permit the artist to share in the success of the book and usually are desirable. The artist receives a royalty for each copy sold, with the royalty rate often increasing with the number of copies sold (model agreement, Paragraph 7). If the artist has done both text and art for a hardcover trade book, the royalties might be 10 percent of retail price on the first five thousand copies sold, 12.5 percent on the

next five thousand copies sold and 15 percent on all copies sold in excess of ten thousand copies.

If the artist has only contributed art to the book, an arrangement that divides the royalties between artist and author is fair. The precise sharing depends on the degree of work done by each party, who originated the concept for the book, and whose name will make the book sell (if this is relevant). Because of the complexity of royalty rates and the fact that these rates vary for different categories of books, the artist should really seek expert advice from more experienced artists or agents when trying to determine whether an offered royalty is fair. It is important to ascertain which copies sold are counted for purposes of reaching the five thousand and ten thousand copy levels at which the royalty percentage escalates. While copies sold through bookstores at full price are generally counted, copies sold to book clubs or at high discounts are not likely to be counted.

Fairness, however, is not based only on the royalty percentages. The way in which the royalty is defined is very important. Basically, the royalty should always be a percentage of the publisher's retail list price, the price at which the book will be sold to the public. If the royalty is based on net price—that is the price after discounts to wholesalers and bookstores—the royalties will be far lower than if based on retail list price. Of course, a royalty based on net price might be acceptable if the royalty percentage were roughly double the royalty rate based on retail price. This is because the discount given bookstores and book wholesalers by the publisher is usually in the forty to 50 percent range. The royalty should not be a specific amount, such as $1 per copy, because the publisher invariably has the power to determine the selling price of the book.

Royalties will often be reduced on copies sold in digest form, in a foreign language edition, at higher than usual discounts, directly by the publisher due to the publisher's advertising, and in other circumstances listed in each contract. The artist must consider whether each reduction is fair because of the significant effect reductions can have on royalties.

Advances

The advance is paid to the artist against royalties to be received in the future (model agreement, Paragraph 8). The artist might reasonably request an advance equal to 50 or 75 percent of the royalties anticipated during the first year of sale of the book. The advance may be paid in full at the time of signing the contract or may be paid in equal installments at the time of signing, delivery of the manuscript, and publication. The artist should always request that the advance be nonreturnable except for failure to deliver the manuscript. Also, the artist should not permit a provision that would allow the advance under one contract to be deducted from royalties earned under a contract for a different book.

Payments, Statements of Account, Inspection of Books

Payment of royalties should be made on a periodic basis, usually quarterly or semiannually (model agreement, Paragraph 10). The right of the publisher to maintain a reserve against returns—that is, to hold part of the royalties in case the books are returned by bookstores—should be limited to a small percentage of the royalties. There should also be a time period beyond which such reserved royalties cannot be held (model agreement, Paragraph 9).

The Authors Guild provision requires a statement of account showing the total sales to date and the number of copies sold for the period just ended, the list price, the rate for royalties, the amount of royalties, the handling of any reserve against returns, and information relating to licensing income (model agreement, Paragraph 9). The Authors Guild provides for the artist to examine the publisher's books and records upon the artist's written request (model agreement, Paragraph 11).

Duty to Publish and Keep Work in Print

The artist should ideally require the publisher to stipulate the date when the book will be published (model agreement, Paragraph 6). The Authors Guild provision requires publication within one year of delivery of the manuscript by the artist, while many other contracts specify a reasonable time or merely state that the date of publication will be at the publisher's discretion. The artist can request a provision expressly reverting all rights to the artist if the book is not published within the stipulated period of time, unless delays are of a nature the publisher cannot avoid.

The artist should also seek to ensure that the book will be kept in print. If the publisher

becomes bankrupt or insolvent or simply ceases to exploit the book by not printing copies for sale, the artist should no longer be obligated under the contract. In such an event, the artist should have the option within a certain time period (for example, sixty days) to purchase film, computer drive tapes, bound copies, and sheet stock at or below the publisher's cost (model agreement, Paragraph 21). In order to seek a new publisher to promote the work more vigorously, the artist should receive back all rights, including any rights of copyright, which the publisher had in the work (model agreement, Paragraph 2). These provisions vary from contract to contract and often require that the artist either demand that the publisher reprint the work or give notice that the work is out-of-print, as defined in the contract.

Copyright and Suits for Infringement

The copyright should be secured in the artist's name by the publisher (model agreement, Paragraph 12). The publisher should be required to gain copyright protection by the use of appropriate notice whenever and wherever the work will be published. To assist in this, the artist should provide the publisher with a list of all previous publications of the work submitted for use in the book.

If the copyright is infringed, the publisher can sue the infringer but is not obligated to do so (model agreement, Paragraph 19). If the publisher or artist sues alone, the other party should have to cooperate. The party bringing the suit would normally bear the costs and recoup them from any recovery. If both parties sue, the cost would be split as agreed in the contract. In either case, provision must be made for the division of amounts recovered in excess of costs. The artist should have exclusive power to sue for infringement of rights retained by the artist.

Warranty and Indemnity

The contract will require the artist to give an express warranty to the effect that the work does not infringe any copyright, violate any property rights, or contain any scandalous, libelous, or unlawful matter (model agreement, Paragraph 13). The artist must agree to indemnify the publisher against all claims, costs, expenses, and attorney's fees. This means the artist will pay for the publisher's expenditures caused by any breach or alleged breach. The

publisher will have the right to withhold the artist's royalties until any suit or threatened suit is settled.

The Authors Guild provision modifies the warranty by having the artist state that the work, "to Author's knowledge," is neither libelous nor violates privacy rights. The artist's liability under the Author's Guild provision is limited to the lesser of a stated amount or a percentage of the sums due the artist under the contract. Such liability exists, however, only as to final judgments for damages after all appeals have been taken, so that alleged breaches of warranty which do not result in final judgments would not make the artist liable for any of the publisher's expenditures. If the artist defends the suit, then the artist is not liable to pay the fees of lawyers retained by the publisher. Also, the Author's Guild limits the amount of royalties that can be withheld by the publisher to a stated percentage, in no event more than the damages claimed in any suit.

A number of leading publishers have extended their liability insurance to protect artists in the event of such lawsuits. Needless to say, this is an important advantage for the artist.

Artistic Control

Since the contract requires the publisher's approval of or satisfaction with the work, artistic control resides in the publisher. Few publishers, if any, would agree to a provision requiring that the book be published in a form approved by the artist. The model agreement proposes consultation between publisher and artist as to title, price, promotion, production, and similar important issues (model agreement, Paragraph 14). However, unless specified otherwise, the publisher is given the final decision-making power. But the artist should insist on the opportunity to make any necessary changes in the work and should certainly seek the right to approve any changes in the work done by other people. If the artist chooses to change the work after the book is in production, he or she may be liable for part of the cost of such changes.

If an edition in the future is to be revised, the artist should have the opportunity to do any necessary revisions. If the artist cannot make such revisions, the cost of the revisions would be deducted from royalties due the artist (model agreement, Paragraph 17). But the artist should not permit any such payments to be deducted

from royalties owed the artist under other contracts with the publisher. The artist can protect against losing royalties due to revisions by requiring that no revisions be made for a specified period after the signing of the contract.

The publisher will have the power to fix the book's retail price, title, form, type, paper, and similar details. If the artist wishes to have a voice in any of these matters, an appropriate provision should be made in the contract.

Credits

The exact nature of the artist's credit should be specified, including size and placement, especially if a writer or editor has also worked on the book (model agreement, Paragraph 12). If another person may revise the book in the future, the credit to be given such a reviser should be specified. The artist should remember that, without a provision for credit, the artist's right to such credit may be in question and reside in the publisher's discretion.

Original Materials

The publisher should be required to return the original artwork to the artist (model agreement, Paragraph 15). The publisher will usually not agree to either insure the work or pay if the work is damaged, although the artist might demand this if the work is of great value. The publisher should agree to try and keep the original artwork in good condition for return to the artist.

Competing Works

The publisher may try to restrict the artist from creating competing works. Such a provision can prevent the artist from creating any work on the same subject as the work to be published. The artist may not be able to agree to such a provision, especially if all the artist's work is similar. The artist might, therefore, seek to have this provision limited to material directly based on the work to be published. Another approach would be to limit the time during which the restrictions on competing works would remain in force. Ideally, the artist should seek to have this provision stricken from the contract.

Options

Another common provision gives the publisher the option to publish the artist's next work. Such a provision may well be unenforceable unless the terms of the future publication are made definite. In any case, the artist should insist that the option provision be deleted from the contract. If the artist and the publisher are satisfied with one another, they will want to contract for future books. If they are not satisfied, there is no reason why the artist should have to offer the next book to the publisher. If an option provision is agreed to, the artist should not give an option for more than one work and should require the publisher to make a determination with regard to that work within a reasonable time period after submission.

Another type of option clause gives the publisher the right to meet the terms offered by another publisher on a succeeding work. In any type of option clause, the publisher should be required to exercise the option based on submission of a proposal (with or without sample chapter) rather than on receipt of a full-length manuscript or completed body of work.

Free Copies

Most publication contracts will provide for the artist to receive five to ten free copies of the final book (model agreement, Paragraph 16). Additionally, provision is made for the artist to purchase unlimited copies at a substantial discount, such as 40 percent, from retail list price. The artist should be certain such a provision is contained in the contract. If the 40 percent discount provision requires the copies be used for personal purposes only, the artist should consider whether he or she might in fact want to sell the copies. And if the artist wants to buy hundreds or thousands of copies, it may very well be possible to negotiate a far higher discount than 40 percent. This is especially true if the artist places an order prior to the publisher's printing or reprinting of the book.

Assignment

This provision usually requires the written consent of either party to an assignment by the other. Presumably the publisher would not wish to have another artist substituted under the contract, but nothing should prevent the artist from assigning to another person money due or to become due under the contract (model agreement, Paragraph 18). The publisher may also require a provision permitting assignment, especially to a new publisher that is taking over the publisher's business.

Agents

Book agents have traditionally received 10 percent of the monies due to an author, although many agents are now asking between 12 1/2 and 15 percent. The artist's contract with an agent may give the agent authority to act on behalf of the artist in all matters arising from the contract. If, in fact, the agent's powers are limited, it would be wise to strike this provision and append a copy of the artist-agent contract to the publishing contract. Also, the artist should always have the right to receive payment directly from the publisher for a minimum of 90 percent (or 85 percent if the fee is 15 percent) of sums due, if the artist wants direct payment once the artist-agent contract has terminated. This can be accomplished by the use of a clause to the effect that "The authorization of the agent to act on behalf of the artist and to collect sums due the artist shall continue in effect until the publisher shall otherwise be instructed in writing by the artist." The exact language of the agency clause will have to be negotiated in the artist-agent contract.

Advertising

Some artists who create books that are potentially very profitable to publishers may be able to require the designation of an advertising budget. If this is done, the budget should only be expendable for the single title, not group ads including other titles. A further breakdown into the categories of advertising is difficult prior to publication, although in special cases it may be possible to pinpoint markets in which advertising should later take place. The artist risks limiting the publisher's flexibility, however, and perhaps also having the publisher cease advertising once the stipulated amount has been expended. The more usual approach is to request the highest possible advance, and leave the publisher to its own ingenuity with respect to advertising and promotion.

Most contracts require that the artist allow the publisher to use the artist's name, likeness, or photograph in advertising and promotion for the work. This clause is desirable, but the artist might want an assurance that suitable decorum will be maintained.

Arbitration

The artist will generally benefit from an arbitration provision, because disputes under the contract can be quickly and easily resolved. Many contracts will provide for arbitration before the American Arbitration Association, but the artist should be satisfied as long as unbiased arbitrators will hear the dispute. The disadvantage of arbitration is that an arbitrator's adverse decision is very difficult to appeal to the courts, so the artist should feel certain the arbitration will be fairly conducted.

Other Provisions

The contract will require that modifications be in writing (model agreement, Paragraph 23). The state's laws that will govern the contract should be specified. The contract will state that heirs, legal representatives, successors, and assigns are bound by its terms (model agreement, Paragraph 18). Waivers or defaults under one provision will usually be restricted, so as neither to permit future waivers or defaults nor to affect obligations under other provisions of the contract (model agreement, Paragraph 24).

Collaborators

The artist may collaborate with another artist, a writer, an editor, a technical expert, or a well-known person. In some cases collaboration may be with someone the artist never meets, but who merely contributes material for the book. In any case, the artist and any collaborator must have a contract between them that divides up all the rights (especially the rights to control and receive income) contained in the publishing contract. In the absence of a provision giving control over uses of the work to one party, all collaborators will normally have the power to authorize nonexclusive licenses and the income will be shared among the collaborators.

The collaboration contract must include a method for resolving disputes, such as a disagreement over publishers to which the completed work will be submitted. Thought must be given to what will happen if one party becomes disabled or dies during the collaboration. Artistic control, and an orderly plan to complete the work, must be determined. Authorship credit will require elaboration. It must be decided who will own the copyright and what the form of copyright notice will be. If each collaborator can sell his or her interest in the work, the other parties may wish a right to have first opportunity to purchase the interest on the same terms being offered by outsiders.

Consideration should also be given to whether the collaborators should have a separate or a joint contract with the publisher. For example, is the artist to be liable for breaches of a warranty by a collaborator? These and similar questions will depend on the contractual relationship of the collaborators to one another and the publisher. And, if the collaboration fails to reach fruition, a determination must have been made as to the rights each collaborator will have in the incomplete work.

Model Publishing Agreement

Agreement, entered into as of this _____ day of _____, 20___, between _____, residing at _____ _____ _____ (hereinafter referred to as the "Publisher"), and _____ _____,residing at_____ _____ (hereinafter referred to as the "Artist").

Whereas, the Artist wishes to create a book on the subject of _____;

Whereas, the Publisher is familiar with the work of the Artist and wishes to distribute such a book; and

Whereas, the parties wish to have said distribution performed subject to the mutual obligations, covenants and conditions herein.

Now, Therefore, in consideration of the foregoing premises and the mutual covenants hereinafter set forth and other valuable considerations, the parties hereto agree as follows:

1. Grant of Rights. The Artist grants, conveys and transfers to the Publisher in that certain unpublished work titled _____ _____, the following rights: [Exclusive North American rights in hardcover book form in the English language for a period of five years would be one example of a possible—although unusually restrictive—grant of rights.]

2. Reservation and Reversion of Rights. All rights not specifically granted to the Publisher are reserved to the Artist, including but not limited to electronic rights. In the event of termination of the Agreement, the Publisher shall grant, convey, and transfer all rights in the work back to the Artist.

3. Delivery of Manuscript. On or before the _____ day of _____, 20_____, the Artist shall deliver to the Publisher a complete manuscript of approximately _____ words and including the additional materials listed in Paragraph 4. If the Artist fails to deliver the complete manuscript within ninety days after receiving notice from the Publisher of failure to deliver on time, the Publisher shall have the right to terminate this Agreement and receive back from the artist all monies advanced to the Artist pursuant to Paragraphs 4, 5 and 8.

4. Additional Materials. The following materials shall be provided by the Artist: (photographs, drawings, maps, tables, charts, index, other illustrations, described more fully as follows _____.) The cost of providing these additional materials shall be borne by the Artist, provided, however, that the Publisher at the time of signing this Agreement shall give a non-refundable and non-recoupable payment of $_____ to assist the Artist in defraying these costs.

5. Permissions. The Artist agrees to obtain all permissions that are necessary for the use of materials copyrighted by others. The cost of providing these permissions shall be borne by the Artist, provided, however, that the Publisher at the time of signing this Agreement shall give a nonrefundable and non-recoupable payment of $_____ to assist the Artist in defraying these costs.

6. Duty to Publish. The Publisher shall publish the book within twelve months of the delivery of the complete manuscript. Failure to so publish shall give the Artist the right to terminate this Agreement ninety days after giving written notice to the Publisher of the failure to make timely publication. In the event of such termination, the Artist shall have no obligation to return monies received pursuant to Paragraphs 4, 5 and 8.

7. Royalties. The Publisher shall pay the Artist the following royalties: t10 percent of retail price on the first five thousand copies sold; 12 1/2 percent of retail price on the next five thousand copies sold; and 15 percent of retail price on all copies sold thereafter.

8. Advances. The Publisher shall, at the time of signing this Agreement, pay to the Artist a nonrefundable advance of $_____, which advance shall be recouped by the Publisher from payments due to the Artist pursuant to Paragraph 10 of this Agreement.

9. Accountings. The Publisher shall render quarterly reports to the Artist showing for that quarter and cumulatively to date the number of copies printed and bound, the number of copies sold, the number of copies returned, the number of copies distributed free for publicity purposes, the number of copies remaindered, destroyed, or lost, and the royalties paid to and owed to the Artist. If the Publisher sets up a reserve against returns of books, the reserve may only be set up for the four accounting periods following the first publication of the book and shall in no event exceed 15 percent of royalties due to the Artist in any period.

10. Payments. The Publisher shall pay the Artist all monies due Artist pursuant to Paragraph 9 within thirty days of the close of each quarterly period.

11. Right of Inspection. The Artist shall, upon the giving of written notice, have the right to inspect the Publisher's books of account to verify the quarterly accountings. If errors in any such accounting are found to be to the Artist's disadvantage and represent more than 5 percent of the payment to the Artist pursuant to the said accounting, the cost of inspection shall be paid by the Publisher.

12. Copyright and Authorship Credit. The Publisher shall, as an express condition of receiving the grant of rights specified in Paragraph 1, take the necessary steps to register the copyright on behalf of the Artist and in the Artist's name and shall place copyright notice in the Artist's name on all copies of the book. The Artist shall receive authorship credit as follows:

_____.

13. Warranty and Indemnity. The Artist warrants and represents that he or she is the sole creator of the book and owns all rights granted under this Agreement, that the book is an original creation and has not previously been published [indicate any parts that have been previously published],

that the book does not infringe any other person's copyrights or rights of literary property, nor, to his or her knowledge, does it violate the rights of privacy of, or libel, other persons. The Artist agrees to indemnify the Publisher against any final judgment for damages (after all appeals have been exhausted) in any lawsuit based on an actual breach of the foregoing warranties. In addition, the Artist shall pay the Publisher's reasonable costs and attorney's fees incurred in defending such a lawsuit, unless the Artist chooses to retain his or her own attorney to defend such lawsuit. The Artist makes no warranties and shall have no obligation to indemnify the Publisher with respect to materials inserted in the book at the Publisher's request. Notwithstanding any of the foregoing, in no event shall the Artist's liability under this Paragraph exceed $_____ or _____ percent of sums payable to Artist under this Agreement, whichever is the lesser. In the event a lawsuit is brought which may result in the Artist having breached his or her warranties under this Paragraph, the Publisher shall have the right to withhold and place in an escrow account _____ percent of sums payable to the Artist pursuant to Paragraph 10, but in no event may said withholding exceed the damages alleged in the complaint.

14. Artistic Control. The Artist and Publisher shall consult with one another with respect to the title of the book, the price of the book, the method and means of advertising and selling the book, the number and destination of free copies, the number of copies to be printed, the method of printing and other publishing processes, the exact date of publication, the form, style, size, type, paper to be used, and like details, how long the plates or type shall be preserved and when they shall be destroyed, and when new printings of the book shall be made. In the event of disagreement after consultation, the Publisher shall have final power of decision over all the foregoing matters except the following, which shall be controlled by the Artist: _____.
No changes shall be made in the complete manuscript of the book by persons other than the Artist, unless the Artist consents to such changes.

15. Original Materials. Within thirty days after publication, the Publisher shall return the original manuscript and all additional materials to the Artist. The Publisher shall provide the Artist with a copy of the page proofs, if the Artist requests them prior to the date of publication.

16. Free Copies. The Artist shall receive ten free copies of the book, after which the Artist shall have the right to purchase additional copies at a 40 percent discount from the retail price.

17. Revisions. The Artist agrees to revise the book on request by the Publisher. If the Artist cannot revise the book or refuses to do so absent good cause, the Publisher shall have the right to have the book revised by a person competent to do so and shall charge the costs of said revision against payments due the Artist under Paragraph 10.

18. Successors and Assigns. This Agreement may not be assigned by either party without the written consent of the other party hereto. The Artist, however, shall retain the right to assign payments due hereunder without obtaining the Publisher's consent. This Agreement shall be binding on the parties and their respective heirs, administrators, successors and assigns.

19. Infringement. In the event of an infringement of the rights granted under this Agreement to the Publisher, the Publisher and Artist shall have the right to sue jointly for the infringement and, after deducting the expenses of bringing suit, to share equally in any recovery. If either party chooses not to join in the suit, the other party may proceed and, after deducting all the expenses of bringing the suit, any recovery shall be shared equally between the parties.

20. Termination. The Artist shall have the right to terminate this Agreement by written notice if: (1) the book goes out-of-print and the Publisher, within ninety days of receiving notice from the Artist that the book is out-of-print, does not place the book in print again; (2) if the Publisher fails to provide statements of account pursuant to Paragraph 9; (3) if the Publisher fails to make payments pursuant to Paragraph 10; or (4) if the Publisher fails to publish in a timely manner pursuant to Paragraph 6. The Publisher shall have the right to terminate this Agreement as follows: (1) as provided in Paragraph 3, if the Artist fails to deliver a complete manuscript; and (2) if the complete manuscript delivered pursuant to Paragraph 3 is unsatisfactory to the Publisher, but in the event of such termination the Publisher shall have no right to receive back monies paid to the Artist pursuant to Paragraphs 4, 5 and 8. This Agreement shall automatically terminate in the event of the Publisher's insolvency, bankruptcy, or assignment of assets for the benefit of creditors.

21. Production Materials and Unbound Copies. Upon any termination, the Artist may, within sixty days of notification of such termination, purchase the plates, offset negatives or computer drive tapes (if any) at their scrap value and any remaining copies at cost.

22. Notice. Where written notice is required hereunder, it may be given by use of first class mail addressed to the Artist or Publisher at the addresses given at the beginning of this Agreement. Said addresses for notice may be changed by giving written notice of any new address to the other party.

23. Modifications in Writing. All modifications of this Agreement must be in writing and signed by both parties.

24. Waivers and Defaults. Any waiver of a breach or default hereunder shall not be deemed a waiver of a subsequent breach or default of either the same provision or any other provision of this Agreement.

25. Governing Law. This agreement shall be governed by the laws of _____ State.

Artist

Publisher

By: (Signer's Name and Title)

17 VIDEO ARTWORKS

rt on videotape, DVD, or the Internet, often combined with pictorial or sculptural elements, is a medium used by some artists. The legal problems of the video artist are for the most part the same as those of the artist using more traditional media. But the possibility of both mass reproduction and public broadcasting of video works raises additional legal issues. The increasing popularity of user-generated content portals like YouTube, Vimeo, and Google Video accentuate the increasing potential for mass distribution and consumption of video works.

Artist-Gallery Agreement

The agreement on pages 124–126 is between an artist and a gallery for the sale or rental of a video work by the gallery. In reviewing such an agreement, the video artist must consider all of the issues raised in chapter 14 regarding artist-gallery relationships. The model agreement specifically deals with the nature and geographic scope of the agency (Article 1), the term (Article 2), the gallery's use of best efforts (Article 3), commissions for sale or rental (Article 4), statements of accounts and payment (Article 4), the quantity of work subject to the agreement (Article 5), prices (Article 7), promotion of work and the artist (Article 9), assignment (Article 10), termination (Article 11), the death of either party or cessation of business by the gallery (Article 12), arbitration (Article 13), modifications to be written (Article 14), and the laws of which state will govern the agreement (Article 15).

The agreement also contains provisions not found when works in more traditional media are being sold or rented. The artist may create a video piece with several videotapes running simultaneously or with videotape to be used in conjunction with photographs, sculptures, or paintings. The artist would not usually want the elements of such work to be exhibited separately. The agreement provides that the sale or rental must be of the entire work (Article 1). Also, the ease of video reproduction makes copyright even more important for the artist working with video than for other artists. For this reason, the agreement specifies that the agency is only to sell the physical videotape cassettes and requires the gallery to protect the copyright against infringement (Articles 1 and 3). The gallery must obtain the agreement of each person who purchases or rents a copy of the work not to make further copies (Article 8). The dealer can only replace copies of the work if the purchaser returns the defective or damaged copy originally purchased (Article 5). The gallery must also seek to prevent a purchaser's broadcasting the work or charging admission (Article 8).

The ease of reproduction also bears on another important issue—whether or not to make the video work a limited edition. This decision may turn on many factors, such as the extent of the market, the price enhancement created by limiting the edition, and perhaps even the desire of the artist to maintain a tie to the traditional media in which work is usually either unique or original. The agreement provides that no more than fifty copies of the work shall be created, guaranteeing originality, and in this case reserves twenty-five copies to the artist for sale outside the scope of the agreement. The artist might wish to use a signed warranty of originality, like that described for photographic works on page 109. This signature and assurance of the limited number

of identical works or works derived from the entire work will reassure the collector as to value in this relatively new art medium.

The cost of creating copies from the master tape is the gallery's responsibility, but the artist keeps control of the master tape and has copyright notice on each copy in the artist's name (Article 6). This particular agreement does not reduce the adjusted gross proceeds specified in Article 4 by the gallery's cost of the copies, although the gallery might insist that such a reduction is only equitable.

If the gallery is to live up to the obligations contained in the agreement, the bill of sale or the rental agreement must conform to the terms restricting the purchaser's rights in the work. The bill of sale on page 116 therefore places many restrictions on the rights of the purchaser. The artist might also use this bill of sale with minor modifications when selling work directly to purchasers.

Broadcasting

Videotape naturally lends itself to the possibility of far wider dissemination than artworks in more traditional media. This potential has been recognized in an excellent article, "The Commissioning Contract for Video Artists," and in the contract draft with explanatory notes prepared for Americans for the Arts by Harvey Horowitz, a member of the New York City law firm of Squadron, Ellenoff, Plesent, Sheinfeld, and Sorkin. The article and contract originally appeared in the *Arts Advocate* and are reprinted here by permission of the Americans for the Arts, © Advocates for the Arts 1975.

The Commission Contract for Video Artists - by Harvey Horowitz

The commissioning contract is standard practice in publishing, film, and commercial television, but it is relatively new for the creative video artist. It is therefore important for the video artists engaged in this field to be aware of the legal ramifications of a video commissioning contract.

In the legal sense a video artist is distinct from an employee for hire who is engaged to make a work for a fee where the finished product belongs to the employer. Video artists are those who conceive and produce their work and view the finished product as their own. They usually function simultaneously as producer, director, cameraman, technician, sound

synchronizer, and editor. There is often confusion over the rights to the product of video artists—who owns it and for how long?

The guiding principle the artist should understand is that the artist originally owns the work and all rights connected to it. From that premise on, what any contract does is to exchange part of those rights for certain benefits to both sides. What this contract tries to do is to keep the give and take on an even basis so that the quid is balanced with the quo equally for both parties. It is up to the artist to make sure he or she is being fairly treated. Some commissioning stations, for example, begin negotiations with a pretty heavy finger on the scale, claiming that the large costs of production, advertising, etc., entitle them to most of the rights over the work. The argument may hold for the station's employees over whose work the station may have blanket rights, but not for the independent artist who already owns his or her package and barters rights in exchange for guarantees of how it is to be used, compensation and so on.

In television, including public broadcasting, contracts are commonplace. The following contract is not earthshaking, innovative, or novel in the law. It may, however, be innovative for the video artist. It is drafted in the traditional legal format and deals with the issues that matter. The artist should become familiar with the import of its language.

If we could win acceptance for a form contract tilted somewhat in favor of the artist who takes most of the risks, makes the most creative effort, and who, by rights, ought to be the one to propose "terms of agreement," we will have taken another small step towards vindicating the economic rights of artists—a primary and continuing concern of Advocates for the Arts.

Model Video Broadcast Contract

Dear _____

This letter will confirm the agreement reached between A. Artist (herein "the Artist") and Broadcasting in Education (herein "BIE").

Part 1. BIE hereby commissions the Artist to create a video work having as a working title, "The High Tower" (herein "the Work"). In connection with the production of the Work the Artist shall have the right to use the production facilities of BIE in accordance with Schedule A attached hereto. The Work shall

be approximately fifty minutes in length and deal with the subject of high towers. The Artist agrees to consult with members of the staff of BIE at reasonable times, although it is recognized that all artistic decisions with respect to the Work shall be made by the Artist.

Comment: The main thrust of the commissioning clause is to provide for the Work to be commissioned. Usually it will be unnecessary to describe the Work beyond the title and possibly the subject matter. The Artist should be able to use the facilities of the station, and, while he may be required to consult with station staff, it should be clear that artistic decisions will be made by the Artist. Schedule A to the agreement is intended to include the details of the Artist's permitted use of the station's production facilities, including such items as hours and days per week a facility will be available, equipment and supplies available to the Artist and personnel available to the Artist.

Sometimes the commissioning program involves the Artist serving as an artist-in-residence, or performing services in addition to producing the Work. Under such circumstances, the contract should be specific concerning the nature of the additional work to be performed by the Artist, the amount of time the Artist will be required to devote and additional compensation, if any. If the rendition of these additional services will possibly cause a time conflict for the Artist, the times and dates for the performance of these additional services should be subject to mutual agreement.

Part 2. In consideration for the rights to the Work granted to BIE hereunder, the Artist shall be paid the sum of three thousand dollars ($9,000) as a fee for the Artist's services payable as follows:

One thousand five hundred dollars ($4,500) upon execution of this agreement; and

One thousand five hundred dollars ($4,500) within 30 days of the completion of the Work or upon broadcast of the Work, whichever is earlier.*

The Work shall be deemed completed upon delivery of a finished master tape to BIE. In connection with the creation of the Work, BIE will reimburse the Artist for the expenses itemized on the expense schedule annexed hereto.

*Note: All money amounts and time periods given are, of course, arbitrary, included for the sake of continuity, and are not intended to suggest actual rates and conditions.

Comment: Aside from the obvious fact that the amount to be paid the Artist should be explicitly stated, some attention should be given to the language used to describe the method of payment. Care should be taken so that payments are related to objective events, such as selected date or delivery of a finished segment, rather than subjective criteria such as approval or acceptance of the Work. Additionally, if a payment is to be made upon the happening of an event under the control of the station, an outside date should be included in the schedule. Thus, if the last payment is to be made when the program is broadcast, the clause should read: "The final installment shall be paid the Artist when the Work is broadcast, but if the Work is not broadcast by November 30, 1996, then the final installment shall be paid the Artist on or before said date." If the station agrees to reimburse the Artist's expenses, the Artist should be prepared to conform to a station policy on expense vouchers. Some care should be taken in the preparation of the expense schedule so as to avoid disagreements over expenses after they have been incurred.

Part 3. All right, title and interest in and to the Work and all constituent creative and literary elements shall belong solely and exclusively to the Artist. It is understood that the Artist may copyright the Work in the Artist's name. The Artist grants BIE the right to have four releases of the Work on station WBIE for a period of two years commencing with the completion of the Work. A release is defined as unlimited broadcasts of the Work in a consecutive seven-day period; such consecutive seven-day period beginning with the first day the Work is broadcast. At the end of said two-year period, the master tape and all copies of the Work in BIE's possession shall be delivered to the Artist by BIE. All rights not specifically granted to BIE are expressly reserved to the Artist. This agreement does *not* grant BIE permission to distribute or broadcast the Work over the Internet or any other form of electronic media.

Comment: The language suggested confirms the principle that the Artist owns

all rights to the resulting Work, including the copyright. The station can be expected to argue that the Artist is an employee for hire under the copyright law and the copyright should belong to the station. When the contract provides for the Artist to retain the copyright, the Artist should, as a matter of practice, register the copyright to the Work. The sentence describing the grant of release rights to the station is intended as an example rather than a suggestion. One major area of discussion will be the "rights" issue. In general, the commissioning station will seek to acquire rights to distribute or broadcast the Work in the non-commercial, educational, nonsponsored or public television markets. While most persons involved in the field have some general understanding of the meaning of the foregoing terms, working out wording for appropriate definitions would be useful.

When dealing with the "rights" question, two issues should be separated. First is the issue of who controls the rights, i.e. who can arrange for broadcasting, and the second is whether there will be a sharing of receipts from the following guidelines:

a. The Artist should not grant a license to the station to exploit or distribute the Work in a market in which the station does not actively participate. Thus, if a station has had no experience dealing with cable television, the station should not request a license in such a market. Certainly, if such a license is granted in a previously unexploited area, it should only be on a non-exclusive basis. Even though the grant of a non-exclusive license has some appeal as a compromise, the Artist should be aware that if the work has commercial value, a distributor may wish to have all the exclusive rights. Accordingly, the fact that there are non-exclusive licenses outstanding might affect the marketability of the Work. On the other hand, if the station is very active in a market, for example distribution to school systems, it might be in the interest of the Artist to have the station serve as a licensee for that market. Under such circumstances the second issue, sharing of revenues or royalties, becomes relevant.

b. All licenses granted by the Artist should be limited as to geographic area and as to time. There should be no reason to grant world wide rights in perpetuity to a station unless the artist views himself basically as creating the Work for the station rather than for him or herself. Retaining the right to permit streaming broadcasts via the station's Web site, or via other electronic or Web based media, also acts as a limitation upon the station to distribute the work to a wider-than-negotiated audience or market.

c. If the Artist expects to realize a financial return from a grant of a license, the Artist should have the right to terminate the license if certain minimum levels of income are not reached. Thus, purely by the way of example, if the Artist grants the station a seven year license to exploit the Work in the educational market, and the Artist has not received at least $3,000 by the end of the third year of the license, he should have the right to terminate the license.

d. If the contract gives the Artist a percent of royalties received from the station's exploitation of the Work, at least three principles should be observed. First, percentages should be based on gross receipts rather than profits. From experience, whenever the concept of net receipts or net profits is introduced, there is created an area of potential dispute as to what can be deducted from receipts to arrive at net profits. Second, the station should be obligated to remit the Artist's share of royalties at least semi-annually and such royalties should be accompanied by a royalty statement. Third, the Artist should have the right to inspect the books of the station at least annually for the purpose of verifying royalty statements. When royalties are involved, the Artist should at least consider requesting an advance against royalties.

e. Theatrical, sponsored television, commercial and subsidiary rights should be held exclusively by the Artist. Some or all of these rights, of course, can be granted to the station in return for a lump-sum payment or royalty participation.

f. All grant of rights or license clauses should end with this sentence: "All rights not specifically granted to the station are expressly reserved to the Artist."

The Artist should recognize that the fee payable under Paragraph 2 and the rights granted to the station under Paragraph 3 are

very much negotiable matters. No general rule covering all artists can be formulated. For example, one artist might be willing to grant greater commercial rights to the station in return for a larger fee. To another artist, however, the amount of the fee could be less important compared to the rights he or she wishes to retain.

Part 4. BIE shall not have the right to edit or excerpt from the Work except with the written consent of the Artist. Notwithstanding the foregoing, BIE shall have the right to excerpt up to sixty (60) seconds of running time from the Work solely for the purpose of advertising the telecast of the Work or publicizing the activities of BIE. On all broadcasts or showings of the Work (except the up to sixty (60) seconds publicity uses referred to above) the credit and copyright notice supplied by the Artist shall be included.

Comment: This clause limits the station's rights to edit or change the Artist's work and limits rights to excerpt except under stated circumstances. The language assumes that the Artist has included a credit and copyright notice in the Work. The station may request the Artist to include an acknowledgment among the credits recognizing the station's contributions to the creation of the Work.

Part 5. BIE will be provided with the Master Copy of the Work, which it shall hold until termination of the license granted to it in Paragraph 3 above (or, if more than one license has been granted, the clause should refer to the lapse of the last license). BIE agrees to take due and proper care of the Master Copies in its possession and insure its loss or damage against all causes. All insurance proceeds received on account of loss or of damage to the Master Copy shall be the property of Artist and shall be promptly transmitted to Artist when received by BIE. Artist shall receive one copy of the Master of the Work in any format selected by the Artist. BIE agrees to use its best efforts to give the Artist reasonable notice of scheduled broadcast dates of the Work.

Comment: Custody of master copies and duplicate versions will largely depend on the nature and extent of rights to exploit the Work granted or reserved by the Artist. The Artist should understand that usually, a station will attempt to disclaim responsibility for caring for the Masters. In general, the law does not impose absolute responsibility on the station to take care of the Masters, be they in tape, DVD, or some other form. In the absence of language in the contract, the station will be held to what is described as a negligence standard. It will be liable for loss of the Master Tape or damage to it if the station has been negligent. While the Artist, through bargaining, may not be able to improve upon this measure of responsibility, the Artist should not contractually relieve the station of this responsibility to adhere to the negligence standard.

Part 6. The Artist authorizes BIE to use the Artist's name, likeness and biographical material solely in connection with publicizing the broadcast of the Work or the activities of BIE. The Artist shall have the right to reasonably approve all written promotional material about the Artist or the Work.

Comment: Because of right of privacy law, the station must acquire the consent of the Artist to use the Artist's name, picture or likeness in connection with advertising or trade purposes. The Artist should limit this consent to use in connection with the Work or in connection with promotions for the station. It is of course desirable for the Artist to be able to approve all promotional material relating to the Artist or the Work. However, the station may not readily agree to this proposal. Under such circumstances, if the Artist wants specific material included in promotional pieces, the Artist should prepare this material beforehand and obtain the station's agreement to include this material in its promotional pieces.

Part 7. The Artist represents that he or she is authorized to enter into this agreement; that material included in the Work is original with the Artist or the Artist has obtained permission to include the material in the Work or such permission is not required; that the Work does not violate or infringe upon the rights of others, including but not limited to copyright and right of privacy; and that the Work is not defamatory. The Artist agrees to indemnify BIE against any damages, liabilities and expenses arising out of the Artist's breach of the foregoing representations.

Comment: The Artist should expect to represent to the station that the Work and material contained in the Work are not defamatory, do not infringe upon any copyrights

and will in general not violate rights of others. The language of the indemnity or hold harmless clause should be examined closely. The Artist should not be liable to the station unless there has been an actual breach of the representations as distinguished from merely a "claimed" breach of the representations. Some hold harmless clauses are worded so that if someone claims the Work is, for example, defamatory, the station is permitted to settle the claim and charge the settlement to the Artist. It is this latter circumstance that is to be avoided. Consideration should also be given to obtaining insurance coverage for the Work against defamation, copyright and right to privacy claims. Stations usually have a form of this so-called "errors and omissions" insurance. Also, at least one artist has suggested that a station should be required as a preliminary matter to have its attorney view the Work to determine the probability of defamation or right of privacy claims. Based upon the advice of its attorney, the station would determine whether or not to broadcast the Work. If it elects to broadcast the Work, it would then assume the risk of such lawsuits. The rationale for such an argument is that a station usually has an existing relationship with a lawyer and, as between the station and the Artist, is in a better position to evaluate the possibility of such litigation and be guided accordingly. This point is being raised for discussion purposes.

Part 8. In the event BIE files for bankruptcy or relief under any state or federal insolvency laws or laws providing for the relief of debtors, or if a petition under such law is filed against BIE, or if BIE ceases to actively engage in business, then this agreement shall automatically terminate and all rights theretofore granted to BIE shall revert to the Artist. Similarly, in the event the Work has not been broadcast within one year from the date the Work is completed (as the term completed is defined in Paragraph 1), then this agreement shall terminate and all rights granted to BIE shall revert to the Artist. Upon termination of this agreement or expiration of the license granted to BIE under this agreement, all copies of the Work shall be delivered to the Artist.

Comment: This clause is intended to terminate the contract if the station should go bankrupt or cease business. Also, while

a station usually will not agree to actually broadcast a Work, if it does not broadcast the Work by a given date, the agreement will terminate. Both of these clauses are intended to allow the Artist to find other means of exploiting the Work if the station goes out of business or, in essence, refuses or fails to broadcast the Work.

Part 9. This agreement contains the entire understanding of the parties and may not be modified, amended or changed except by a writing signed by the parties. Except as is expressly permitted under this agreement, neither party may assign this agreement or rights accruing under this agreement without the prior written consent of the other except either party may assign rights to receive money or compensation without the other party's consent. This agreement shall be interpreted under the laws of the State of New York.

Comment: This is the "boilerplate" or standard jargon usually included in written agreements, and should be self-explanatory. Also, as a miscellaneous matter, the Artist should be prepared to adhere to policy "taste" standards or rules adopted by the station. Most stations have some form of policy guidelines and the Artist should obtain a copy of these guidelines before signing the contract.

Broadcasting in Education

_____ By:_____
A. Artist Authorized Signatory

Model Artist-Gallery Video Agreement

Agreement dated the _____ day of
_____, 20___, between
_____(the "Dealer"),
residing at _____

and _____ (the
"Artist"), residing at _____
_____.

Whereas the Artist has produced and created a work of art titled_____
_____ and described as a one-hour color videotape three-quarter inch cassette showing_____

(the "Work"); and

190

Whereas the Artist desires to have this Work distributed by the Dealer; and

Whereas the Dealer wishes to undertake the distribution of said Work; and

Whereas the parties wish to have said distribution performed subject to the mutual obligations, covenants, and conditions herein.

Now, Therefore, in consideration of the foregoing premises and the mutual covenants hereinafter set forth and other valuable considerations, the parties hereto agree as follows:

1. Artist hereby grants to the Dealer the exclusive right to sell or lease the Work in the United States of America for the term of this agreement. The exclusive right granted hereby includes only the limited license to sell or lease the physical videotape cassettes representing single copies of the Work recorded thereon. All rights not granted hereunder are reserved to the Artist, including but not limited to the right to distribute or broadcast the Work over the Internet or in any other electronic media. In no event shall there be a sale or leasing consisting of less than the entirety of the Work as described above.

2. The term of this agreement shall be for a period of two (2) years, commencing as of the date set forth above.

3. Dealer agrees to give best efforts to promote the sale and leasing of the Work and to protect the Work from copyright infringement or illicit copying or distribution by others.

4. Dealer agrees to pay Artist for the rights granted hereby royalties in an amount equal to the following percentages of Dealer's adjusted gross proceeds from the Work:

 a. For the sale of copies of the Work by Dealer...50 percent;

 b. For all leasing proceeds 50 percent.

 For the purpose of this provision, "Dealer's adjusted gross proceeds from the Work" shall mean all revenues derived by Dealer from the sale or leasing of the Work after deducting only all taxes collected by the Dealer. Dealer shall furnish Artist quarterly reports during January, April, July and October of each year showing, for the preceding three months, and cumulatively from the commencement of this agreement, the number of copies of the Work sold by the Dealer, "Dealer's adjusted gross proceeds from the Work," and the royalties due Artist. Such report shall be accompanied by payment of all royalties to Artist for the period covered by such report.

5. It is understood that only fifty (50) copies of the Work shall be made, of which the Dealer shall have the right to sell twenty-five (25) of the said copies. The Dealer shall also have the right to request additional copies of the Work for leasing, subject to the consent of the Artist. Artist agrees that the Dealer may contract with purchasers or lessees of the Work to replace worn, defective or mutilated copies of the Work and, further, that the Artist shall be entitled to no royalty in the event of such replacement. Dealer agrees that no copy of the Work alleged to be worn, defective, or mutilated will be replaced unless said copy is returned to the Dealer for destruction by the purchaser or lessee.

6. All copies of the Work shall be made at Dealer's cost from the master tape. It is understood that the master tape will remain the Artist's property and in his or her control, provided that it shall be used as necessary to make copies of the Work for sale or leasing under the terms of this agreement. All copyright and other literary property rights in the Work for the entire term of the copyright and any renewal thereof shall belong exclusively to the Artist. The master tape of the Work and each copy thereof shall bear a copyright notice in the Artist's name.

7. The retail selling price of each copy of the Work shall be _____. It is agreed that Dealer may, in the exercise of reasonable business discretion, increase or reduce the price charged for any copy of the Work by ten percent (10%) in order to further the sales of the Work and the realization of returns from the exploitation of the Work. Dealer shall periodically consult with the Artist concerning Dealer's marketing program and pricing policies with respect to the Work.

8. Dealer shall not sell or lease any copy of the Work unless the purchaser or lessee agrees, in writing, that under no circumstances shall any further copies of the Work be made by the purchaser or lessee and that the purchaser or lessee shall neither broadcast their copy of the Work nor permit the charging of admission to view the Work.

9. The Artist agrees that Dealer shall have the right to list the Work, with appropriate descriptive material, in any catalog that Dealer publishes or maintains. The Artist further agrees that Dealer may use and authorize others to use the Artist's name, likeness, and biographical material for the purpose of publicizing and promoting sales or leasing of the Work pursuant to this agreement.

10. Dealer agrees that neither this agreement nor any rights granted Dealer hereunder may be assigned without the prior written consent of the Artist. The Artist may freely assign this agreement, either in whole or in part.

11. This agreement shall automatically be renewed for successive periods of one year, each renewal commencing on the expiration date set forth above unless canceled by sixty (60) days written notice given by either party prior to the expiration of the term of this agreement or any renewal thereof.

12. This agreement shall be binding upon the parties and their respective heirs, successors and assigns.

13. Dealer and Artist agree to arbitrate any claim, dispute, or controversy arising out of or in connection with this agreement, or any breach thereof, before an agreed-upon arbitrator, or, if no arbitrator can be agreed upon, before the American Arbitration Association, under its rules in the following city_____.

14. The agreement constitutes the entire agreement of the parties and may not be changed except by an agreement in writing signed by both parties.

15. This agreement shall be construed under the laws of the State of New York applicable to agreements made and to be performed solely within such State.

IN WITNESS WHEREOF, the parties have signed this agreement as of the date set forth above.

_____ _____
Artist Dealer

Model Video Bill of Sale

Date:

Sold to: _____(Name)

_____(Address)

Artist:
Title:
Medium:
Length:
Description:
Price:

It is hereby acknowledged and agreed that the copy of the videotape listed above is being purchased solely for noncommercial use and that acquisition of this copy is subject to the following conditions:

1. All copyrights and other rights of reproduction or commercial exploitation, including the right to make copies of the videotape, are reserved to the gallery.

2. The purchaser agrees not to make or permit others to make any copies of this videotape; not to broadcast or charge admission fees to any showings of the copy in any place; not to utilize the copy in advertisements in any media or utilize the copy commercially in any way; and not to make photographs or reproductions from the copy.

3. The purchaser agrees not to show the videotape to others, other than in its entirety and with sound, if any.

4. The purchaser agrees not to sell or transfer this copy to anyone unless the person acquiring the copy agrees to be bound by the provisions of this agreement. The purchaser further agrees to notify the seller of any such transfer and to furnish the gallery with the name and address of the new owner.

5. The purchaser agrees not to rent or lend the copy to others or to permit others to use the copy in violation of the terms of this agreement.

6. The purchaser agrees that the rights given by this agreement shall also run in favor of the artist who is the author of the videotape and to the present and future holders of the copyrights thereon.

7. The gallery agrees to replace the copy of the videotape upon the purchaser's return of the copy purchased. The cost of replacement shall be the gallery's if the copy is defective and the purchaser's if the copy has been damaged in use.

The gallery acknowledges receipt of the purchase price set forth above and the purchaser acknowledges receipt of the copy of the videotape.

_____ _____

Purchaser Gallery

18 MULTIMEDIA CONTRACTS

ultimedia is an exciting revolution with high stakes for the professional communicator. To define multimedia is like describing Proteus, but the hallmarks include some or all of the following features: (1) the use of more than one medium, such as combining still pictures, text, music, and film or video; (2) digitization of information; (3) delivery using electronic media, such as DVD, computer networks, the Internet, or by innovations in existing media, such as cable television; and (4) interactivity, which allows the end user to interact with the material in a variety of ways, such as choosing different viewing sequences or ordering additional products.

The digital emphasis of modern multimedia, and the rapid evolution of its various delivery systems, suggests that multimedia works are themselves extremely adaptable. Digital works suffer no loss of quality from one generation to the next. In addition, carrier media often change or become obsolete. In the realm of physical media, magnetic storage like floppy and Zip discs were dominant through the 80's and early 90's, but were quickly eclipsed by high capacity optical media such as the CD-ROM, whose costs plummeted in the mid 1990's. Later, the even more capacious Digital Versatile Disc (DVD) supplanted the then-ubiquitous CD-ROM. Modern artists are likely familiar with flash-memory based devices which allow content to be deleted and added at any time. Such memory is at the heart of keychain-sized "thumb-drives," which can hold as much data as a DVD, yet require nothing more than a USB port to interface with any Macintosh, Window, or UNIX-based computer.

Indeed, the increasing popularity of high-speed Internet connections, permitting direct transmission of data between distant computers, renders the use of any physical media to be almost quaint. The Internet may be used via hard-wired connections, high-speed WiFi networks, or high-speed wireless networks accessible using the latest generation of smartphones. The Internet facilitates direct peer-to-peer transmission, but the proliferation of user-generated content sites such as YouTube also allows artists to broadcast their creative expression to entire communities of Internet users diligent enough to search the site's archives. As a whole, systems based on the Internet allow multimedia works to effortlessly traverse national boundaries, thereby implicating the laws of many nations. In this increasingly interconnected and complicated world, a knowledge of American law may not be sufficient to understand how multimedia affects, or is affected by, the legal orders it may inhabit.

The artist may play a number of roles in the creation of a multimedia work. The most likely is the creation of visuals to be incorporated into the overall work. So the artist becomes one of many contributors. For example, the artist contributing visuals may be joined by an author who writes text, a videographer who creates video footage, famous people or experts or actors who are interviewed or narrate, composers and performers who supply music, and software or Web designers who develop interfaces and regulate the flow of the work. Researchers may locate existing or stock film clips, photographs, and music. Many decisions have to be made whether to incorporate existing materials or commission new work.

While the artist may be most likely to contribute visuals, which raises the question of the terms and fees, the artist with a larger vision may want to be the producer of the entire multimedia work. The tremendous power of modern software tools enables any talented artist to independently produce sophisticated works. However, with such power comes a veritable minefield of potential liabilities and legal responsibilities. The artist seeking to be a producer should keep in mind that, at one conference discussing multimedia and the law, the attorneys in attendance responded with delight as speaker after speaker said that the evolution of multimedia will prove "a full employment act for attorneys." The artist who wants to produce would be well advised to be mindful of the potential legal complexities inherent in producing multimedia work, and seek appropriate legal assistance from an attorney knowledgeable in this developing area. One reason why attorneys can look forward to so much additional employment is that each multimedia work is likely to require a large number of permissions.

Rights and Pricing

If an artist is approached by a multimedia producer to create art for a multimedia work, the issues that arise are similar to those already discussed in chapter 15. If new work is to be created, the assignment must be carefully described, due dates given, cancellation fees specified, the right to do revisions assured for the artist, and so on. If an existing work is being licensed for stock usage, the scope of rights must be carefully delineated. The forms at the end of chapter 15 can certainly be used for multimedia as well as other uses.

Several factors make multimedia rather unique. One factor is the interdependence of so many different art forms in the building of the final work. Another factor is best expressed by terms like "interactivity" and "nonlinearity," which mean that the end user may determine the sequence, timing, and repetitions of the work. To complicate this factor further, concepts such as "scalability" or "manipulability" suggest how images can changed in size and modified by the end user or consumer who is interacting with the work. This makes certain traditional pricing concepts based on size, placement, or number of insertions difficult to apply or even irrelevant in the multimedia context.

Yet another factor is the inchoate state of multimedia. On the level of large companies, computer and multimedia companies are striving to secure the content, the raw material, for multimedia from traditional entertainment and publishing companies. This is not so easy to do, because the traditional companies are uncertain of the ultimate multimedia use and market potential of the properties that they own (such as movies, books, and photography). This same ambivalence is played out on the micro-level when an artist is approached to contribute to a multimedia work. What will the ultimate use be of this work? The very revolution that makes multimedia exciting also causes it to be constantly in flux, always subject to newer turns in the technology of creation, storage, and delivery of information.

How can the artist decide what to charge if the ultimate use cannot be determined? What if DVD-ROM is replaced by a newer storage medium? And, as modern trends indicate, computers continue to gain ascendency over cable television networks as information providers, how will usage be measured and the artist paid?

Multimedia producers are likely to demand work-for-hire contracts. They will argue that the art is simply one part of a larger work, and that the artist cannot limit the use of the larger work by holding back rights. But if the artist does work for hire, especially in the digital age, more and more stock material will accumulate in the hands of large producers. The negative effect of this could harm the individual artist and centralize the control and ownership of imagery in large corporate entities.

The artist should certainly seek to negotiate out of work-for-hire. The transfer of rights should be limited to known delivery media, which are specifically enumerated. Payment should be a fee, which may also be treated as an advance against a royalty based on total distribution. For example, the sale of CD-ROMs is certainly a basis for royalties, like the royalties paid to artists for book sales or licensing. The amount of such royalties should be reasonable in view of the economics of the overall distribution arrangement (such as how much the producer receives from its distributors, overhead costs, unit production costs, the proportion that the artist's contribution bears to the total creativity in the multimedia work, etc.) Needless to say, it may be difficult for the artist to determine these factors with exactitude, but

the concept should be to share in the overall success of the venture.

Of course, the artist does not want to lose the possibility of participating in an exciting project by being too rigid. It is so early in terms of multimedia that industry standards are not yet in place, although guides like *Pricing and Ethical Guidelines* (Graphic Artists Guild) and *Pricing Photography* (Allworth Press) will eventually cover whatever pricing structures do emerge. However, the artist who wants to participate might show a willingness to learn about the fine points of multimedia. What is the product? Who will contribute to it? Who will its audience be? How will it be delivered to that audience? Through this process, the artist will become a more informed participant and feel more comfortable dealing with the issues of rights and pricing.

The producer that cannot obtain work for hire may seek some kind of joint ownership of the copyright in the art. The reason for this is that multimedia works, which by their nature incorporate many elements, are likely to meet the definition under the copyright law for a joint work. While joint work has the drawbacks discussed in chapter 4 for the producer, joint work also has drawbacks for the artist who basically loses control over the usage of the work. Although the artist has a right to share in profits, such profits may be difficult and expensive to prove.

The artist should seek to use a contract like those appearing in chapter 15. These contracts, when properly completed, resolve rights issues. In addition, the very process of negotiating the issues raised by the contracts will reveal points of dispute that must be resolved for the collaboration to be a success. For the artist who feels that he or she must do work for hire, perhaps because of the nature of a particular project and the payment of an unusually large fee, it is still possible to limit the usage of the work by contract. In such a situation, the producer would own the copyright but the contract could require additional payments if certain usage boundaries were exceeded.

Alteration of the art is a special consideration with multimedia works, simply because the digital nature of the work lends itself to modification. The artist must be satisfied that any changes to the work will either be made by or acceptable to the artist. This includes using parts of the art, using the art to form part of other images or using the art in a transformed image (which, as discussed in chapter 6, is quite possible in the digital environment).

The Artist as Producer

The artist who seeks to move into a new creative role as a producer of multimedia will find challenges both in the creation of the work and in its distribution. The artist/producer must assemble all the different pieces that are combined to make the multimedia work. The complicated task of handling permissions may involve negotiating with other artists. How can fair boundaries be established that both give the artist/producer the rights necessary to exploit the work and yet do not take so much of the rights as to exploit the artist?

The artist/producer will also have to contemplate how the multimedia work will reach its audience and how the artist/producer will be compensated. For example, the artist/producer might be hired by a larger company to create a particular work to be added to that company's multimedia line. Or the artist/producer might create the work independently and then seek distribution. Such distribution might be another company that specializes in reaching the outlets that in turn sell to the consumer, or it might be by sales reps employed or commissioned by the artist/producer to reach the market.

Whenever an artist contracts with a larger entity for distribution, issues arise with respect to the geographic extent of the distribution, the duration of the distribution agreement, how payments are calculated, the time when payments are made, the right to accountings, termination, and related issues. These same issues apply to multimedia, although the nature of the actual distribution channels may change with time. A review of the types of issues that arise between an artist and gallery, an artist and publisher, or an artist and television station would offer a good framework in which to approach the distribution contracts that an artist/producer is likely to encounter (see chapters 14, 16 and 17). To focus precisely on multimedia, the artist/producer will want to turn to one of the in-depth informational resources discussed later in this chapter.

Permissions

The artist/producer is likely to find it necessary to obtain licenses from the owners of copyrights in photographs, illustrations, designs, paintings, music, sound recordings, video, and

film—all for a single work of multimedia. Each of these constituent parts may require releases from models, actors, performers, and directors, and perhaps involve union agreements (such as with SAG or AFTRA). Obtaining the materials may also raise issues pertaining to trademarks, unfair competition, trade secrets, and libel as discussed in chapter 9.

The complexity of these permissions may exceed what would be expected in the visual arts. For example, music can require obtaining permissions from different sources. This might involve mechanical rights, which would include the rights to make copies or record music; synchronization rights, which would allow presenting the music with images; performance rights, which would allow presenting the song publicly; and perhaps other rights such as sheet music rights.

While a permission form like the one on page 53 can be modified, the artist/producer will really need a battery of permission forms to apply to a variety of different types of material to be incorporated. No wonder lawyers are so delighted with multimedia and its promise as a full employment act for lawyers.

An Unfolding Drama

Multimedia is an unfolding drama. It offers tools of heretofore unimagined power to the creator; yet it also attracts concentrations of capital that make for highly disparate bargaining strengths between creators, producers, and distributors. The creative and technological challenges require great ingenuity, but so do the business challenges. If the struggles of the past have taught us anything at all, it is certainly that creators must be fairly compensated if they are to thrive and contribute to the dynamism that makes industries grow—including the ever so promising industry of multimedia.

19 STUDIOS AND LEASES

Many artists find their work ideally requires a great deal of studio space. Such space is often only affordable in older structures such as rural barns or buildings in urban districts zoned for commercial or manufacturing use. If the space is unfinished, the artist may to spend a lot of money to secure the necessary utilities and install fixtures. On the other hand, if this installation has been made and paid for by a prior tenant, the artist may have to pay for fixtures that seem neither useful nor aesthetically pleasing. Also, while the artist may wish to reside in the space, zoning laws and regulations may impair the right of the artist to do this and, in some cases, create an occupancy that is illegal. Zoning laws may also affect artists who create studios in residential areas.

Practical Considerations

The artist who is not an expert should find either a contractor or someone else with expertise to examine the building and space for a determination as to whether the structure and facilities will be adequate and safe for the artist's work and, if necessary, living quarters. An artist creating large and heavy works will have to be certain doorways, hallways, elevators, and loading ramps can accommodate the completed work. An artist who needs power machinery must be certain the building is wired for such use. Heating, plumbing and gas lines must all be adequate for the artist's needs. Finally, if the building is considered sound, the artist can arrive at a figure—perhaps thousands of dollars—necessary to put the space into the condition the artist desires.

Ownership of Fixtures

The artist faced with such substantial fix-up costs, or perhaps a payment to a previous tenant for fixtures, is now offered a standard form lease by the landlord. A wise course is always to consult a lawyer when confronted with a legal document, and a lease is certainly no exception. The standard lease, developed for commercial space by the Real Estate Board of New York, states, "Tenant shall make no changes in or to the demised premises without Landlord's prior written consent." If written consent is obtained and the changes are made, the lease then provides, "All fixtures and all paneling, partitions, railings, and like installations, installed in the premises at any time, either by Tenant or by Landlord in Tenant's behalf, shall become the property of Landlord and shall remain upon and be surrendered with the demised premises..."

The landlord's ownership of fixtures at the end of the lease term is a crucial factor with which the artist must contend when the lease is negotiated. The landlord may, in fact, permit the artist at the end of the lease term to sell the fixtures to the incoming tenant. But the landlord generally does not have to do this (except, for example, in New York City where premises covered by Article 7-C of the Multiple Dwelling Law are subject to special rules regarding the tenant's right to sell fixtures). Also, if the market for commercial space is not good, there may be no incoming tenant and the artist may be forced to leave the space without receiving any payments at all.

The Lease Term

The fix-up costs bear on what the use of the space is truly costing over the lease term. The lease, for example, may provide for an annual

rent of $12,000—that is, $1,000 per month. If the fix-up cost is $6,000, there is a substantial difference between the two-year and a five-year lease term on what can be called the "real rent" —the total monthly or yearly cost to the artist as a tenant. If the lease term is two years, the $4,000 of fix-up costs increase the rent by $3,000 each year. The real rent is $13,000 per year, not the $1,000 per year which appears in the lease. But if the lease term is five years, the $6,000 of fix-up costs only increase the rent by $1,200 each year, making the real rent $13,200.

The artist benefits from a longer lease term because the fix-up costs can be enjoyed over a longer period. The artist may, therefore, seek a longer lease term, perhaps five years instead of two years. If the landlord agrees, the artist has the advantage of a rent fixed for a longer term, as well as a longer period to enjoy fix-up costs. The disadvantage is that the artist may wish to move before the end of the longer lease term without being responsible for rent to the end of the term.

Options to Renew

A good alternative to requesting a longer lease is to request, in the lease, the option to renew (which must be definite as to term and rent). Thus, the initial lease term could be two years, but the artist might have the option to renew the lease for another three-year term at a specified rent. This gives the artist the advantage of five years to benefit from fix-up costs, but the opportunity to leave sooner if need be. A disadvantage of asking for an option to renew might occur if the landlord decides the option itself is valuable and insists that the rent during the renewal term be at an increased rate. Whether the option to renew is worth a certain rent increase is a decision the artist has to make on a case-by-case basis. It is also worth noting that when an artist moves into a building scheduled for destruction, renewal options to extend the lease term to the actual destruction date are a reasonable request and can be of great benefit if the destruction is delayed for any reason.

The Right to Terminate

An alternative, even more flexible than an option to renew, is the right to terminate. The artist might, for example, demand the right to terminate the lease upon one month's written notice to the landlord. Often this right can only

be exercised after part of the lease term, perhaps six months or a year, has elapsed. In this way, the artist can take a long lease term while retaining the power to leave at will, without liability for the remaining rent.

Right to Sublet or Assign

A desirable lease clause, particularly important when a longer lease term is obtained, is the tenant's right to sublet. A typical lease provision reads: "Tenant...shall not...underlet, or suffer or permit the demised premises or any part thereof to be used by others, without the prior written consent of Landlord in each instance." This lease prohibition on underlets or sublets is absolute and the landlord need not justify a refusal to accept a proposed subtenant.

The artist should negotiate for the right to sublet, since such a right will make the artist certain of being able to have the fix-up costs reimbursed—as long as a new tenant can be found who desires the space. A typical compromise sublet clause would require the landlord's consent for any sublet, but would provide that the landlord cannot unreasonably withhold that consent. If the proposed subtenant is financially responsible, will pay the rent and use the space properly, the landlord will not be able, arbitrarily, to refuse the subletting. When a space is sublet, the subtenant pays the rent to the tenant, who in turns pays the landlord. A simpler method—with the landlord's consent—is to have the artist assign the lease to the new tenant. In contrast to a sublet, an assignment means the artist permanently gives up the lease and any right to return to the premises and the rent payments will go directly from the new tenant to the landlord. Nonetheless, the artist will still usually be liable for the rent if the new tenant defaults.

The limitation of a sublet or assignment clause is that the artist only has the right to find another tenant as a replacement. If another tenant can't be found, the artist will remain responsible for the rent. When the lease has an option to renew, of course, the artist's responsibility for rent ends with the initial lease term and only continues for the renewal period if the artist exercises the option to renew the lease. The right to terminate would also protect the artist as to remaining rent. Ideally, in order to have maximum flexibility, the artist should seek either an option to renew or a right to terminate, as well as a right to sublet or assign.

Hidden Lease Costs

The artist should be aware that the lease may contain costs other than rent. For example, the artist in a commercial space will usually be responsible for making all nonstructural repairs. The artist must be certain who will pay for electricity, air conditioning, and even water. The lease may provide for escalations of the artist's rent in proportion to increases in the landlord's real estate taxes or other expenses, such as that for heating fuel. Indeed, the lease may even contain a cost-of-living clause that increases the rent automatically to keep up with inflation. If the artist cannot negotiate these clauses out of the lease, a current cost for the landlord on each item should definitely be specified in the lease to establish an objective basis upon which future increases can be calculated. But the artist should try to include a maximum cost beyond which there can be no increases. In each of these cases, the artist must attempt to approximate costs, perhaps by inquiring of the landlord and other tenants as to past increases or by relying on an expert's opinion, so these costs can be added into the calculation of real rent.

Violations

The lease will also provide that the tenant must not use the space in violation of the building's certificate of occupancy and that the tenant must act promptly to end any violations arising from the artist's use or occupancy of the space. This sounds ominous, but may in fact not create a problem. If a violation is found, the artist at least has the opportunity under these lease provisions to correct the conditions causing the violations before the landlord can seek eviction. The artist should try to avoid any clauses that might allow automatic termination of the lease if violations are not corrected within a limited time period, such as ten days.

The Use Clause

An important lease clause is one that specifies what use may be made of the space by the artist. For example, this clause might provide, "Tenant shall use and occupy the demised premises for an artist's studio and for no other purpose." It is generally best for the artist to have as much latitude under this clause as possible. For example, a better clause for the artist would be, "Tenant shall use and occupy the demised premises for an artist's studio, residence and gallery."

But the artist who chooses to live illegally in a commercial space, perhaps even without the landlord's knowledge, cannot expect the landlord to agree to a lease clause permitting use as a residence. At the least, however, the artist should not accept a use clause specifying that no living in the space will be permitted, such as "artist's studio, no living." Such a clause will place the artist clearly in breach of the lease and subject to eviction by the landlord, unless state or local laws provide special protections for tenants.

Zoning: Working in a Residential Zone

Zoning governs the way in which buildings may be used. The development of a city or town may be guided through the use of zoning laws to control the density of buildings and population as well as the nature of activities in different areas. For example, zoning restrictions may limit the type of materials that an artist can use and store in the premises. Inflammable and volatile solvents may be prohibited in certain buildings.

If an area is zoned for residential use, questions may be raised as to the legality of an art studio. Certainly an artist should be able to paint, draw, or take photographs without worrying about the reaction of neighbors. Technically, however, if this is done in the pursuit of business, the zoning ordinance may be violated. If the business involves a lot of traffic to and from the premises, it is more likely that such a violation will be brought to the attention of the zoning authorities.

For example, an artist conducted ceramics classes at home in an area that was zoned to allow an artist's studio in a residence as long as the art use "is merely incidental to the primary residential use." During weekdays up to fifteen children attended the classes, while a slightly smaller number of adults attended in the evenings. The court observed that:

If we were concerned with an occasional gathering of persons interested in the subject of ceramics who merely discussed their problems or experiences it may very well be that any zoning ordinance which prohibited such gatherings would be ruled invalid; but here we have a regular schedule of classes with many students in attendance.

Despite the fact that the students did not pay to attend the classes, the court upheld

the zoning appeals board in its determination that the classes violated the zoning ordinance. (*Schweizer v. Board of Zoning Appeals*, 8 Misc.2d 878, 167 N.Y.S.2d 764, 766.)

Zoning ordinances and rulings vary from locality to locality. If the artist contemplates conducting a business in a residential space, he or she should find out whether or not a zoning ordinance forbids such business activity and what the penalties are if the zoning is violated. One likely penalty would be a court order to cease and desist from conducting the art business on the premises. To avoid this risk, the artist might prefer to seek appropriate administrative permission, usually obtained by a variance procedure, which would allow use of the premises for activities otherwise forbidden.

Zoning: Residing in a Commercial Zone

The reverse situation, residing in commercially zoned space, also arises, especially in cities. In New York City, for example, artists often took up residence in areas zoned for manufacturing in order to benefit from the good floor space and high ceilings of these industrial lofts. Recognition of these illegal tenancies brought a liberalization of the zoning laws which, starting in 1964, allowed people to reside and work in up to two spaces in nonresidential buildings which met certain maximum size and safety requirements if the spaces were registered with the Building Department.

Many artists resisted this registration process and continued living as illegal tenants. In Soho, where there was a concentration of illegal tenancies, the Soho Artists Association led the campaign that, in 1971, resulted in the creation of legal living zones in Soho, subject again to certain limitations such as maximum loft size. Artists must be certified as artists by the City's Cultural Affairs Department. Once certification is obtained by the artist, the building in which the space is located has to conform to New York City's Building Code and Multiple Dwelling Law in order for a certificate of occupancy to be issued by the Building Department. This process is often difficult and expensive.

In 1976, legal living zones were created in Noho and Tribeca. More recently, living was legalized in many other areas of the city. An artist facing a challenge over his or her status in a space in New York City may contact the Lower Manhattan Loft Tenants Association (page 260) for advice and referral to an attorney. Outside New York City it would be wise to contact a local attorney who is knowledgeable regarding real estate law.

Cooperative Buildings

Some artists may be offered the opportunity to purchase space in a cooperative or condominium that owns the building. In such a case, the determination by experts as to the adequacy of both the building and the space for the artist is even more important than in the usual rental situation. Sponsors sometimes lure potential purchasers by concealing the extent of repairs and renovations that will be necessary after the building becomes a cooperative. Once the repairs are completed, the maintenance costs—basically the carrying costs of the building which each individual owner must bear—take an upward leap and make ownership of the space far less attractive than it originally appeared. In New York, the attorney general seeks to prevent frauds by requiring extensive disclosures in the selling prospectus. The artist should be particularly cautious when considering the purchase of space, and consultation with an attorney is a necessity.

20 TAXES: INCOME AND EXPENSES

The artist's professional income—for example, from sales of work, commissions, copyright royalties and wages—is taxed as ordinary income by the federal government and by the state and city where the artist lives, if such a state or city has an income tax. The business expenses of being an artist, however, are deductible and reduce the income that will be taxed. Both income, as gross receipts, and expenses are entered on Schedule C, Profit or (Loss) from Business or Profession, which is attached to Form 1040. A sample Schedule C is on pages 211–212.

The artist should also check whether any state and city sales taxes have to be collected. If they do, the artist may be entitled to a resale number that permits the purchase of materials and supplies without payment of any sales tax. The artist must also determine whether any other state or local taxes, such as New York City's unincorporated business tax and commercial rent or occupancy tax, must be paid in addition to the personal income tax. These taxes vary with each state and city, so guidance must be obtained in the artist's own locality.

General guides to federal taxation are IRS Publication 17, *Your Federal Income Tax*, for individuals and IRS Publication 334, *Tax Guide for Small Businesses*, for businesses. These, and other IRS publications mentioned in the income tax chapters of *Legal Guide*, can all be obtained free of charge from any IRS office, or downloaded from the IRS Web site at *www.irs.gov*. The IRS Web site also allows artists to download forms, perform limited research on tax questions, file their tax forms electronically, and check the status of their refunds online. The IRS also has a Tele-Tax service that allow artists to use the telephone to check the status of a refund or listen to recorded tax information on a number of subjects (which are listed in Publication 17). The IRS will also give free tax advice by telephone, as detailed in its *Guide to Free Tax Services*. Another helpful IRS guide is *Your Rights as a Taxpayer*, which explains the taxpayer's rights at each step in the tax process.

The artist should keep in mind, however, that these publications and tapes represent the views of the IRS and are sometimes inconsistent with precedents already established by the courts. The artist may prefer to purchase a privately published guide, such as *J.K. Lasser's Your Income Tax*, which is updated each year. Lasser has also established an Internet presence by which artists can access a wide range of tax literature and advice, after paying a subscription fee of approximately $20 per year. (*www.jklasser.com*).

The tax laws are changed frequently. Lawmakers' addiction to almost annual tax-code tinkering requires artists to consult a tax guide that is updated annually. Nonetheless, the chapters on income and estate taxation in this book will provide a valuable overview of the area of taxation as it pertains to the artist.

Recordkeeping

Good recordkeeping is at the heart of any system to make the filling out of tax returns easier. All income and expenses arising from the profession of being an artist should be promptly recorded in a ledger, database, or spreadsheet, regularly used for that purpose. The entries should give specific information as to dates, sources, purposes, and other relevant data, all supported by checks, bills, and receipts whenever possible. It is advisable to maintain

business checking and saving accounts through which all professional income and expenses are channeled, separate from the artist's personal accounts. IRS Publications 552, *Recordkeeping for Individuals* and 583, *Taxpayers Starting a Business*, offer details as to the permanent, accurate, and complete records required. There are many accounting programs, such as Quicken, that can help with the task of recordkeeping.

A good ledger or spreadsheet might be set up in the following way. The first column is for the date, the second column shows the nature of the income or expense, the third column specifies the check number and the receipt number, the fourth column shows the amount of income, the fifth column shows the amount of expenses, and the sixth and subsequent columns list different expenses based on the artist's special needs. This means that each expense is entered twice, once in the expense column and again under the particular expense category into which it falls. This will be helpful when it comes to filling out Schedule C. If the artist's expense categories can be made to fit easily into the expense categories shown on Schedule C, the task will be even easier. 1 Date 2 Description 3 Check/ Receipt 4 Income 5 Expense 6-End Expense Categories

Accounting Methods and Periods

Like any other taxpayer, the artist may choose either of two methods of accounting: the cash method or the accrual method. The cash method includes all income actually received during the year and deducts all expenses actually paid during the tax year. The accrual method, on the other hand, includes as income all that income which the artist has earned and has a right to receive in the tax year, even if not actually received until a later tax year, and deducts expenses when they are incurred instead of when they are paid.

The Treasury regulations require accrual accounting for inventories "to reflect [taxable] income correctly...in every case in which the production, purchase or sale of merchandise is an income-producing factor." So, for example, a manufacturer who produced five hundred replicas of a statue would have to use accrual accounting for inventories. This would mean that the cost of the five hundred replicas would be capitalized (that is, not currently expensed)

and could only be deducted as the replicas were sold. Some commentators even suggested that a sculptor might have to use accrual accounting for inventories, if the sculptor's works required substantial costs in materials and the labor of others. However, Rubin L. Gorewitz, a New York C.P.A. who represents many artists, argued that the income of artists, including sculptors, could only be correctly reflected by the use of cash basis accounting, because of the obsolescence of artworks as artists change styles, the possibility that even a completed work may be destroyed to use the materials in a newer work, and the unknown sales potential of any work.

Artists won an important victory in 1988 when they were exempted from having to capitalize their expenses. A provision of the Tax Reform Act of 1986 would have required that creators only deduct expenses over the period that income from their creative works would be received. After vigorous lobbying by creator's organizations, the Technical and Miscellaneous Revenue Act of 1988 allowed creators to deduct their expenses in the year incurred. Qualified works include photographs, paintings, sculptures, statues, etchings, drawings, cartoons, graphic designs, and original print editions, as long as the work is created by the personal efforts of the artist. Congress enumerated certain types of art that are not qualified works and are subject to capitalization. These include "jewelry, silverware, pottery, furniture, and other similar household items..." This reflects a distinction between whether work is original, unique, and aesthetic—or utilitarian. Utilitarian objects are likely to be subject to capitalization. Personal service corporations are also exempt from capitalization, as long as the expenses directly relate to the activities of the owner and the owner of substantially all of the stock is a qualified artist.

Since most artists operate on the simpler cash method, the chapters on income taxes will assume that the cash method is being used.

Income taxes are calculated for annual accounting periods. The tax year for the vast majority of taxpayers is the calendar year: January 1 through December 31. However, a taxpayer could use any fiscal year (for example, July 1 through June 30), although there must be a reason to change from a calendar to a fiscal year. Since most artists use the calendar year as their tax year, the income tax chapters will assume the use of a calendar year.

The cash method of accounting in a few cases, however, may include income not actually received by the artist, if the income has been credited or set apart so as to be subject to the artist's control. For example, income received by a gallery acting as agent for the artist will, when received by the gallery, be taxable to the artist unless substantial limitations or restrictions exist as to how or when the gallery will pay the artist.

One valuable tax-saving device for the cash basis, calendar year artist is to pay expenses in December while putting off receipt of income until the following January when a new tax year has begun. The expenses reduce income in the present year while the income is put off until the new tax year.

Further information on accounting methods and periods can be obtained in IRS Publication 538, *Accounting Periods and Methods.*

Types of Income
The artist must be aware of the different types of income. The first distinction is between ordinary income and capital gains income. The artist realizes ordinary income from all income-producing activities of the artist's profession. Ordinary income is taxed at the regular income tax rates, which go up as high as 35 percent. Capital gains income is realized upon the sale of capital assets, which are assets held for investment (such as stocks, real estate, or silver bullion), and some business assets such as land and depreciable property held in a trade or business. Capital gains from assets owned more than one year are classified as long-term gains and receive preferential tax treatment (by being taxed at a maximum rate of 15 percent today, or up to 20 percent after 2011).

The substantial tax discrimination in favor of long-term capital gains as compared to ordinary income will cause the artist to wonder why an artwork is not an asset receiving favorable capital gains treatment. Congress, when enacting the tax laws, specifically stated that "a copyright...or artistic composition...held by a taxpayer whose personal efforts created such property" cannot be an asset qualifying for capital gains treatment. And if the artist gives an artwork to someone else, that person will own the work as the artist did—as ordinary income property rather than an asset qualifying for capital gains treatment. Unfair as it may seem, if the work is sold to a collector, the collector owns the work as a capital asset and may obtain the lower capital gains rate upon sale of the work, as discussed on page 245.

Another distinction to be kept in mind is between ordinary income that is earned and that which is unearned. The professional income of the artist is considered earned income, but income from stock dividends, interest, rent, and capital gains, for example, is treated as unearned income. As a practical matter, most artists will be concerned about earned income in such areas as retirement plans (discussed on pages 216–217), income earned abroad (discussed on pages 218–219) and the self-employment tax, which represents Social Security contributions that must be paid by the self-employed such as freelance artists (discussed on page 215).

Basis
The amount of profit to an artist on the sale of work is usually the sale price less the cost of materials in the work. The cost of materials is called the "basis" of the work for tax purposes. The cash-basis artist, who deducts the cost of art materials and supplies currently when purchased, must remember that such materials and supplies cannot be deducted again as the basis of the artworks when sold. In other words, if the artist deducts materials and supplies currently, then the artworks have a zero basis and the entire amount of the proceeds from the sales will be taxable. If the work is given to someone else, that person will have the same zero basis of the artist and, as mentioned earlier, realize ordinary income upon sale. The basis for a collector who purchases the work, however, will be the purchase price. The collector's gain on resale will be the difference between the price on resale and the basis. And the gain, as stated earlier, will be taxed at the favorable capital gains rates.

Grants
Grants to artists for scholarships or fellowships may be excluded from income only by degree candidates, and only to the extent that amounts are used for tuition and course-related fees, books, supplies and equipment at a qualified educational institution. Qualified scholarships cannot include expenses for meals, lodging or travel. Nor can such scholarships include payments to the artist for teaching, researching, or other services by the artist that are required

as a condition for receiving the scholarship. Nondegree candidates have no right to exclude scholarship or fellowship grants from income.

A qualified educational institution is one that normally maintains a regular faculty and curriculum and has a regularly enrolled body of students in attendance at the place where the educational activities are carried on.

Prizes and Awards

All prizes and awards given to artists are now included in taxable income, unless the recipient assigns the prize or award to a governmental organization or a charitable institution. This applies to all prizes and awards made after December 31, 1986. Even to be eligible to be assigned in order to avoid paying taxes, the prize or award must be for religious, charitable, scientific, educational, artistic, or civic achievement, and the artist must be selected without taking any action and without any requirement to render future services. Under the new law, the person assigning a prize or award is treated as having received no income and having made no charitable contribution. For tax purposes it is as if the prize or award were never received.

Valuation

Valuation is important when the artist realizes income in the form of goods or services. In such event, the amount included in gross income is the fair market value of the goods or services received, which is basically the price to which a buyer and a seller, dealing at arm's length, would agree. Valuation will be particularly important to the artist who gives artworks in exchange for either the artworks of friends or the services of professionals, such as lawyers, doctors, and dentists. Such exchanges of artworks for other works or services are considered sales and, therefore, taxable income.

Pop artist Peter Max found himself in trouble with the IRS when the government accused him of trading his artworks as partial payment for properties that he purchased in Woodstock and Southampton, New York, and St. John in the Virgin Islands, then failing to pay the proper income taxes on the value of the art. In November, 1997, Max pled guilty to concealing more than $1.1 million from the IRS in connection with sales of his work. Under Federal sentencing guidelines, a short prison term was required.

Since fair market value can be a factual issue, the artist should consider using the services of a professional appraiser. Such an appraisal will be helpful if the artist needs to make an insurance claim for work that has been damaged, lost, or destroyed. Insurance proceeds are taxable as if a sale has occurred.

Professional Expenses

Deductible business expenses are all the ordinary and necessary expenditures that the artist must make professionally. Such expenses, which are recorded on Schedule C, include, for example, art materials and supplies, work space, office equipment, certain books and magazines, repairs, travel for business purposes, promotional expenses, telephone, postage, premiums for art insurance, commissions of agents, and legal and accounting fees.

Art Supplies and Other Deductions

Art materials and supplies are generally current expenses, deductible in full in the year purchased. These include all items with a useful life of less than one year, such as canvas, film, brushes, paints, paper, ink, pens, erasers, typewriter rentals, mailing envelopes, photocopying, file folders, stationery, paper clips, and similar items. In addition, the sales tax on these and other business purchases is a deductible expense and can simply be included in the cost of the item. Postage is similarly deductible as soon as the expense is incurred. The cost of professional journals is deductible, as is the cost for books used in preparation for specific works. Dues for membership in the artist's professional organizations are deductible, as are fees to attend workshops sponsored by such organizations. Telephone bills and an online service are deductible in full if used for a business purpose. If, however, use of the telephone is divided between personal and business calls, then records should be kept itemizing both long-distance and local message units expended for business purposes and the cost of any answering service should also be prorated. Educational expenses are generally deductible for the artist who can establish that such expenses were incurred to maintain or improve skills required as an artist (but not to learn or qualify in a new profession). IRS Publication 970, *Tax Benefits for Education*, can be consulted here.

Repairs to professional equipment are deductible in full in the year incurred. If the

artist moves to a new house, the pro rata share of moving expenses attributable to professional equipment is deductible as a business expense.

Self-employed artists are able to deduct a percentage of health insurance costs for themselves and their families from their adjusted gross income. The percentage of health insurance premiums that are deductible steadily increased from 40 percent in 1997 to 100 percent in 2007. If the artist employs people, they must also be covered for the artist to be eligible for the deduction. The deduction will not be allowed if the artist is eligible to participate in a health plan offered by the artist's employer or the artist's spouse's employer. Also, the deduction may not exceed net earnings from self-employment.

Work Space

If the artist rents work space at a location different from where the artist lives, all of the rent and expenses in connection with the work space are deductible. However, the tax law places limitations on business deductions attributable to an office or studio at home. Such deductions will be allowed if the artist uses a part of the home exclusively, and on a regular basis, as the artist's principal place of business. Even though the artist may have another profession, if the studio at home is the principal place of the business of being an artist, the business deductions may be taken. Also, the artist who maintains a separate structure used exclusively, and on a regular basis, in connection with the business of being an artist is entitled to the deductions attributable to the separate structure. Provisions less likely to apply to artists allow deductions when a portion of the home is used exclusively, and on a regular basis, as the normal place to meet with clients and customers or when the artist's business is selling art at retail and the portion of the home, even though not used on an exclusive basis, is the sole, fixed location of that business.

For employees, the home office deduction is available only if the exclusive use is for the convenience of the employer, in addition to the criteria listed above. In a case involving employee-musicians who practiced at home, the United States Court of Appeals decided their home practice studios were the principal place of business—not the concert hall where they performed. The court wrote:

Rather, we find this the rare situation in which an employee's principal place of business is not that of his employer. Both in time and in importance, home practice was the "focal point" of the appellant musicians' employment-related activities. (Drucker v. Commissioner, 715 F.2d 67)

Might this discussion apply as well to artists whose home studio work is crucial to their employment—for example, as teachers? Yet, in a case involving a self-employed anesthesiologist, the United States Supreme Court found that his office at home was not his principal place of business, despite his spending several hours each day working there and the fact that the hospitals where he worked provided no office space for him. The Court reasoned that some professionals who work in several places may have no principal place of business at all, and considered the relative importance of the work done and the amount of time spent at different locations to be crucial criteria in determining where, and if, a principal place of business existed. *(Commissioner v. Soliman, 113 S. Ct. 701)* Fortunately, legislation to change the impact of the *Soliman* case has now been enacted. For all tax years after 1998, principal place of business will include a place of business used by the writer for administrative or management activities if there is no other fixed location where the writer performs such activities.

To determine what expenses are attributable to an office or studio, the artist must calculate how much of the total space in the home is used as work space or what number of rooms out of the total number of rooms are used as work space. If a fifth of the area is used as work space, 20 percent of the rent is deductible. A homeowner makes the same calculation as to the work space use. However, capital assets, those having a useful life of more than one year, must be depreciated. A house has a basis for depreciation (only the house, land is not depreciated), which is usually its cost. Depending on whether the house was acquired before the end of 1980 or after 1980, different systems are used to determine the number of years over which depreciation is taken and the percentage of basis taken each year. Thereafter, the percentage of the house used professionally is applied to the annual depreciation figure to reach the amount of

the depreciation that is deductible for the current year. IRS Publication 529, *Miscellaneous Deductions*, and 534, *Depreciating Property Placed in Service Before 1987*, can help in the determination of basis and the calculation of depreciation. IRS Publication 587, *Business Use of Your Home*, should be consulted with regard to deductions for or related to work space.

The portion of expenses for utilities, insurance, and cleaning costs allocable to the work space are deductible. Repairs to maintain the house or apartment are also deductible on this pro rata basis. Property taxes and mortgage interest are deductible in full regardless of whether or not the artist's home is used for work purposes, provided the artist itemizes personal deductions on Schedule A of Form 1040. If personal deductions are not itemized on Schedule A, the portions of property taxes and mortgage interest deductible as business expenses would be entered on Schedule C.

The tax law also limits the amount of expenses that may be deducted when attributable to a home office or studio. Assuming the artist qualifies to take the deductions under one of the tests described above, the deductions for work space cannot exceed the artist's gross income from art, reduced by expenses that are deductible without regard to business use (such as real estate taxes and mortgage interest, which can be itemized and deducted on Schedule A) and all other deductible expenses for the art activity that are not allocable to the home studio. The effect of this is to disallow any deduction to the extent that it creates or increases a net loss from the art business. Any disallowed amount may be carried forward and deducted in future years.

For example, an artist earns income of $3,000 in a year from art, while exclusively, and on a regular basis, using one-quarter of the artist's home as the principal place of the business of being an artist. The artist owns the home, and mortgage interest is $2,000, while real estate taxes are $1,600, for a total of $3,600 of deductions which could be taken on Schedule A, regardless of whether incurred in connection with a business. Other expenses, such as electricity, heat, cleaning, and depreciation, total $8,800. A one-quarter allocation would attribute $900 of the mortgage interest and real estate taxes and $2,200 of the other expenses to the artist's business. The artist's

gross income of $3,000 is reduced by the $900 allocated to the mortgage interest and real estate taxes, leaving $2,100 as the maximum amount of expenses relating to work space which may be deducted.

Gross income..............................$3,000
Home office expenses allocated
to the business
Interest and property taxes.............$900
Electricity, heat, cleaning,
depreciation............................$2,200
Total home office expenses..............$3,100
Expenses of art business
excluding home office expenses
(such as supplies, postage, etc.).....$2,400
Total expenses..........................$5,500

The artist must apply against gross income (1) the deductions for the art business expenses, excluding expenses allocable to the home studio, and (2) the taxes and interest allocable to the business use of the home. Since (1) $2,400 and (2) $900 total $3,300, the gross income of $3,000 would be reduced to a negative figure. A zero or negative figure means that no additional expenses may be deducted, so the other expenses allocable to the home office ($2,200) are lost for the year. However, the expenses that cannot be deducted under this test can be carried forward for use as a deduction in a future year when income is sufficient. Of course, mortgage interest and property taxes remain fully deductible on Schedule A for those who itemize deductions.

An artist who rents will make a simpler calculation, since the deduction for art business expenses, excluding expenses attributable to the home studio, will simply be subtracted from gross income from art to determine the limitation amount.

These home studio provisions work a hardship on the majority of artists who sacrifice to pursue their art despite not earning large incomes.

Professional Equipment

Traditionally, the cost of professional equipment having a useful life of more than one year could not be fully deducted in the year of purchase. It had to be depreciated. However, the constant changes in the tax laws have made an exception to this rule and changed the method by which depreciation is determined. Again,

IRS Publication 946, *How to Depreciate Property*, will aid in the computation of depreciation. Form 4562, *Depreciation and Amortization*, is used for all types of depreciation discussed here.

(1) Current expensing. The tax law allows a certain dollar amount of professional equipment to be deducted in full in the year of purchase. For 2009 this treatment of such equipment as a current expense is limited to $250,000. This amount is reduced by the cost of qualified property placed in service during the tax year in excess of $800,000. If an artist chooses to treat some purchases of equipment as current expenses, an election must be made on Form 4562 for the tax year in which the equipment was acquired and the items of equipment must be specified along with the amount of the cost to be treated as a deduction for the year of purchase. Depreciation cannot be taken with respect to that part of the cost of equipment that is deducted under these provisions in the year of purchase.

(2) Depreciation. The Modified Accelerated Cost Recovery System (called MACRS) applies to property placed in service from 1987 to the present. MACRS depreciates property using several different depreciation methods. It places assets into different classes with different class lives. Five-year property includes cars; seven-year property includes office furniture and fixtures. Residential real property has a twenty-seven-and-one-half year life. These classifications, and the method of depreciation, determine how quickly the cost of property can be expensed.

The tax law restricts the use of MACRS for cars (and other personal transportation vehicles), entertainment or recreational property (such as a television or record player) and computers unless these types of equipment are used more than 50 percent for business purposes. If they are used less than fifty for business purposes, special rules apply. In any case, deductions can only be taken for that portion of use that is business use. For the listed types of property, adequate records must be kept to document how much of the use is business use or there must be sufficient evidence to corroborate an owner's statements as to whether use is for business. This is true regardless of when the property was acquired.

Also, expensive cars used predominantly for business will nonetheless be restricted as to the amounts of the MACRS deductions that may be taken each year. A standard mileage rate may be used for cars instead of calculating depreciation and actual operating and fixed expenses for the car. Electric vehicles, by contrast, enjoy slightly higher deduction and depreciation schedules. Publication 964 details the interplay of these provisions, but it will often be advantageous to calculate depreciation and not use the standard mileage rate (which is adjusted periodically).

Travel, Transportation, and Entertainment

Travel, transportation, and entertainment expenses for business purposes are deductible, but must meet strict record-keeping requirements. Travel expenses are the ordinary and necessary expenses, including meals, lodging, and transportation, incurred for travel overnight away from home in pursuit of professional activities. Such expenses would be deductible, for example, if the artist traveled to another city to hang a gallery show, and stayed several days to complete the work. If the artist is not required to sleep or rest while away from home, transportation expenses are limited to the cost of travel (but commuting expenses are not deductible as transportation expenses). Entertainment expenses, whether business luncheons or parties or similar items, are deductible within certain limits. Expenses for business meals and entertainment are only 50 percent deductible, reflecting Congress' belief that such meals and entertainment inherently include some personal living expenses. In addition, a meal that is merely conducive to discussing business is not deductible. Nor is a meal deductible if the party taking the deduction (or an employee of that person) does not attend. To be deductible, both meals and entertainment must either be directly related to the business of being an artist or include a substantial business discussion. There are some exceptions, but these will probably not have great relevance to artists. Bills and receipts are not necessary from meals or entertainment expenses unless those expenses exceed $75. Business gifts may be made to individuals, but no deductions will be allowed for gifts to any one individual in excess of $25 during the tax year.

Accurate and contemporaneous records detailing business purpose (and the business relationship to any person entertained or receiving a gift), date, place, and cost are particularly important for all these deductions. The artist should also get into the habit of writing these details on copies of bills or credit card charge receipts. IRS Publication 463, *Travel, Entertainment, Gift, and Car Expenses*, gives more details, including the current mileage charge, should the artist own and use a car. Also, self-promotional items, such as advertising, printing business cards, or sending Christmas greetings to professional associates, are deductible expenses.

Commissions, Fees and Salaries

Commissions paid to agents and fees paid to lawyers or accountants for business purposes are tax deductible, as are the salaries paid to assistants, researchers, and others. However, the artist should try to hire people as independent contractors rather than employees, in order to avoid liability for social security, disability, and withholding tax payments. This can be done by hiring on a job-by-job basis, with each job to be completed by a deadline, preferably at a place chosen by the person hired. The criteria that distinguish an employee from an independent contractor are discussed at length in chapter 23. Record-keeping expenses and taxes will be saved, although Form 1099-MISC, *Miscellaneous*

Income, must be filed for each independent contractor paid more than $600 in one year by the artist.

Schedule C-EZ

While Schedule C is not a difficult form to complete, the IRS also makes available Schedule C-EZ. This is a simplified form which can be used if the artist meets a number of requirements: (1) the cash method of accounting must be used; (2) gross receipts are $25,000 or less; (3) business expenses are $5,000 or less; (4) there is no inventory at any time during the tax year; (5) there is only one sole proprietorship; (6) there is no home office expense; (7) there is no depreciation to be reported on Form 4562; (8) the business has no prior year suspended passive activity losses; and (9) there were no employees that year. That's a lot of requirements, but some artists—especially those starting out—may be able to use Schedule C-EZ.

Beyond Schedule C

The completion of Schedule C—by use of the guidelines in this chapter—finishes much, but not all, of the artist's tax preparation. The next chapter discusses other important tax provisions, not reflected on Schedule C, which can aid the artist or which the artist must observe. A sample Schedule C appears on pages 211–212 along with Form 8829, Expenses for Business Use of Your Home and Schedule C-EZ.

SCHEDULE C
(Form 1040)

Department of the Treasury
Internal Revenue Service (99)

Profit or Loss From Business
(Sole Proprietorship)

▶ For information on Schedule C and its instructions, go to *www.irs.gov/schedulec.*
▶ Attach to Form 1040, 1040NR, or 1041; partnerships generally must file Form 1065.

OMB No. 1545-0074

20**12**

Attachment
Sequence No. **09**

Name of proprietor

Social security number (SSN)

A	Principal business or profession, including product or service (see instructions)	B Enter code from instructions ▶

C	Business name. If no separate business name, leave blank.	D Employer ID number (EIN), (see instr.)

E Business address (including suite or room no.) ▶
 City, town or post office, state, and ZIP code

F Accounting method: **(1)** ☐ Cash **(2)** ☐ Accrual **(3)** ☐ Other (specify) ▶

G Did you "materially participate" in the operation of this business during 2012? If "No," see instructions for limit on losses ☐ Yes ☐ No

H If you started or acquired this business during 2012, check here ▶ ☐

I Did you make any payments in 2012 that would require you to file Form(s) 1099? (see instructions) ☐ Yes ☐ No

J If "Yes," did you or will you file required Forms 1099? ☐ Yes ☐ No

Part I Income

1	Gross receipts or sales. See instructions for line 1 and check the box if this income was reported to you on Form W-2 and the "Statutory employee" box on that form was checked ▶ ☐	1	
2	Returns and allowances (see instructions)	2	
3	Subtract line 2 from line 1	3	
4	Cost of goods sold (from line 42)	4	
5	**Gross profit.** Subtract line 4 from line 3	5	
6	Other income, including federal and state gasoline or fuel tax credit or refund (see instructions) ▶	6	
7	**Gross income.** Add lines 5 and 6	7	

Part II Expenses Enter expenses for business use of your home only on line 30.

8	Advertising	8		18	Office expense (see instructions)	18	
9	Car and truck expenses (see instructions)	9		19	Pension and profit-sharing plans	19	
10	Commissions and fees	10		20	Rent or lease (see instructions):		
11	Contract labor (see instructions)	11		a	Vehicles, machinery, and equipment	20a	
12	Depletion	12		b	Other business property	20b	
13	Depreciation and section 179 expense deduction (not included in Part III) (see instructions)	13		21	Repairs and maintenance	21	
				22	Supplies (not included in Part III)	22	
				23	Taxes and licenses	23	
				24	Travel, meals, and entertainment:		
14	Employee benefit programs (other than on line 19)	14		a	Travel	24a	
15	Insurance (other than health)	15		b	Deductible meals and entertainment (see instructions)	24b	
16	Interest:			25	Utilities	25	
a	Mortgage (paid to banks, etc.)	16a		26	Wages (less employment credits)	26	
b	Other	16b		27a	Other expenses (from line 48)	27a	
17	Legal and professional services	17		b	Reserved for future use	27b	

28	**Total expenses** before expenses for business use of home. Add lines 8 through 27a ▶	28	
29	Tentative profit or (loss). Subtract line 28 from line 7	29	
30	Expenses for business use of your home. Attach **Form 8829**. Do **not** report such expenses elsewhere	30	
31	**Net profit or (loss).** Subtract line 30 from line 29.		

• If a profit, enter on both **Form 1040, line 12** (or **Form 1040NR, line 13**) and on **Schedule SE, line 2.** (If you checked the box on line 1, see instructions). Estates and trusts, enter on **Form 1041, line 3.**

• If a loss, you **must** go to line 32.

31	

32 If you have a loss, check the box that describes your investment in this activity (see instructions).

• If you checked 32a, enter the loss on both **Form 1040, line 12,** (or **Form 1040NR, line 13**) and on **Schedule SE, line 2.** (If you checked the box on line 1, see the line 31 instructions). Estates and trusts, enter on **Form 1041, line 3.**

• If you checked 32b, you **must** attach **Form 6198.** Your loss may be limited.

32a ☐ All investment is at risk.
32b ☐ Some investment is not at risk.

For Paperwork Reduction Act Notice, see your tax return instructions. Cat. No. 11334P Schedule C (Form 1040) 2012

Schedule C (Form 1040) 2012

Part III **Cost of Goods Sold** (see instructions)

Page **2**

33 Method(s) used to
value closing inventory: **a** ☐ Cost **b** ☐ Lower of cost or market **c** ☐ Other (attach explanation)

34 Was there any change in determining quantities, costs, or valuations between opening and closing inventory?
If "Yes," attach explanation . ☐ Yes ☐ No

35 Inventory at beginning of year. If different from last year's closing inventory, attach explanation . . .	35	
36 Purchases less cost of items withdrawn for personal use	36	
37 Cost of labor. Do not include any amounts paid to yourself	37	
38 Materials and supplies	38	
39 Other costs	39	
40 Add lines 35 through 39	40	
41 Inventory at end of year	41	
42 **Cost of goods sold.** Subtract line 41 from line 40. Enter the result here and on line 4	42	

Part IV **Information on Your Vehicle.** Complete this part **only** if you are claiming car or truck expenses on line 9 and are not required to file Form 4562 for this business. See the instructions for line 13 to find out if you must file Form 4562.

43 When did you place your vehicle in service for business purposes? (month, day, year) ▶ ____ / ____ / ____

44 Of the total number of miles you drove your vehicle during 2012, enter the number of miles you used your vehicle for:

 a Business _____ **b** Commuting (see instructions) _____ **c** Other _____

45 Was your vehicle available for personal use during off-duty hours? ☐ Yes ☐ No

46 Do you (or your spouse) have another vehicle available for personal use?. ☐ Yes ☐ No

47a Do you have evidence to support your deduction? ☐ Yes ☐ No

 b If "Yes," is the evidence written? . ☐ Yes ☐ No

Part V **Other Expenses.** List below business expenses not included on lines 8–26 or line 30.

48 **Total other expenses.** Enter here and on line 27a	48	

Schedule C (Form 1040) 2012

SCHEDULE C-EZ
(Form 1040)

Department of the Treasury
Internal Revenue Service (99)

Net Profit From Business

(Sole Proprietorship)

▶ Partnerships, joint ventures, etc., generally must file Form 1065 or 1065-B.
▶ Attach to Form 1040, 1040NR, or 1041. ▶ See instructions on page 2.

OMB No. 1545-0074

20**12**

Attachment
Sequence No. **09A**

Name of proprietor

Social security number (SSN)

Part I General Information

You May Use Schedule C-EZ Instead of Schedule C Only If You:	• Had business expenses of $5,000 or less. • Use the cash method of accounting. • Did not have an inventory at any time during the year. • Did not have a net loss from your business. • Had only one business as either a sole proprietor, qualified joint venture, or statutory employee.	**And You:**	• Had no employees during the year. • Are not required to file **Form 4562,** Depreciation and Amortization, for this business. See the instructions for Schedule C, line 13, to find out if you must file. • Do not deduct expenses for business use of your home. • Do not have prior year unallowed passive activity losses from this business.

A Principal business or profession, including product or service

B Enter business code (see page 2)
▶

C Business name. If no separate business name, leave blank.

D Enter your EIN (see page 2)

E Business address (including suite or room no.). Address not required if same as on page 1 of your tax return.

 City, town or post office, state, and ZIP code

F Did you make any payments in 2012 that would require you to file Form(s) 1099? (see the Schedule C instructions) . ☐ Yes ☐ No

G If "Yes," did you or will you file required Forms 1099? ☐ Yes ☐ No

Part II Figure Your Net Profit

1 **Gross receipts. Caution.** If this income was reported to you on Form W-2 and the "Statutory employee" box on that form was checked, see *Statutory Employees* in the instructions for Schedule C, line 1, and check here ▶ ☐ | **1** |

2 **Total expenses** (see page 2). If more than $5,000, you **must** use Schedule C | **2** |

3 **Net profit.** Subtract line 2 from line 1. If less than zero, you **must** use Schedule C. Enter on both **Form 1040, line 12,** and **Schedule SE, line 2,** or on **Form 1040NR, line 13** and **Schedule SE, line 2** (see instructions). (Statutory employees, **do not** report this amount on Schedule SE, line 2.) Estates and trusts, enter on **Form 1041, line 3** | **3** |

Part III **Information on Your Vehicle.** Complete this part **only** if you are claiming car or truck expenses on line 2.

4 When did you place your vehicle in service for business purposes? (month, day, year) ▶ _____ .

5 Of the total number of miles you drove your vehicle during 2012, enter the number of miles you used your vehicle for:

a Business _____ b Commuting (see page 2) _____ c Other _____

6 Was your vehicle available for personal use during off-duty hours? ☐ Yes ☐ No

7 Do you (or your spouse) have another vehicle available for personal use? ☐ Yes ☐ No

8a Do you have evidence to support your deduction? ☐ Yes ☐ No

b If "Yes," is the evidence written? . ☐ Yes ☐ No

For Paperwork Reduction Act Notice, see your tax return instructions. Cat. No. 14374D Schedule C-EZ (Form 1040) 2012

Form **8829**

Department of the Treasury
Internal Revenue Service (99)

Name(s) of proprietor(s)

Expenses for Business Use of Your Home

▶ File only with Schedule C (Form 1040). Use a separate Form 8829 for each
home you used for business during the year.
▶ Information about Form 8829 and its separate instructions is at *www.irs.gov/form8829.*

OMB No. 1545-0074

2013

Attachment
Sequence No. **176**

Your social security number

Part I	**Part of Your Home Used for Business**			
1	Area used regularly and exclusively for business, regularly for daycare, or for storage of inventory or product samples (see instructions)		**1**	
2	Total area of home		**2**	
3	Divide line 1 by line 2. Enter the result as a percentage		**3**	%

For daycare facilities not used exclusively for business, go to line 4. All others go to line 7.

4	Multiply days used for daycare during year by hours used per day	**4**		hr.
5	Total hours available for use during the year (365 days x 24 hours) (see instructions)	**5**	8,760	hr.
6	Divide line 4 by line 5. Enter the result as a decimal amount	**6**	.	
7	Business percentage. For daycare facilities not used exclusively for business, multiply line 6 by line 3 (enter the result as a percentage). All others, enter the amount from line 3 ▶	**7**		%

Part II	**Figure Your Allowable Deduction**

8 Enter the amount from Schedule C, line 29, **plus** any gain derived from the business use of your home and shown on Schedule D or Form 4797, minus any loss from the trade or business not derived from the business use of your home and shown on Schedule D or Form 4797. See instructions **8**

See instructions for columns (a) and (b) before completing lines 9–21.

			(a) Direct expenses	(b) Indirect expenses	
9	Casualty losses (see instructions)	**9**			
10	Deductible mortgage interest (see instructions)	**10**			
11	Real estate taxes (see instructions)	**11**			
12	Add lines 9, 10, and 11	**12**			
13	Multiply line 12, column (b) by line 7		**13**		
14	Add line 12, column (a) and line 13			**14**	
15	Subtract line 14 from line 8. If zero or less, enter -0-			**15**	
16	Excess mortgage interest (see instructions)	**16**			
17	Insurance	**17**			
18	Rent	**18**			
19	Repairs and maintenance	**19**			
20	Utilities	**20**			
21	Other expenses (see instructions)	**21**			
22	Add lines 16 through 21	**22**			
23	Multiply line 22, column (b) by line 7		**23**		
24	Carryover of operating expenses from 2012 Form 8829, line 42		**24**		
25	Add line 22, column (a), line 23, and line 24			**25**	
26	Allowable operating expenses. Enter the **smaller** of line 15 or line 25			**26**	
27	Limit on excess casualty losses and depreciation. Subtract line 26 from line 15			**27**	
28	Excess casualty losses (see instructions)		**28**		
29	Depreciation of your home from line 41 below		**29**		
30	Carryover of excess casualty losses and depreciation from 2012 Form 8829, line 43		**30**		
31	Add lines 28 through 30			**31**	
32	Allowable excess casualty losses and depreciation. Enter the **smaller** of line 27 or line 31			**32**	
33	Add lines 14, 26, and 32			**33**	
34	Casualty loss portion, if any, from lines 14 and 32. Carry amount to **Form 4684** (see instructions)			**34**	
35	**Allowable expenses for business use of your home.** Subtract line 34 from line 33. Enter here and on Schedule C, line 30. If your home was used for more than one business, see instructions ▶			**35**	

Part III	**Depreciation of Your Home**		
36	Enter the **smaller** of your home's adjusted basis or its fair market value (see instructions)	**36**	
37	Value of land included on line 36	**37**	
38	Basis of building. Subtract line 37 from line 36	**38**	
39	Business basis of building. Multiply line 38 by line 7	**39**	
40	Depreciation percentage (see instructions)	**40**	%
41	Depreciation allowable (see instructions). Multiply line 39 by line 40. Enter here and on line 29 above	**41**	

Part IV	**Carryover of Unallowed Expenses to 2014**		
42	Operating expenses. Subtract line 26 from line 25. If less than zero, enter -0-	**42**	
43	Excess casualty losses and depreciation. Subtract line 32 from line 31. If less than zero, enter -0-	**43**	

For Paperwork Reduction Act Notice, see your tax return instructions. Cat. No. 13232M Form **8829** (2013)

21 TAXES: BEYOND SCHEDULE C

The artist must also be aware of a number of other tax benefits and obligations in order to be able to make rational choices and to seek professional advice when necessary. These provisions, while not gathered neatly in one place like income and expenses on Schedule C, are of great significance to the artist.

Self-Employment Tax

The social security system of the United States creates numerous benefits for those who have contributed from their earnings to the federal social security system. It provides benefits for a person's family in the event of death or disablement as well as providing a pension and certain medical insurance. Artists, whether employees or self-employed, are covered by the system. Since the payments for social security are not automatically withheld for a self-employed artist, as they are for one who is an employee, the self-employed artist must file with Form 1040 a Schedule SE, Computation of Social Security Self-Employment Tax, and pay the self-employment tax shown on the Schedule SE. Self-employment income is basically the net income of the artist reported on Schedule C, subject to certain adjustments. If an artist and spouse both earn self-employment income, each must file a separate Schedule SE. If an artist has more than one business, the combined business earnings should be totaled on Schedule SE for purposes of calculating the self-employment tax.

Social security coverage, to gain the various benefits, is created by having a certain number of quarters for which a worker makes payments for social security. If a minimum number of years of work credit is established,

the artist qualifies for benefits. The amount of benefits is based on average yearly earnings covered by social security. Therefore, the artist who pays more self-employment taxes will be eligible for larger benefits from the system.

The self-employed artist must file Schedule SE for any tax year in which net self-employment income is more than $400. The maximum amount of income on which tax must be paid has been increasing constantly over the years—for example, from $14,000 in 1975 to $37,800 in 1984 to $68,400 for 1998 to $106,800 in 2009—and the rate has also increased over the years (for example, the rate was 11.3 percent in 1984 but in recent years has been 12.4 percent for social security). In addition, there is a Medicare tax of 2.9 percent on all self-employed income (but note that self-employment income is multiplied by .9235 to reduce it before the tax calculations are made). One half of the self-employment taxes paid are a deductible expense on Form 1040.

Additional information as to the benefits available under social security to either the artist or the artist's family is available from the local offices or the Web site (*www.ssa.gov*) of the Social Security Administration, including a helpful publication titled *Understanding the Benefits* and an information sheet titled *If You Are Self-Employed.*

Estimated Tax

Employers withhold income and social security taxes from the wages of their employees. However, the self-employed artist must pay income and social security taxes in quarterly installments computed on Form 1040-ES, Estimated Tax, and mailed on or before April 15, June 15, September 15, and January 15. In

most cases, Form 1040-ES is required if the artist estimates that the total of income and self-employment taxes for the next year will exceed any withheld taxes by $1,000 or more.

The failure to pay a sufficient amount of estimated tax subjects the artist to liability for penalties, as well as having to pay the tax deficiency. A simple way to avoid the risk of such penalties is to pay as estimated tax in the current year what the actual tax amount was in the prior year. IRS Publication 505, *Tax Withholding and Estimated Tax*, gives more detailed information regarding the estimated tax and how to avoid penalties for underpayment.

Retirement Plans

Keogh plans permit a self-employed person, such as an artist, to contribute to a retirement fund and to deduct the amount of the contribution from gross income when computing income taxes. However, the deduction is allowed in any year only if the artist places the amount to be deducted in one of the following retirement funds: a trust, annuity contracts from an insurance company, a custodial account with a bank or another person, special U.S. Government retirement bonds or certain face-amount certificates purchased from investment companies. Even if the artist is employed by a company with a retirement program, the artist may still have a Keogh plan for self-employment income from the career in art.

There are several ways to determine the amount of contributions to be made to a Keogh plan, which are limited by certain caps. To be able to contribute the maximum amount, the artist would have to have a certain income level. If this level is not achieved, lesser contributions can be made. If an artist has employees, it is quite likely that a plan to benefit the artist will also require contributions for the benefit of the employees.

A contribution to a Keogh plan can be made before the filing date of the tax return, which is usually the following April 15th, or any extensions of the filing date, as long as the Keogh plan was in existence during the tax year for which the deduction is to be taken. Because the money contributed to a Keogh plan is deductible, there are penalties for withdrawal of monies from a plan prior to age fifty-nine and a half, unless the artist becomes permanently disabled. No taxes are levied on the growth of a Keogh fund until the funds are withdrawn. Distributions are taxed when made, and must begin no later than age seventy-and-a-half (or, in some cases, the year of retirement if the person is older than seventy and a half on retiring). The artist's tax bracket then, however, may be much lower than when the contributions were made and the funds have had tax-free growth. If a trust is created, it is possible for the artist to act as trustee and administer the investments. More information about Keogh plans can be obtained from the institutions, such as the local bank or insurance company, which administer them. Also helpful is IRS Publication 560, *Retirement Plans for Small Business*.

A self-employed person may also create a SEP (Simplified Employee Pension), which is not as flexible as a Keogh plan in terms of being customized. However, SEPs need not be set up by the end of the year for which the contribution is to be made and do not have the same annual filing requirements as Keoghs. For artists who want to make the largest possible contributions, the Keogh is preferable to the SEP.

Separate from either a Keogh plan or a SEP, the artist may begin an IRA (Individual Retirement Account) and contribute into this account each year. A married artist with a nonworking spouse may be able to contribute for him- or herself and make an additional IRA contribution and deduction for a nonworking spouse, subject to certain qualifications and limitations.

To qualify to make a deductible contribution to an IRA, an artist must either (1) not be covered by another retirement plan (such as a Keogh or SEP), or (2) if covered by another retirement plan, the artist must not exceed certain limits on adjusted gross income (which increase if the artist is married).

The amount of the IRA contribution is a deduction from gross income. Again, the funds contributed must be taken out of the artist's hands and placed in a trust, a custodial account with a bank or other person, annuity contracts with a life insurance company or special U.S. Government retirement bonds. The payment, to be deductible, must be made by April 15 of the year following the tax year for which the deduction will be taken. More information may be obtained from the institutions administering Individual Retirement Accounts, as well

as IRS Publication 590, *Individual Retirement Arrangements (IRAs)*.

If an artist were covered by a retirement plan and could not make a deductible contribution to an IRA, it might be worthwhile to make a nondeductible contribution (subject to the current limitations on the amount of the contribution). Several types of nondeductible IRAs have been created. While contributions are nondeductible, any growth in value of a Roth IRA or an education IRA will escape taxation because distributions are not taxed. While these new IRAs apply to all taxpayers and are beyond the scope of this book to cover in detail, they are worth considering when the artist is planning for retirement or education (such as education of the artist's children).

Keogh, SEP, and IRA plan contributions are claimed on Form 1040. The artist should consult with the plan administrator to determine what additional forms may have to be filed. Also, the custodial fees charged by a plan administrator may be deducted as investment expenses on Schedule A if these fees are separately billed and paid for. Commissions paid on transactions in the retirement fund do not qualify as deductible.

Child and Disabled Dependent Care

An artist's payments for child or disabled dependent care may create a tax credit. A tax credit is subtracted directly from the tax owed, so it is more beneficial than a deduction of the same amount that merely reduces income prior to application of the tax rates. Basically, this credit is available to the artist who maintains a household including either a child under age thirteen or a disabled dependent or spouse for the care of whom it is necessary to hire someone so the artist can gainfully pursue employment, self-employment or the search for employment. IRS Publication 503, *Child and Dependent Care Expenses*, describes in greater detail the availability of and limitations on this credit.

Contributions

Contributions to qualified organizations are deductible if personal deductions are itemized on Schedule A. Since the artist's own artworks, and any gifts of works by other artists, have a tax basis of zero (if the artist is on a cash basis) or the cost of materials (if the artist is on an accrual basis), the artist's deduction is limited to such basis.

For example, an artist claimed an advertising and public relations expense for six paintings he donated to charities. The expense was at what the artist considered to be fair market value, despite the fact that he had already deducted the cost of materials in prior years. The court concluded that the tax law "does not permit a business expense deduction based on the value of the taxpayer's own labor and... expressly limits taxpayer's charitable contribution deduction for his own labor as an artist to his cost basis." (*Maniscalco v. Commissioner*, 632 F.2d 6) Rejecting the artist's contention that the tax code is unconstitutional on this point, the court observed, "Artists, while a unique segment of the population, must be treated equally with all others by the tax laws. Creativity, unfortunately, does not support a tax deduction as an ordinary and necessary business expense." Numerous bills have been proposed to rectify this inequitable treatment, and perhaps the artist will someday be able to deduct either part or all of the fair market value of contributed works.

The rule, of course, is otherwise for the collector who purchases work that increases in value. The deductions for a collector's contributions are discussed on page 221. A number of states have enacted laws giving artists the right to deduct their own contributed art on the basis of fair market value for the purpose of state taxes. These states include Arkansas, Maryland, Michigan, and Oregon.

Bad Debts

A common error is the belief that if an artist (on the cash basis) sells a work for $1,000 and the purchaser never pays, the artist can take a bad debt deduction. The artist cannot take such a deduction, since the $1,000 purchase price has never been received and included in income. As stated in Publication 334, *Tax Guide for Small Business*, "If you use the cash basis of accounting, you normally report income when you receive payment. You cannot take a bad debt deduction for amounts owed to you that you have not received and cannot collect if you never included those amounts in income."

A cash basis taxpayer can, however, gain a tax benefit from either business or nonbusiness bad debts of the proper kind. In almost all cases, the artist's bad debts will be nonbusiness. For example, if the artist makes a loan to a friend who never repays the loan, the amount

of the loan will be a nonbusiness bad debt. The loan cannot be a gift, however, and must be legally enforceable against the borrower. The nonbusiness bad debt deduction is taken in the year in which the debt becomes worthless. It is reported as a short-term capital loss on Schedule D.

Net Operating Losses

The artist who experiences a business loss as determined on Schedule C will carry the loss to Form 1040, where it is eventually subtracted from gross income in the calculations to reach taxable income. However, if the loss is large enough to wipe out other taxable income for the year, the excess loss can first be carried back to reduce taxable income in two prior years and then carried forward for twenty future taxable years. This type of loss is likely to arise when a professional artist is changing over from being employed to devoting all working time to art. The result is that the artist will be entitled to a tax refund (if taxable income in previous years is reduced) or will save on taxes in future years. IRS Publication 536, *Net Operating Losses (NOLs) for Individuals, Estates, and Trusts*, describes the net operating loss, but the artist will probably need an accountant's help for the computation of a net operating loss.

American Artists Living Abroad

American citizens, whether or not they live in the United States, are taxable by the United States government on all of their income from anywhere in the world. However, a tax benefit for many American citizens living abroad is the exclusion from American taxable income of $91,400 of earned income from foreign sources. The $91,400 exclusion apples for 2009, having increased from $72,000 for 1998. This exclusion can result in substantial tax benefits when the tax rates of the foreign country—such as Ireland, where a qualified artist can live tax free—are lower than the tax rates in the United States. The exclusion can be negatively affected if an artist travels in countries restricted to United States citizens under the Trade with the Enemy Act of the International Emergency Economic Powers Act.

Publication 54, *Tax Guide for U.S. Citizens and Resident Aliens Abroad*, generally explains the guidelines for eligibility for these exclusions. The basic requirements are either a one-year residence or a physical presence in a foreign country and earned income created from work done in the foreign country. Residence is a flexible concept based on the circumstances of each individual. While the residence must be uninterrupted (for example, by owning or renting a home continually), remaining abroad for all the taxable year in question is not necessary. Brief trips to the United States do not affect the tax status as a resident abroad. However, the length of each visit and the total time spent in the United States must be watched carefully. Physical presence requires the taxpayer to be present in a foreign country or countries for at least 330 days (about eleven months) during a period of twelve consecutive months. Regardless of which test is met, the income to be excluded must be received no later than the year after the year in which the work was performed which generated the income. Certain foreign housing costs may also be excludable or deductible from income.

Assuming the artist met either the residence or physical presence test, the requirement that the income to be excluded had to be earned income often proved fatal to the artist's attempt to benefit from the exclusion. The reason for this was the definition, once found in Publication 54, of most of the income of an artist as unearned.

This unjust rule was rectified, however, in a case involving the painter, Mark Tobey, while he was a resident of Switzerland. In *Tobey v. Commissioner*, the issue before the tax court was whether Mark Tobey, all of whose "works were executed...without prior commission, contract, order, or any such prior arrangement," had earned income such that he could avail himself of the exclusion from United States taxable income. The court, noting that "earned" generally implies a product of one's own work, reasoned:

The concept of the artist as not "earning" his income for the purposes of Section 911 would place him in an unfavorable light. For the most part, the present day artist is a hard-working, trained, career-oriented individual. His education, whether acquired formally or through personal practice, growth and experience, is often costly and exacting. He has keen competition from many other artists who must create and sell their works to survive. To avoid discriminatory treatment, we perceive no sound reasons for treating income earned by the

personal efforts, skill and creativity of a Tobey or a Picasso any differently from the income earned by a confidence man, a brain surgeon, a movie star or, for that matter, a tax attorney. (Tobey v. Commissioner, *60 T.C. 227*)

This rationale necessarily led to the conclusion that Tobey's income was earned. Publication 54 now reflects this by stating, "Income of an artist. Income you receive from the sale of paintings you created is earned income."

Each artist hoping to benefit from the exclusion for income earned abroad must, of course, consult with a lawyer or an accountant to determine the effect of the foregoing legal provisions on his or her unique situation. Artists already living abroad should also inquire at their American consulate to determine whether any treaty regarding taxation between the United States and the country in which they live might affect their tax status.

The artist living abroad should also consider whether any income taxes paid to a foreign government may be taken as either a deduction or a tax credit. No such credit or deduction will be allowed on foreign income taxes paid on earned income excluded from the United States taxation. IRS Publication 514, *Foreign Tax Credit for Individuals*, explains these provisions further.

Foreign Artists in the United States

Foreign artists who are residents of the United States are generally taxed in the same way as United States citizens. Foreign artists who are not residents in the United States are taxed on income from sources in the United States under special rules. A foreigner who is merely visiting or whose stay is limited by immigration laws will usually be considered a nonresident. A foreigner who intends, at least temporarily, to establish a home in the United States and has a visa permitting permanent residence will probably be considered a resident. IRS Publication 519, *United States Tax Guide for Aliens*, should be consulted by foreign artists for a more extensive discussion of their tax status.

Employee Expenses

Often artists who work as employees will find that they are required to incur expenses in the performance of their duties. The nature of the expenses is the same as the expenses that a self-employed person could deduct, such as supplies, work space, equipment, travel, and so on. These expenses, if ordinary and necessary, will be deductible on Schedule A if the artist itemizes (and will only be allowed to the extent that these and certain other expenses total in excess of 2 percent of adjusted gross income). To deduct these expenses, the artist must complete Form 2106, Employee Business Expenses.

The artist who incurs expenses as an employee can consult IRS Publications 521, *Moving Expenses*, and 535, *Business Expenses*, for further information on deductibility.

Forms of Doing Business

Depending on the success of the artist, various forms of doing business might be considered. There may be both business and tax advantages to conducting the artist's business in the form of a corporation or partnership, but there may be disadvantages as well.

Generally, the non-tax advantages of incorporation are limited liability for the stockholders, centralized management, access to capital, transferability of ownership, and continuity of the business. For the artist, the most important of these non-tax advantages will probably be limited liability. This means that a judgment in a lawsuit will affect only the assets of the corporation, not the personal assets of the artist. Limited liability is quite significant when the work locale, machinery, chemicals, or even artwork are potentially hazardous. The attribute of limited liability applies to all corporations—the regular corporation and the Subchapter S corporation. The tax treatment, however, differs significantly between the two types of corporations.

For regular corporations, net corporate income is taxed at 15 percent on net income up to $50,000, 25 percent from $50,000 to $75,000, 34 percent from $75,000 to $100,000, 39 percent from $100,000 to $335,000, 34 percent from $335,000 to $10,000,000, 35 percent from $10,000,000 to $15,000,000, 38 percent from $15,000,000 to $18,333,333, and 35 percent over $18,333,333. Usually the tax on the corporation can be substantially avoided by the payment of a salary to the artist, which creates a deduction for the corporation. Such an arrangement can effectively average the artist's income from year to year.

The Subchapter S corporation is not taxed at all, but the income is credited directly to the

accounts of the stockholders and they are taxed as individuals. Both types of corporations are less likely to be audited than an individual proprietor. It may also be easier to choose a fiscal year (any tax year other than the calendar year) and, particularly in the case of a regular corporation, shift some of the artist's income into the next tax year. Some of the disadvantages of incorporation are additional record keeping, meetings, and paper work, as well as significant expenses both for the initial incorporation and for any ultimate dissolution.

A partnership is an agreement between two or more persons to join together as co-owners of a business in pursuit of profit. Partnerships are not subject to the income tax, but the individual partners are taxable on their share of the partnership income. Partners are personally liable for obligations incurred on behalf of the partnership by any of the partners. A partnership offers to the artist an opportunity to combine with investors under an agreement in which the investors may gain tax advantages by being allocated a greater share of partnership losses. A variation of the usual partnership is the "limited partnership," in which passive investors have limited liability (but the artist, running the business actively, is still personally liable). Another variation is the "joint venture," which can be described simply as a partnership created for a single business venture.

Many states have legislated into existence a new form of business entity called a "limited liability company," which combines the corporate advantage of limited liability for its owners while still being taxed for federal income tax purposes as a partnership. The limited liability company offers great flexibility in terms of the mode of ownership and the capital structure of the company as well as what corporate formalities the company must observe.

In general, the tax law requires that a partnership, an S corporation, or a personal service corporation (which is a corporation whose principal activity is the performance of personal services by an employee-owner) use a calendar tax year, unless there is a business purpose for using a fiscal year.

The artist contemplating doing business as either a corporation, partnership or limited liability company should consult a lawyer for advice based on the artist's unique needs.

Gifts

The artist can avoid paying income taxes by giving away the artist's creations. Both artworks and copyrights can be transferred by gift to family members or others whom the artist may wish to benefit. The artwork and copyright on the work can be transferred separately from one another if the artist chooses. The artist could keep the work and transfer the copyright, transfer the copyright and keep the work, or transfer both the work and the copyright.

If the person who receives the gift is in a lower tax bracket than the artist, tax savings will result upon sale by the person who received the gift. Gifts over certain amounts, however, are subject to the gift tax. Transfers of income-producing property from adults to children under eighteen will have a very limited tax advantage. Basically, the unearned income of the child will be taxed at the child's or parents' top rate, whichever is greater. Of course, the transfer of art or other assets to the child might still be a wise decision, since the art might appreciate in value without producing income until a sale at a much later date.

The making of gifts and the gift tax are discussed on pages 236–237, but careful planning is a necessity if gifts are to play an effective role in tax planning.

22 TAXES: THE HOBBY LOSS CHALLENGE

Often the artist, sufficiently dedicated to pursue an art career despite year after year of losses on Schedule C, will face a curious challenge from the IRS: the losses incurred by the artist cannot be deducted for tax purposes because the artist was only pursuing a hobby and did not have the profit motive necessary to qualify the art career as a business or trade. A hobbyist in any field may deduct the expenses of the hobby only up to the amount of income produced by the hobby. For example, if a hobbyist makes $500 in a year on the sale of art, a maximum of $500 in expenses can be deducted. On the other hand, an artist actively engaged in the business or trade of being an artist—one who pursues art with a profit motive—may deduct all ordinary and necessary business expenses, even if such expenses far exceed income from art activities for the year.

A Test: Three Years out of Five

But how can an artist show that the requisite profit motive is present and avoid being characterized as a hobbyist by the IRS? At the outset, there is an important threshold test in favor of the taxpayer. This test is a presumption that an artist is engaged in a business or trade—and hence is not a hobbyist—if a net profit is created by the activity in question for three of five consecutive years ending with the taxable year at issue. Thus, many artists who have good and bad years need not fear a hobby loss challenge to a loss in one of the bad years.

If a hobby loss problem is anticipated, artists on the cash basis may be able to create profitable years by regulating the time of receipt of income and payment of expenses. For example, instead of having five years of small losses, an artist is far better off having three years in which a small profit is earned and two years in which larger than usual losses are incurred. Another way to create a profitable year is to sell art to a friend and buy some of the friend's art. In essence a trade, this will lose some deductions but gain a profitable year (and also entitle the artist to hold the purchased art as a collector, which may have favorable tax consequences). If the artist has an art-related job, some daring accountants enter the wages from the job on Schedule C as income from the business of being an artist. While not recommended, an artist might wish to discuss this with his or her own professional advisors.

Profit Motive: The Nine Factors

But even if an artist does not have three profitable years in the last five years of art activity, the contention by the IRS that the artist is a hobbyist can still be overcome if the artist can show a profit motive. The Regulations to the Internal Revenue Code specifically provide for an objective standard to determine profit motive based on all the facts and circumstances surrounding the activity. Therefore, statements by the artist as to profit motive are given little weight. But the chance of making a profit can be quite unlikely, as long as the artist actually intends to be profitable.

The regulations set forth nine factors used to determine profit motive. Since every artist is capable, in varying degrees, of pursuing art in a manner that will be considered a trade or business, these factors offer an instructive model. The objective factors are considered in their totality so that all the circumstances surrounding the activity will determine the result in a given case. Although most of the factors are

important, no single factor will determine the result of a case. The nine factors follow.

1. Manner in which the taxpayer carries on the activity. The artist should keep accurate records of all business activities, especially receipts and expenses.
2. The expertise of the taxpayer or his advisors. Study is one indication of expertise, but equally important is professional acceptance as shown by gallery exhibitions, encouragement by agents or dealers, the winning of prizes, professional memberships, or critical recognition in articles or books. Use of professional equipment and techniques can also be important. The appointment to a teaching position, if the appointment is based at least in part on professional artistic ability, further demonstrates expertise.
3. The time and effort expended by the taxpayer in carrying on the activity. The activity does not have to absorb all of the artist's time, but a failure to work at all is not consistent with having a profit motive. Exactly what qualifies as sufficient time has never been spelled out, but on one occasion the court found four hours a day acceptable. It is helpful if the art activity is the only occupation of the artist, but employment in another field does not negate the presence of a profit motive with respect to art.
4. Expectation that assets used in activity may appreciate in value. This factor has yet to be applied to the arts, although artists, of course, expect that their art will increase in value.
5. The success of the taxpayer in carrying on other similar or dissimilar activities. Previous critical or financial success in art, despite an intervening slack period, is helpful.
6. The taxpayer's history of income or losses with respect to the activity. Increasing income each year from the art activity is very positive. On the other hand, losses do not imply a lack of a profit motive, unless such losses continue over a lengthy time period during which income is being received from non-art sources and a large imbalance exists between art-related income and expenses. Paradoxically, the change of profession to a non-art activity after an unprofitable art career would also show that a profit motive had existed in the pursuit of the art activity.
7. The amount of occasional profits, if any, which are earned. Here the amount of profits is compared to the amount of expenses, but this factor is only important when the taxpayer is sufficiently wealthy to gain tax benefits from disproportionate expenses without feeling any financial strain from the amount of the expenses.
8. The financial status of the taxpayer. Wealth and independent income are unfavorable to having a profit motive, while the need for income from the art activity and the lack of funds to support a hobby would tend to indicate the presence of a profit motive.
9. Elements of personal pleasure or recreation. This has little application, since the pursuit of an art career is as painstaking and rigorous as any occupation. However, where travel is involved, the artist should be fully prepared to justify such travel in terms of its furtherance of the art business.

Cases

To give perspective to these nine factors, a look at three hobby loss cases will be helpful. In the first case, the tax court found the artist a hobbyist; in the second case, a professional artist. In the third case, the court found the artist to be a professional and focused on the factors that demonstrated the artist's profit motive. These cases should serve as models for the artist because they illustrate the approach taken by the tax court in hobby loss cases.

Case 1: The Hobbyist

Johanna K. W. Hailman was a prominent social leader in Pittsburgh, Pennsylvania. Born in 1870, she had painted from an early age—mainly portraits and flowers—and by the time of her death in 1958 had completed five to six hundred paintings. She owned a large estate and received substantial income from investments and a trust established by her deceased husband. On her estate she had a fully equipped and heated four-room studio located about one hundred and fifty feet from her main house. During the winter, she maintained a room in her Florida residence for a studio. She was recognized as a leading artist in western Pennsylvania and had good standing throughout the United States. She had shown her work in the First International Exhibition at Carnegie Institute in 1896 and, apparently, exhibited at all the subsequent International Exhibitions at Carnegie through 1955.

Between 1920 and 1949 she sold about fifty paintings, but made no sales from 1949 to 1954. She did not use a dealer or agent, but offered her paintings for sale at various exhibitions in Pittsburgh and other places. In the 1950s, the prices paid for her paintings ranged from $700 to $1,500, and she refused to accept offers she felt would be inadequate to maintain her prestige as an artist. From 1936 to 1954 her income from painting amounted to $7,200, while her expenses incidental to making and selling paintings came to $131,140. The IRS did not allow all of these expenses, but instead adopted the practice through 1951 of permitting as a deduction the amount of $3,000 per year.

Though she stopped selling work in 1949, Hailman continued to incur expenses. In 1952, she had expenses of $9,654. An additional $7,718 in expenses were incurred in 1953, and another $6,457 in 1954. The IRS determined that none of the expenses in these three years should be allowed as deductions because Mrs. Hailman was not engaged in the business of being an artist.

The tax court agreed with the IRS. The court concluded that when, over a lengthy period such as 1936 to 1954, expenses are eighteen times as great as receipts from an activity, and only independent wealth permits the continuance of the activity, including the setting of high prices and the retention of most of the artworks, then the activity must be determined to be pursued for the pleasurable diversion provided by a hobby without the necessary profit motive for one engaged in a business or trade. The result was that no deductions were allowed for the years 1952, 1953, and 1954.

Case 2: The Professional

Anna Maria de Grazia, who painted under the name of Anna Maria d'Annunzio, was born in Switzerland. The granddaughter of Gabriele d'Annunzio, the famous Italian writer and military hero, she was raised in Italy where, in 1940, she became interested in painting. During World War II, she served as a guide for the Allied forces, continuing to paint during the war and even when, in 1944, polio forced her to learn to paint with her left hand. In 1942, she won first prize in an exhibition of young painters in Florence and in the same year placed third in a contest open to all Italians. She did not paint from 1943 to 1947 but did paint and exhibit from 1948 to 1951. During this period she was admitted to the Italian painters' union upon the attestation of three professional artists that she was also a professional artist. In 1952 she moved to the United States, married Sebastian de Grazia, and neither painted nor exhibited until 1955, when she also became a naturalized citizen of the United States. By 1957, she had studied with artists Annigoni, Carena, and Kokoschka and was recognized by having her self-portrait and biographical background appear in a book on Italian painting from 1850 to 1950.

She resumed her painting in 1956 and 1957, supported by the modest income of her husband, who was a visiting professor at Princeton University. In 1957 she painted at Princeton in a rented house that she felt had inadequate facilities for a studio. Finally, in May, she left to paint at the Piazza Donatello Studios in Florence, Italy, which had been built for artists and had excellent light. Her decision to go to Florence was prompted by her familiarity with the Italian art world, and came after she had made several unsuccessful visits to New York in 1957 in an attempt to find an art gallery for her work. She painted four hours a day in 1957, devoting additional time to stretching and preparing her canvases and transacting business with art dealers and her frame maker. She had been told that a prestigious gallery in New York would require numerous paintings for an exhibition, and by the end of 1957 she had completed between twelve and fifteen paintings with ten more in progress. After 1957, she did exhibit successfully, having a number of solo shows in Italy as well as having her work exhibited in Princeton and New York City.

In 1957, she had no income from her painting, while her expenses were $5,769; in 1958, she had $500 in receipts, while her expenses were $6,854; in 1959, she had $575 in receipts, while her expenses were $5,360; and, in 1960, she had $710 in receipts, while her expenses were $4,968. She did not keep formal business books, but did have records relating to her receipts and expenses as an artist. The IRS challenged her deduction of $5,769 in 1957 on the grounds that she had been merely pursuing a hobby or preparing to enter a business or trade, but had not actively engaged in the business or trade of being an artist in that year.

The tax court, in an excellent opinion, disagreed with the IRS and concluded that she had

indeed been in the business or trade of being an artist in the year 1957. The tax court found several facts that demonstrated Anna Maria de Grazia's profit motive. She began painting in her youth and won prizes for her work. She struggled to overcome the handicap imposed by polio. She studied with recognized artists, and received recognition from the Italian painters' union and in critical publications. She had exhibited both prior and subsequent to 1957. She worked continually and unstintingly at her painting and necessary incidental tasks. She had no other sources of income, and as such, her losses were a financial strain. Finally, she had constantly increasing receipts in the years after 1957. The tax court also explicitly rejected the argument that she had merely been preparing to enter a trade or profession, stating that the history of her art activities after 1940 rebutted any such contention. In a notable section of the decision, the court wrote:

It is well recognized that profits may not be immediately forthcoming in the creative art field. Examples are legion of the increase in value of a painter's works after he receives public acclaim. Many artists have to struggle in their early years. This does not mean that serious artists do not intend to profit from their activities. It only means that their lot is a difficult one. (Sebastian de Grazia, *T.C.M. 1962-296*)

Case 3: Finding the Profit Motive

In another case favorable to artists, a woman who had painted for twenty years without making a profit was found to have a profit motive. For the three years in which the IRS tried to deny her deductions, she had only one sale for $250. The tax court noted that she had made extensive efforts to market her work, including running a gallery for a year, keeping a mailing list, seeking other galleries and making different efforts—such as making posters and writing books—to enhance the likelihood of sales. She kept a journal for sales and kept all her receipts. Also, she had studied and taught art. Her work did appear at least once a year in commercial galleries and she had been written up in newspapers and magazines. She had also received a grant to do a film. She devoted a substantial amount of time to her artistic activities.

In holding that the artist had a profit motive, the court wrote:

It is abundantly clear from her testimony and from objective evidence that petitioner is a most dedicated artist, craves personal recognition as an artist, and believes that selling her work for a profit represents the attainment of such recognition. Therefore, petitioner intends and expects to make a profit. For section 183 purposes, it seems to us irrelevant whether petitioner intends to make a profit because it symbolizes success in her chosen career or because it is the pathway to material wealth. In either case, the essential fact remains that petitioner does intend to make a profit from her artwork and she sincerely believes that if she continues to paint she will do so. (Churchman v. Commissioner, *68 T.C. 696*)

An Overview

Artists with wealth and independent incomes, whose art activity expenses are large relative to their receipts over a lengthy period, are most likely to be treated as hobbyists by the IRS. Artists who devote much time to their art, who have the expertise to receive some recognition, and for whom the expenses of art are burdensome, will probably qualify as engaged in a business or trade. Especially younger artists, who are making the financial sacrifices so common to the beginning of an art career, should be considered to have a profit motive, even if other employment is necessary for survival during this difficult early period.

Each case in which an artist is challenged as a hobbyist requires a determination on its own facts. However, being aware of the relevant factors a court would consider in imputing profit motive will help the working artist avoid being characterized as a hobbyist. It is advisable to have the professional assistance of an accountant or lawyer as soon as a hobby loss issue arises during an audit. Such professional advisors can be particularly helpful in effectively presenting the factors favorable to the artist. The presence of a lawyer or accountant at the earliest conferences with the IRS can aid in bringing a hobby loss challenge to a quick and satisfactory resolution.

23 TAXES: WHO IS AN EMPLOYEE?

Artists, including graphic design firms, photography studios, and fine artists, frequently hire assistants or other freelancers as needed to bolster the work capacities of any regular staff. Often these additional workers are treated as independent contractors. The advantage of this to the hiring artist is that he or she need only file a Form 1099-MISC at the end of the tax year. However, the IRS would prefer to categorize such additional help as employees. All artists, from designers to photographers to fine artists, must consider whether a part-time helper will prove to be an employee under the IRS standards.

For an employee, the artist must withhold federal, state and local income taxes, pay half of the tax mandated under the Federal Insurance Contributions Act (for Social Security), pay the full tax required under the Federal Unemployment Tax Act and any state unemployment tax laws; pay for Worker's Compensation, file a number of returns during the course of the year with the various tax authorities, and provide a W-2 by January 31. The employee will also have rights to any employee benefits, such as health insurance, vacations, holidays, or retirement plans.

Reclassification

If the IRS or state tax authorities reclassify independent contractors as employees, the result can be substantial liabilities not only for the current year but also for earlier tax years "open" to IRS review. A firm that intentionally misclassifies will face the payment of back taxes, penalties, and interest—a total that may be double what should have been paid originally.

Hence, if there are any independent contractors who could be classified as employees, it is far better for the artist to consult with an accountant or tax specialist immediately, rather than face this issue on an audit. If the IRS is successful in reclassifying independent contractors, the very existence of the art business can be threatened.

What Makes an Employee?

The IRS has issued a twenty factor control test (Revenue Ruling 87-41, 1987-1CB296) to clarify the distinction between employees and independent contractors. The control test is easy to state: Is the outside help subject to the control or right to control of the artist? Unfortunately, the guidelines are too general to resolve every situation. Often some factors suggest employee status while others suggest independent contractor status.

Some key factors the IRS looks into include:

(1) Instructions. Is the worker required to obey the artist's instructions about when, where and how work is to be performed? If the artist has the right to require compliance with such instructions, the worker is likely to be an employee.

(2) Training. Training a worker suggests that the worker is an employee. The training may be by having an experienced employee labor with the worker, by requiring that the worker attend meetings, by correspondence, or by other methods.

(3) Integration. If a worker's services are part of an artist's operations, this suggests that the worker is subject to the artist's control. This is especially true if the success

or continuation of the artist's business is dependent in a significant way upon the services performed by the worker.

(4) Personal services. If the artist requires that the services be performed in person, this suggests control over an employee.

(5) Use of assistants. If the artist hires, directs, and pays for assistants to the worker, this indicates employee status for the worker. On the other hand, if the worker hires, directs, and pays for his or her assistants, supplies materials, and works under a contract providing that the worker is only responsible for achieving certain results, this would be consistent with being an independent contractor.

(6) Ongoing relationship. If the relationship is ongoing, even if frequent work is done on irregular cycles, the worker is likely to be an employee.

(7) Fixed hours of work. This would suggest that the worker is an employee controlled by the artist.

(8) Full-time work. If the worker is hired on a full time basis, this suggests that the artist controls the time of work and restricts the worker from taking other jobs. This would show employee status.

(9) Work location. If the artist requires that the worker be at the artist's premises, this suggests employment. The fact that the worker performs the services off premises implies being an independent contractor, especially if an employee would normally have to perform similar services at an employer's premises.

(10) Work flow. If the worker must conform to the routines, schedules and patterns established by the artist, this is consistent with being an employee.

(11) Reports. A requirement that reports be submitted, whether oral or written, would suggest employee status.

(12) Manner of payment. Being paid by the hour, week, or month suggests being an employee, while being paid an agreed upon lump sum for a job suggests being an independent contractor.

(13) Payment of expenses. The artist's payment of expenses implies the right to control expenses and thus suggests employment status.

(14) Providing tools and equipment. If the artist does this, it suggests the worker is an employee.

(15) Investment. If the worker has a significant investment in his or her own equipment, this implies being an independent contractor.

(16) Profit or loss. Having a profit or loss (due to overhead, project costs, and investment in equipment) is consistent with being an independent contractor.

(17) Multiple clients. Working for many clients would suggest the status of an independent contractor, although it may be that the worker is an employee of each of the businesses (especially if there is one service arrangement for all the clients).

(18) Marketing. If the worker markets his or her services to the public on a regular basis, this indicates being an independent contractor.

(19) Right to discharge. If the artist can discharge the worker at any time, this suggests employment. An independent contractor cannot be dismissed (without legal liability) unless he or she fails to meet the contractual specifications.

(20) Right to quit. An employee may quit at any time without liability, but an independent contractor may be liable for failure to perform according to the contractual terms.

A Matter of Intention

The danger is that an artist will either misinterpret these factors or intentionally misclassify a worker as an independent contractor. Since the payment of back taxes, penalties, and interest may be double what should have been paid by the artist, the very life of the artist's business may be threatened. Also, the IRS may argue that workers with a very peripheral connection to the artist—for example, mechanical artists or even illustrators—are employees. In one case involving state tax authorities, a mechanical artist worked four days for an artist on one project. The artist then filed for unemployment benefits. Not only did the state tax agency determine that the artist was an employee, they also commenced an audit of the artist for three years. The potential liability approached $100,000 and the case took several years to resolve.

The exposure for unintentional misclassification of an employee is serious, but not nearly as serious as the risk for an intentional misclassification. If the misclassification is unintentional, the employer's liability for

income taxes is limited to 1.5 percent of the employee's wages. The employer's liability for FICA taxes that should have been paid by the employee would be limited to 20 percent of that amount. The employer would have no right to recover from the employee any amounts determined to be due to the IRS. Also, the employer would still be liable for its own share of FICA or unemployment taxes. Interest and penalties could be assessed by the IRS, but only on the amount of the employer's liability.

If the misclassification is intentional, on the other hand, the employer can be liable for the full amount of income tax that should have been withheld (with an adjustment if the employee has paid or does pay part of the tax) and for the full amount of both the employer and employee shares for FICA (which might have an offset if the employee paid FICA-self employment taxes). In addition, the employer is liable for interest and penalties. However, the interest and penalties are being computed on far larger amounts than in the case of an unintentional misclassification.

An Ounce of Prevention

After conducting a careful review of how workers should be classified under the IRS's twenty factor control test, an artist may remain uncertain what is correct. A wise approach is certainly to err on the side of caution and classify workers as employees when in doubt.

If the artist believes a worker to be an independent contractor, a carefully worded contract should be executed with that worker. It should be legally binding and accurately set forth the parties' agreement. To be most helpful in the event of an IRS challenge, it must be apparent from the contract that the worker is an independent contractor under the twenty factor test. The contract must then be adhered to by the parties. If an artist has such contracts in place already, they should be reviewed with the IRS test in mind—and whether the parties in fact are following the terms of the contract.

Safe Harbors

The tax law also creates certain safe harbors, areas in which artists can know that their classification practices will stand up to IRS review. Taxpayers must have a reasonable basis for their classification decisions. According to the law, a reasonable basis will be found to exist if the taxpayer made a "reasonable reliance on any of the following: (A) judicial precedent, published rulings, technical advice with respect to the taxpayer, or a letter ruling to the taxpayer; (B) a past Internal Revenue Service audit of the taxpayer in which there was no assessment attributable to the treatment (for employment tax purposes) of the individuals holding positions substantially similar to the position held by this individual; (C) long-standing recognized practice of a significant segment of the industry in which such individual was engaged," or (D) reliance upon some other reasonable basis, such as the advice of a business attorney or accountant who is aware of the specific facts surrounding the business.

So the law, as stated in (A), creates a safe harbor if an IRS determination is made as to the worker's status. If the IRS concluded that a worker was an independent contractor, it would of course be bound by its own determination. While the IRS offices in Washington, D.C., are issuing very few determinations as to status and artists ought not to expect to obtain guidance in this way, the local district offices of the IRS do issue determinations if requested on Form SS-8 with respect to an individual's status. However, the SS-8 is very specific and may not help as to other employees. And, if the individuals have already been employed, sending in the SS-8 may simply be waving a red flag and asking for an audit. Also, neither judicial precedents nor published rulings are offering clear guidelines for artists to follow.

If the artist has been audited before and no employment tax issues were raised as to a worker performing similar tasks to the worker at issue, this will also provide a safe harbor for the artist. However, not every artist is so fortunate as to fall within this safe harbor.

Further, the artist may argue that its treatment conforms to the long-standing recognized practice of a significant segment of the industry in which such individual was engaged. This is an empirical test that is not necessarily nationwide, but can be by industry and locale. Historical practices are established by evidence which may take the form of surveys, affidavits and testimony.

Finally, since the IRS may forgive taxpayers who rely on some "reasonable basis" in making the wrong classification, it is extremely important to seek expert advice when in doubt. Relying on the counsel of a business attorney or tax accountant protects business owners from

the most serious penalties of an IRS reclassification, provided the attorney or accountant examines specific factual details of the business. Again, an ounce of prevention may preclude potentially bankrupting audit.

The focus of the IRS on worker classification raises a baffling problem here. If the safest course is to classify workers as employees (even if they might be independent contractors under the twenty factor control test), is the IRS actually forcing the industry to change its practices? And will this change of practice then be used to defeat artists who seek to assert that their practices are consistent with the practices of a significant segment of the industry?

Also, the safe harbor provisions will not be available at all if the artist is inconsistent in its treatment of workers. If one worker is treated as an employee and a worker performing similar tasks is treated as an independent contractor for the same period, this inconsistency will deny the taxpayer the protection of the safe harbors. If a worker had been treated as an employee in prior years, but in the audit year was doing substantially the same work while being categorized as an independent contractor, this will also smash the artist's safe harbor defense on the reefs of inconsistency.

Another important point is that, regardless of a worker's classification, all required information returns should be filed. The filing of 1099s may aid in arguing that the artist has been consistent in its classification practices. Also, the 1099s will encourage tax compliance by the worker, so that the exposure of the artist will be less in the event the IRS successfully reclassifies the worker.

Interns

A related issue can arise with respect to interns. A number of firms in the creative fields have adopted the practice of using unpaid interns who are either college students or recent graduates. The rationale for not paying wages is that the students are having a learning experience. The students discover the shape of the landscape and feel forced to be acquiescent in order to get started in their profession. Of course, if the firm was a nonprofit, such a failure to pay wages might be acceptable because people often work as volunteers for nonprofits. However, such unpaid work for a profit-making firm raises both moral and legal issues.

The Department of Labor gives guidelines in its *Field Operations Handbook* with respect to whether trainees and student-trainees can be considered not to be employees (in which case no wages would be required). For unpaid interns to be legal, there are six factors that must be met: 1) The training must be similar to that which would be given in a vocational school; 2) The training must be for the benefit of the students; 3) The students must not displace regular employees; 4) The employer must derive no immediate advantages from the activities of students; 5) The students must not be entitled to a job at the end of the training period; and 6) The employer and the student must understand that the student is not entitled to wages.

If the internship does not meet these criteria, then the intern is an employee and subject to minimum wage laws and payroll withholding requirements. The failure to pay minimum wages and withhold properly can violate both state and federal laws and subject the employing firm to substantial liability in the event the employment is discovered by the authorities.

In addition, from a moral standpoint, it is wrong to take the benefit of someone's labor without paying wages. We hardly have to refer to *The Communist Manifesto* to understand that if the intern's work gives value to the employer, then it should be paid for. The fact that students are desperate to get the experience that will allow them to enter their chosen professional field is no reason to take advantage of them. Since hardly any intern fails to do some work of value for his or her employer, unpaid internships should really be the rare exception (perhaps permissible only if course credit is being received by the student) and certainly not the rule.

24 THE ARTIST'S ESTATE

Estate planning should begin during the artist's lifetime with the assistance of a lawyer and, if necessary, a life insurance agent and an officer of a bank's trusts and estates department. Artists, like other taxpayers, seek to dispose of their assets to the people and institutions of their choice, while reducing income taxes during life and estate taxes after death. But artists must take special care with their estate planning because of the unique nature of artworks and the manner of valuing artworks at death for the purposes of determining the value of the estate on which the appropriate estate tax rate will be levied. This chapter cannot substitute for consultation and careful planning with the professional advisors mentioned above, but it can at least alert the artist to matters of importance that will make the artist a more effective participant in the process of planning the estate.

The artworks are unique because they are the creation of the artist and possess aesthetic qualities not found in other goods that pass through an estate. The artist may wish to control the completion, repairs, reproductions, exhibitions, and sales of the works even after death.

Integrity of the Art

David Smith, for example, during his life condemned a purchaser of one of his painted metal sculptures who removed the paint from the sculpture after purchase. Smith branded this "willful vandalism" and considered the work a ruin that he repudiated as "60 lbs. of scrap steel."

Smith, in his will, had carefully selected as his executors the critic Clement Greenberg, the painter Robert Motherwell, and the attorney Ira Lowe. Yet after Smith's death, these executors permitted important changes in some of the works remaining in the estate. *Circle and Box*, a work originally painted white, was stripped and apparently varnished. *Primo Piano III*, also white, was repainted brown. Another work, *Rebecca's Circle*, was permitted to deteriorate and rust.

Unauthorized Reproductions

Another important aesthetic control is that exercised by executors (or beneficiaries, if the copyrights are bequeathed with the works, once the distribution of estate assets occurs) over reproductions of the artist's work. If a painter usually authorized the sale of photographic reproductions of paintings, the executors may confidently continue to do so. Serious questions arise, however, as commercial offers to reproduce and profit from the art reach into areas in which the artist never authorized reproductions. If the painter permitted photographic reproductions, would reproductions on tee shirts, jewelry, plates, or potholders be permissible? The executors are bound to conserve the assets of the estate, so these offers are tempting. Indeed, a failure to accept a lucrative offer might even be argued to be a wasting of the assets of the estate. But the executors must deal as well with the intangible factors of the artist's wishes and reputation.

A not uncommon event is the authorization of reproductions by the beneficiaries who receive the work. For example, the heirs of sculptor Julio Gonzalez allowed posthumous bronze replicas of the sculptures to be cast and sold. Not only had Gonzalez always used iron as the material for his sculptures, but in some cases the bronze replicas were sold without any indication of their being made posthumously. An even more egregious example involved

lithographs supposedly executed by Renoir. The entrepreneur exploiting Renoir's name advertised "authentic Renoir lithographs." The prospectus for purchasers advised:

You have been selected as one of a very limited number of collectors in the United States, South America, and Japan to receive notice of this unique opportunity to possess a Renoir.... Starting with the original lithograph stones left by his grandfather, Paul Renoir...personally supervised every step in the creation of each lithograph (from mixing the colors, to finally embossing the only official Renoir signature and Atelier Renoir Seal).

Each lithograph, priced at $375, was stated to be part of a limited, numbered edition of 250. The United States Attorney intervened, however, and the entrepreneur agreed in a court stipulation to send a letter to all purchasers of the lithographs telling a very different story:

The lithograph you purchased is part of a limited edition of 250 and was authorized by Paul Renoir, grandson of the French Impressionist painter Pierre Auguste Renoir. However, the master himself had nothing to do with its creation. The lithographs are reproductions of oil paintings done by Pierre Auguste Renoir. They were executed in 1972.

The lithographs did not start with original lithographic stones left by Renoir, but rather with paintings never made into lithographs during Renoir's lifetime. Surely an artist has a right to more respectful treatment by those who posthumously wield power over the artist's creations.

To prevent situations such as these from arising, the will of Jacques Lipchitz, for example, provided:

These terra-cotta and plaster models are the prime of my inspiration, my only true original work, and are the most precious property I possess. It is my desire that no reproductions of any sort except photographs be made from said terra-cotta and plaster models.

Exhibitions

Executors must also stand in for the artist by objecting to any exhibition of work the artist would have sought to prevent. Mark Rothko, for example, had strong preferences as to the manner in which his paintings were displayed.

Considering both atmosphere and the placement of paintings important, he canceled a commission to paint murals for the Seagram Building when he learned they were to hang in the Four Seasons Restaurant.

The artist, while alive, can prevent such inappropriate exhibitions or, at least, object to them if the work is owned by another party. But for executors to act as the artist would have in objecting to inappropriate exhibitions of work requires an unusual joining of sensitivity and determination.

Artists and collectors often bequeath art to museums. The reasons for this vary widely: to benefit a worthy institution, to perpetuate the donor's name, and to gain a federal estate tax deduction. If such a bequest is of large magnitude, the museum may accept it despite restrictions which require a certain manner or frequency of exhibition. Thus, the Lehman Collection in The Metropolitan Museum of Art in New York is housed in rooms like those which held the art in the collector's own home, and the collection is always on display.

Others who have given substantial quantities of art have not been as fortunate in having their restrictions observed. Adelaide deGroot, a collector who died in 1967, donated much of her art to The Metropolitan with the express request that any art not kept by The Metropolitan be given to other museums. Correctly interpreting this restriction as merely a wish which was not legally binding, The Metropolitan began selling and trading paintings from the deGroot bequest in the early 1970s. The Metropolitan considered its collection improved by these actions, but the moral issue of violating the intent of the bequest remains.

Museums have even ignored or evaded restrictions that were intended to be legally binding. Another collector, Benjamin Altman, required in his will that The Metropolitan exhibit his bequest in two rooms of suitable size, one room for his Chinese porcelains and the other room for his paintings (which would hang in a single row on the wall, not one above another). No other art would be exhibited in the rooms. Altman stated in his will that the bequest would be forfeited if the restrictions were violated and the art would go to an Altman Museum of Art, for which funds had been set aside. After his death, however, the agreed-upon two rooms

gave way to an arrangement of Altman's art through several galleries. Altman's executors failed to prevent this. Likewise, the executors of the Michael Friedman estate agreed to permit The Metropolitan to disperse his collection throughout the entire museum although the bequest was conditioned on the collection being kept separate and intact.

While in these cases the wishes of collectors were disregarded, the artist bequeathing work to a museum or similar cultural institution is in the same position as the collector. Unless the artist's executors possess both the sensitivity and the will to resist abuse of the artist's intentions, the artist can expect no better treatment than these collectors received. This concern prompted the agreement discussed on pages 240–241 between Hans Hofmann and the University of California regarding the exhibition and disposition of Hofmann's work to be received by the university. Less prominent artists might seek similar understandings with local universities and cultural institutions.

Precipitous Sale of Works

An artist's reputation is often built through a carefully designed program of sales, with both prices and the prestige of the purchasers orchestrated to rise ever higher. Litigation over the Mark Rothko estate revealed that the painter had been extremely concerned with his reputation as an artist. When he died, Rothko owned 798 paintings, many from his early Surrealist period. His decision to own these paintings and sell them gradually, if at all, was a decision of great importance to his reputation. He had, like David Smith, carefully chosen his executors to maintain this course and achieve a balancing of backgrounds and talents: Bernard Reis, an accountant, Theodoros Stamos, a painter, and Morton Levine, an anthropologist.

Yet these executors entered into highly controversial contracts to sell outright to the Marlborough Galleries one hundred paintings for $1,800,000 to be paid over twelve years and to consign to the Marlborough Galleries another 698 paintings at a commission rate of 50 percent, which many people considered too high for works by an artist of Rothko's reputation. Both these contracts were executed only three months after Rothko's death. Not only could this bulk transaction have been interpreted as the executors lacking confidence in Rothko's future reputation and sales potential, but the contracts were also made on very unfavorable terms. Rothko's heirs commenced a complex, bitter, and costly legal struggle, which was joined by the New York Attorney General because a substantial part of the estate had been left to the Mark Rothko Foundation. The court rescinded the contracts and awarded damages of $9,252,000 against the executors, Marlborough Galleries, and the owner of Marlborough Galleries (one of the executors was liable only for the lesser amounts of $6,464,880).

These examples could be multiplied, but their import for the artist is that lifetime planning is a necessity if the artist has concern for the posthumous artistic and financial treatment to which the work passing through the estate will be subject.

The Will

A properly drafted will is crucial to any estate plan. A will is a written document, signed and witnessed under strictly observed formalities, which provides for the disposition of the property belonging to the maker of the will on his or her death. If the maker wishes to change the will, this can be done either by adding a codicil to the will or by drafting and signing a completely new will. If no will is made, property passes at death by the laws of intestacy. These laws vary from state to state, but generally provide for the property to pass to the artist's spouse and other relatives. An administrator, often a relative, is appointed by the court to manage the estate. An artist's failure to make a will concedes that the artist will not attempt to govern the distribution, aesthetic standards, or financial exploitation of the work after death.

A will offers the opportunity to distribute property to specific persons. For artworks, this usually is done by bequest either to specific individuals or to a class. A bequest means a transfer of property under a will, while a gift is used to mean a transfer of property during the life of the person who gives the property. An example of a bequest to a specific individual would be:

I give and bequeath to my son, John Artist, who resides at _____ _____, the oil painting created by me, titled _____ and dated _____, if he should survive me.

An example of a bequest to a class would be:

I give and bequeath to my son, John, my daughter June, and my daughter Mary, or the survivors or survivor of them if any shall predecease me, all my paintings, sculptures and other artworks, except such articles specifically disposed of by Paragraphs _____ of this Will. If they shall be unable to agree upon a division of the said property, my son, John shall have the first choice, my daughter June shall have the second choice, and my daughter Mary shall have the third choice, the said choices to continue in that order so long as any of them desire to make a selection.

Copyrights, of course, can also be willed. For example:

I give and bequeath all my right, title, and interest in and to my copyrights (describe which copyrights) and any royalties therefrom and the right to a renewal and extension of the said copyrights in such works to my daughter June.

The right of termination under the copyright law effective in 1978 provides that the artist's copyrights passing by his or her own will cannot be terminated. Also, the right of termination cannot be passed by will but automatically goes to the artist's surviving spouse, children, and grandchildren.

Use of a will permits: (1) the payment of estate taxes in such a way that each recipient will not have any taxes assessed against the work received, (2) the uninterrupted maintenance of insurance policies for the works, and (3) the payment of storage and shipping costs so the recipient need not pay to receive the work. The estate taxes are usually paid from the residuary of the estate, the residuary being all the property not specifically distributed elsewhere in the will.

Choosing Executors

The will allows an artist to choose the executor or executors of an estate. Since decisions of the executors were the focal points of the controversies as to the alterations of David Smith's work and the sale of Mark Rothko's work, the importance of choosing suitable executors cannot be emphasized too strongly. Yet both Smith and Rothko had chosen as executors men whom the artists knew and trusted and chose in part to achieve a diversity of backgrounds.

Smith chose a critic, an artist, and a lawyer. Rothko chose an anthropologist, an artist, and an accountant. Each estate had, at least in theory, the benefit of both artistic and financial expertise. Yet the failure of the executors to continue dealing with the artworks as the artists would have intended is a warning to every artist, regardless of the size of the estate, who seeks to plan what will become of work after his or her death.

The College Art Association, a national organization with a membership of diverse art professionals, has issued guidelines, applicable to unethical bronze castings, which can be given a wider scope. "Sculptors should leave clear and complete written instructions or put into their wills their desires with respect to the future of their works after their death or in the event of their incapacity to continue working." All artists, as well as sculptors, should take such precautions.

If necessary, the artist's wishes can be written into a will to specify how the artworks are to be repaired, reproduced, exhibited, and sold. This may conflict, however, with the usually desirable practice of giving to the executor the maximum powers for management of the estate. Each estate, whether large or small, will require a decision by the artist as to executors and their powers, based on the unique facts of the artist's own situation. At the least, however, the College Art Association states, "All heirs and executors of the sculptor's estate should be scrupulous in discharging their responsibilities and when necessary consult with experts on such questions as those of new castings," or, it can be added, artistic questions generally.

The executor, especially for a small estate, will often be a spouse or close relative. It is important, however, to be certain that such a person will be capable of making the necessary artistic and financial decisions for the estate. Joint executors, particularly when one is an art expert and the other a financial expert, would seem well suited to run the estate. For example, the determination to sell bronze castings of an iron sculpture is a decision with both artistic and financial implications. The extent to which the artist may safely restrict the discretion of the executors as to artistic matters may depend upon other aspects of the estate, such as whether sufficient funds are available to pay estate taxes and meet the immediate needs of the estate. Only by resolving problems such as

these can the artist be certain the executors will act as the artist would have wished.

Some artists divide the duties between executors, so that one executor handles general financial matters while an Art Executor handles issues pertaining to the art. Because financial and art issues are likely to be woven together in an artist's estate, the duties of the Art Executor have to be carefully delineated, along with specific provisions to resolve disputes between the Executor and the Art Executor. Such a clause might read as follows:

I appoint _____ to be the literary and artistic executor of my estate (hereinafter referred to as my "Art Executor"), to have custody of, act with respect to, and be empowered to make all determinations concerning the use, disposition, retention, and control of the art that I have created or own, my letters, correspondence, documents, private papers, writings, manuscripts, and all other literary and artistic property of any kind created by me, whether or not any such items are unfinished or are completed but not yet divulged to the public.

Although this clause seems to give the Art Executor absolute power over the art, what would happen if the art had to be sold in order to pay taxes? Because this is quite likely to happen, the will should indicate that the Executor's power to gather and dispose of the estate assets takes precedence over the Art Executor's power to decide whether to retain or dispose of art.

Estate Taxes

The will also offers the opportunity to anticipate and control the amount of taxes to be levied by the state and, more importantly, the federal government. Reforms in the tax laws have benefited artists by removing the tax burden from many estates.

If artworks are scattered among a number of states—for example, on long-term museum loans or perhaps long-term gallery consignments—the estate plan can avoid the vexing problem of multiple state estate proceedings by gathering such works in the state where the artist permanently resides. An artist who lives in more than one state may risk having a so-called double domicile and being taxed by more than one state, but careful planning can avoid such a danger.

The artist will also wish to benefit from a number of deductions, discussed below, which can substantially reduce the estate if planned for properly. But tax planning is especially necessary for the artist because artworks are valued at fair market value in computing the artist's gross estate.

Trusts

Trusts are a valuable estate-planning device in which title to property is given to a trustee to use the property or income from the property for the benefit of certain named beneficiaries. Trusts can be created by the artist during life or, at death, by will. Trusts can also be revocable—subject, that is, to dissolution by the creator of the trust—or irrevocable, in which case the creator cannot dissolve the trust. An excellent guide to trusts, including the frequently used living trust, is *Your Living Trust and Estate Plan* by Harvey Platt (Allworth Press). Trusts are frequently used to skip a generation of taxes, for example, by giving the income of a trust to children for their lives and having the grandchildren receive the principal. In such a case, the principal would not be included in the estates of the children for purposes of estate taxation. The tax law, however, severely restricts the effectiveness of generation-skipping trusts and other transfers for a similar purpose.

If the artist is concerned that the recipients, perhaps minor children, will not be in a position to make decisions regarding the art, trusts can be created in order to let the trustees fill this decision-making role. The artist can certainly create a trust (or foundation, as Mark Rothko did in his will) while alive, so that the capacity of the trustees can be evaluated.

The Gross Estate

The gross estate includes the value of all the property in which the artist had an ownership interest at the time of death. Complex rules, depending on the specific circumstances of each case, cover the inclusion in the gross estate of such items as life insurance proceeds, property that the artist transferred within three years of death and in which the artist retained some interest, property over which the artist possessed a general power to appoint an owner, annuities, jointly held interests, and the value of property in trusts.

Valuation

The property included in the artist's gross estate is valued at fair market value as of the date of death or, if so chosen on the estate tax return, as of an alternate date six months after death. Fair market value is the price at which the property would change hands between a willing buyer and a willing seller, if both had reasonable knowledge of relevant facts and were under no compulsion to buy or sell.

Expert appraisers are used to determine fair market value of artworks. But whether an estate is large or small, the opinions of experts can exhibit surprising variations. Because of this, the Internal Revenue Service in 1968 created an Art Advisory Panel, composed of art experts representing museums, universities, and dealers, to determine for income, estate, and gift tax purposes whether or not privately obtained appraisals of fair market value were realistic. While the Panel's reports are only advisory, local IRS district offices tend to consider the reports binding. The success of the Art Advisory Panel led the IRS to create an Art Print Panel in 1980, which operates in a similar manner to the Art Advisory Panel but only deals with art prints.

Estate of David Smith is an example of the extremes that are possible in appraisals of fair market value. When David Smith died at age fifty-nine in an automobile accident, he still owned 425 of his metal sculptures, many of substantial size and weight and located at Bolton Landing, New York. Smith had never had great success financially during his life. He sold only seventy-five works during the entire period from 1940 to his death in 1965. He insisted on maintaining high prices and the size of much of the work also limited possible buyers. In the two years after his death, sales soared and sixty-eight works were sold for nearly $1,000,000.

Smith's executors, in attempting to determine fair market value, first estimated the retail price of each piece individually if sold on the date of death. The total for the 425 works was $4,284,000, which the executors then discounted by 75 percent because any sale made immediately would have to be in bulk at a substantial discount. This figure was further reduced by one-third to cover commissions that would be paid to the Marlborough Galleries. The executors concluded that the fair market value of the 425 sculptures was therefore $714,000. The Internal Revenue Service, however, disagreed that any discounting should be allowed and simply placed a fair market value of $4,284,000 on the works.

The tax court considered numerous factors related to fair market value, such as the market effect of a bulk sale, Smith's growing reputation, the lack of general market acceptance of nonrepresentational sculpture, the quality of the works, sales, prices paid immediately before and after death, and the inaccessibility of the 291 works located at Bolton Landing. Terming its decision "Solomon-like," the tax court found the fair market value of the 425 sculptures to be $2,700,000 as of the date of Smith's death. (*Estate of David Smith*, 57 T.C. 650, *acquiesced in*, I.R.B. 1974-27) This is approximately the figure that would result if the values argued for by the executors and the Internal Revenue Service were added together and then divided in half. This is certainly not scientific, but the artist must prepare for these possible variations in the valuation of the gross estate when attempting to gauge what will be the amount of the estate taxes.

Taxable Estate

The gross estate is reduced by a number of important deductions to reach the taxable estate. The deductions include funeral expenses, certain administrative expenses, casualty or theft losses during administration, debts and enforceable claims against the estate, mortgages and liens, the value of property passing to a surviving spouse subject to certain limitations, and the value of property qualifying for a charitable deduction because of the nature of the institution to which the property is given.

Proper estate planning offers the opportunity to be as certain as possible that expenses, particularly selling commissions for artworks, will be deductible as administration expenses.

The marital deduction offers an important tax advantage. The deduction equals the value of property left to the surviving spouse (provided that the value of the property has also been included in the gross estate). A spouse, especially a wife, is entitled in any case to a share of the deceased spouse's estate by law in most states. In New York, for example, a surviving spouse has a right to one-half of the deceased spouse's estate, but the right is reduced to one-third if there are also surviving

children. The value of property used for the marital deduction must basically pass in such a way that it will eventually be taxable in the estate of the surviving spouse. The marital deduction thus postpones estate taxes but does not completely avoid them.

The charitable deduction is of particular interest to the artist, since this provides the opportunity to give artworks to institutions such as museums or schools that the artist may wish to benefit. The fair market value of such donated works is deducted from the artist's gross estate. A will clause is used stating that if the institution is not of the type to which a bequest qualifying for a charitable deduction can be made, the bequest will be made to a suitable institution at the choice of the executor.

The tax effect of willing a work to a charity is identical to the artist's destroying the work prior to death. If the work is willed to charity, fair market value is included in the gross estate, but the same fair market value is then subtracted as a charitable deduction in determining the taxable estate. But even if the estate tax rate were as high as 55 percent, keeping the work would still pass 45 percent of the value to the recipients under the will.

However, if the estate does not have cash available to pay the estate taxes, charitable bequests may be an excellent way to reduce the amount of the estate taxes. Also, the intangible benefits, including perpetuating the artist's reputation, may well outweigh considerations of the precise saving or loss resulting from such bequests. Once the gross estate has been reduced by the deductions discussed above, what is left is the taxable estate.

Unified Estate and Gift Tax

As this book goes to press, there is confusion about estate taxation. After a number of years in which estates had to be larger and larger to be taxed, in 2010 the estate tax ended entirely—but only for 2010. If nothing is done, in 2011 the size of a taxable estate will go back to what it was before the law was changed in 2001. It appears that neither the Democrats nor the Republicans want this to happen, but the parties disagree as to what should be done. The Democrats would accept the exclusion from taxation of $3.5 million with a top rate of 45 percent, while the Republications might prefer the exclusion to be closer to $5 million with a top rate limited to 35 percent.

It's quite likely that if a new law is enacted in 2010, it will be retroactive to January 1, 2010. This retroactivity may very well be challenged in the courts, leaving the status of many estates in limbo for years. In any event, it's likely that a progressive tax will apply to the artist's cumulated total of taxable gifts and the taxable estate. The progressive rates will rise, perhaps from 18 percent if the cumulated total of taxable gifts and taxable estate is small, to 35 or 45 percent if the cumulated total is over $3,500,000 or perhaps $5,000,000. It should be noted that the federal estate tax is reduced by either a state death tax credit or the actual state death tax, whichever is lesser.

The discussion that follows assumes that an estate tax will exist in the future.

Liquidity

The tax court in *Estate of David Smith* found a fair market value of $2,700,000 for the 425 artworks. As of the date of death, cash available to the estate other than from sales of sculptures amounted to only $210,647. The discrepancy between estate taxes owed, which normally must be paid within nine months of death at the time the estate return is filed, and available cash can plague estates composed largely of artworks.

One of the best ways to have cash available to pay estate taxes is to maintain insurance policies on the life of the artist. The proceeds of life insurance payable to the estate are included in the gross estate. So are the proceeds of policies payable, for example, to a spouse or children if the insured artist keeps any ownership or control over the policies. But policies payable to a spouse or children and not owned or controlled by the artist will not be included in the artist's gross estate. If a spouse or children are the beneficiaries under both insurance policies and the will, they will naturally want to provide funds to the estate to pay estate taxes so that the artworks do not have to be sold immediately at lower prices. The funds can be lent to the estate or used to purchase artwork from the estate at reasonable prices. Such policies should probably be whole or universal life insurance, rather than the less expensive term insurance that may be nonrenewable after a certain age or under certain health conditions. Also, such life insurance may sometimes best be maintained in a life insurance trust, especially if a trustee may have a greater ability than the beneficiaries

to manage the proceeds. This stage of estate planning requires consultation with the artist's attorney and insurance agent to determine the most advisable course with regard to maintaining such life insurance.

Another method for easing estate liquidity problems may be available to an artist's estate. Upon a showing of reasonable cause, the district director may extend the time for payment up to ten years. The interest on such unpaid taxes is adjusted to reflect the current prime interest rate.

Tax deferral may also be achieved under a different provision of the tax law. If more than 35 percent of the adjusted gross estate consists of an interest in a closely held business (such as being the sole proprietor engaged in the business of making and selling art), the tax can be paid in ten equal yearly installments. And, if the executor so elects, the first installment need not be paid for five years. Interest payable on the estate tax attributable to the value of the business property is eligible for special low rates of interest subject to certain limitations.

Gifts

After seeing the tax computations, the artist may decide that it would be advisable to own fewer artworks at death. If the artist makes gifts of artworks while alive, the value of the gross estate at death could be reduced. The incentive for making gifts is a yearly exclusion of $13,000 applicable to each gift recipient. If an unmarried artist in one year gave paintings with a fair market value of $14,000 each to each of three children and two friends, there would be total gifts of $70,000. This gift to each person, however, would be subject to the $13,000 exclusion applied each year to each person to whom a gift is given—one person or a hundred. Thus, the $14,000 gifts to each person would be taxable only to the extent of $1,000. The total taxable amount would, therefore, be $5,000. The artist who can afford gifts should usually take advantage of the yearly exclusions.

If the artist were married rather than single, the artist and spouse could elect to treat all gifts as being made one-half from each. This has the effect of increasing to $26,000 the yearly exclusion for each gift recipient. Also, an artist may generally make unlimited gifts to a spouse without payment of any gift tax.

Gifts must be complete and irrevocable transfers, including transfers in trust, for the benefit of another person or group. Especially if the gift of an artwork is to a family member, every effort should be taken to show a gift has truly been given. This can be done by delivery of the work and execution of a deed of gift. After the gift, the artist must completely cease to exercise control over the work. If, for example, the work is exhibited, the name of the owner should be that of the family member who has received the work, not of the artist. If the artist retains rights, there will not be a valid gift for tax purposes and the value of the work given will be included in the artist's gross estate. Also, the artist should not serve as custodian of gifts given to minor children, since such custodianship will again cause the value of the gift property to be included in the artist's gross estate.

Gift tax returns must be filed on an annual basis. The failure to file a gift tax return can result in assessments of interest, penalties, and, in some cases, even criminal charges.

A factor that might make the artist wary of giving too many artworks as gifts is the elusiveness of financial security and the possibility that an artist's earlier work may be more valuable than later work. Work from the critical period that forged the artist's sensibility and perhaps contributed to the definition of an art movement may prove far more valuable than work done when other new movements have become predominant or the artist has developed a different style. Giorgio de Chirico was acclaimed as a leader in the development of surrealistic art, but his later work never met with as favorable a reception. While early work he no longer owned sold for higher and higher prices, his later style was so unrewarding that he occasionally resorted to imitating his earlier work and misdating the results to his earlier period, creating what were truly self-forgeries.

The artist can also make gifts to charities without having to pay a gift tax. Such gifts may give the artist the opportunity to see if the charities will put the artworks to suitable uses. But charitable gifts have no advantage over charitable bequests under the will in terms of saving estate taxes. After the gift of a work, the artist of course would not own the work at death and its value could not be included in the gross estate. While the value of the same work would be part of the gross estate if owned at death, a charitable bequest would reduce the

gross estate by the value of the work. The taxable estate would be the same in either case. After 1981, both a work of art and its copyright will be considered separate properties for estate and gift tax charitable deductions. So a charitable deduction would be allowed for a work of art given or bequeathed to a charity even if the copyright were not also transferred to the charity.

Deed of Gift

I,_____, residing at _____ being the absolute owner of an artwork titled _____ created by _____ and described as_____ do hereby give, assign and transfer to _____ residing at _____ all of my right, title and interest in and to said artwork, absolutely and forever. It is my intention that this transfer of the above described artwork shall constitute a gift of the same by me to

_____.

IN WITNESS WHEREOF, I have hereunto set my hand and seal with this_____ day of _____, 20____.

Donor _____

Notary public

Basis

The recipient of an artwork as a gift holds the work as ordinary income property and takes the basis of the artist who gave the gift. But a beneficiary who receives an artwork under a will holds the work as a capital asset with a stepped-up basis of the work's fair market value as included in the gross estate. For example, an artist in 2012 created an artwork with a zero basis. If the artwork were given to a daughter, the daughter would have a zero basis and receive ordinary income when she sold the work. If the sale price were $5,000, she would receive $5,000 of ordinary income. On the other hand, if the artist died in 2015 and the work was valued in the estate at $5,000, the daughter who received the work under the will would have a basis of $5,000. So if she sold the work for $5,000, she would not have to pay any tax at all. If she sold the work for $7,500, the tax would only be on $2,500 and at the favorable capital gains rates. This difference in treatment may be an important factor in determining whether to make gifts or bequests. (It should be noted that if the estate tax is not continued for 2010 and years thereafter, which seems unlikely, there would no longer be stepped-up basis and substantial additional income taxes would be collected as assets are sold.)

The Estate Plan

The planning of an artist's estate is a complex task, often requiring the expertise of accountants, insurance agents, and bank officers, as well as that of a lawyer. But an informed artist can be a valuable initiator and contributor in creating a plan that meets both the artistic and financial estate planning needs of the artist.

CHAPTER

25 ARTISTS AND MUSEUMS

Museums in the United States are usually controlled privately by a board of trustees and supported by tax-exempt gifts and endowments. The development of museums coincided with the growth of large industrial fortunes. The patronage of the wealthy has often been critical to the creation and continued vitality of museums. Because of this, many artists feel alienated from the power structures controlling the museums despite their interest in the cultural institutions that preserve art and make it available to the public. Museums must make difficult decisions, such as whether to acquire art obtained illegally in foreign countries or whether to exhibit controversial art, and the advice of artists might be invaluable. But, since the wider spectrum of issues confronting museums has been considered in other sources, this chapter will focus on the artist's specific concerns when either loaning or giving art to museums.

Loans to Museums

The concerns of the artist in lending work are quite similar to the concerns when consigning work (discussed on pages 141–142). The most important assurance is that the work will be returned promptly and in good condition or, if this is not possible, that the artist will be reimbursed for any damage to the work or for the cost of replacement.

If the artist simply lends work to a museum or similar exhibitor without a contract, the museum or borrower will hold the work under a bailment and will have to exercise reasonable care in keeping the work. But since neither the museum nor the artist normally will be satisfied with such an arrangement, the best method of guaranteeing satisfaction to both parties is

insurance. The museum should provide wall-to-wall insurance in the amount specified by the artist as the value of the work. Wall-to-wall insurance takes effect when the work leaves the hands of the artist and lasts until the work is returned to the artist. The lending contract will usually specify that the museum will not be liable for any amount greater than the stated insurance value, which is likely to be less than the artist's valuation of the work.

If the museum or other borrower refuses to provide insurance, the artist should either not lend the work or should insist on a provision making the borrower absolutely liable, regardless of fault, in the event that the work is lost, damaged, or stolen.

But even wall-to-wall insurance or absolute liability may be insufficient to protect an irreplaceable work. Attacks on works in museums—Picasso's *Guernica* and Rembrandt's *Night Watch*, for example—are not uncommon, despite laws penalizing such vandalism. The artist might wish to have certain minimum security precautions specified in the lending contract, regardless of who would have to pay for the work if damaged.

Of course, the lending contract should also specify receipt of specific works described by title, size (and weight for sculpture), and medium. The duration of the loan, and the exact location where the works will be shown, should be included. If work can be sold from the exhibition, as is often the case, the commission rate and other relevant provisions—such as price, time of payment to the artist and risks with regard to the purchaser's credit—should be set forth. Shipment, storage, framing, photography, restoration, and similar costs will each need to be specified.

Artistic control is also an important consideration. The artist's work will be exhibited, but in what manner? Publicity about the artist may accompany the exhibition. Reproductions of the works may be used in catalogs, or even sold as postcards or jewelry. The artist will want to control all of the aesthetic aspects of lending work. Even if the copyright for the work is in the public domain, the artist can fairly demand payments for any commercial exploitation of the work by the museum. Certainly, the artist should expressly condition the licensing of any reproduction right on the affixation of copyright notice in the artist's name on all reproductions. Some remaining uncertainty as to whether a loan to a museum will be a publication suggests that copyright notice should be placed on the work prior to any loan. Also, since the copyright encompasses the right of display (except that the owner of a work may also display it to viewers who are present where the work is), a museum taking art on loan will need the artist's permission to display the art.

Before sending work on loan to other states, the artist should consider whether any creditors in that state might seize the work. The United States has enacted a statute exempting from seizure works on loan from foreign countries, provided certain requirements are met. Following this lead, New York State has enacted a similar provision for works loaned by out-of-state exhibitors to non-profit exhibitions in New York State. But the artist with creditors should exercise caution when loaning work in states without such a statute.

Lastly, the artist might well demand an assurance from the museum that the work in fact will be exhibited for the time specified in the loan contract. This provision, like the others, will be subject to negotiation based on the needs of both the artist and the museum.

Gifts or Bequests to Museums

The artist, either while alive or at death, may want to transfer works to museums and similar cultural institutions. If, however, the artist thought the museum would either deaccession (that is, sell) or never exhibit the work, the artist would undoubtedly reconsider. Museums, on the other hand, are reluctant to restrict their flexibility by accepting works with requirements as to exhibition or restrictions against deaccessioning. The

moral issues, particularly when a will asks for, but does not legally require, a certain course of action with regard to a collection, can be difficult for the museum. If the museum has accepted legal restrictions, in changed circumstances it may go to court to request a different use for the works than the restrictions allow.

A collection of immense value, like that now housed in the Lehman Pavilion at the Metropolitan Museum of Art in New York City, can be used to gain legal guarantees of highly favorable treatment from the museum. Most artists, of course, do not have collections rivaling that in the Lehman Pavilion. However, their collections might be given intact to a smaller museum or cultural institution that would be willing to make concessions in order to receive the work. In this connection, the agreement between Hans Hofmann and the regents of the University of California makes an interesting study.

The Hans Hofmann Agreement

In 1963, Hans Hofmann made an agreement with the regents of the University of California under which he donated certain works to the University of California as a permanent Hofmann Collection to be kept in a separate wing or gallery as a memorial to Hofmann and his wife, Maria.

Hofmann initially transferred an undivided one-half interest in twenty works to the university, and agreed to transfer the same interest in another twenty works of his choosing before December 1, 1968. An agent of Hofmann's selection was appointed with the power to sell those works and raise $250,000 for the university before that date. If, by December 1, 1968, or Hofmann's death, whichever occurred later, $250,000 had not been raised for the university from the sale of forty paintings, Hofmann's estate would pay the balance.

The university in return agreed to expend $250,000 to build the separate wing or gallery for the Hofmann Collection by December 1, 1968. If the wing or gallery were destroyed, the university would be obliged to rebuild it only to the extent of insurance proceeds.

The Hofmann Collection was then specified to consist of thirty-five additional paintings, ten of which were listed in the agreement and twenty-five of which were to be transferred or bequeathed by Hofmann.

The university had the power to accept works transferred and to select from all Hofmann's paintings if the balance of the paintings were bequeathed.

The university agreed to substantial restrictions over what could be done with the works composing the Hofmann Collection. The Hofmann Collection, or a part of the collection, along with other works by Hofmann the university might have, would be primarily exhibited in a separate wing or gallery. Until December 1, 1993, work by persons other than Hofmann could be shown only if the Hofmann Collection were temporarily exhibited at another museum or gallery. After December 1, 1993, the university could retain the entire Hofmann Collection but would only have to exhibit the collection exclusively thirty days during each year.

Alternatively, after December 1, 1993, the university could sell or exchange twenty paintings from the Hofmann Collection and use the proceeds to purchase modern art considered avant garde at that time. The remaining fifteen paintings of the Hofmann Collection would have to be exhibited primarily in the wing or gallery. Primarily is defined as exhibition during a major portion of the calendar year and not being exhibited only when loaned temporarily to another museum or gallery. Thus a balance was struck that guaranteed either the collection of thirty-five paintings would be exhibited one month per year or the collection of at least fifteen paintings would be exhibited during most of the year.

The agreement between Hans Hofmann and the regents of the University of California is a good example of balancing the needs of each party. Hofmann received guarantees that the collection would be exhibited and would not be deaccessioned. The university received the paintings, a new wing or gallery, and the power eventually either to sell part of the collection or to exhibit the entire collection less often. These considerations are typical and the artist giving work to any museum or cultural institution should certainly try to negotiate similar restrictions.

Rights of the Artist in the Museum-Owned Works

The artist who gives or sells work to a museum should treat the museum like any other purchaser. If the artist wishes to retain rights in the work, such as the power to control the manner of exhibition or to repair the work, the contract of sale should so specify. Similarly, if the artist sells the work to any purchaser, these rights must be retained at the time of sale. Otherwise, when a purchaser gives a work to a museum, the museum will own the work without restrictions. In such a situation the museum may exhibit the work with little fear of the artist being able to take successful legal action.

In the 1976 exhibition, "200 Years of American Sculpture," at the Whitney Museum in New York City, for example, both Robert Morris and Carl Andre sought to prevent the Whitney from showing certain works. Morris contended the Whitney was showing a damaged work from its own collection rather than any work submitted for the exhibition. Andre withdrew the work he had submitted on the ground that it was placed next to a bay window and a fire exit. He then sought to purchase for $25,000 the work which the Whitney substituted from its own collection for the exhibition. Andre contended that the substitute piece had been incorrectly installed by placing rubber under copper floor pieces. If the artists had retained rights over their works, these controversies would not have arisen. Today, of course, the Visual Artists Rights Act might offer them legal relief based on their moral rights (see the discussion of VARA at pages 131–132).

Also, the museum will have the power to commercially exploit works that it owns, unless the artist retains the copyright. There is no reason for an artist to sell a copyright to a museum, although the artist might be willing to sell certain rights to make reproductions. Museums will, in any case, often pay royalties or fees for commercial exploitation, although exact payments vary and will be completely within the discretion of the museum if the artist fails to retain the copyright.

CHAPTER

26 THE ARTIST AS A COLLECTOR

The artist often becomes—through trades, gifts, and purchases—a collector of work by other artists. While the collector will often have to know the legal and practical considerations relevant to artists, certain problems are unique to collectors. The following discussion highlights some of the unique areas so that artists who collect will know when legal advice may be helpful.

The Value of Art

Most collectors own art for the sake of enjoyment, but the value of art as a commodity cannot be ignored. The concept of art as an investment has been closely associated with the activities of auction houses such as Christie's and Sotheby's. Auctions often show the public art that has increased fantastically in value.

The prices for art are so high that art thefts and forgeries have become a fact of life in the art world. The illicit trade in art is international and extends to antiquities that are illegally excavated and exported from the countries where ancient cultures flourished. To prevent this illegal antiquities trade, the United States has signed a treaty with Mexico, passed a law affecting numerous Latin American countries, and passed the enabling legislation for the UNESCO Convention on the Means of Prohibiting and Preventing the Illicit Import, Export, and Transfer of Cultural Property. Many of the large cities of Europe now have specialized art crime squads—as does New York City. Interpol, with the assistance of the International Council of Museums, has even gone so far as to create wanted posters of the world's Most Wanted Works of Art.

The response of collectors to this art crime has been varied. Some insure their collections, a definitive but often expensive solution. Others have fakes created that are then substituted for the real works. French collectors can avail themselves of a tower 240 feet high and 180 feet in diameter that is hidden behind the facade of a former bank and can be seen only from the top of the Eiffel Tower. The security includes cameras, special keys, electronic devices, and a tunnel that fills with water and lethal gas.

Art thieves will often offer back the stolen works to the owner and demand a ransom. For example, a collector of rare Russian enamels entrusted them to a New York City storage company before leaving for Europe. When he returned, he found the storage company had, without checking for identification, given the enamels to another person who claimed to be a messenger for the collector. The enamels were valued at $731,000, which the storage company was liable to pay the collector if the enamels couldn't be recovered. The collector advertised that a ransom would be paid and, by paying $71,000, received back almost the entire collection. He then sued the storage company for the $71,000, having saved the company from paying the $731,000. The storage company, however, argued that perhaps no ransom had been paid since the collector refused to disclose the persons through whom he had recovered the enamels. The collector refused such disclosure because he said he had been threatened with death. The New York Court of Appeals upheld a jury verdict for the collector despite this refusal, although the dissenters on the court argued strongly that the payment of such a ransom should be against public policy. (*Kraut v. Morgan & Brother Manhattan Storage Company*, 38 N.Y.2d 445)

The crime problem is not limited to theft. Today, sophisticated forgers create art that accurately mimic the expensive work of more famous artists. Sometimes art of another period may be attributed to an artist rather than the school that surrounded the artist or the period generally in which the artist worked—far more subtle issues. Authentication requires statements by experts who are often reluctant to give opinions because of the risk of being sued for defamation of the artwork should they be incorrect. The most modern scientific techniques are brought to bear on solving authenticity problems, but forgers can rely upon science as well. The collector must be vigilant if art crime is to be avoided.

Purchasing Art

The collector will wish to consult pages 108–109 to determine what warranties are created upon the purchase of an artwork. The purchaser can certainly rely on the fact that the seller has title or the right to convey title in the artwork. For example, in 1932, a couple living in Belgium purchased a work by Marc Chagall for about $150. Forced to flee the German invasion of 1940, the couple found, when they returned six years later, that the painting had disappeared. In 1962, they noticed a reproduction of the painting in an art book indicating the name of the collector who had innocently purchased the work from a New York City gallery in 1955, paying $4,000 for it. The couple sued the collector for the value of the work in 1962—$22,500—or the return of the work. Not only did the couple win, but the collector also successfully sued the gallery for his loss. The gallery, which had received only $4,000 on sale, became liable for $22,500 which could only be recouped, if at all, by bringing suit against a gallery in Paris. (*Menzel v. List*, 24 N.Y.2d 91)

Auctions have become a major force in the art market. Auctions are a process of offer and acceptance through public bidding. If the auctioneer sells art with a reserve price, no offers by purchasers will be accepted which are less than the reserve price. This protects the person who has consigned art to the auctioneer from receiving too low a price. The auctioneer can, therefore, withdraw the art from the bidding at any time if the price is not satisfactory. On the other hand, if the auction is without a reserve price, the auctioneer must accept the highest bid made. The art cannot be withdrawn once the bidding has begun. The purchaser, regardless of whether the auction is with or without reserve, may withdraw a bid at any time prior to the fall of the hammer or other customary completion of the sale.

The collector may be inclined to rely upon the representations made in an auctioneer's catalog. But the Uniform Commercial Code warranties may not be fully effective to protect the collector, particularly since most catalogs contain warranty disclaimers. Also, certain of the representations made in the catalog can be construed merely as puffing—touting a salable item in a way that the purchaser should know not to accept at face value.

In 1962 a doctor paid $3,347.50 to Parke-Bernet for a painting stated in the catalog to be the work of Raoul Dufy. In fact, the work was a forgery. However, the catalog stated that Parke-Bernet disclaimed all warranties and sold any property "as is." The New York Supreme Court held for the doctor, who sought to recover what he had paid. The Appellate Term reversed and held for Parke-Bernet on the rationale that authenticity was a factor in the sale price and the purchaser had the burden to satisfy himself with regard to authenticity (*Weisz v. Parke-Bernet Galleries, Inc.*, 67 Misc.2d 1077, *reversed* 77 Misc.2d 80).

The New York attorney general recommended legislation to rectify this ruling. In 1968, a law passed regulating the "Creation and Negotiation of Express Warranties in the Sale of Works of Fine Art." This law covers any sale by an art merchant, which includes an auctioneer, to a purchaser who is not an art merchant, if a written instrument such as a catalog or prospectus makes representations as to authorship. Such statements as to authorship, even if not stated to be warranties, shall be considered express warranties and a basis upon which the purchaser made a purchase. For example: (1) a work stated to be by a named artist must be by such artist; (2) a work attributed to a named artist means a work of the period but not necessarily by the artist; and (3) a work of the school of the artist means work of a pupil or close follower of the artist, but not by the artist.

An art merchant can disclaim warranties created by this law, but only if the disclaimer satisfies certain conditions. The disclaimer must be conspicuous and written separately from any statements as to authorship. It must not be

general, such as a negation at the beginning of a catalog that all warranties are disclaimed, but must be specific as to the particular work. If a work is counterfeit, defined as fine art made or altered to appear to be by a certain artist when it is not, the fact of the counterfeiting must be conspicuously disclosed. Also, if a work is unqualifiedly stated to be by a given artist, such a statement cannot be disclaimed.

The effect of this New York law is to create valuable protections beyond those contained in the Uniform Commercial Code for purchasers from art merchants. Another New York law enacted in 1969 makes the falsification of a certificate of authenticity punishable as a misdemeanor.

The New York laws are important safeguards for collectors who may be prone to rely too much on statements contained in catalogs or certificates of authenticity. But the absence of such laws in other states, where only the Uniform Commercial Code would govern transactions, is a warning to collectors to exercise caution in the purchase of art. Also, while auctions are subject to some legal regulation, irregular practices such as collusive bidding are reported from time to time. The auction house rules have often become complex as well, so expert advice may be a necessity for the collector buying in the auction market.

Importing Art

The collector who purchases art abroad should be aware that many countries have enacted laws to protect artistic and archeological objects. Italy's law, for example, regulates such objects, but does not apply either to works of living artists or to works created within the last fifty years. Collectors must obtain an export license from the Office of Exportation for items that come within the law. The export license will not be issued if exportation would cause great injury to the national patrimony. The collector must declare the market price of each item, and the Ministry of Education has the power to purchase at that price within two months of the application for an export license. The result is that the collector either may not be allowed to export art from Italy or may find that the Ministry of Education intends to purchase the art for the stated market price. The collector must be aware that these laws, however erratically enforced, exist in most of the nations that possess an abundance of art.

If the art can legally be exported from the nation where purchased, the collector must next consider whether United States custom duties will be payable on the work to be imported. Generally, however, no duties are payable on original works of art, such as paintings, drawings, fine prints (which must be printed by hand from hand-etched, hand drawn, or hand-engraved plates, stones or blocks), sculptures (the original and up to ten replicas), mosaics and works of the fine arts not fitting into the other categories (such as collages). To be eligible for duty-free entry, sculptures must be produced by a professional sculptor, which is defined as someone who has graduated from a recognized school of art or has given public displays of sculpture in exhibitions limited to the fine arts. Because crafts are dutiable, disputes often arise as to whether an object should be classified as art or as craft. The artist who has created work while living temporarily abroad is subject to the same rules as a collector with respect to whether such work can be brought back to the United States without paying duties.

Tax Status of the Collector

A collector may fall into three categories for tax treatment: a dealer, an investor or a hobbyist. Each category has distinctly different tax consequences.

One who very frequently buys and sells artworks will be taxed as a dealer and will receive ordinary income from art sales, rather than the more favorable capital gains. A dealer will be able to deduct all the ordinary and necessary expenses of doing business. (*Hollis v. United States*, 121 F.Supp. 191).

On the other hand, the collector may be an investor in artworks, similar to a person who invests in stocks and bonds. An investor will have capital gains and losses. Ordinary and necessary expenses will be deductible if incurred for the management and preservation of the works, such as insurance and storage costs. However, the investor must own the artworks primarily for profit. In one case, collectors, who kept their collection in their homes and derived personal use and pleasure from the collection, were found not to own the collection primarily for profit (*Wrightsman v. United States*, 428 F.2d 1316). But the alternative of storing art will hardly satisfy most collectors.

The third category, the hobbyist, includes the collector who buys and keeps artworks mainly

for pleasure. Gains on sale will be taxed as capital gains, not ordinary income. But if a capital loss is incurred upon the sale of an artwork, there must be a profit motive for the loss to be deductible. A limited exception to this allows the hobbyist to deduct capital losses up to the amount of capital gains, when the losses and gains result from the same activity (the sale of artworks) during the tax year. Similarly, the expenses of keeping up the collection can be deducted up to the amount of income generated by the collection.

Charitable Contributions

The collector also has an advantage over the artist in the area of charitable contributions, because the collector can deduct either all or part of the fair market value of contributed works of art (fair market value is defined on page 234). However, the tax laws have complex limitations designed to prevent tax abuses of charitable deductions. Taxpayers may only receive a charitable deduction for donations up to a percentage of their contribution base (which is their adjusted gross income with some modifications). The deduction limit is 50 percent of the contribution base for most charities, including a church, hospital, school, museum, publicly supported religious, charitable or similar organization, or certain limited private foundations. The collector must verify whether the organization is exempt and, if so, whether it is a 50 percent organization. The purpose of these limitations is to prevent reducing taxable income to zero through the use of charitable contributions.

If cash is being donated, the full amount is a deduction. However, if the artworks being donated have increased in value, complicated rules regarding the contribution of appreciated property come into play. Basically, these rules reduce the amount that can be taken as a charitable deduction when appreciated work is contributed. Also, the amount of the deduction will be reduced if the artwork that has appreciated in value will not be used for a purpose related to the exempt purpose or function of the organization that receives the donation. A lawyer or an accountant should be consulted to aid in determining the best strategy for charitable contributions involving artworks that have appreciated in value are involved. For any artwork valued at more than $5,000, an appraisal must be obtained and attached to the tax form. It must be made within sixty days of the donation and cannot be done by the person giving the donation, the person who sold the artwork originally, or the institution receiving the work. IRS Publications 526, *Income Tax Deductions for Contributions* and 561, *Determining the Value of Donated Property*, will aid collectors who seek to take advantage of the deduction for contributions.

27 GRANTS AND PUBLIC SUPPORT FOR THE ARTS

The important role of the artist in society raises the issue of what assistance society should appropriately offer to the artist. The legislation creating the National Endowment for the Arts (the "NEA") in 1965 stated:

[T]hat the encouragement and support of national progress and scholarship in the humanities and the arts, while primarily a matter for private and local initiative, is also an appropriate matter of concern for the Federal Government... [and] that the practice of art and the study of the humanities requires constant dedication and devotion and that, while no government can call a great artist or scholar into existence, it is necessary and appropriate for the Federal Government to help create and sustain not only a climate encouraging freedom of thought, imagination, and inquiry, but also the material conditions facilitating the release of this creative talent.

Whether the NEA has created such material conditions is certainly a matter of debate, since most supporters of the arts contend that far more must be done to aid artists than the NEA has achieved. In fact, with the politicization of funding for the NEA and the consequent reduction of its budget, the elusive goal of facilitating creativity appears to farther away rather than nearer.

NEA Funding
The budget for the NEA in 1966, the first year of operation, was $2,500,000. From 1965 through 1968 the NEA made more than 128,000 grants that totaled more than $4 billion. From 1980 to the mid-1990s the NEA budget was in the range of $160 to $180 million, but strong political opposition to the NEA

caused the budget to fall to $99,500,000 for the 1997 fiscal year. Although this enormous cut was mitigated to some degree, the NEA budget for the 2009 fiscal year is only $144.1 million. Taking account of inflation, this is far less than the budgets prior to 1997. Also, this budget has to be allocated among all the arts. In addition, the amount allocated to the visual arts does not go to individual artists, but rather to the official arts agencies of the states and territories as well as to tax-exempt, non-profit organizations. The law requires that the NEA allocate 40 percent of its annual program funds to states and regions. Artists must apply to state and local organizations based on their guidelines for grants.

State and Local Support
The first state arts council was created in 1902, but by 1960 only six councils were in existence. However, the period since 1960, when the New York State Council on the Arts was created, has seen the creation of an arts council in every state and territory. The National Assembly of State Arts Agencies (*www.nasaa-arts.org*) reports that the total of state arts council appropriations for fiscal year 2009 is approximately $328 million and that the state arts councils manage about $412 when additional funds from the NEA and other sources are taken into account. According to Americans for the Arts, for fiscal year 2009 the state arts agencies funded nearly 24,000 projects in over 5,000 communities, often by providing money to local organizations. Of 23,943 grants awarded by states arts agencies, 2,668 were awarded to individual artists. However, grants to local organizations may then be regranted to artists or used for projects involving artists. In

general, individuals receive fellowships, public art commissions, and support to work in schools or other community settings.

One innovative step has been supplied by localities requiring a percentage—usually 1 or 2 percent—of construction funds for government buildings to be used for art. Philadelphia initiated the first "1 percent for art" program in 1959. Baltimore followed in 1964. In 1965, San Francisco enacted even more comprehensive legislation giving its arts commission control over design for all public buildings, regardless of whether they were publicly financed. In 1974, Both Miami and Miami Beach became beneficiaries of a similar program under legislation enacted by Dade County, Florida. In 1972, the federal General Services Administration reinstated a policy of spending one half of a percent of estimated construction budgets on art. Many states have now enacted similar programs, including Alaska, Arkansas, California, Colorado, Connecticut, Florida, Hawaii, Illinois, Iowa, Louisiana, Maine, Massachusetts, Michigan, Minnesota, Montana, Nebraska, Nevada, New Hampshire, New Mexico, North Carolina, Ohio, Oregon, Pennsylvania, Rhode Island, Texas, Utah, Vermont, Virginia, Washington, Wisconsin, and Wyoming.

The Artist in the Great Depression

One model for public support of artists was created in the 1930s when the Great Depression made the precarious profession of the artist even more untenable. The federal government, as part of the overall effort to create work, funded a number of extensive art projects. The first program, created under the Treasury Department, was the Public Works of Art Project lasting from December, 1933 to June, 1934, employing about 3,700 artists without a rigid relief test. The cost was $1,312,000. The next program, also under the Treasury Department, was the Section of Painting and Sculpture which obtained artworks by competitions for new federal buildings. It began in October, 1934, and lasted until 1943, awarding approximately 1,400 contracts costing about $2,571,000. The third program, the Treasury Relief Art Project under the Treasury Department, started in July, 1935, and lasted until 1939. The cost was $833,784 and 446 people were employed, about 75 percent of whom had been on relief.

The final and most important project was the Works Progress Administration's Federal Art Project (WPA) that began in August, 1935, and lasted until June, 1943. The WPA employed more than 5,000 artists at one point, subject to the WPA rules for relief, and had a total cost of $35,000,000. Some of the results of the WPA were: (1) Over 2,250 murals for public buildings; (2) 13,000 completed pieces of sculpture; (3) 100,000 paintings, of which 85,000 were permanently loaned to public institutions; (4) 239,727 prints created from 12,581 original designs; (5) 500,000 photographs; and (6) art centers organized in 103 communities.

The nearly $40,000,000 of federal support spent in the 1930s on the visual arts is of a vastly different magnitude from the support the NEA can now generate. But the WPA suffered from political turmoil, mainly challenges of Communist domination, which even caused some to doubt even the artistic accomplishments and importance of the WPA. If there were a sea change in the contemporary political climate, perhaps the NEA, with increased funding, could use the WPA "as a model for the years ahead, for the artists and the public of tomorrow... for never in the history of any land has so much cultural progress been achieved in so brief at time as in the New Deal years." (Audrey McMahon, "A General View of the WPA Federal Art Project in New York City and State," *The New Deal Art Projects: An Anthology of Memoirs*, pages 75-76)

The need for a model suggests the value of looking to other countries that have created systems to support and encourage the arts and the artist. Two countries—Ireland and Japan—are presented to suggest possible programs that differ from the NEA.

Ireland

In 1969, the year that Irish playwright and novelist Samuel Beckett won the Nobel Prize in Literature, the government of Ireland enacted an unprecedented law designed to give tax relief to artists, composers and writers within the boundaries of Ireland. The minister of finance, in presenting the legislation to the Dail Eireann, stated:

The purpose of this relief is... to help create a sympathetic environment here in which the arts can flourish by encouraging artists and writers to live and work in this country. This

is something completely new in this country and, indeed, so far as I am aware, in the world... I am convinced that we are right in making this attempt to improve our cultural and artistic environment and I am encouraged by the welcome given from all sides both at home and abroad to the principle of the scheme. I am hopeful that it will achieve its purpose.

The legislation completely frees the artist, regardless of nationality, from any tax obligation to Ireland with respect to income derived from art. The main requirement for application is that the artist be a resident of Ireland for tax purposes. Simply explained, this requires the artist to rent or purchase a home in Ireland and work at that home during a substantial part of the year. However, while the residence must be uninterrupted, an artist does not necessarily have to be in Ireland for the entire year. Brief trips back to the United States, for example, would not affect an artist's tax status as a resident of Ireland. Every United States artist should remember, however, that the United States reserves the right to tax its citizens anywhere in the world.

Either a resident or a non-resident artist may apply for the exemption on the grounds that he or she has produced "original and creative work(s) having cultural or artistic merit." The determination of "cultural or artistic merit" is made by the Irish Revenue Commissioners after consultation, if necessary, with experts in the field. Once an artist qualifies, all future works by the artist in the same category will be exempt from Irish tax. The application forms can be obtained from the Office of the Revenue Commissioners, Secretary Taxes Branch, Blocks 8-10, Dublin Castle, Dublin 2, Ireland. For the artist exempt from Irish tax, the sole Irish tax requirement is that a tax return showing no tax due be prepared and filed with the Revenue Commissioners in Dublin.

While this Irish generosity has not created an enormous incursion of foreigners (its intent was more to keep Irish talent at home than to bring foreigners to the Emerald Isle), enough wealthy Brits took up Irish residence for tax avoidance purposes to bring the whole program into question. As a result, the legislation was amended and, starting on January 1, 2007, limits were placed on the ability of high income earners to take these deductions. In any event, while the assistance to the individual artist who comes to or remains in Ireland is certainly valuable, Ireland's hope to create a new Byzantium has yet to be realized.

Japan

Japan has a unique approach under which an organization or individual artist can be registered as a "Living National Treasure." Legislation in 1955 created the National Commission for Protection of Cultural Properties, which can designate people and organizations as living national treasures for their role in aiding and continuing the culture and arts of Japan. Fields where living national treasures have been designated include ceramic art, dyeing and weaving, lacquered ware, metalwork, special dolls, Noh and Kabuki acting, Bunraku puppets, music, dance, singing, and so on.

The Living National Treasures receive a stipend in order to be able to improve their special artistic talent while training students to perpetuate their art form. Since the total annual budget for Living National Treasures is set at 232 million yen (roughly $2.6 million) and each person receives 2 million yen (roughly $22,500), the maximum number of Living National Treasures is limited to 116.

Grants

For the visual artist who considers seeking a grant there are a variety of funding sources, including state arts agencies, private foundations, and prizes and awards.

All fifty states, as well as the District of Columbia, Puerto Rico and the Virgin Islands, have art agencies. The programs and application procedures differ from state to state. Since many state agencies give most of their grants to organizations, individuals seeking grants often must be affiliated with an eligible organization. A listing of the state agencies can be found on the Web site of the National Endowment for the Arts (*www.nea.gov*).

Of the more than 100,000 private foundations in the United States, a relatively small number currently offer support to individual projects. Application procedures vary with each foundation or grant-giving agency. It is important that applicants pinpoint the organization best matched to their qualifications, so careful preliminary research is necessary.

An excellent source of reference for grant seekers is The Foundation Center Network, an independent national service organization that provides authoritative sources of information on private philanthropy. The Foundation Center has its main office at 79 Fifth Avenue, New York, New York 10003. Branch offices are located at 1627 K Street, NW, Third Floor, Washington, DC 20006-1708; 1422 Euclid, Cleveland, Ohio 44115; 50 Hurt Plaza, Suite 150, Atlanta, GA 30303; and 312 Sutter Street, San Francisco, CA 94108. There are also one hundred cooperating library collections, which can be located by calling the following toll-free information number: 1-800-424-9836.

The Foundation Center publishes a number of invaluable books, including The Foundation Directory 2009 and Supplement 2009 which contain listings of grantmakers giving interests, addresses, telephone numbers, financial data, grant amounts, gifts received, plus full application information. Foundation Grants to Individuals is the only publication devoted entirely to foundation grant opportunities for individual applicants. The listings include over 8,300 independent and corporate foundations. In addition, artists can learn about applying for grants in Grantseeking Basics for Individuals. In addition, The Foundation Directory Online and Foundation Grants to Individuals Online allow online access by subscription to this information. The Web site of The Foundation Center is *www.foundationcenter.org*.

The American Council for the Arts, 1 East 53rd Street, New York, N.Y. 10022, has resources available to visual artists seeking grants. Their Web site is at *www.artsusa.org/*. The New York Foundation for the Arts also maintains such resources available via phone at 1-800-232-2789, or on the Internet at *www.artswire.org*.

Awards, Honors, and Prizes (published by Gale Research Company in Detroit) is a two-volume directory of awards for many disciplines, including the visual arts. It describes many different programs that include trophies, medals, scrolls and monetary awards.

Another organization that provides information concerning grants and fellowships is the Grantsmanship Center, P.O. Box 17220, Los Angeles, CA 90017, or on the Internet at *www.tgci.com*. The Center conducts proposal-writing workshops and publishes a quarterly newsletter for public and private nonprofit

organizations. The Center's services, and benefits programs, are designed for organizations, not for individual artists who are working independently.

Grants and Due Process

Controversial art, and controversial legislation, resulted in several court decisions that clarified the due process requirements that apply to grant-making agencies such as the NEA. In 1990, Congress amended the statutory framework governing the NEA by adding the following provision:

None of the funds authorized to be appropriated for the National Endowment for the Arts... may be used to promote, disseminate, or produce materials which in the judgment of the National Endowment for the Arts... may be considered obscene, including, but not limited to, depictions of sadomasochism, homoeroticism, the sexual exploitation of children, or individuals engaged in sex acts and which, when taken as a whole, do not have serious literary, artistic, political or scientific value.

To conform to the law, the NEA added a certification requirement that grant recipients would have to sign in advance in order to receive their grants. The recipients had to certify that the grant would not be used to create and disseminate materials that "in the judgment of the NEA ... may be considered obscene." The legislative restrictions, and the certification requirement, caused a furor in the art world. A number of artists and arts organizations brought lawsuits to challenge the restrictions. The success of these challenges is instructive with respect to the constitutional limitations that apply to agencies giving grants.

In two consolidated cases, *Bella Lewitzky Dance Foundation v. National Endowment for the Arts* and *Newport Harbor Art Museum v. National Endowment for the Arts* (754 F.Supp. 774), the plaintiffs had been awarded grants but refused to sign the certification and, therefore, could not use the grant money. The plaintiffs argued that the law was unconstitutionally vague, since the NEA would be judging what was obscene. The court agreed that the NEA would have no way of applying at least that part of the relevant judicial test for obscenity that requires a determination of varying community standards. If the NEA cannot really determine what is obscene, how can it give clear

guidelines to applicants as to what obscenity is? So requiring the applicants to sign such a certification violates Fifth Amendment due process safeguards, especially in view of the fact that attempts to comply with the certification requirement would have a chilling effect on the freedom of expression safeguarded by the First Amendment.

The defendants tried to argue that the obscenity ban did not violate the Fifth or the First Amendments because the ban was not on expression, but rather was a refusal to subsidize such expression. The court did not accept this argument and observed:

In simple terms, the government may well be able to put restrictions on who it subsidizes, and how it subsidizes, but once the government moves to subsidize, it cannot do so in a manner that carries with it a level of vagueness that violates the First and Fifth Amendments.

In 1991 Congress passed a new law specifying that the courts, not the NEA, would judge the issue of obscenity in the grant-making process and adding a "general standards of decency" test with respect to content. Highly controversial art brought a confrontation under these provisions in *Finley et. al. v. National Endowment for the Arts* (795 F. Supp. 1457). In this case, the appropriate Panel at the NEA recommended that four performance artists should be funded. The Chairman of the NEA, feeling political pressure, made individual calls to poll the NEA Council, which has to approve the Panel's recommendations. After this polling, the Panel's recommendations were not followed and the applications were denied. The four artists then brought legal action against the NEA.

The court reaffirmed that once the government decides to subsidize an activity, it cannot withdraw the subsidy in such a way that free expression is chilled. Beyond this, the NEA had certain guidelines as to how it must approach the making of grants. Plaintiffs' rights might, therefore, have been violated by overturning the Panel's decision to give grants on the basis of political considerations. As the court stated, "Political expediency is neither an express nor implied criterion under the statute for the denial of an NEA grant." Also, the Chairman violated the procedural requirements when he polled the Council, since the

Council should have met as a body to consider the recommendations of the Panel. In addition, the privacy rights of the plaintiffs were violated when the NEA released information from the plaintiffs' application files. Finally, the court concluded:

The decency clause sweeps within its ambit speech and artistic expression which is protected by the First Amendment. The court, therefore, holds that the decency clause, on its face, violates the First Amendment for overbreadth and cannot be given effect.

On appeal before the Ninth Circuit Court of Appeals, the artists won again when the court decided that (1) the First Amendment is violated because utilizing the "decency and respect" clause is viewpoint discrimination, and the NEA fails to "articulate a compelling state interest served by the provision"; and (2) the Fifth Amendment is violated because the clause is unconstitutionally broad, and "decency and respect" are terms that "are inherently ambiguous, varying in meaning form individual to individual." (*Finley v. National Endowment for the Arts,* 100 F.3d 671)

The United States Supreme Court, however, held that taking into consideration the general standard of "decency and respect" was not unconstitutionally vague and did not violate the First and Fifth Amendments. The statutory language merely added some imprecise considerations to an already subjective selection process. The Court observed that, "although the First Amendment certainly has application in the subsidy context, we note that the Government may allocate competitive funding according to criteria that would be impermissible were direct regulation of speech or a criminal penalty at stake. So long as legislation does not infringe on other constitutionally protected rights, Congress has wide latitude to set spending priorities." (*National Endowment for the Arts v. Finley,* 524 U.S. 569).

Microlending: A Local Initiative

Public support for the arts can take forms other than grants. For example, in New Bedford, Massachusetts, the New Bedford Economic Development Council has created a micro loan program for the purpose of helping artists, performers, and creative entrepreneurs.

Modeled on programs that have had success in assisting entrepreneurial activities by poorer

people in Third World Countries, the theory of such loans is that access to a releatively small amount of capital can be a stimulus to entrepreneurial success. The program in New Bedford seeks to assist artists to increase their capacity, open a successful business, expand their retail capabilities, move into a live/work space, purchase equipment, and provide working capital.

The loans are in the range of $5,000 to $35,000 per year with an interest rate based on the prime rate and repayment over a period of one to five years. Collateral (that is, property that will be taken if the loan is not repaid) can be either business or personal assets. To be eligible for a loan, an artist must either live or work in the City of New Bedford.

While the program has not been in existence long enough to judge how valuable it will be for artists, this innovative initiative is exciting because of its potential for artists. Perhaps its imaginative force can be the impetus for communities to explore this and other local programs to benefit artists and, through a greater local presence for art and the economic activity generated by the arts, to benefit the community as well.

28 HOW TO AVOID OR RESOLVE DISPUTES WITH CLIENTS

Artist beware! The warning signs that a client will become problematic vary from the obvious to the subtle. How much more pleasant life would be if an artist could interpret even the subtlest of signs and know the best way to respond. Certainly artists want to accept work that a client offers. Recognizing the warning signs discussed in this chapter may enable the artist to explore further, feel reassured that a potential client will be worthwhile and build the trust that will make for an ongoing relationship. In case the relationship breaks down, this chapter will also investigate mediation, arbitration, small claims court, and how to find a lawyer.

The Semiotics of Clients

One important sign is whether the client has any interest in the success of the artist who will undertake the client's project. If the client, for whatever reason, does not care whether the artist succeeds, the artist may discover that he or she has been set-up for failure.

The tight-lipped client may be one example of the scenario in which failure is made more likely. If the client is grudging in giving the artist the information needed to evaluate the job, the artistic process may very well be uncomfortable. Who knows why the client can't be more forthcoming. It may be internal politics within the client corporation or it may be paranoia. In fact, any signs of paranoia about anything should raise the artist's worry quotient to the point of weighing whether to take the job.

The client who cannot articulate the job at all has to be avoided. A contract is a meeting of the minds, but here one party seems to have no mind to meet. This client may simply accept whatever the artist delivers, but maybe not. It is more likely the artist will never get the job, since the client is on some sort of fishing expedition—perhaps trying to use the artist as a free consultant to flesh out some dimly perceived skeleton of an idea.

The client whose budget is unrealistically low, or who makes other unreasonable demands such as setting impossible schedules, is likely to be impossible to work with. This can be generalized to include clients who don't seem to understand the artistic process and show no willingness to learn about it.

Minds and Meetings

The client who is reluctant to give an artist a written contract or some assurance that the artist's interests are protected may have to be avoided. A written contract is a useful tool to achieve understanding, a meeting of the minds, and to avoid conflict later. At the least, however, the artist should have an advance payment or other indications of good faith and the strong likelihood of payment before starting any work.

A minor point, but not an unimportant one, is for the artist to make sure that the person representing the client is in charge of artistic decisions. If this person is not, the artist may be wasting his or her time. Along these lines, the artist should also make certain that anyone signing a commission contract is authorized to do so.

Another sign is whether the potential client has ever worked with artists before. If the client has not, the danger of a misunderstanding increases. The artist should be cautious if he or she does not know any artist or firm with whom the client has worked. In such a case, the artist

might want to ask for references, although that can be awkward. Also, references may give assurances that the client will pay promptly, but say nothing about other problems that are likely to be encountered in the process of creating the art.

The client might show the artist work done by other artists. If the artist objectively feels the work does not meet even minimal standards for professional quality, beware. The client who has no aesthetic sensibility may prove difficult to work with, although the artist may be able to educate such a client to some degree.

The client who has a big ego, and no aesthetic sensibility, is likely to be beyond educating. One sign of an enlarged ego is the inability to listen. If the client is too busy massaging his or her ego to hear what the artist has to say, trouble lies ahead.

A related problem is the client who has a low regard for artists. This may be an ego problem, or it may simply be a symptom of mental imbalance. In any case, the artist is likely to be unhappy about being treated like a lowly factotum and so should avoid such personalities and their jobs.

In the obvious category of risks are all clients who tell of the tortuous lawsuit still in progress with the last artist that they hired. In fact, if they mention litigation with anyone, beware. Everyone loses in a lawsuit, including the loss of time and legal fees. Most litigants (unless they are completely immoral) sound as if they were wronged and that justice will be served by their winning the lawsuit. If the artist is in doubt, he or she should not sympathize, but simply wish the potential client a pleasant farewell.

Mediation and Arbitration

Of course, even after reading this chapter, it may not be possible to avoid all litigious and otherwise troublesome clients and situations. If an artist has a dispute with a client, there are several steps short of a lawsuit that can be taken, including mediation or arbitration.

In a mediation, parties seek the help of a neutral party to resolve disputes. They are not bound, however, by what the mediator proposes. Arbitration requires that the parties agree to be bound legally by the decision of the arbitration panel. If someone who has lost an arbitration refuses to pay, the arbitration award can be entered in a court for purposes of enforcement.

In New York City the Joint Ethics Committee (JEC) used to offer mediation and arbitration services. The advantage of the JEC was that its mediators and arbitrators were familiar with the practices of the art world.

The best resource currently available is Arts Resolution Services, a national collaborative project funded by the National Endowment for the Arts and several foundations to coordinate alternative dispute resolution and negotiation services for artists around the country. This project, which was started by California Lawyers for the Arts in 1989, works with lawyers for the arts organizations in several states, including New York, Texas, Missouri, and Illinois. The participating organizations provide dispute resolution services for artists and arts organizations. (A complete list of the participating organizations can be obtained from the volunteer lawyers groups listed on page 263.)

The organizations participating in Arts Resolution Services assist in resolving interstate as well as local disputes. "Through the cooperation of the participating organizations, we are now able to help an artist who lives in one state and has a problem with a publisher, gallery, or collaborator in another state," says Alma Robinson, Executive Director of California Lawyers for the Arts. For example, a California photographer who received damaged slides back from a New York publisher worked with the mediation staff at Volunteer Lawyers for the Arts in New York and at California Lawyers for the Arts to resolve the problem. Through their joint conciliation efforts, she received a satisfactory settlement from the publisher.

Mediation is especially useful when the participants have an emotional investment in a project, or an interest in maintaining their relationship in the future. The mediators work to help both sides hear each others concerns and develop a sense of overall fairness. By improving their communication through the mediation process, the participants are often able to continue to work together for their mutual benefit.

In addition to mediation, arbitration is available through Arts Arbitration and Mediation Services, a program that was started by California Lawyers for the Arts in 1980 and is now available through its Santa Monica, Sacramento, and San Francisco offices, or through other arbitration providers such as the American Arbitration Association or JAMS

(*www.jamsadr.com*). An arbitration award may be enforced by a state court.

One advantage of using the programs affiliated with Arts Resolution Services is that the panels of trained mediators and facilitators include artists and arts administrators, as well as accountants, attorneys, and others. To the extent possible, panelists are matched for the technical knowledge of the artists' discipline, as well as for the nature of the legal issues. In addition, fees are tailored according to an affordable sliding scale.

California Lawyers for the Arts encourages artists who are negotiating contracts to consider adding a clause calling for alternative dispute resolution methods in the event of a dispute. A contract might include the following provision: "All disputes arising out of this agreement shall be submitted to mediation through a program participating in Arts Resolution Services (or through a mutually selected mediation service)."

If an artist chooses the arbitration route, such language could specify the following:

All disputes arising out of this agreement shall be submitted to final and binding arbitration. The arbitrator shall be selected in accordance with the rules of Arts Arbitration and Mediation Services, a program of California Lawyers for the Arts. If such services are not available, the dispute shall be submitted to arbitration in accordance with the laws of the State of California. The arbitrator's award shall be final, and judgment may be entered upon it by any court having jurisdiction thereof.

Alternatively, the artist may choose to use the American Arbitration Association, or another arbitration provider. If this is done, the artist might review this specific language to see if the arbitration provider would prefer to use other rules or state laws. For example, if the American Arbitration Association is selected, the language would be changed as follows: "All disputes arising under this Agreement shall be submitted to binding arbitration before the American Arbitration Association in the following location _____ and settled in accordance with the rules of the American Arbitration Association." The American Arbitration Association's Web site (*www.adr.org*) provides additional information about its services.

Since it might be easier to go to small claims court for amounts within the small claims jurisdictional limit, the following clause might be added at the end of the arbitration provision: "Notwithstanding the foregoing, either party may refuse to arbitrate when the dispute is for a sum of less than $_____." The amount of the small claims limit in the parties' local jurisdiction would be inserted as the dollar amount. This should be decided on a case-by-case basis. If the small claims court in the artist's area is quick and inexpensive, it may preferable to sue there for any amount up to the maximum claim allowed in small claims court.

In some cases, artists have chosen to use mediation first, and if that is not successful, go to binding arbitration. Through this "med-arb" alternative, there is a remedy available if the problem is not resolved voluntarily through mediation.

Nor should any party fear that they will face a hostile arbitration panel. While arbitration is more like being in court than mediation, most arbitration procedures allow for a method by which both sides can avoid or remove arbitrators who they feel might be biased in some way. The savings on legal fees can be enormous. For amounts above the small claims court limit and less than $10,000, it is very difficult to bring a lawsuit because of the likelihood that lawyers' fees will devour any damages that are won (or devour the litigants' savings if the case is lost). An agreement to arbitrate ensures that justice can be pursued in disputes involving amounts in this problematic range.

Collections and Small Claims Court

Sending out an invoice is usually followed by payment. In some cases, however, the client either makes partial payment, places restrictions on the check used for payment, or refuses to pay at all. In such a situation, the artist should first determine whether the client has a legitimate grievance. If the grievance is legitimate, the amount billed in the invoice might be reduced. If the grievance is not legitimate or if the client is simply refusing to pay, the artist will have to take steps to collect the invoiced amount.

A client may sometimes pay a partial amount and mark the check "paid in full." Or a client may write on the back of a check that the assignment was done as work for hire and

signing the check is to serve as a signed contract for copyright purposes. The best course of action in such cases is to return the check and receive a check in full payment without any restrictive statements on it. If the artist is pressed for funds and reluctant to return the check, it would be wise to consult an attorney before crossing out anything or cashing the check. The client's refusal to pay properly is a breach of contract that can be the basis for a lawsuit.

Before suing, of course, the artist will try to collect the money owed by persuasion and persistence. Suing will involve time, energy and expense on the artist's part, not to mention the almost certain loss of the client. Collection procedures begin gently, often by sending a second invoice stamped "Past due" and then sending a pleasant letter directing the attention of the client to the overdue invoice. This may be followed by a phone call asking for an explanation of the failure to pay. If it seems the client does not plan to pay, the artist can build pressure through repeated e-mails, letters, telephone calls, faxes, registered letters, threats to report the client to a credit bureau or to use a collection agency or attorney to collect, and finally turning the claim over to a collection agency or attorney. It is worth noting that a collection agency can do no more than the artist can, so such agencies (which charge 25 to 50 percent of the amount collected) should only be used when the artist is unwilling to devote time and energy to collections.

Instead of turning the claim over to a lawyer, the artist may choose to sue in small claims court. Such courts provide an avenue for the inexpensive resolution of disputes, especially when the artist is only seeking to collect amounts up to several thousand dollars. The amount that can be sued for in small claims court varies from locality to locality in a range of approximately $3,000 to $10,000. Since the maximum limit will often be more than the amount in dispute, small claims courts can be a helpful resource. A call to the local bar association or courthouse will provide the relevant information as to the location of the small claims court, which in turn can advise as to local procedures. Of course, going to small claims court will deprive the artist of the opportunity to be heard by his or her peers.

Retaining a Lawyer

If the artist decides to retain a lawyer to handle the case, pages 105 may be consulted with respect to how to find an attorney who will be familiar with the issues that artists are likely to face.

APPENDICES

Artists' Groups and Organizations for the Arts

Along with federal, state, and local governmental agencies that provide programs supporting individuals and groups in the arts, the following is a small sample of national and local service and membership organizations for the visual artist. The reader is advised to consult local directories for similar groups or chapters of national groups in their geographical area.

ADVERTISING PHOTOGRAPHERS OF AMERICA (APA),

560 4th Street, San Francisco CA 94107; *www.apanational.com/*. The purpose of APA national is to promote high professional standards and ethics and to communicate and exchange information among APA chapters, APA chapter members and APA members-at-large. APA national works toward the advancement of advertising and commercial photographers by exchanging information and ideas, resolving common problems, and strengthening the relationships between photographers, advertising agencies, clients, and suppliers. All APA chapters and APA national are independently managed and funded.

ADVERTISING PHOTOGRAPHERS OF NEW YORK, INC. (APANY),

27 West 20th Street, New York, NY 10010; *newyork.apanational.com*. APANY began as Advertising Photographers of America, Inc. (APA) in 1981 and became APNY in 1990. A professional trade association, APANY promotes the highest standards of business practice within the industry. Benefits include theAPA Business Manual, a monthly newsletter, free legal consultation, group medical insurance, group disability income, auto and home insurance discounts, seminars, competitions, and workshops.

ALLIANCE OF ARTISTS' COMMUNITIES,

255 S Main Street, Providence, RI 02903; *www.artistcommunities.org/*. The Alliance of Artists Communities is an international association of more than 1,000 community and residency programs worldwide that support artists of any discipline in creating new work. The Alliance advocates on behalf of artists' communities to funders, policymakers, researchers, and the public; holds an annual conference; and maintains online resources.

ALLIANCE OF PROFESSIONAL ARTISTS (APA),

1500 Park Center Drive, Orlando, FL 32835; *www.allproartists.org*. APA is a national organization committed to supporting and educating art-driven individuals and groups and serving as an advocate for the art community. Members receive a subscription to *Art Calendar*, a business magazine for visual artists, and resources such as sample resumes, artist statements, educational webinars, and a monthly e-newsletter. Members also have access to art supply and book discounts, as well as discounted health and life insurance.

AMERICAN CENTER FOR DESIGN (ACD),

325 West Huron, Suite 711, Chicago, IL 60610. ACD is a national organization of more than two thousand design professionals, educators, and students. The ACD is committed to connecting its members to each other and to the research, ideas, and technologies that are

continually shaping, reshaping, and influencing design and design practice. In addition to promoting excellence in design education and practice, ACD serves as a national center for the accumulation and dissemination of information regarding design and its role in our culture and economy.

AMERICAN CRAFT COUNCIL (ACC),

72 Spring Street, 6th floor, New York, NY 10012-4019; *www.craftcouncil.org*. A national, nonprofit educational membership organization founded in 1943 by Aileen Osborn Webb. The mission of the council is to foster an environment in which craft is understood and valued. Membership in the Council is open to all. Professional membership is open to crafters and owners of craft galleries. The council produces craft shows in nine locations that are open to the public and three locations that are open to the trade. The Council publishes the bimonthly magazine, *American Craft*. The council also maintains a special library containing a comprehensive collection of print and visual information on 20th century American fine craft, with an emphasis on the post-war period since 1945. Library staff can assist research efforts in person, by mail, e-mail, telephone, and facsimile. Other Council activities include workshops, an annual awards ceremony, and a grant program.

THE AMERICAN INSTITUTE OF GRAPHIC ARTS (AIGA),

164 Fifth Avenue, New York, NY 10010; *www. aiga.org*. Founded in 1914, the AIGA is the national, nonprofit organization of graphic design and graphic arts professionals with forty-two chapters nationwide. Members of the AIGA are involved in the design and production of books, magazines, periodicals, film and video graphics, and interactive multimedia as well as corporate, environmental, and promotional graphics. The AIGA national and chapters conduct an interrelated program of competitions, exhibitions, publications (including an annual of graphic design and a quarterly journal), and educational activities and projects in the public interest to promote excellence in, and the advancement of, the graphic design profession. The Institute holds a biennial design conference and a biennial business conference. The AIGA has over 22,000 members.

AMERICANS FOR THE ARTS,

1 East 53rd Street, 2nd floor, New York, NY 10022; *www.americansforthearts.org*. Americans for the Arts offers multilayered programs in arts education and in the study and application of arts policy; publishes books, reports and periodicals; maintains a clearinghouse of public arts policy; encourages and supports private sector initiatives for increased giving to the arts; advocates before Congress for legislation benefitting the arts; disseminates information to improve artists' living and working conditions; conducts research, organizes conferences and public forums; and sponsors and administers such prestigious programs as the Visual Artist Information Hotline (1-800-232-2789), the annual Nancy Hanks Lecture on Arts and Public Policy, and Arts Advocacy Day.

AMERICAN SOCIETY OF MEDIA PHOTOGRAPHERS (ASMP,

formerly American Society of Magazine Photographers), 150 North Second Street, Philadelphia, PA 19106; *www.asmp.org*. This organization, with thirty-nine chapters throughout the country, promotes the photographic profession through advocacy, education, and information exchange on rights, ethics, standards, and business practices. Its services include publications, insurance, surveys, member support with clients, business counseling, and marketing assistance.

AMERICAN SOCIETY OF PICTURE PROFESSIONALS (ASPP),

117 S. Saint Asaph Street, Alexandria, VA 22314; *www.aspp.com*. The ASPP has a wide membership base and a number of chapters that include photographers, stock agencies, researchers, and buyers. The organization publishes a quarterly magazine, the *Picture Professional,* a newsletter, an annual directory, and provides a job posting service for members on its Web site.

ART DEALERS ASSOCIATION OF AMERICA (ADAA),

205 Lexington Avenue, Suite #901, New York, NY 10016; *www.artdealers.org*. Representing over 170 established galleries, its general purposes are to promote the interests of individuals and firms dealing in works of fine art and to enhance the confidence of the public

and the government in responsible fine arts dealers. The ADAA appraises works of fine art that are donated to museums or other not-for-profit organizations when an appraisal is needed for income tax purposes. Other activities include a series of seminars held at the Metropolitan Museum of Art in October and the Art Show, a major art fair held in New York City each year.

ART DIRECTORS CLUB, INC. (ADC),
106 West 29th Street, New York, NY 10001; *www.adcglobal.org*. Established in 1920, the Art Directors Club is an international nonprofit membership organization for creative professionals, encompassing advertising, graphic design, new media, photography, illustration, typography, broadcast design, publication design, and packaging. Programs include publication of the Art Director's Annual, a hard cover compendium of the year's best work compiled from winning entries in the Art Directors Annual Awards. The ADC also maintains a Hall of Fame, ongoing gallery exhibitions, speaker events, portfolio reviews, scholarships, and high school career workshops.

ART INFORMATION CENTER (AIC),
55 Mercer Street, 3rd Floor, New York, NY 10013. The AIC is a nonprofit organization that offers a consultation service to help artists determine which New York galleries would be most suitable for their work.

ARTISTS FOUNDATION (AF),
516 East 2nd Street, #49, Boston, MA 02127; *www.artistsfoundation.org*. Incorporated in 1973, the Foundation arranges artist-initiated projects in collaboration with the state, corporations, or other organizations. Artists submit ideas—usually for public artwork—that can be produced in collaboration with another organization. The Foundation mostly serves artists in Massachusetts.

ARTISTS RIGHTS SOCIETY (ARS),
536 Broadway, 5th Floor, New York, NY 10012; *www.arsny.com*. ARS is a copyright collective whose membership includes prominent 20th Century artists such as Pablo Picasso, Mark Rothko, and Andy Warhol. ARS provides liaison services to those who wish to reproduce artworks in printed and electronic media, as well as in products based on an artist's work. ARS protects members from piracy, illicit use, and copyright infringement by monitoring use and also provides reputable publishers and producers of commercial goods with a one-step clearing house for rights and permissions.

ATYPI (ASSOCIATION TYPOGRAPHIQUE INTERNATIONALE),
ATypI Secretariat and Conference Office, 6050 Boulevard East, Suite 17E, West New York, NJ 07093; *www.AtypI.org*. This is the premier worldwide organization dedicated to type and typography. Founded in 1957, ATypI provides the structure for communication, information, and action among the international type community.

ASSOCIATION OF PROFESSIONAL DESIGN FIRMS (APDF),
450 Irwin Street, San Francisco, CA 94107; *www.apdf.org*. APDF is dedicated to elevating the standards of design and professional practice for design consulting firms.

THE BUSINESS COMMITTEE FOR THE ARTS,
1775 Broadway, Suite 510, New York, NY 10019; *www.bcainc.org*. This is the first and only national, not-for-profit organization of business leaders committed to supporting the arts and to encouraging new and increased support to the arts from the American business community.

CHICAGO ARTISTS' COALITION (CAC),
1550 North Damen Avenue, Suite 201, Chicago, IL 60622; *www.chicagoartistscoalition.org*. The Coalition is an artist-run, service organization for visual artists. Services include a newsletter, alternative exhibition opportunities, professional development workshops, art supply store discounts, and a Coalition Gallery.. CAC offers student, senior citizen, individual, and family memberships.

DESIGN MANAGEMENT INSTITUTE (DMI),
29 Temple Place, 2nd floor, Boston, MA 02111; *www.dmi.org*. Founded in 1975, the Design Management Institute has become the leading resource and international authority on design management. DMI has earned a reputation

worldwide as a multifaceted resource, providing invaluable know-how, tools and training through its conferences, seminars, membership program, and publications. DMI is a nonprofit organization that seeks to heighten awareness of design as an essential part of business strategy.

DESIGN STUDIES FORUM (DSF);

www.designstudiesforum.org. Design Studies Forum is a College Art Association Affiliated Society. Founded as Design Forum in 1983 and renamed in 2004, Design Studies Forum seeks to nurture and encourage the study of design history, criticism, and theory and to foster better communication among the academic and design communities. DSF's 350+ members include practicing designers, design historians/critics, and museum professionals. For information about membership and DSF's electonic announcement list, please visit the Web site.

THE FOUNDATION CENTER,

79 Fifth Avenue, New York, NY 10003, *www.foundationcenter.org*. The Foundation Center Network is an independent national service organization which provides authoritative sources of information on private philanthropic giving. There are Foundation Centers in New York City, Washington, D.C., Cleveland and San Francisco, with over one hundred cooperating library collections. Toll-free information at 1-800-424-9836 will provide locations.

GRANTSMANSHIP CENTER,

P.O. Box 17220, Los Angeles, CA 90017; *www.tgci.com*. The Center conducts proposalwriting workshops throughout the United States and produces publications on funding for nonprofit organizations, including a newsletter, *Centered*, which is free to public and private nonprofit organizations. Their services are generally designed for use by organizations, not individual artists.

GRAPHIC ARTISTS GUILD (GAG),

32 Broadway, Suite 1114, New York, NY 10004; *www.graphicartistsguild.org*. This national organization represents artists active in illustration, graphic design, textile and needle art design, computer graphics, and cartooning. Its purposes include: to establish and promote ethical and financial standards, to gain recognition for the graphic arts as a profession, to educate members in business skills, and lobby for artists' rights legislation. Programs include: group health insurance, newsletters, publication of the handbook *Pricing and Ethical Guidelines*, legal and accounting referrals, artist-to-artist networking, and information sharing.

INTERNATIONAL COUNCIL OF GRAPHIC DESIGN ASSOCIATIONS (ICOGRADA),

Icograda Secretariat, 455 Saint Antoine Ouest, Suite SS 10, Montréal, Québec, Canada H2Z 1J1; *www.icograda.org*. Icograda is the professional world body for graphic design and visual communication. Founded in London in 1963, it is a voluntary coming together of associations concerned with graphic design, design management, design promotion, and design education. Icograda promotes graphic designers' vital role in society and commerce. Icograda unifies the voice of graphic designers and visual communication designers worldwide.

INTERNATIONAL SCULPTURE CENTER,

19 Fairgrounds Road, Suite B, Hamilton, NJ 06819; *www.sculpture.org*. Devoted exclusively to contemporary sculpture, the Center publishes *Sculpture* magazine, holds International Sculpture annual conferences, symposia, workshops, has student membership rates, group rates on insurance, and maintains a resource directory.

LOWER MANHATTAN LOFT TENANTS ASSOCIATION (LMLT),

P.O. Box 276, New York, NY 10018; *www.lmlt.org*. LMLT is a volunteer organization which provides a clearinghouse for information about the loft situation, periodicals, public meetings, housing clinics, and legal referrals. LMLT holds a housing clinic, providing one-on-one counseling, every Wednesday at locations to be determined by calling the hotline at 212-539-3538.

NATIONAL ASSEMBLY OF STATE ARTS AGENCIES (NASAA),

1029 Vermont Avenue, NW, 2nd Floor, Washington, DC 20005; *www.nasaa-arts.org/*. The NASAA is a nonprofit organization that serves fifty-six states and jurisdictions that

have created agencies to support the arts. The mission of NASAA is to strengthen state arts agencies.

NATIONAL ASSOCIATION OF SCHOOLS OF ART AND DESIGN (NASAD),

11250 Roger Bacon Drive, Suite 21, Reston, VA 20190; *www.nasad.arts-accredit.org/*. The major responsibilities of the Association are the accreditation of postsecondary educational programs in art and design, and the establishment of curricular standards and guidelines.

NATIONAL PRESS PHOTOGRAPHERS ASSOCIATION (NPPA),

3200 Croasdaile Drive, Suite 306, Durham, NC 27705; *www.nppa.org*. The NPPA membership services include major medical and equipment insurance as well as a variety of publications. The NPPA offers student, professional, and international memberships.

NATIONAL SCULPTURE SOCIETY,

75 Varick Street, 11th Floor, New York, NY 10013; *www.nationalsculpture.org*. National Sculpture Society was founded in 1893 and is dedicated to the support of figurative sculpture through exhibitions, publications, and education. Publishes quarterly *Sculpture Review* and a bimonthly online journal for members.

NEW YORK ARTISTS EQUITY ASSOCIATION, INC.,

498 Broome Street, New York, NY 10013; *www.anny.org*. This service organization representing professional visual artists was formed to further the economic, cultural, and legislative interests of artists. Services available include: health insurance and dental plans, term life insurance, newsletter, contract forms, legal information, legislative advocacy, and cultural programs.

NEW YORK FOUNDATION FOR THE ARTS (NYFA),

20 Jay Street, 7th Floor, Brooklyn, NY 11201; *www.nyfa.org*. NYFA enables contemporary artists to create and share their works and provides the broader public with opportunities to experience and understand the arts. The Foundation accomplishes this by providing responsive leadership and advocacy, offering financial and informational support, and building collaborative relationships with others who

are committed to the arts in New York and throughout the United States.

ORGANIZATION OF BLACK DESIGNERS (OBD),

300 M Street, SW, Suite N110, Washington, DC 20024-4019; *www.obd.org*. The OBD is a non-profit national professional association dedicated to promoting the visibility, education, empowerment, and interaction of its membership and the understanding and value that diverse design perspectives contribute to world culture and commerce. The Organization of Black Designers (OBD) is the first national organization dedicated to addressing the unique needs of African-American design professionals. The OBD membership includes over 3,500 design professionals practicing in the disciplines of Graphics Design/Visual Communications, Interior Design, Fashion Design, and Industrial Design.

THE ORGANIZATION OF INDEPENDENT ARTISTS (OIA),

419 Lafayette Street, 2nd floor, New York, NY 10003; *www.oia-ny.org*. Founded in 1976 as a grass roots movement among artists, OIA turned a federal mandate encouraging the use of government buildings for cultural and educational activities into an innovative resource for visual artists' exhibitions. The OIA sponsors artist-curated shows in public spaces and maintains an extensive artist's resource center.

PHILADELPHIA/TRI-STATE ARTISTS EQUITY ASSOCIATION, INC.,

22 Laurelgate Place, Millersville, PA 17551; *www.artistsequity.org*. Artists Equity works to establish fair guidelines for juried exhibitions and clear documentation for original prints and reproductions. Services include: newsletters, networking opportunities, and programs cover topics from copyright law to conservation techniques.

PICTURE ARCHIVE COUNCIL OF AMERICA (PACA),

23046 Avenida de la Carlota, Suite 600, Laguna Hills, CA 92653; *www.pacaoffice.org*. PACA's goal is to develop uniform business practices within the stock picture industry based upon ethical standards established by the Council. PACA serves member agencies, their clients, and their contributing photographers

and illustrators by promoting communication among picture agencies and other professional groups. Through these improved channels of communication, the Council hopes to make available information necessary to improve and protect the business of its members. An annual directory of the membership is available.

PROFESSIONAL PHOTOGRAPHERS OF AMERICA (PPA),

229 Peachtree Street, NE, Suite 2200, Atlanta, GA 30303; *www.ppa.com*. PPA publishes *Professional Photographer*. PPA offers a variety of memberships for photographers of various specialties, including portrait, wedding, industrial, and specialist categories.

THE SOCIETY FOR ENVIRONMENTAL GRAPHIC DESIGN (SEGD),

1000 Vermont Ave., NW, Suite 400, Washington, DC 20005; *www.segd.org*. An international, nonprofit organization founded in 1973, SEGD promotes public awareness and professional development in the field of environmental graphic design—the planning, design, and execution of graphic elements and systems that identify, direct, inform, interpret, and visually enhance the built environment. The network of over one thousand members includes graphic designers, exhibit designers, architects, interior designers, landscape architects, educators, researchers, artisans, and manufacturers. SEGD offers an information hotline, job bank, bimonthly newsletter, quarterly journal, information clarifying the Americans with Disabilities Act as it pertains to signage, an annual competition and conference, and more than thirty regional groups that help connect people working in the field and offer a variety of tours, demonstrations, and meetings.

SOCIETY FOR NEWS DESIGN (SND),

424 E. Central Blvd. Suite 406, Orlando, FL 32801; *www.snd.org*. SND is an international professional organization with more than 2,600 members in the United States, Canada, and more than fifty other countries. The membership is comprised of editors, designers, graphic artists, publishers, illustrators, art directors, photographers, advertising artists, Web site designers, students, and faculty. Membership is open to anyone with an interest in journalism and design. Activities include annual newspaper design workshop and exhibition, quick courses, the Best of Newspaper Design Competition, and publications including the quarterly magazine *Design* and the monthly newsletter *SND Update*.

SOCIETY FOR PHOTOGRAPHIC EDUCATION (SPE),

2530 Superior Avenue, #403, Cleveland, OH 44114; *www.spenational.org*. SPE is a nonprofit organization that seeks to promote a broader understanding of photography in all its forms. Membership benefits include: an annual, four-day national conference, a journal and newsletter, a resource guide and membership directory, membership in one of eight regional organizations, job and exhibition listings, and more.

SOCIETY OF ILLUSTRATORS (SI),

128 East 63rd Street, New York, NY 10021; *www.societyillustrators.org*. Founded in 1901 and dedicated to the promotion of the art of illustration, past, present, and future. Included in its programs are the Museum of American Illustration; annual juried exhibitions for professionals, college students, and children's books; publications; lectures; archives and library. SI also sponsors member exhibits in one-person and group formats, and government and community service art programs. Membership benefits are social, honorary, and self-promotional, and include Illustrator, Associate, Friend, Student, Educator, and more options.

SOCIETY OF PHOTOGRAPHER AND ARTIST REPRESENTATIVES (SPAR),

630 9th Avenue Suite 707, New York, NY 10036; *www.spar.org*. SPAR was formed in 1965 for the purposes of establishing and maintaining high ethical standards in the business conduct of representatives and the creative talent they represent as well as fostering productive cooperation between talent and client. This organization runs speakers' panels and seminars with buyers of talent from all fields, works with new reps to orient them on business issues, offers model contracts, and offers free legal advice. Categories for members are regular (agents), associates, and out-of-town. Publishes a newsletter.

SOCIETY OF PUBLICATION DESIGNERS (SPD),

27 Union Square West, Suite 207, New York, NY 10003; *www.spd.org*. Begun in 1964, the SPD was formed to acknowledge the role of the art director/designer in the creation and development of the printed page. The art director as journalist brings a visual intelligence to the editorial mission to clarify and enhance the written word. Activities include an annual exhibition and competition, five blogs, special programs, lectures, and the publication of an annual book of the best publication design.

VISUAL ARTISTS AND GALLERIES ASSOCIATION, INC. (VAGA),

350 5th Avenue, Suite 2820, New York, NY 10118; *www.vaga.org*. VAGA is a copyright collective formed in 1976 to administer and protect reproduction rights. VAGA seeks to ensure that an artistic work is licensed before it is reproduced and that for every use an appropriate fee is paid to the creator. VAGA maintains a slide library and a legal hotline to provide advice concerning copyright and artists' rights issues.

VOLUNTEER LAWYERS FOR THE ARTS (VLA),

1 East 53rd Street, 6th floor, New York, NY 10022; *www.vlany.org*. VLA is dedicated to providing free arts-related legal assistance to low-income artists and not-for-profit arts organizations in all creative fields. Five hundred plus attorneys in the New York area annually donate their time through VLA to artists and arts organizations unable to afford legal counsel. VLA also provides clinics, seminars, and publications designed to educate artists on legal issues that affect their careers. California, Florida, Illinois, Massachusetts, and Texas, to name a few, have similar organizations. Check "Lawyer" and "Arts" phone directory listings in other states.

WEDDING AND PORTRAIT PHOTOGRAPHERS INTERNATIONAL (WPPI),

6059 Bristol Parkway, Suite 100, Culver City, CA 90230; *www.wppionline.com*. WPPI publishes a monthly newsletter, has print competitions, and sponsors an annual convention.

SELECTED BIBLIOGRAPHY

The American Institute of Graphic Arts (AIGA). *AIGA Professional Practices in Graphic Design.* 2nd ed. New York: Allworth Press, 2008.

The American Society of Media Photographers (ASMP). *ASMP Professional Business Practices in Photography.* 7th ed. New York: Allworth Press, 2008.

Associated Councils of the Arts; The Association of the Bar of the City of New York; and Volunteer Lawyers for the Arts. *The Visual Artist and the Law.* 1st Rev. ed. New York: Praeger Publishers, 1974.

Basa, Lynn. *The Artist's Guide to Public Art.* New York: Allworth Press, 2008.

Battenfield, Jackie. *The Artist's Guide: How to Make a Living Doing What You Love.* Cambridge, MA: Da Capo Press, 2009.

Brinson, J. Dianne, and Mark F. Radcliffe. *Internet Legal Forms for Business.* Menlo Park, CA: Ladera Press, 1997.

Brinson, J. Dianne, and Mark F. Radcliffe. *Multimedia Law Handbook: A Practical Guide for Developers and Publishers.* Menlo Park, CA: Ladera Press, 1994.

Caplin, Lee Evan. *The Business of Art.* 3rd ed. Englewood Cliffs, NJ: Prentice-Hall, Inc., 1998.

Crawford, Tad. *Business and Legal Forms for Authors and Self-Publishers.* 3rd ed. New York: Allworth Press, 2005.

Crawford, Tad. *Business and Legal Forms for Fine Artists.* 3rd ed. New York: Allworth Press, 2005.

Crawford, Tad. *Business and Legal Forms for Illustrators.* 3rd ed. New York: Allworth Press, 1998.

Crawford, Tad. *Business and Legal Forms for Photographers.* 4th ed. New York: Allworth Press, 2009.

Crawford, Tad, and Eva Doman Bruck. *Business and Legal Forms for Graphic Designers.* 3rd ed. New York: Allworth Press, 2003.

Crawford, Tad, and Kay Murray. *The Writer's Legal Guide.* 3rd ed. New York: Allworth Press, 2002.

Crawford, Tad, and Susan Mellon. *The Artist-Gallery Partnership.* 3rd ed. New York: Allworth Press, 2008.

DuBoff, Leonard D. *The Art Business Encyclopedia.* New York: Allworth Press, 1994.

DuBoff, Leonard D. *The Law (in Plain English) for Art Galleries.* Rev. ed. New York: Allworth Press, 1999.

DuBoff, Leonard D. *The Law (in Plain English) for Crafts.* 6th ed. New York: Allworth Press, 2005.

DuBoff, Leonard D. *The Law (in Plain English) for Photographers.* 3rd ed. New York: Allworth Press, 2010.

DuBoff, Leonard D., and Christy King. *Art Law in a Nutshell.* 4th ed. St. Paul: West Publishing Co., 2006.

DuBoff, Leonard D., and Christy King. *The Deskbook of Art Law.* 2nd Rev. ed. 2 vols. Dobbs Ferry: Oceana Press, 2006.

Feldman, Franklin; Stephen E. Weil; and Susan Duke Biederman. *Art Law: Rights and Liabilities of Creators and Collectors.* 2 vols. Boston: Little, Brown and Company, 1986. Supp. 1993.

Grant, Daniel. *The Business of Being an Artist.* 4th ed. New York: Allworth Press, 2010.

Grant, Daniel. *Selling Art Without Galleries*. New York: Allworth Press, 2006.

Graphic Artists Guild. *Pricing and Ethical Guidelines*. 12th ed. New York: Graphic Artists Guild, 2007.

Heron, Michal, and David MacTavish. *Pricing Photography: The Complete Guide to Assignment and Stock Prices*. 3rd ed. New York: Allworth Press, 2002.

Hollander, Barnett. *The International Law of Art*. London: Bowes & Bowes, 1959.

Leland, Caryn R. *Licensing Art and Design*. Rev. ed. New York: Allworth Press, 1995.

Lerner, Ralph E., and Judith Bresler. *Art Law: The Guide for Collectors, Investors, Dealers, and Artists*. 3 vols. New York: Practicing Law Institute, 2005.

Liberatori, Ellen. *Guide to Getting Arts Grants*. New York: Allworth Press, 2006.

Michels, Caroll. *How to Survive and Prosper as an Artist*. 6th ed. New York: Henry Holt and Co., 2009.

Norwick, Kenneth P., and Jerry Simon Chasen. *The Rights of Authors and Artists*. 2nd Rev. ed. New York: Bantam Books, 1992.

Scott, Michael D. *Scott on Multimedia*. Aspen, CO: Aspen Publishers, 1996.

Salvesen, Magda, and Diane Cousineau. *Artists' Estates: Reputations in Trust*. Piscataway, NJ: Rutgers University Press, 2005.

Volunteer Lawyers for the Arts. *To Be or Not To Be: An Artist's Guide to Not-For-Profit Incorporation*. New York: Volunteer Lawyers for the Arts, 1986.

Winkleman, Edward. *How to Start and Run a Commercial Art Gallery*. New York: Allworth Press, 2009.

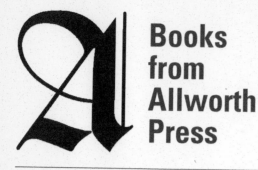

Books from Allworth Press

Allworth Press is an imprint of Allworth Communications, Inc. Selected titles are listed below.

The Artist-Gallery Partnership, Third Edition: A Practical Guide to Consigning Art
by Tad Crawford and Susan Mellon (6 × 9, 224 pages, paperback, $19.95)

The Business of Being an Artist, Fourth Edition
by Daniel Grant (6 × 9, 408 pages, paperback, $27.50)

Business and Legal Forms for Fine Artists, Third Edition
by Tad Crawford (8 ½ × 11, 176 pages, paperback, $24.95)

Business and Legal Forms for Photographers, Fourth Edition
by Tad Crawford (8 ½ × 11, 208 pages, paperback, $29.95)

Business and Legal Forms for Graphic Designers, Third Edition
by Tad Crawford (8 ½ × 11, 160 pages, paperback, $29.95)

Business and Legal Forms for Illustrators, Third Edition
by Tad Crawford (8 ½ × 11, 160 pages, paperback, $29.95)

Business and Legal Forms for Crafts, Second Edition
by Tad Crawford (8 ½ × 11, 144 pages, paperback, $29.95)

The Law (in Plain English)° for Photographers, Third Edition
by Leonard D. DuBoff and Christy O. King (6 × 9, 256 pages, paperback, $24.95)

Art Without Compromise*
by Wendy Richmond (6 × 9, 256 pages, paperback, $24.95)

Artist's Guide to Public Art: How to Find and Win Commissions
by Lynn Basa (6 × 9, 256 pages, paperback, $19.95)

Selling Art Without Galleries: Toward Making a Living From Your Art
by Daniel Grant (6 × 9, 288 pages, paperback, $24.95)

How to Start and Run a Commercial Art Gallery
by Edward Winkleman (6 × 9, 256 pages, paperback, $24.95)

Inside the Business of Illustration
by Steven Heller and Marshall Arisman (6 × 9, 240 pages, paperback, $19.95)

Guide to Getting Arts Grants
by Ellen Liberatori (6 × 9, 272 pages, paperback, $19.95)

Fine Art Publicity: The Complete Guide for Galleries and Artists, Second Edition
by Susan Abbott (6 × 9, 192 pages, paperback, $19.95)

The Artist's Complete Health and Safety Guide, Third Edition
by Monona Rossol (6 × 9, 416 pages, paperback, $24.95)

Caring for Your Art: A Guide for Artists, Collectors, Galleries, and Art Institutions
by Jill Snyder (6 × 9, 192 pages, paperback, $19.95)

Artists Communities: A Directory of Residences that Offer Time and Space for Creativity
by Alliance of Artists Communities (6 × 9, 336 pages, paperback, $24.95)

AIGA Professional Practices in Graphic Design, Second Edition
edited by Tad Crawford (6 ¾ × 10, 325 pages, paperback, $29.95)

Marketing Illustration: New Venues, New Styles, New Methods
by Steven Heller and Marshall Arisman (6 × 9, 240 pages, paperback, $24.95)

ASMP Professional Business Practices in Photography, Seventh Edition
by American Society of Media Photographers (6 × 9, 480 pages, paperback, $35.00)

The Photographer's Guide to Marketing and Self-Promotion, Fourth Edition
by Maria Piscopo (6 × 9, 256 pages, paperback, $24.95)

To request a free catalog or order books by credit card, call 1-800-491-2808. To see our complete catalog on the World Wide Web, or to order online, please visit **www.allworth.com**.